Mapping Benjamin

WRITING SCIENCE

EDITORS Timothy Lenoir and Hans Ulrich Gumbrecht

MAPPING BENJAMIN

THE WORK OF ART IN THE DIGITAL AGE

EDITED BY

Hans Ulrich Gumbrecht
Michael Marrinan

Stanford University Press
Stanford, California

Stanford University Press
Stanford, California
© 2003 by the Board of Trustees of the
Leland Stanford Junior University
Printed in the United States of America

Library of Congress Cataloging-in-Publication Data

Mapping Benjamin : the work of art in the digital age / Edited by Hans
Ulrich Gumbrecht, Michael Marrinan.
 p. cm.
 Includes bibliographical references.
 ISBN 0-8047-4435-1 (cloth : alk. paper) pbk —
 ISBN 0-8047-4436-X (pbk. : alk. paper)
 1. Aesthetics, Modern. 2. Digital communications. 3. Mass media.
4. Technology and the arts. I. Gumbrecht, Hans Ulrich. II. Marrinan,
Michael.

BH201 .M32 2003
111'.85—dc21 2003009916

This book is printed on acid-free, archival-quality paper.

Original printing 2003
Last figure below indicates year of this printing:
12 11 10 09 08 07 06 05 04 03

Typeset at Stanford University Press in 10/12.5 Sabon

To the memory of
PAUL ZUMTHOR
and
BILL READINGS

Contents

Editors' Preface xi

AESTHETICS / PERCEPTION 1, 5

AURA / DIRK BAECKER
The Unique Appearance of Distance 9

HISTORY / NORBERT BOLZ
Aesthetics of Media: *What Is the Cost of Keeping
Benjamin Current?* 24

REPLICATION / BERNHARD SIEGERT
There Are No Mass Media 30

TECHNOLOGY / KARLHEINZ BARCK
Connecting Benjamin: *The Aesthetic Approach to
Technology* 39

APPARATUS / MONTAGE 45, 49

AESTHETICS / PETER GILGEN
History After Film 53

AURA / RICHARD SHIFF
Digitized Analogies 63

HISTORY / WALTER MOSER
The *Photomonteur* Recycled: *A Benjaminian Epilogue to
Heartfield's 1991 Berlin Retrospective* 71

TECHNOLOGY / SIEGFRIED J. SCHMIDT
From Aura-Loss to Cyberspace: *Further Thoughts on
Walter Benjamin* 79

AURA / TECHNOLOGY 83, 87

AUTHENTICITY / ANTOINE HENNION AND BRUNO LATOUR
How to Make Mistakes on So Many Things at Once—
And Become Famous for It 91

FETISH / JÜRGEN LINK
Between Goethe's and Spielberg's "Aura": *On the Utility
of a Nonoperational Concept* 98

HISTORY / ROGER CHARTIER
From Mechanical Reproduction to Electronic
Representation 109

PRESENCE / URSULA LINK-HEER
Aura Hysterica or the Lifted Gaze of the Object 114

AUTHENTICITY / REPLICATION 125, 129

APPARATUS/ LINDSAY WATERS
"The Cameraman and Machine Are Now One": *Walter
Benjamin's Frankenstein* 133

PRESENCE / PAUL ZUMTHOR
Concerning Two "Encounters" with Walter
Benjamin: *The Reproducibility of Art* 142

RITUAL / ALEIDA ASSMANN AND JAN ASSMANN
Air From Other Planets Blowing: *The Logic of
Authenticity and the Prophet of the Aura* 147

TECHNOLOGY / ROBERT HULLOT-KENTOR
What Is Mechanical Reproduction? 158

CRITICAL DISCOURSE /
REPRESENTATION 171, 175

ABSENCE / KERSTIN BEHNKE
The Destruction of Representation: *Walter Benjamin's
Artwork Essay in the Present Age* 179

AURA / KLAUS WEIMAR
Text-Critical Remarks et Alia 188

FETISH / RITUAL 195, 198

APPARATUS / HENNING RITTER
Toward the *Artwork* Essay, Second Version 203

AURA / HORST WENZEL
The Reverent Gaze: *Toward the Cultic Function of the
Artwork in the Premodern and the Postmodern Age* 211

HISTORY / PERICLES LEWIS
Walter Benjamin In the Information Age? *On the Limited
Possibilities for a Defetishizing Critique of Culture* 221

POLITICS / NIELS WERBER
Media Theory After Benjamin and Brecht: Neo-Marxist? 230

HISTORY / POLITICS 239, 243

APPARATUS / JOÃO CÉZAR DE CASTRO ROCHA
Museums of the Present: *Rimbaud Reads Benjamin* 249

AURA / STEPHEN G. NICHOLS
The End of Aura? 256

PRESENCE / BRIAN NEVILLE AND BILL READINGS
A Commonplace in Walter Benjamin 269

TECHNOLOGY / JOSHUA FEINSTEIN
If It Were Only for Real 274

PRESENCE / ABSENCE 281, 285

AUTHENTICITY / MARÍA ROSA MENOCAL
The Flip Side 291

FETISH / BEATRIZ SARLO
Post-Benjaminian 301

HISTORY / ROBERT P. HARRISON
Pietà 310

RITUAL / STEPHEN BANN
Confronting Benjamin 318

Bibliography 325
Indexes: Names and Titles 337 / Concepts 343

Editors' Preface

Conceived, written, and first published—but not very widely discussed—during the mid- to late-1930s, Walter Benjamin's essay "The Work of Art in the Age of Mechanical Reproduction" has become a central point of reference in cultural studies ever since Benjamin began to receive broad international attention some thirty years later. For plausible reasons, the *Artwork* essay has been understood—and has been used—as both condensation and emblem of what Benjamin's admirers find most typical of his intellectual style: a familiarity with, and active interest in, the cultural phenomena of his own time; an awe-inspiring depth of historical knowledge; a fascination with "facts" in all of their factual bluntness; a passion for the joy of speculation reminiscent of the great protagonists of German Idealism; a commitment to political causes of the Left that does not narrow predictably the range of intellectual options. It must also be mentioned that the *Artwork* essay, beyond being read as a metonymy of Benjamin's entire oeuvre, is probably the most frequently cited and most intensely debated essay in the history of the academic humanities of the twentieth century.

The unusual appeal of this text is not due exclusively to the problems that Benjamin tackles in often innovative ways. Another reason—very likely the main one—for the authentic spell cast by the *Artwork* essay over our community of scholars and students has to do with Walter Benjamin's courage to present predictions about the future development of culture and its technical arrays. He was the marginal critic who made the claims that many of his colleagues and successors (especially during the 1960s) were dreaming but did not dare to articulate. However, this general (and certainly well-deserved) enthusiasm for what we might call "Benjamin's bet" has prevented most of his readers and admirers from admitting that the past seven decades have shown that almost none of Benjamin's central predictions have proven

to be right. Aura has definitely not disappeared as Benjamin antici-
pated; rather, it has actually conquered the field of art's technical re-
production. Film has not developed into the critical medium about
which he was dreaming; or, at least, it has not done so as a medium re-
ceived broadly by the "masses." Finally, many of us are no longer
completely convinced that Benjamin's notorious political advice—his
prescription to opt for a politicization of art against an aesthetization
of politics—is pertinent or plausible in our own time.

A realization that the central theses of Benjamin's *Artwork* essay
have not come true—a situation that bears some resemblance to Hans
Christian Andersen's tale of the "Emperor's New Clothes"—was the
starting point for the intellectual project materialized in this volume.
When we invited a broad range of scholars from different disciplines,
cultural contexts, and generations to reread and reassess Benjamin's
text in light of contemporary developments in digital recording tech-
niques, it was not our intention to "prove him wrong." Rather, we
were interested in finding answers to the question of why this particu-
lar text has so successfully engaged several generations of scholars in
intense debates, despite a failure of the historical prognostication that
Benjamin took to be its central function. To continue with the analogy
of Andersen's tale: it turned out that the emperor was not wearing the
clothes he was supposed to wear, but he was fascinating nonetheless,
even if why this is so was not entirely clear. The clusters of short essays
presented in our volume have collectively opened, shaped, and devel-
oped a very specific hermeneutic situation. On one hand, to admit the
"failure" of Benjamin's predictions leads us to reconstruct the historical
specifics of Benjamin's intellectual context (the mid-1930s) within
which his prognoses might have been plausible. On the other hand, the
direction and dynamics of our questioning obliges us to rethink our
own cultural, technological, and media environments at the beginning
of the twenty-first century.

The distance and contrast between our situation and that of Walter
Benjamin are what the title of our book tries to capture: a mapping
that measures the distance and locates the coordinates of Benjamin's
essay so as to clarify the contrast that accounts for the essay's strength
and intellectual appeal. Precisely because Benjamin's critical concepts
and his analytic yield were so historically specific—probably more spe-
cific than even Benjamin imagined—they have obliged later generations
of readers to ask: what, precisely, have been the intervening changes in
the relationship between the arts (in the largest sense of this word) and

their technological environments? There can be no single answer to such a question, nor even an emerging point of convergence: certainly not in this book, and probably not in today's debates within the Humanities. Indeed, we believe the most compelling reason to read and to think through the essays presented here lies on a different level, one that was not necessarily part of our original conception of this project. This level, this plateau, is a mapping of the intellectual field established and shaped by Benjamin's *Artwork* essay. When we speak of a "field" here, we use the metaphor in the sense of "magnetic field," because the essays we received have convinced us that the mapping of Benjamin's concepts is dynamic, never completely closed, uneven in its zones of intellectual intensity, and constantly offering and asking for revisionist moves. Representing many different reactions to Benjamin's text, the essays characterize it as a dynamic force field of concepts; at the same time, they establish a conceptual field of their own—one that proceeds from Benjamin's provocations without necessarily repeating the basic outlines of his thought.

Our intuition about this secondary effect has structured our presentation of the essays. Based upon our own reading of the *Artwork* essay, we isolated sixteen critical terms that seemed germane to Benjamin's analysis. We decided to proceed, in a strictly formal operation, by "tagging" each of the thirty readings with the three most apparent conceptual links to Benjamin's text, selected from our pool of sixteen. As it turns out, this extremely formalized approach helped us to cluster the different readings of Benjamin into overlapping zones of intellectual interest and intensity, while it simultaneously marked out the zones of intellectual space that our volume would have to leave blank. The Table of Contents is no less than the schematic diagram of this mapping operation.

Rather than trying to summarize each of the thirty essays in a "traditional" editors' introduction, we have elected to develop the armature of the mapping presented by the Table of Contents. In a second— equally arbitrary—formal decision, we grouped our sixteen key terms into eight pairs of juxtapositions, corresponding broadly to their use and function within Benjamin's argument, yet sufficiently distinct from it to draw the contours of new terrains that might simultaneously connect back to the *Artwork* essay and open onto contemporary cultural concerns. In so doing, we wanted to re-create some of the conceptual tensions that give the *Artwork* essay its famous intellectual dynamism (perhaps one could even say its productive intellectual unrest). We then

wrote, independent of one another, commentaries on "one side" of each pairing, trying in each case to refer centrally to the "other side" of the pair. In other words, we wrote eight "dialogues" to open or chart the intellectual terrain for the eight large sections of the book. Instead of a single running commentary written in a mastering voice, we offer something akin to a zigzag of ideas to sketch the horizon of a space in which the heterogeneous voices of the essays themselves might interact. Proceeding from the complexity of the *Artwork* essay that we assume Benjamin intended, yet cognizant of the alternate mapping suggested by the diverse readings of that essay presented in this volume, our interventions—in two times eight "stations" within the volume—both develop and engage the interpretations, insights, and proposals suggested by our thirty authors. As the word "stations" might suggest, our "commentary" is somewhat discontinuous and certainly not definitive: in fact, we designed it to be intrinsically inconclusive.

Historically speaking, Benjamin's *Artwork* essay has been an amazing catalyst for intellectual activity: our goal for this collection was to ride the essay's momentum without exhausting its energy. Indeed, we believe the lasting power of Benjamin's work resides in its ability to complexify our thinking about culture even today—despite our "full immersion" in the data streams of the digital age.

Mapping Benjamin

AESTHETICS

> Originally, the contextual integration of art in tradition found its expression in the cult. We know that the earliest art works originated in the service of a ritual (223)

> With the advent of the first truly revolutionary means of reproduction, photography, simultaneously with the rise of socialism, art senses the approaching crisis which has become evident a century later. At the time, art reacted with the doctrine of *l'art pour l'art*, that is, with a theology of art. This gave rise to what might be called a negative theology in the form of the idea of "pure" art, which not only denied any social function of art but also any categorizing by subject matter (224)

> Thus, for contemporary man the representation of reality by the film is incomparably more significant than that of the painter, since it offers, precisely because of the thoroughgoing permeation of reality with mechanical equipment, an aspect of reality which is free of all equipment. And that is what one is entitled to ask from a work of art (234)

> [Art] will tackle the most difficult and most important [tasks] where it is able to mobilize the masses (240)

> This is the situation of politics which Fascism is rendering aesthetic. Communism responds by politicizing art (242)

At first glance, it looks as if concepts like "art," "artist," "artwork," and "aesthetics" did not rank very highly in Walter Benjamin's appreciation. It must have been the first self-assigned goal of his essay to develop new—and not necessarily critical or nostalgic—concepts of "art" and of "aesthetic perception," concepts that he wanted to correspond and to react to the most advanced contemporary environments in technology and politics. But as these new concepts of art (necessarily perhaps) remained quite vague, the meaning and the connotation of the word "art" continued to depend heavily on Benjamin's view of art's traditional positions and functions. The "earliest art works," he believed, "originated in the service of a ritual," and "cult," for Benjamin, was the context that had determined the place of art in society. Now,

what bothered Benjamin about the cult was the idea that it tends to completely "absorb" the spectator's (or the worshipper's) attention—whereas Benjamin's ideal vision was that of a flexible and distanced type of perception, a perception that would give the recipient's reaction and judgment more independence.

Benjamin believed that the traditional concept and the traditional practices of art had managed to escape (temporarily at least) the challenges of the new medium of photography (and, as he insinuated, of socialism) by developing the ideology of *l'art pour l'art*—and by thus cutting off their relations with modern society. While the specific claim of a correlation between photography and the emergence of an ideology of *l'art pour l'art* can be regarded as Benjamin's own, original thesis, criticisms of the ideas and the phenomena of "aesthetic autonomy" had been commonplace among avant-garde intellectuals at least since the beginning of the twentieth century. Obviously, the doctrine of autonomy implied the idea of a distance separating art from society. But what had been a proud title of independence for many artists and Bohemian intellectuals throughout the nineteenth century was now turning into the observation that autonomous artworks could progressively lose content (could "deny any categorizing by subject matter") and might thus no longer be able to fulfill specific functions within society.

Today, even for those who take the structural fact of art's autonomy for granted (although there is ample reason to doubt it), the question may come up whether it would indeed be scandalous if art didn't fulfill any social functions. In contrast, what made the obsession with art's autonomy so painful for artists, critics, and connoisseurs, especially on the political Left during the 1920s and 1930s, was the (well-justified) fear that the political Right knew better how to put art to economic and political use. It is against this fear—but also within the general expectation of history making "progress"—that intellectuals like Walter Benjamin or Bertolt Brecht, who had the ambition of being recognized as Marxists (but also eminent artists and theorists of art with less outspoken political convictions, such as Kandinsky and Meier-Graefe, Clive Bell, Roger Fry, and Clement Greenberg), tried to come up with new conceptions of art in which new instruments of artistic production, sociologically different groups of recipients, and revised functions of art were to be combined into a complex movement of convergence. Among a range of programmatic possibilities, Benjamin was opting for a redefined concept of art that lay at the intersec-

tion of his hopes invested into new media (photography and, above all, film), of "the masses" as a new target group of artistic production, and of "perception" as a notion associated with a "different"—that is, more "distant" and more "analytic"—mode of reception.

But who are the masses? The word does not refer to truly new phenomena. Rather, it focuses, from a new angle, on what used to be called, throughout the eighteenth and most of the nineteenth centuries, "the people," "the nation," and also simply "society." The new angle that produced the concept of the masses was indeed the angle of perception—that is, the angle of a world-appropriation based on the senses. Perception is opposed to experience—that is, to world-appropriation based on concepts. The discourse of perception had emerged during the eighteenth century (facilitating, among other things, the emergence of aesthetics as that philosophical subdiscipline which includes sensual perception)—although, strictly speaking, the idea of a "discourse of perception," of a repertoire of concepts based on perception, is an oxymoron (because the distinction of perception and experience presupposes that concepts belong only to the side of experience). If, however, the association between the masses and perception was simply based on the assumption that a large group of people would appear as a "mass" as long as it was perceived from a strictly sense-based angle (if it presented the masses as an object of perception), Benjamin, in contrast, seemed to fill the concept of "perception" both with specific political hopes invested into the proletariat and with the new concept of a no longer "autonomous" art whose subject the masses would be.

All these hopes and hopeful attributions came together in Benjamin's—programmatic and programmatically positive—concept of the "exhibition value" of art. But while it is clear that "exhibition value," in Benjamin's discourse, stands in contrast to the "cult value" of traditional art, the implicit relation between "perception" as the body-based form of world-appropriation, on the one side, and, on the other side, "distanced," "analytic," "nonabsorbed" reactions was never clarified in the context of an explicit argumentation. Nevertheless, striking up the discourse of perception, Benjamin—at least indirectly—put a question on the epistemological agenda that has become (once again?) central for us since the late twentieth century. It is the question regarding the relation between experience and perception. We might go so far as to say that philosophical aesthetics is enjoying an increasing interest today because it cannot avoid the problem of the relation between ex-

perience and perception. This is an epistemological interest whose pertinence transcends the limits of a "theory of art and literature."

By comparison, those strong statements of the 1920s and 1930s about art as a natural medium of political solidarity and political opposition have lost much of their appeal during the past three decades. In part, this may have to do with some sobering empirical evidence. By now we know, for example, that the art forms with the purest political intentions of the Left are not always the most successful in "mobilizing the masses." We also know that the "masses" have shown an—unfortunate?—preference for indulging in melodramatic content and, above all, in the cult of the actor, rather than going for the most avant-garde techniques of artistic production. Of course it is easy to interpret—and to thereby dismiss—these facts by saying that they are the sad outcome of capitalism's victory in the twentieth-century arena of political and ideological battles. But one could also speculate that, even within a different political scenario, Benjamin's prognosis about the art of his future would not have come true—because of an intrinsic conceptual problem. This conceptual problem concerns the unclear status of the senses and of sensual world-appropriation within Benjamin's emerging theory of aesthetic experience. Likewise, within our changed intellectual and cultural environment, many of us are no longer completely convinced that the "politicization of art" is a universally positive principle, and the "aestheticization of politics" a universally negative one. In other words: we have become less optimistic than the 1930s about what we may now (ironically) call the "teleological efficiency of politics"—and less modest (or even less systematically suspicious) when it comes to assess the intrinsic values of art.

PERCEPTION

The manner in which human sense perception is organized, the medium in which it is accomplished, is determined not only by nature but by historical circumstances as well (222)

[P]hotographic reproduction, with the aid of certain processes, such as enlargement or slow motion, can capture images which escape natural vision (220)

For the entire spectrum of optical, and now also acoustical, perception the film has brought about a deepening of apperception (235)

[If] changes in the medium of contemporary perception can be comprehended as decay of the aura, it is possible to show its social causes (222)

In a long footnote (n. 8) dedicated to explain the polarity he sets up between "cult value" and "exhibition value," Benjamin remarks—almost in passing—that it "cannot come into its own in the aesthetics of Idealism." He goes on to suggest that Hegel himself was not clear about how to account for the transition from "the first kind of artistic reception to the second," and he uses an example of recent scholarship on Raphael's *Sistine Madonna* to illustrate how, in fact, "a certain oscillation between these two modes of existence can be demonstrated for each work of art."

Benjamin's notions of "cult value" and "exhibition value" can be mapped onto the two dominant accounts of perception in Western philosophic thought still current in his day: on one hand, a "nativist" model in the spirit of Spinoza and Kant; on the other, an "empiricist" model best represented by the tradition of Locke and Hume. For the first group, perception is an innate skill, while the second claims that it is a learned behavior. Moreover, the process of perception differs dramatically within each model: nativists are also rationalists who believe that perception is an active, deductive, and interpretive process; empiricists claim that perception is a passive activity, an inductive process that works with the raw material of sensory data. Finally, nativists tend to think of individual percepts as structurally coherent (gestalt psychology is an example), whereas empiricists consider the percept itself to be

a singular arrangement of distinct elements (basic premise of cognitive psychology discussed below). In short, to make the transition from a magic-laden, highly revered image of "cult value" to an object whose "exhibition value" depends upon an appreciation of specific salient qualities is to pass from one model of perception to another: not only is it "easier to exhibit a portrait that can be sent here and there than to exhibit the statue of a divinity that has its fixed place in the interior of a temple" (225), but we effectively perceive them in radically different ways.

Benjamin sensed there was a problem in Hegel's treatment of value in works of art, and he tried to avoid the same pitfall by suggesting that a somewhat alchemical process was now underway: "With the different methods of technical reproduction of a work of art, its fitness for exhibition increased to such an extent that the quantitative shift between its two poles turned into a qualitative transformation of its nature" (225). How can this be? Because the camera—especially the movie camera—is able to show us things that "escape natural vision" and thereby expand and deepen the range of human apperception.

A threat, one that is profoundly connected to "humanity's entire mode of existence," lurks in Benjamin's thinking; namely, that the fundamental parameters of perception itself might escape the limits of our physical bodies. If the old polarities that circumscribed our perceptions of works of art lay comfortably on the continuum from "cult value" to "exhibition value," Benjamin seemed unable—or unwilling—to think of a technically expanded field. Nor could he think of human perception in the ways that contemporary cognitive psychology has reframed our understanding of it: the body as "information processor" that deploys a complex system of long-term and short-term memory storage, of hierarchical coding schemes, and a modular chain of cognitive operations very much like a computer. Indeed, today's dominant model of perception is perfectly attuned to the production and dissemination of digital data in which images or sounds are reduced to code, compressed according to algorithmic standards (JPEG or Dolby), transmitted, decompressed, and re-experienced with no perceivable loss of detail or resolution.

Unable to conceive the seemingly inhuman models of perception that are stock-in-trade of our digital culture, Benjamin retheorized what he already knew—the nativist/empiricist duality of his philosophical training—into the corresponding poles of "cult value" and "exhibition value." As for that "certain oscillation between these two po-

lar models"—without speaking of its unthinkable disappearance—we might then understand the intellectual background of aura as Benjamin's last-ditch effort to save, in the face of a growing challenge from technology, the physical limits of our human bodies as the yardstick of perception itself.

The Unique Appearance of Distance

An ambivalent position

"Art in the era of its communicational reproduction" could be the title of an essay concerned with the shift of reference that would be required when moving from the theory of art presented by Walter Benjamin in "Das Kunstwerk im Zeitalter seiner technischen Reproduzierbarkeit"[1] to that worked out by sociological systems theory.[2] The latter no longer dwells on the problem of technical reproducibility, but rather the problem of communicational reproduction. At issue is not the loss of aura attributed by Benjamin to technology, but rather the almost inevitable reappearance of aura as the result of communication and irrespective of the technology deployed. In what follows I will not present a full-fledged sociological theory, but will only sketch some first ideas toward recontextualizing Benjamin's notion of aura in art.

Benjamin noted shifts in the media of perception that he attributed to social changes in the superstructure of capitalist production—changes that both brought into reach and jeopardized the seizure of power by the proletariat. On one hand film, like architecture, presented itself as a medium of perception that no longer required the beholder's undivided attention, but rather encouraged distraction. As such, both film and architecture conform to a mode of reception in which the masses do not so much lose themselves in the work of art as let the work lose itself in them. On the other hand, this mode of reception is completely appropriate to the seductive ends of Fascism.

Fiona Greenwood assisted in the editing of this paper.

1. *Editors' Note*: Parenthetical page references in this essay are keyed to the edition of Benjamin's text listed in the Bibliography as: Benjamin, "Das Kunstwerk" (*Gesammelte Schriften*, 1974).

2. See Luhmann, "The Work of Art and the Self-Reproduction of Art" and "The Medium of Art."

This is why Benjamin was ambivalent about such changes in the medium of perception. It is characteristic that he does not speak of the "proletariat" but of the "masses," which suggests a reservation, a moment of judgment, which produces a tension in the text that makes it possible to observe with equal precision both vanguard developments and the uneasiness experienced by observers. When works of art are immersed in the masses, what becomes of people like Benjamin? What place remains for people wholeheartedly committed to the perceptive mode of composure and aware of the secrets hidden in works of art, but—although on the side of the proletariat—certainly not committed to a society in which the proletariat has seized power? Of what usefulness is keeping the bourgeoisie at a distance—carefully cultivated in a very bourgeois manner—if this distance, once established, cannot further the emergence of a society in which all distance is impossible, where everybody and everything are in close contact?

Benjamin welcomes a deconstruction of traditional notions—such as creativity and ingenuity, eternal value and secrecy—propagated by new media of perception like film that are based on a structural shift from statuesque to sequential, from immobile to movable, and from spatial to temporal. But his next phrase emphasizes that an uncontrolled adherence to traditional notions can be fatal because of their suitability to Fascist practices. The implication is that one can preserve certain traditional notions if one is careful to control them. Thus, it is possible to read Benjamin's text as an attempt to critique and control these notions, even in those areas where their dismissal is not just at issue but already a fait accompli. Benjamin is as interested in understanding the deconstruction of tradition as in reconstructing a secure position for the observer, who is about to become the victim of deconstruction.

Theodor W. Adorno sensed very well Benjamin's ambivalence. One of his letters to Benjamin concerning the *Artwork* essay is perfectly legible as a plea in favor of art and its intrinsic values over an art so proletarianized that it becomes useless as a sensor of social change or, most important, as a tool to remember unredeemed social possibilities.[3] Adorno pleaded for an autonomous art, conducting experiments with matter, form, and meaning, and open to the retrospective interpretation of an observer who assumes that art is committed to the betterment of

3. See Adorno's letter dated 18 March 1936, reprinted in Benjamin, *Gesammelte Schriften*, I, 3, pp. 1001–6.

society. Adorno pleaded for the maintenance of such an observer posi-
tion, and consequently for the maintenance of a critical stance whose
social justification depends upon the assumption that the society in
question deserves to be criticized. In this respect, Benjamin and Adorno
agreed in their assessments of Mallarmé and jazz: they are both suc-
cessful forms of art and obvious seductions of the masses. For the same
reasons, they disagreed about Bertolt Brecht and Charlie Chaplin: the
popular success of Chaplin's movies, obtained by means of a Brechtian
defamiliarization, was seen by Adorno as a betrayal of Brecht's Chap-
linesque intentions.

The cult value of the work of art

There can be no discussion of the autonomy of art without bringing
to bear an argument relative to what one understands a work of art to
be. When Benjamin defined aura as a "unique appearance of a distance
however close it may be," one wonders if this might not also be the
definition of a work of art (479). Benjamin designed his definition of
aura to be applied to the "cult value of the work of art." One might
ask: what characterizes something as a "work of art" if not this cult
value? Were not Benjamin and Adorno—followed by Ernst Bloch and
many others—interested in works of art precisely because they exhibit
this cult value of a unique appearance of distance?

Such questions about works of art are not answered by Benjamin's
thesis on the loss of aura in the era of technical reproducibility. Rather,
they are made unanswerable. Reverting to what Kenneth Burke calls a
"planned incongruity,"[4] Benjamin attributes the loss of aura, on one
hand, to the passionate desire among contemporary masses for closer
contact with things both spatially and humanly, and, on the other
hand, to new possibilities of technical reproduction, many of which en-
tail the loss of tradition or cult (479–80). Of course, all this is part of
the same problem, which has not been made any clearer. Is aura a
function of the cult surrounding a work of art? Is it a function of the
nonreproducibility of a work of art? Or is it a question of a form of re-
ception not used by the masses and not taught to them?

Benjamin avoids answering these questions, although he employs a
criterion derived directly from his definition of aura. He does not name
the specific distinction between distance and closeness as the salient

4. See Burke, *Permanence and Change*, p. 91.

characteristic of aura, but rather the uniqueness of the "appearance of a distance, however close it may be." The "here and now of the work of art"—note that he specifies a work of art and not a work of cult—is at stake when it loses its aura (475). Herein lies the rationale for the title of Benjamin's essay: technical reproducibility, not the masses' reception nor the loss of tradition, both questions this uniqueness and cancels it. In short, Benjamin passes the buck to technical reproducibility.

It remains an open question whether technical reproducibility—engraving, etching, lithography, photography, and eventually film—is the condition for a shift in the medium of perception from composure to distraction (and subsequent loss of ritualistic traditions), or whether, vice versa, changes in the medium of perception (and subsequent taking of liberties with ritualistic traditions) facilitate and encourage technical reproductions. Benjamin did not decide this question, and we are even less tempted to decide it today, for we would be obliged to consider the phenomenon of coevolution made possible by accidental achievements, and stabilized by changes in social attitudes, which may have altogether different motivations.

Nonetheless, it seems clear that if we are to assess Benjamin's suspicions about a loss of aura, we must accept the thesis that uniqueness of "here and now" of the work of art has been lost. Benjamin did not literally demand that a work of art be unique. He did not mean by uniqueness that there is nothing in the world comparable. Rather, uniqueness is the condition of the possibility of a work's "here and now." Every work of art exists alongside other works of art in the "imaginary museum" described by André Malraux. Only by being compared to something similar does the uniqueness of a thing become evident. A work of art becomes incomparable by being compared, and it is unique because something comparable also exits.

Cult value contributes even less toward making a work of art unique, because cult value essentially depends upon repetition and is the precondition for the communicational reproduction of a work of art. Whenever and wherever a cult is practiced, one finds works of art important to the cult. In Christian culture, for example, pictures of the Virgin Mary proliferate, although one might say that to the degree their attraction remains framed by the cult they do not count as works of art. Their value within cult practice neutralizes a comparison with similar kinds of artifacts not associated with the cult: such images are monads in the Leibnizian sense in that they have but one window—that is, one reference or reverence—and it looks constantly upward.

But when a work of art is emancipated from this traditional role within cult practice, it not only loses cult value but it also gains new windows opening toward several sides. It now demands to be viewed as something that once had cult value, and the beholder who is interested only in cult value must now "cover" the side windows, close the doors, and make an effort to imagine the work of art as a black box looking only upward. Unfortunately, one cannot ignore the covered windows, and that awareness spoils the cult experience.

The uniqueness about which Benjamin writes is the epitome of experiencing a work of cult as a work of art: it is a made artifact that points to something that cannot be made; it conjures up a distance yet remains perfectly proximate. Benjamin's aura is characteristic for a work of art in a nonart—in this case, religious—context: the loss of aura is the trace left behind by a work of cult when it is removed from its religious context and placed in the new context of art. In short, the loss of aura is the memory of religion in art.

Keeping in mind the role of comparison discussed above, a work of art becomes unique when the beholder of art encounters an object in a foreign terrain: in cult. When a beholder of art identifies as "art" something that is not—strictly speaking—a work of art, a "loss of aura" is produced at the moment of identification. To name a cult object a "work of art" entails a simultaneous acknowledgment that it is "no longer a work of cult": the beholder of art generates his own problem by guaranteeing a suffering that enhances his pleasure of art as a memory of something lost. This self-canceling operation of naming produces the play of tensions around Benjamin's discussion of the loss of aura. A work of art is distinguished as such, but what one values as the "art" component cannot be identified, although the functional dimensions of the object—its role in cult or art appreciation—can be distinguished from one another and still held to be indistinguishable. In this case, differentiation is motivated by de-differentiation.

The explosive nature of this naming operation resides in the fact that it can be performed only by the observer or, in the present case, only by Walter Benjamin. Benjamin maintains that the cult value of a work of art, meaning its uniqueness, cannot be sustained in a comparable work of art nor in a work of cult that, following the demands of a cult, must be repeatable. It can only be sustained in the process of making-and-canceling the distinction between art from cult, which is an act of the observer rather than a function of the work.

A *blind man seeing*

Are Benjamin's meditations on a theory of art therefore invalid? Must we change our context for reading Benjamin and accept him as a philosopher who both reveals and conceals his expectations with respect to art? with respect to works of art? with respect to the cult value of a work of art? Or should Benjamin become our model for the beholder of art (indispensable for the communicational reproduction of art in modern society) who works his way through the various levels of expertise—that is, levels of comparison—and yet claims that expertise and comparison are the least important issues? Does his insistence on the lost cult value of art sanction or condemn the reproduction of supposedly unique works of art? Does he imply that artists, along with beholders, have access to that context of transcendence to which all immanent operations of art owe their appeal, their meaning, and their wit? Is his theory of art really a theory of beholding art—that is, a theory anchored in the phenomenology of looking and concerned with distinctions that may be of use when looking? Had Benjamin already sensed what Jean Baudrillard later described as the loss of all negativity in the infinitely positive operations of hypermodern society?[5]

That kind of prognosis would at least make comprehensible the endless fascination with Benjamin's position, which is almost as fascinating as a work of art. We seem to have covered the side windows of Benjamin's black box and focused only on its tendency to look upward. We refuse to see the architecture of Benjamin's thought and position him as the guarantor of an altogether different agenda. That is why reading Benjamin is so often ritualistic: it consists of second-order observations—observations about observing Benjamin's observations—whose point is to explain why one cannot see what Benjamin saw, because Benjamin himself could not see the lost cult value of a work of art. This kind of ritualistic reading observes a man who is essentially blind, and does so precisely because of that blindness.

Of course, there is another way to read Benjamin. One can forgo treating the paradoxical construct of his discussion as if it were itself an artwork, and take a cue from a term in his definition of aura to ask whether it might be better suited—pro and con Benjamin—to define the work of art. Let us return to the insight that Benjamin's eye is the

5. Baudrillard, *La transparence du mal*, passim.

eye of a beholder of art who is happily unhappy: his blindness is self-imposed. What he sees in the instant before blindness, and which can never be seen again, is the "appearance of a distance, however close it may be." Visible only once, and thus truly "unique," this appearance forces Benjamin to accept a kind of blindness, because he must not see closeness in order to see distance, and he must not see distance in order to see closeness. For Benjamin, to "see" this appearance he must blind himself to the distinction between distance and closeness, but he must also conceal this blindness in order to speak of "distance" and "close-ness" as distinct terms.

The distinction between distance and closeness occurs in the blind-ness that enables Benjamin to observe the work of art as a work of cult. The beholder's blindness is the condition for making this distinc-tion, because Benjamin wants to suggest that the terms refer to proper-ties inherent in the work of art/work of cult rather than concepts im-posed upon it. But Benjamin thwarts himself by not building the rest of his argument on this distinction, preferring instead to base it on the loss of aura in art forms that are supposed to be socially determined and constituted. This double act of self-obstruction makes it difficult for us to determine if Benjamin knows what he is doing. But this blind man also sees: like the three-crane-model of a crane flying behind itself in order to see itself flying behind, Benjamin adopts a model of third-order observation that is actually a second-order self-observation.

All of this returns us to the question: is Benjamin the model for a perhaps philosophical gift to a theory of observation? A model for self-observing, paradoxical observation able to reflect upon the indistin-guishable of what is distinguished by one's own distinctions? A model for a divine piece of devilry able to constitute a system almost without conceding the use of necessary distinctions? Or is there hidden in Ben-jamin's maneuver an insight into what constitutes a work of art that might be useful outside philosophical or theological contexts? In other words, is aura Benjamin's bridge to theology, or is it a bridge to a the-ory of art? (Such a question assumes that a nontheological theory of art exists—Benjamin would probably be ambivalent and affirm its possi-bility and resolutely deny it.) I will not follow any further the trajectory of Benjamin's thinking into an art of paradox, but ask instead whether his ideas about art can be supported by a theory of art. (This suggests, perhaps inadmissibly, that one can have a theory of art without an art of paradox: I will return to paradox later.)

"The appearance of a distance, however close it may be" is a definition that immediately places aura at risk. Benjamin's definition implies that observing a work of art constantly presents a choice: one can attend to the distance conjured up by the work, or to the techniques deployed in the work of art to conjure up the distance. Moreover, one can switch from one to the other—from what is present and absent in the distance to the material techniques used when presenting that absence—and one can repeat this back and forth process many times. In fact, Benjamin's observer eventually realizes that one misses the work, as such, when making this switch, for only by viewing together what one knows is separate—distance and closeness—does one apprehend the work as such. This means that evaluating a work of art can end only in an act of recognizing that its aura is lost. We look for something that is "missing," but if we stop looking without finding it we say the thing is "lost." So too for Benjamin's observer: the work of art gains aura by losing it, by engaging us in a search for the "unique appearance of a distance, however close it may be," yet when our searching stops aura remains hidden; it is "lost." Aura is present so long as we regard the object as a work of art, and in this way we can say that "aura" and "work of art" are functionally identical.

A determined indeterminateness

What happens if we do not take Benjamin's notion of aura as the experience of loss, but as the definition of the work of art? What if we treated Benjamin's insight as a "theorem" that could be exported from his text for use "inside the frame" of a work of art? In short, is it possible to read Benjamin without getting lost in Benjaminian exegesis? Obviously, such an attempt forces us into art theory, and notably into the question of how to differentiate art in society. If the task of aesthetic theory "after Adorno and Derrida" is to acknowledge art as the sovereignty of its autonomy, then one must (a "must" resulting from the type of question posed) look for an "aesthetic operation" that determines art as simultaneously work and observation.[6] One must ask: what does art communicate, and what distinguishes that communication from every other communication in society?

Christophe Menke, following modern aesthetes, determines the imperative moment of aesthetic understanding, as that of a "de-automat-

6. See Menke, *Die Souveränität der Kunst*, passim.

ing processuality."[7] He means by this that there is a delay of understanding generated by irritations, a delay that produces its own temporality. While working on these irritations, understanding is both anticipated and delayed, and that temporal deferral shifts the contingency of understanding onto the work of art. Obviously, the most important element of this procedure is the delay, for slowing down the process of understanding reveals the degree to which it is summoned up by what is to be understood. In the language of systems theory, the delay guarantees the other-reference of the self-reference. For the true aesthete, it matters that what is to be understood consists entirely of his own performance of understanding. For him this delay must be infinitely long: anything less falls short in a situation where approaching the material object is assumed to be an experience of unreachability, and where understanding is taken to be recognizing the limits of understanding (the model for this type of description is the Kantian sublime, in which the beholder's attention, as Lyotard maintains, is able to switch from the form—the beautiful—to the matter—the sublime).[8] Closure risks laying bare the self-referential construct of the distinction between self-reference and other-reference: more than anything else, the aesthete wants to avoid admitting this intrinsic performativity.

Thus, the problem of the aesthete is not a problem of art. While the aesthete demonstrates his special relationship to the material object by showing that his understanding is infinitely delayed, the work of art goes about its business as a discrete thing. Art lures the aesthete, a learned observer, into oscillating between the poles of an undecidable question, which he freights with various motives and contexts, until that moment when he comes to view his own considerations as a work of art in itself—and he publishes them. The work of art, however, is finished well before, as soon as decisions are made that release undecidability. Certainly, publications of the aesthete play a role in this, so that the circle begins to close again, leaving determinate indeterminateness to the discretion of a society that is both fascinated and indifferent. (It is not the achievement of art in isolation, but the achievement of art in a society attuned to just such an art that makes the originary irritations possible.)

My point is that Benjamin's "unique appearance of a distance, however close it may be" can be interpreted as a model for describing

7. Ibid., p. 51.
8. Lyotard, "After the Sublime," pp. 297–304.

this determinate indeterminateness. In such a reading, the delay attributed by the aesthete to the work of art would be the product of a distinction between distance and closeness which must be both drawn and not drawn if one wants to participate in the aura of a work of art. The delay is produced by oscillating between observing distance and observing closeness: time is not extended by pausing in either of these operations, but only—if this were truly possible—in the open-ended duration of the oscillation itself. For the aesthetic operation of a work of art and its observation, distinctions between distance and closeness must endlessly mirror themselves, with each pole constantly reappearing in the other: if one approaches closeness, motives are found that refer to distance; approaching distance, one nevertheless remains aware of the near-at-hand material techniques that make it visible. From this dynamic arise observations that provide a work of art with something it can only feature as lost: an aura as the unique appearance of a distance, however close it may be.

According to the calculus of indication projected by G. Spencer Brown, an aesthetic operation requires that the distinction between distance and closeness be capable of re-entry.[9] Moreover—and this is what is at stake for Benjamin—the distinction must already have reentered the domain of art, since there could be no talk of it otherwise. Art is auratic by loss only if it both draws the distinction between distance and closeness and simultaneously reveals it. However, in order to reveal the distinction—that is, to make it visible—an art of auratic loss cannot draw it or, at least, cannot draw it while showing it. Spencer Brown's point is that a distinction can be said to have re-entered the domain of the distinguished if it can be observed with respect to its performance: as an operation the distinction is a "cross"; as something observed—that is, when distinguished among others—it is a "marker." As a marker, a distinction cannot perform, but it is only as marker that its performance can be described. From this paradox follows the general rule that we function in the world by doing what we do only because we do not know what we are doing, for when we know what we are doing we are already doing something else.

In this way, we can say that Benjamin's attention to lost aura of works of art amounts to writing an "unwritten cross." A work of cult is the unique appearance of a distance, however close it may be. But as soon as it is described as such, it is no longer what it was. Rather, it

9. See Brown, *Laws of Form*, passim.

becomes a "work of art" able to play at being a work of cult—if we take "play" to mean performing and showing distinctions at the same time.[10] The work of art marks itself as something that once was nothing other than a real distinction.

The communication of perception

It is indeed surprising that at the very moment art reveals itself as play it does not end. Rather, it takes up religious motives to become a secular version of the difference between transcendence and immanence still ritualized in churches but no longer really credible. This is why one still finds the masses immersed into works of art in contemporary museums and exhibitions, an immersion exactly opposite to what Benjamin expected. Of course religion has also had its revivals, and did not completely surrender its function to art. So we can ask: what might be a social function for art that does not consist of simply inheriting the functions of religion? We do not know what happened when works of cult were suddenly recognized and named works of art. But this lacuna does not exclude the hypothesis that at this very moment of art's differentiation there emerged a social function for it, which took charge of its continuation and communicational reproduction with a far greater reliability than theological or eschatological motives could ever muster.

Art is traditionally burdened by its origins in procedures of immanent visualization of transcendence. The more clearly these procedures are seen as procedures, the less they support the claim of transcendence. Transcendence can be destroyed repeatedly and be conjured up again and again, but at some point it nonetheless vanishes. At this moment, other purposes and other problems can appropriate these procedures, which are then varied as needed. My suggestion is that art is the achievement of a special type of communication that develops in conditions of increasing social differentiation of society—namely, an increasing problematization of the self-referentiality of communication. It develops in response to the problem posed when a society discovers that it can communicate, but not perceive. Perception can only be exercised by consciousness, which we might call psychic systems in the environment of social systems. To see, hear, taste, smell and feel are faculties reserved for operationally closed psychic systems observing the organic system of their environment.[11] Art, I have suggested elsewhere,

10. Bateson, *Steps to an Ecology of Mind*, pp. 177–93.
11. See the several essays by Luhmann, *Die Soziologie und der Mensch*, passim.

compensates for the inability of communication to perceive by communicating perception itself.[12]

Thus, we might translate "the unique appearance of a distance, however close it may be" as "the communicational addressing of perception." The essential term of this translation is *addressing*: on one hand, to "address" implies communication; on the other hand, to "address" perception also implies a communicative dimension, insofar as perception must be addressable. Art "addresses" perception by stimulating all the senses—sight, sound, taste, smell, touch, and sense of space—and it communicates this address. It moves further away from or closer to that which it faces as perception and, in this back-and-forth movement, it has recourse to communication when addressing perception. The oscillation deployed by the work of art, and noted by the aesthete, is literally an oscillation between references to communication (society) and references to perception (consciousness).

When describing a work of art, and already in its making, this oscillation cannot be stilled. Rather, its perpetuation is guaranteed by the fact that every work of art is an object of perception and, more than this, an artifact that inevitably references the circumstances of its communication, the way an electric spark jumps the gap between two energized poles. I suggested earlier that the work of art lives a paradox, in a state of indeterminateness and undecidability. Ideally, the entire coevolutionary history of communication and perception should be considered when describing a work of art. But replacing that impossible history is an actual operation that is only a communication of perception: not perception itself, but informed by perception on the other side of an ecological, thus unbridgeable, difference between communication and consciousness. (Heidegger also posits an ecological difference—a "fissure"—when he situates the work of art within a circle of artist, art, and object and defines that place as the site of a combat between earth and world, closure and opening.)[13]

The claim of uniqueness couples the ideal of art to an object: there is no art without works of art, and every object is unique. In these works, art allows itself to be attributed to communication and to perception without being wrapped up in either of them. Every work of art is an object of perception and an element of communication. The work confirms and bridges the ecological difference between communication

12. Baecker, "Die Adresse der Kunst."
13. Heidegger, "Der Ursprung des Kunstwerkes," pp. 1–72.

and perception, and it takes the place of this difference in every instance where art reproduces itself as art.

The hypothesis of situating art at the boundary between communication and perception is remarkably simple—so simple, in fact, that one may call it socially robust to the degree that art can rely on it even when aesthetics do not follow suit. In this case, aesthetics is left the task of mobilizing surplus meaning. Moreover, the hypothesis may prove useful for linking the theory of art back to one of the most important ideas in Benjamin's *Artwork* essay—that is, the notion of describing changes in the medium of perception as conditions for, and products of, social developments. A sociological theory of art could realize this project as a program of research.

I have suggested that an irrevocable distinction motivates the work of art, and observing this distinction is of importance to aesthetes, sociologists, psychologists, and cognitive scientists. Their research is on the verge of finding new grounds for the oscillation between communication and perception that the work of art stops without stopping. Whether one retains the notion of aura to name this irrevocable distinction is mainly a matter of remembering Benjamin's paradoxes. One might hesitate to describe perceivable qualities as the aura of a communicated work of art, or to describe its participation in communication as the aura of a perceived work of art. But why hesitate? One may speak of the unique appearance of a distance, however close it may be in both cases, and especially because they cannot be separated from one another. In both cases reference to aura is appropriate, since what is at stake is a "here and now" that is not exhausted in the reference, but disseminated in meanings open to different perceptions and communication.

The unique work

Let me return to the idea so important to Benjamin of the uniqueness of the appearance of a distance. Uniqueness marks the extent to which perceiving a work of art is, or is not, at the disposal of communication. Uniqueness stands for a disruption of the self-referential and communicational reproduction of art by referring to perception, which is essential to qualifying something as a work of art but which cannot be performed by communication. Even conceptual art, like academic art in the past, relies more heavily on communication than other formal styles of art, but it maintains its status as "art" only by featuring

perceivable qualities. The more these qualities are reduced to the "chic" of graphic effects—that is, to some kind of "writing" (communication)—the more the status of "art" is jeopardized: unless, of course, if the writing addresses perception in ways that correspond primarily to a perceptual experience of communication (for example, Japanese "sho").

Conversely, uniqueness may also mark the extent to which communicational qualities of a work of art are, or are not, at the disposal of perception. It is not sufficient that we perceive something as an object if we want to call it a "work of art." The object must be perceived as a thing freighted with certain communicative intentions: an *objet trouvé* must also be an *objet montré*. To the degree that only perception is addressed, the status of the object as "work of art" is increasingly endangered. If references to communication and its intentions (not identical, to be sure, with the "intentions" of individuals), to other works of art and the range of solutions established by them, or—last but not least—to the social situation of producing and observing works of art cannot be made, then the perception remains artistically ineffective (as examples of works that stress communicated perception at the very boundary of communication, see the "actions" and "installations" of Joseph Beuys).

In both cases uniqueness indicates a coupling of perception and communication that only the work of art can achieve and yet dissolve—indeed, must dissolve—as soon as it has succeeded. Uniqueness is the marker of that moment in which communication and completely different perception coincide. This coincidence has its subject in the object but its place in the observing of the object as a work of art. Uniqueness marks a kind of recursive observation that becomes event in the work of art, and whose profile is etched by the comparability that generates a sense of unique (see above). Without this profile there would be no event, just as there is no figure without a ground. In the same way that thought exists only when it is a thought of something, a work of art is perceived and communicated only when is it a communication of perception. The performance of art in modern society is peculiar for its focus on the unity of this distinction, and its interpretation of both sides: the side of unity as well as the side of difference—an attention to the distance from, and closeness to, one another.

There are many instances of unity between communication and perception: in language; in small interactive systems relying on the presence of participants (that is, on the mutual perception of percep-

tion); and in the "symbiotic mechanisms" of the media of communication where violence conditions power, need, money, sexuality, and love or, in the case of science, perception as such.[14] A distinction between communication and perception also arises naturally when we are involved in writing, in time, in organization, and in the distinction of media of communication and their symbiotic mechanisms. However, in today's society, only art attends to the unity of difference in the light of the differences in the unity. Art operates exactly where the differentiation of communication is at stake. It is a form of observing the form of the society. If the latter can be described by a distinction between what lies inside communication and everything else, then it is clear that whatever lies "outside" society—the light of the world, the loneliness of the individual, the violence of life, or the sex of death—is the domain of art.

14. Luhmann, *Social Systems*, Chapter 6, § IX.

Aesthetics of Media

What Is the Cost of Keeping Benjamin Current?

Walter Benjamin is economical, but does he have currency?[1] The question cannot easily be answered in the affirmative if we consider the strict standards set by Benjamin himself on the concept of currency. At any rate, one suspects that for cultural phenomena, like fashion, a "scent of what is current" manifests itself. Symposia and collections of essays acknowledging his birthday and the anniversary of his death are obvious surrogates for a "now of recognition," the esoteric concept with which Benjamin described his experience of the radical contingency of historical knowledge. In a letter of 9 October 1935 to Gretel Karplus he wrote: "I have found that aspect of nineteenth century art, which is only recognizable 'now,' which never before was, and which never again will be."[2]

If this self-assessment is taken seriously, it follows that the perceptual comprehension of historical knowledge, by which Benjamin defined his prehistory of the nineteenth century, is itself dated, and thus impossible for us to understand today. Indeed, the fact that Benjamin's Baudelaire studies hardened into dogmatic interpretations can be read as symptomatic of a "no-longer-recognizableness." More precisely, we can no longer explore the trade secrets of the nineteenth century as the seed of currency in our own time. Rather, I want to ground Benjamin's currency in a theory of modern media and to argue that his concepts of art and aesthetics are transformed in this new light. From the perspective of media aesthetics, the connecting links among otherwise dispa-

1. *Translator's Note*: In this translation the English word *current* has been used for the German *Aktuell*, which carries a connotation of topicality and relevance, as well as posing the question as to whether thought can be "realized" or made actual.

2. Letter from Benjamin to Gretel Karplus, dated 9 October 1935, in Benjamin, *Gesammelte Briefe*, V, p. 171.

rate thematic structures like romantic *Kunstkritik*, baroque *Trauerspiel*, Baudelaire's modernism, and film theory become clear. In a letter to Alfred Cohn from early July 1936, Benjamin underscored an aspect of his own studies that he had not immediately grasped—namely, that there was an astonishing "continuity" within his work, and that he "had searched all his life to come to an ever more precise and uncompromising concept of what constitutes a work of art."[3] Obviously, this concept is neither specifically literary nor is it directed toward philosophical aesthetics; in fact, it would probably be more correct to say that he worked on the problem by inverting it, and that he reoriented aesthetics toward the study of perception.

Aesthetics is not simply a theory of the beautiful in art, nor can aesthetics be encompassed by the field of art history. Proceeding directly from the question "what is a work of art?" Benjamin pushed his archaeology of modernity into the study of dream-consciousness, phantasmagoria, fashion, and advertising. In short, aesthetic powers were emancipated from the traditional arts, and we obscure his insights into the aesthetic potential of modernity if it is subsumed under an "aesthetic" concept of art. Benjamin's central question (what is a work of art?) thus leads to recognizing that the decisive aesthetic problem of the twentieth century only becomes completely visible if we liquidate our fetishistic, nineteenth-century concept of the art object.

Benjamin presupposes a twofold liberation from the chains of traditional art appreciation: first, the explosion of historical contemplation in general; second, a sublation of the autonomous areas of humanistic thought, each with its own particular history. At this point the social theorists among the Benjaminians (what other kinds could there be?) are narcissistically wounded, for Benjamin advocates nothing less than a shattering of the humanities. Yet there are certain concepts that exist in a kind of semantic blind spot and leave an inexplicable residue of meaning: such is the case with Benjamin's notion of aura. Obviously, the concept of auraticization works in relation to aesthetics, a bit like Max Weber's concept of World-Mystification in religious sociology. In modernity—we might also say *as* modernity—the auratic object is empowered by statistics, and the decisive turn for Benjamin was the reversion of reproductive technologies into aesthetic practices, rather than the secularization of art. Thus, the aesthetic object is not eliminated,

3. Letter from Benjamin to Alfred Cohn, dated 4 July 1936, in ibid., p. 325.

but shattered into pieces and newly rebuilt: one could also say that destruction of the aesthetic makes it possible for us to connect with its currency—that is, its value as current knowledge. For Benjamin, the artwork is not only the arena for integrating disparate areas of study but also the agent driving the process.

It is characteristic of Benjamin's aesthetics that the specific artistic value of a work of art is only a waste product of its founding social function; he repeatedly underscores instrumentality and serviceability, as the case may be, of aesthetic praxis. Benjamin proceeds to compare methodically the prehistory of art, where "pure" aesthetic value was not operative, to the current praxis of technologized art, in which "pure" aesthetic value is only partially in play. This comparison generates several fruitful distinctions—such as that between first and second nature—from which he derives the distinction between first (ritual bound) technology and second (mechanistic) technology. In this scheme, second nature signifies the world of technological forms; using the concept of a second technology, Benjamin projects a relation to the world that is no longer distorted by a domination of nature, but presents itself as an "interplay between nature and humanity."[4]

I cannot pursue this dream further, but merely want to suggest that the function of art is radically transformed under the conditions of second nature and second technology. Parallel to its function in prehistory, second technology art is an instrument (but not of magic), and is pressed into service (but not the service of ritual). Rather, art today is the instrument of a "rehearsal" for every "ensemble performance"; it stands in the service of a synergy between man and machine. The decisive and crucial move in this analysis is to suggest that the emancipation of human technology from its ritual ties manifests itself in machines, so that humankind achieves a distance from nature. Benjamin models this achievement with the concept of play, as if to say that modern society had yet another nature to master: machine technology crystallized into second nature. In that case, the sacred transformation of the "domination of nature" into an "interplay with nature" presupposes a process that would include "making the tremendous technical apparatus of our time into an object of human innervation."[5] In short, Benjamin formulates a "postmodern" function for art that can be stated simply: art is the training of perception in a mechanized world.

4. Benjamin, "Das Kunstwerk" (Zweite Fassung), p. 359.
5. Benjamin, "Das Kunstwerk" (1935), p. 445.

In Benjamin's time, film was the only medium thought capable of instantiating this process. The world of modern machines prepares the sensorium for film, which alone constitutes aesthetic experience in the present, and this explains why cinema occupies such a central place in Benjamin's thinking: the technical characteristics of film correspond exactly to the modern problem of form. "Film: unwrapping of all forms of visualization [*Anschauungsformen*], tempo and rhythm, which are performed [*präformiert*] in the machines of today, to such an extent that all the problems of contemporary art find their final formulation [*Formulierung*] only in relation to film."[6] In this definition, the words Anschauungsform, Präformierung, and Formulierung determine a precise relationship to one another and reference a strict, objective relationship with a technical standard, a change of perception, and a theory of media: as is readily visible from the words themselves, this is a relationship of form.

Benjamin views his own moment as determined by forms imposed on his existence by the operation of mechanical and technical apparatuses. In his view, "modernity" shifts the natural process of "relating to the world" from humans to their machines and to their technologies of media. This also implies that a free use of new media and technologies is possible only if they are perceived and processed as natural forms, as "beings-in-the-world."

The utopian idea of a new, "nature-of-technology" needs further work before it can be carried over into humanistic discourse and, in particular, Benjamin must describe how "second nature" technology might be transformed into a "first nature" humanist subject. To make his point, Benjamin adopts a radical perspective on the entire problem by reframing the operative distinctions already in play (first and second nature; first and second technology) within a new formulation of the relationship between individual and collective. Benjamin ascribes to humanity the concrete, self-organizing task of innervating technology, and suggests that for individuals this will remain an abstract, utopian goal (which makes it as sterile as science fiction). The key inversion is nonetheless critical: the goals of a collective are not determined by the aggregate personal goals of individuals; individuals will never feel that their lives have "fulfilled" the collective goals. Benjamin places art (postmodern, in this sense) in the service of humanity rather than individuals: "The technical apparatus of our time is second nature for the

6. Benjamin, "Passagen-Werk," p. 498, Konvolut K (K3, 3).

individual; to make it a first to the collective, is the historical task of film."[7]

Apologists among the Benjaminians [*Benjaminforschern*] generally agree (and I agree with them) that Benjamin demanded too much from film and hopelessly overrated its organizational power. Apologists cannot ignore, however, that the key difficulty of his approach to aesthetics is not its focus on the medium of film, which is only an epiphenomenon, but rather Benjamin's reformulation of the distinction individual/collective upon which he based his claim for the transformative function of art. That reformulation made it possible for him to switch the signs on usual assessments of behavior and perception, and to propose a schema of private vices/public virtues. Consider two examples of how this "inverted" schema operates:

> Psychosis and Dream: for the individual, they are the powers of the spell; in the collective perception of film, they conquer new regions of consciousness.
> Diversion: for the individual it is a narcotic; in the collective it becomes a "responsible" form as a kind of world perception under the conditions of shock.

From Benjamin's perspective—that is, accepting his distinction of individual/collective—the concept of media develops a clear contour as the historical-technical a priori that organizes the collective's perception. This means that a genuinely Benjaminian aesthetic theory is, by definition, a lesson in perception and ought not to be concerned with the "artistic value" of artworks: post-Hegelian aesthetics tend to be oriented toward construction of forms rather than styles.

The consequences can be reframed in different focal lengths: in wide angle, Walter Benjamin's aesthetic is a theory of perception; in midrange, a theory of the collective's perception; in close-up, a theory of collective perception organized by technical process and media. These consequences are not linear but "nested," so that we cannot separate the question of Benjamin's currency from the mortgage of his concept of the collective. This is not a question of "styles of reading" or of some "other" Benjamin, but one of deep structure. To those who might call attention to the proud remarks in "The Task of the Transla-

7. Manuscript variant of a passage written for Benjamin, "Das Kunstwerk" (Zweite Fassung), p. 360, and recorded in Benjamin, *Gesammelte Schriften*, VII, 2, p. 688.

tor," where Benjamin dismisses any consideration of the reader as unfruitful, let it be said: here too the contradiction is resolved if reframed by his specialized understanding of the distinction individual/collective. In this case, consideration of individual readers obviously remains unfruitful (literary theory knows the phantom of the "ideal" reader), but with his handling of the collective Benjamin already exposes the matrix of a different concept for the work of art. The question retains a currency, but the principle seems to be that realizing Benjamin's utopia means assuming the mortgage. This essay has tried to state the cost.

There Are No Mass Media

In the year 1935 the question concerning the work of art was posed not once but twice. The title of Benjamin's *Artwork* essay sounds like a direct response to Heidegger's essay *The Origin of the Work of Art* (which, however, was published more than a month after Benjamin finished the first version of his text). Heidegger's question of origin appears, in fact, to be opposed to the question concerning reproduction. But it merely appears so. No less than the question concerning the original in Benjamin's essay, the question of origin leads thinking into a circle (*UdK* 8/149).[1] Insofar as the concept of the original presupposes the concept of reproduction, the "presence in time and space" of the work of art (475/220) is always supplementary and constituted as that which is supplemented only by the supplement of reproduction. To the same degree that "authenticity" is not subject to reproducibility, it does derive from reproducibility. Consequently, the same holds true for the aura, which discloses itself as the origin of the work of art only in the age of mechanical reproduction. Origin and reproduction thus are merely two sides of the same coin.

In addition to that, Benjamin's statement that "the work of art has always been reproducible" (474/218) causes a strange confusion in the context of film. Namely, there is a noticeable confusion of two things: on the one hand, the reproduction of works of art (whenever it is a matter of manual reproduction) and, on the other hand, technologies of reproduction that as such imply technical reproducibility (as is the case,

1. *Editors' Note*: References in the text and notes of this essay are organized in the following manner: *UdK* refers to the work listed in the Bibliography as Heidegger, "Der Ursprung des Kunstwerkes," with the first number being the page of this edition. The second number refers to the page in the (abbreviated) English translation listed in the Bibliography as Heidegger, "The Origin of the Work of Art." Unlabeled pairs of numbers in parentheses refer, respectively, to two editions of Benjamin's *Artwork* essay: the first to pages of the so-called second edition, listed in the Bibliography as Benjamin, "Das Kunstwerk" (*Gesammelte Schriften*, 1974), the second to pages of the English edition listed in the Bibliography as Benjamin, "The Work of Art."

for example, with film negatives) but do not presuppose a work of art as the original. The statement that works of art in principle have always been reproducible therefore not only drops the unique "presence in time and space" of the work of art with the same degree of principle, but it also obfuscates a distinction—namely, between the reproduction of works of art and the much more fundamental storage and processing of data. Whereas Benjamin does not at all draw the distinction between physical data and works, Heidegger opens it up explicitly in order to trace the question concerning the work of art back, first of all, to the problem of data processing. Whereas Benjamin's circumscription of the "aura of natural objects" (479/222) operates with (as Heidegger would call it) "de-severance,"[2] Heidegger restores the work of art to *physis*: "[M]etals come to glitter and shimmer, colors to glow, tones to sing, the word to say. All this comes forth as the work sets itself back into the massiveness and heaviness of stone, into the firmness and pliancy of wood, into the hardness and luster of metal, into the lighting and darkening of color, into the clang of tone, and into the naming power of the word" (*UdK* 35/171). In contrast to a reproducibility of works of art from the beginning of all time, the reproducibility of colors and noises as colors and noises is precisely the achievement of technical media (as opposed to the arts). Until the arrival of film and the gramophone, the reproduction of color was limited to the threshold differentiation of the perception of color tones on the painter's palette, and the reproduction of noises was limited to intervals that can be written down within the tonal system or words that can be recorded in alphabetical letters.

The definition of technical reproducibility as the gradual negation of manual reproducibility (476/221) has the effect that sensory data from the outset are thought of as culturally coded data—as if a camera could record only productions of *Faust* (477 n. 4/243 n. 3), and a gramophone only opera arias. However, the cultural-philosophical per-

2. *Translator's Note*: Heidegger's *Ent-fernung* has no etymological equivalent in English, since the hyphenation of the standard *Entfernung* stresses the privative prefix and thereby turns the standard meaning on its head. Instead of a "removal" or "distance," Ent-fernung—that is, "de-severing" or "de-severance"—amounts, in Heidegger's own words, "to making the farness vanish . . . , making the remoteness of something disappear, bringing it close" (Heidegger, *Being and Time*, p. 139, § 23). A translators' note (ibid., pp. 138–39, n. 2) gives an exhaustive explanation for the choice of "de-severance" and "de-severing." Furthermore, they note that the use of the hyphenated Ent-fernung and of the standard Entfernung is far from consistent in the different editions of *Sein und Zeit*—presumably due to typographical errors.

spectivization of media theory tends to imply precisely this: from the concepts of the original and authenticity no path leads to an equation of van Gogh's paintings and coal from the Ruhr region, or Beethoven's quartets and potatoes—with which, after all, Heidegger's essay makes its scandalous beginning (*UdK* 9/150). But this foolishness, the peculiarity of the technical media to distinguish no longer between works and things, transforms aesthetic data into mere signals, colors, and sounds into mere frequencies. In the age of technology, the difference between aesthetics and physics is the same as that between testing and measuring. The test, to which the actor in front of the camera is subjected, has nothing to do with the technically relevant frequency of frames, but is directly related to the aesthetically relevant frequency of cuts. Thus, it tests the limits of perception but without ever falling below this threshold. For physical measuring, however, audible and visible frequencies are but a small selection from the spectrum of frequencies that can be used by media technology. What Benjamin's aesthetics by definition fails to recognize is the possibility of data storage as the processing of signals. An example would be the simple case, described by Jacques Lacan, of a circular communication line as the storage facility of a telegraphic message.[3]

Transmission is the blind spot of Benjamin's essay, obvious already in his little media history. The condition of possibility for "lithography enabl[ing] graphic art to illustrate everyday life" (472/219) was the postage stamp—forgotten by Benjamin—which alone made it possible for lithographic reproductions to achieve daily delivery frequencies. That Benjamin barely takes note of the radio (which was, after all, the source of his income for many years) demonstrates dramatically that the "summer afternoon" (479/222) of analogous low-frequency optical storage media excludes the night of high-frequency acoustical transmission media—a night, to be sure, that is night to an even more unimaginable degree than the night that literally ruled in the "sensory deprivation" of the trenches of World War I. But, since the digital media are married to this night, an aesthetics that still adheres, qua negation of psychological categories of visual perception (such as attention and gaze),[4] to the level of consciousness, is insufficient as a media theory in the digital age. Digital image media cannot be thought of without recourse to the history of transmission media (radio, television) and the

3. Lacan, *Das Seminar: Buch II*, p. 117.
4. See esp. the passages on aura in Benjamin, "Über einige Motive bei Baudelaire," pp. 646ff.

technology of "signal processing." Only on the phenomenal level are they related to film—that semidigital, semianalog hybrid—insofar as even their samples are digital and not simply the process of sampling itself (as with film, in which the sampled signal is a two-dimensional analog—namely, chemical—representation of countless segments of the color spectrum).

The difference between Benjamin's and Heidegger's essays could be described as the difference between production on the one hand and research and development on the other: while Benjamin's starting point is the serial production of being, Heidegger's starting point is the experimental investigation of being. Consequently, what remains unthought in Heidegger's essay on *The Origin of the Work of Art* is the serial production of shoes—as well as the fact that van Gogh's painting of peasant shoes is also part of a series of images.

Whereas Heidegger, in a Nietzschean fashion, displaces the origin of the work of art in the nonidentity of strife (between lighting and concealing), Benjamin transfers the origin of the work of art—admittedly qua negation—into an identity that cannot be represented. In fact, Benjamin's most illuminating remark concerning the aura is that it cannot be depicted; this does not apply only to technical depictions, but it denies any depiction of aura. Thus, a negative theology of images emerges at the heart of the reproduction thesis. No matter whether this points, obviously, to the Jewish prohibition of images or, less obviously, to the Nicene pretemporal logic of the image of the trinity (which turns the prohibition of images into the principle of the image), either way Benjamin's media theory reveals itself as a negative theology. Film is the death of God.

But insofar as only the era of technical reproducibility reveals the aura as the lost origin of the work of art, the question arises: what sense does the death of God make from the perspective of shock? From this point of view God functions as a protection against stimuli. As Samuel Weber has shown, aura serves to localize shock by assigning it to an "exact place in time in consciousness": "To the extent that this allocation of a place fails and that, therefore, the stimuli have no *assigned value*, they form no *gestalt* and threaten the unity of consciousness. In other words, the *traumatic power* increases in inverse proportion to the *assigned value*. Benjamin attempts to think this inverse proportion in the concept of *aura*."[5] In Nietzsche's sense the aura stands in

5. Weber, "Der posthume Zwischenfall," p. 188.

the service of life: its truth is nothing but the will to appearance, to illusion, to lie in order to control the nonidentity inherent in the neural stimuli.[6]

From a physiological point of view, the prohibition of images is therefore a form of protection against stimuli: it protects media theory from too many images and from images that are too quick by assigning to them a specific value and importance within the history of the decay of aura. Moreover, it protects media theory from having to place media history within the horizon of shock—that is, within the history of war. In contrast, aura and shock in *The Origin of the Work of Art* appear as "shape" and "thrust." But Heidegger thinks of the shape of the work from the perspective of shock—as the sample of strife, of conflict. However, this sample is of interest only for the reason *that* it is; this *that* communicates itself in the shock or thrust (*UdK* 53–54/183). Heidegger thinks of the work of art as a radar station. It locates the *that* of beings.

The auratic protection against stimuli and, more precisely, against the shocks that war inflicts on thinking is called the public sphere. The aura of aura is nothing else—from a nominalistic point of view. For "all that is transmissible" (477/221) in the meaning of the word "aura"—the breeze—is the daylight, the public sphere. In Virgil the word is documented in the expression *ferre sub auras*, "to make known," and also in *aura fugere*, "to avoid the daylight, the public sphere." Judged from the sensorium of the soldiers, World War I was a single fugue of the aura. Thus, in the concept of aura the "negative horizon of war" (as one might call it with Wolfgang Hagen) of the technical media is already established: "To all of the newer media adheres therefore a negative horizon of war. Negative . . . , because it almost instantly disappears in the perception of that 'public' into whose sphere the media are 'released' as if into a harmless sphere of entertainment of the civilized world. This happened with radio in the 20s, with VHF and television in the early 50s, and with the computer in the 80s."[7] If therefore the concepts of technical reproducibility and media are, supposedly, determined by the withdrawal of the aura, neither the concept of a public sphere, nor all related concepts from the supply of the Institute for Social Research, escape this withdrawal of the aura. The further Benjamin's aura is deconstructed, the clearer it can be recognized as a

6. Nietzsche, "Über Wahrheit und Lüge im außermoralischen Sinn," in *Werke*, III, pp. 312ff.

7. Hagen, "Mediendialektik," passim.

trap for the follies of Adorno's theory of mass media as formulated in the 1930s.[8]

In the area of theory, Benjamin's reduction of historical conditions of perception to "social" instead of technical a prioris, this reduction to the increasing importance of the masses, is a particularly eminent strategy of protection against stimuli vis-à-vis the war horizon of the media. The shock, inflicted on theory through the decentering of the subject of perception, is diverted by transposing subjectivity onto the masses. The shock does not destroy, but rather displaces subjectivity—as if the "masses" ever had been concerned with "bring[ing] things 'closer' spatially and humanly" (479/223). By contrast, bringing masses closer to each other spatially and humanly by means of railroads had been a concern of the Prussian chiefs of staff ever since the war of 1866, and of all the warring powers in World War I.

Benjamin's own analysis, however, infuses the desire of "the masses" for the cinema with noticeable doubts. In a nutshell and against its own intent, as it were, the *Artwork* essay contains a history of mass media that marks their historical deconstruction. Already in the case of photography, the still metaphorical, but no less explicit, observation that the photograph transforms the depicted setting into the scene of a crime makes clear that the medium of photography is not demanded by the masses but rather by criminology (485/226). Criminology occupies the most prominent place among the modern powers that decide matters of form and aesthetics. Benjamin's analysis of the camera apparatus as a testing examiner removes it entirely from a "society" (488/228–229). Benjamin's remark that "one knows nothing

8. The core of this pessimistic media theory—that is, the thesis of the alienated or manipulated masses—developed as a theory of mass media from Adorno in the 1930s up to Enzensberger in the 1970s and was already deconstructed a decade ago by Baudrillard. In the age of TV, the time has come for the insight that an undistorted reality or human nature can no longer be isolated as a fundamental element. Consequently, the suspicion arises that "this idea of alienation has probably never been anything but a philosopher's ideal perspective for the use of hypothetical masses." Baudrillard suggests inverting the thesis of the masses alienated by the media in order "to evaluate how much the whole universe of the media, and perhaps the whole technical universe, is the result of a secret strategy of this mass which is claimed to be alienated, *of a secret form of the refusal of will,* of an involuntary challenge to everything which was demanded of the subject by philosophy—that is to say, to all rationality of choice and to all exercise of will, of knowledge, and of liberty" (Baudrillard, "The Masses," pp. 584–85 and passim). Nevertheless, as one can see, media theory continues to be a theory of mass media even for the philosopher Baudrillard. The inversion of the theory of the Frankfurt school still falls under its a priori—namely, that the "masses" are the subject of media history. However, what is at stake here is not a more intelligent theory of mass media, but rather its complete abrogation.

of a person's posture during the fractional second of a stride" (500/ 237) is not the example it was meant to be, for it was above all Marey's assistant Georges Demeny who, appointed by the French chiefs of staff, was preoccupied with the posture of striding persons. And it was Eadweard Muybridge who was concerned with the posture of the horses of the former governor of California, Leland Stanford, while striding and galloping.

The story is well known, but cannot be told often enough. At the end of the 1860s the physiologist Étienne-Jules Marey—like many of his professional colleagues ever since the research of the Weber brothers—was studying the movement of living bodies. One of the things he recorded, using a four-part device that recorded at a certain rate of pulsation, was the sequence of motions in the movements of horses. One Captain Duhousset, who apparently could draw as well as he could ride, produced drawings of the postures of the horses which corresponded to the graphs recorded by Marey's device. Through mysterious channels these drawings fell into the hands of Governor Stanford. Stanford, however, had more faith in his genre painters than in Marey's recording device. In particular, Stanford could not bring himself to believe that, in a specific phase of its movement, a galloping horse touches the ground with only one of its front legs. He was so convinced that he made a bet with his friend McCrellish and commissioned Muybridge, who at that time was in charge of the photographic survey of the Pacific Coast, to decide the bet by means of serial photography. In 1872 Muybridge began taking his famous photographs in the trotter paddocks of Palo Alto.[9] In 1881, Marey learned about Muybridge's work and improved his method by replacing the series of cameras used by Muybridge with a "photographic gun." Benjamin's example points to the scientific prehistory of the cinema: to chrono-photography, which was not concerned with the synthesis but rather the analysis of movement. The reconstruction of the history of media as a history of the decay of the aura, by comparison, requires sound film to emerge from photography (475/219). But the masses as the historical subject of the mass medium of photography—or rather, photography as the medium of disciplining the masses—is not the origin of the filmic work of art. Rather, this origin lies in research laboratories (like Marey's) where bodies were cut into pieces on behalf of the military. Historically

9. Zglinicki, *Der Weg des Films*, p. 173.

speaking, slow motion actually preceded the motion picture projected at normal speed.

Finally, even the famous "reception in a state of distraction" can be freed from mass media dogma, and the concept of the audience as an examiner, but a distracted one (505/240–241), can be replaced by a historically more concrete concept—for example, a surveillance officer in his airplane. "For the tasks which face the human apparatus of perception at the turning points of history cannot be solved by optical means, that is, by contemplation, alone. They are mastered gradually by habit, under the guidance of tactile appropriation" (505/240). Referentialization [*Referentialisierung*] causes the philosophical discourse to dissolve into a description of the situation. The "turning points of history" refer to World War I. The "human apparatus of perception" is that of artillery observers, of pilots, or of sappers in the "war below the surface." "Habit," far from being a free historical subject that could provide "guidance," is instead guided by the sciences, which switched over to war-industry production.

Nothing, therefore—as the latest research demonstrates—is more questionable than Benjamin's hope that the concepts he elaborates are incompatible with Fascist aesthetics. Soviet avant-garde art—Eisenstein, Vertov, Lev Kuleshov, and many more to whom Benjamin refers—directly applied the methods of industrial engineering, especially the methods of Gilbreth who was a student of Taylor.[10] Industrial engineering imported from America had a direct connection (like Kuleshov or Vertov) to Meyerholt's "biomechanics."[11] When Benjamin speaks of the "identity of the artistic and scientific uses of photography" (499/236), he obviously and very concretely is thinking of industrial engineering and the "artists" that serve it, such as Vertov or Kuleshov.[12] The *terminus ad quem* of Gilbreth's use of the camera was the moment when the ideal working motions (as designed by industrial engineering) and the empirical working motions were short-circuited. In the approximated real time of their feedback, the cinematographic ideal and the empirical body merged into the type of *the worker*. Working

10. For this reference I thank Hans-Christian von Herrmann (Berlin), whose studies on Brecht's media aesthetics are to be published soon.

11. Gregor, "Meyerholt und das Kino der Revolutionäre," pp. 30–32.

12. Benjamin explicitly mentions industrial engineering in a footnote: "Thus, vocational aptitude tests become constantly more important. . . . The camera director in the studio occupies a place identical with that of the examiner during aptitude tests" (488 n. 17/246 n. 10).

motions, copied onto endless meters of Soviet celluloid, became a constant test of the degree to which this worker-type had been achieved in practice. Suddenly, Jünger and Benjamin stand in close proximity.

For the reasons enumerated, there are no mass media, just as there are no "masses." Marx, whom Benjamin quotes, complained no less than Theodor Mommsen, that the masses never are *populus*—that is, a singular subject, but always *plebs*—that is, amorphous plurality. Aesthetics is therefore the science of the a prioris of perception. Whether these a prioris have a social or a technical quality is the question to which Benjamin's entire text gives strangely contradictory answers. But the analysis of the camera as an apparatus for testing directs the discussion from the public sphere of mass media into the seclusion of laboratories. Aesthetics, like the body, depends on the historical ruptures of media history. Nietzsche (whom Benjamin does not mention) knew this already. The survival of an aesthetics with a scientific claim drawing a conclusion from this insight with regard to the digital age. The thinking of media as mass media may be explained as an effect of the negative horizon of war, but this understanding and its inclusion in the concept of "public sphere" are lies that sustain the human sciences. In the digital age, these lies have become lethal. The time has come to do away with them.

—Translated by Peter Gilgen

Connecting Benjamin

The Aesthetic Approach to Technology

In 1918 Benjamin told his friend Ernst Schön that he was thinking intently about the question of "where one would finally be able to find open space, development, and greatness for the fundamental concepts of aesthetics so that they could be liberated from their miserable isolation (which is for aesthetics what mere artistry is for painting)."[1] Ten years later, while planning a book on "Theory and the Situation of Criticism," he referred to the need for starting "with the insight that absolutely all aesthetic categories (standards) have lost their validity. And they cannot be generated by even the most masterful "development" of the old aesthetics. Rather, a detour via materialistic criticism is necessary, one that places the books in the context of time. Such criticism will then lead to a new, dynamic, dialectical aesthetics."[2]

This was written in 1928, at the time his study on German Baroque drama was about to be published, and just as he started his research in the Bibliothèque Nationale for the Arcades project. We may suppose that the *Artwork* essay eventually took the place of his unwritten theory of criticism. In a letter to Alfred Cohn (21 November 1935), Benjamin described his essay as "the first materialistic theory of art that deserves the name. It is based, as it surely should be, on the conditions

1. Wo endlich freier Raum, Entfaltung und Größe für die "Aesthetischen" Grundbegriffe überhaupt gefunden werden könnten und sie aus ihrer ärmlichen Isoliertheit (die in der Ästhetik das ist was bloße Artistik in der Malerei ist) erlöst werden könnten (Benjamin, *Gesammelte Schriften*, VI, p. 702). *Editors' Note:* All translations from German in this essay are the author's own. For reference, the original language is reprinted in the notes, along with an indication of the source.

2. In der Einsicht, daß die aesthetischen Kategorien (Maßstäbe) samt und sonders außer Kurs gekommen sind. Sie können auch durch eine noch so virtuose 'Entwicklung' der alten Aesthetik nicht hervorgebracht werden. Vielmehr ist der Umweg über eine materialistische Kritik nötig, der die Bücher in den Zusammenhang der Zeit einstellt. Eine solche Kritik wird dann zu einer neuen, bewegten, dialektischen Aesthetik führen (ibid., VI, p. 166).

of the immediate present, and especially on an absolutely original and new historical exposé of film. The work was created as the apparatus of my big book on the nineteenth century, but I believe that it will have its own historical position, independent of it."[3] Such statements can be taken as clues that help us to place the *Artwork* essay as the culmination of a twenty-year effort to overthrow the mainstream of cultural and aesthetic thinking in Germany. Indeed, a detailed consideration of two of the basic issues mentioned in the preceding quotations—the need to find new concepts for changing situations, and the object of a "dynamic dialectical aesthetics"—can provide us with a concrete understanding of what I would like to call the Benjaminian revolution in aesthetic thinking, or Benjamin's revolutionary manner of thinking the aesthetic.

With regard to the first topic, Benjamin draws our attention to the political and discursive function of theoretical concepts, as expressed in the opening chapter of the *Artwork* essay: "The concepts which are introduced into the theory of art in what follows differ from the more familiar terms in that they are completely useless for the purposes of Fascism. They are, on the other hand, useful for the formulation of revolutionary demands in the politics of art."[4] The importance given to the value of theoretical concepts as a weapon is due not only to historical circumstances (the Nazis' rise to power), but is also the result of the movability of Benjamin's thinking mode, his epistemo-critical method of analysis and writing. He explicitly explains this mode in the long "Epistemo-critical Preface" ["Erkenntniskritische Vorrede"] to his study on German Baroque drama. The book opens with the unusual confrontation between two catastrophic experiences—World War I and the Thirty Years' War—and their cultural representations (or, as he would prefer, their expressive characters)—namely, German expres-

3. Die erste Kunsttheorie des Materialismus, die diesen Namen verdient—begründet, wie das in der Ordnung ist, aus den Verhältnissen der unmittelbaren Gegenwart und vor allem auf einer von Grund auf erstmaligen geschichtlichen Erhellung des Films. Die Arbeit ist als Apparatur meines großen Buches über das neunzehnte Jahrhundert entstanden, wird aber unabhängig von ihm ihre, wie ich glaube, historische Stelle haben (ibid., VII, 2, p. 863).

4. Die im folgenden neu in die Kunsttheorie eingeführten Begriffe unterscheiden sich von geläufigeren dadurch, daß sie für die Zwecke des Faschismus vollkommen unbrauchbar sind. Dagegen sind sie zur Formulierung revolutionärer Forderungen in der Kunstpolitik brauchbar (ibid., VII, 1, p. 350). I should point out that I am citing the "second" version of the essay, first published in 1989 as part of volume VII of the collected works, and which differs considerably from the version published in *Illuminations* that was sent out by the editors of the present volume.

sionism and Baroque drama. To name the latter he coined a new concept—Trauerspiel—rather than using "tragedy," the traditional nomenclature for such plays. Benjamin begins with a succinct reflection upon the role of representation from the very first sentence of his book: "It is a characteristic quality of philosophical writing that with every turn anew it faces the question of representation."[5] What he is targeting here, and what he will eventually deconstruct, is the logic of those theories that have no notion of their mode of representation: "The task of the philosopher seemed to have no place anywhere for the consideration of representation."[6]

Benjamin was the first critic of our century to give discursive concepts such as Trauerspiel and "allegory" a theoretical status, and he discovered that a precondition for inventing them was a new mode of writing history—*à rebours* in a nonlinear way, as it were—and in the "white heat" light of actual experience. Throughout the *Artwork* essay we can follow the same process as Benjamin searches for new concepts to replace the old, with the epicenter of his thinking always the concept of a new aesthetic. This idea is already present in the book on Baroque drama (but without a clear technological approach), as when Benjamin writes: "The large classifications—the most general ones being logic, ethics, and aesthetics—that determine not only the systems but also the terminology of philosophy are not significant as names of specific disciplines, but as monuments of the discontinuous structure of the world of ideas."[7] This is a clear critique of the largely secular tradition (especially in Germany) where aesthetics has been institutionalized as the "name of a special discipline." It is this tradition that Benjamin leaves behind when he substitutes a new concept of the aesthetic framed by the much broader, original sense of the term *aisthesis*.

This new concept is grounded in and results from Benjamin's technological approach to the arts and to the modes of human perception. It is clearly articulated in the closing sentence of chapter XVIII of the *Artwork* essay where, after describing the "reception in distraction" of the cinema public, Benjamin writes: "Reception in distraction, which

5. Es ist dem philosophischen Schrifttum eigen, mit jeder Wendung von neuem vor der Frage der Darstellung zu stehen (ibid., I, 1, p. 207).

6. Nirgends schien in der Aufgabe des Philosophen für Rücksicht auf die Darstellung ein Ort (ibid., I, 1, p. 212).

7. Die großen Gliederungen, welche nicht allein die Systeme, sondern die philosophische Terminologie bestimmen—die allgemeinsten: Logik, Ethik und Ästhetik—, haben denn auch nicht als Namen von Fachdisziplinen, sondern als Denkmale einer diskontinuierlichen Struktur der Ideenwelt ihre Bedeutung (ibid., I, 1, p. 213).

has become increasingly noticeable in all fields of the arts and which is, in fact, the symptom of a profound change of apperception, has its genuine instrument of practice in film. Due to its shock effect, film reinforces this mode of reception. Thus, here again, film turns out to be the currently most important object *of that theory of perception which was called aesthetics by the Greeks*" [my emphasis].[8] Aesthetics, taken in this broader sense of aisthesis, is for Benjamin a sort of sensual perception theory. And this, in turn, suggests that what might be called Benjamin's "aesthetic approach to technology" is a genuine contribution to debates about the media in our own day.

Curiously enough, the aesthetic dimension of this ongoing debate (at least since the 1980s) has not taken his contribution much into account. Completely marginalized in his lifetime, Benjamin was among the very few in Germany (or in Europe) who understood the consequences of Siegfried Giedion's "Mechanization takes Command" in our cultural and social life.[9] It is a remarkable point that his fellow travelers of the Frankfurt School, who were in California writing the *Dialectic of Enlightenment* during the 1940s, failed to register the full impact of Benjamin's aesthetic approach in their chapter on the Culture-Industry. In contrast, and unbeknownst to one another, the community of American and Canadian investigators at work during the 1950s in Toronto (where the Centre of Culture and Technology was founded in 1963), adopted many ideas similar to those of Benjamin in their analysis of what Marshal McLuhan called the "interplay of senses" in a technical environment.[10]

I want to discuss just one area where Benjamin's aesthetic approach intersects with McLuhan's later research: both insist on tactility as the attitude that continues to connect the human senses in spite of the increased specialization and isolation of perception induced by technical evolution. In response to the questionnaire of the editors of this volume, I would like to suggest that Benjamin's noninstrumental view of technology, which is a kind of theoretical leitmotif in the *Artwork* es-

8. Die Rezeption in der Zerstreuung, die sich mit wachsendem Nachdruck auf allen Gebieten der Kunst bemerkbar macht und das Symptom von tiefgreifenden Veränderungen der Apperzeption ist, hat im Film ihr eigentliches Übungsinstrument. In seiner Schockwirkung kommt der Film dieser Rezeptionsform entgegen. So erweist er sich auch von hier als der derzeitig wichtigste Gegenstand *jener Lehre von der Wahrnehmung, die bei den Griechen Ästhetik hieß* (ibid., VII, 1, p. 381).

9. Giedion, *Mechanization takes Command*, passim.

10. McLuhan, *Gutenberg Galaxy*, passim; McLuhan and Fiore, *War and Peace in the Global Village*, passim.

say, constitutes a vision of great contemporary importance. Benjamin's militant critique of cultural and aesthetic concepts breaks down the "Great Wall" between technology and aesthetics to create a border-crossing that resembles, for example, McLuhan's account of how our involvement with the perception of television images increases our tactile abilities. Books such as *The Gutenberg Galaxy* and *Understanding Media* have taught us to see the parallels between the starring role played by typography in the shaping of human thought and life and the changes in perceptual modes effected by life in the "electric age." What links these is touch, which, as McLuhan has suggested, "is not so much a separate sense as the very interplay of senses."[11]

Benjamin's main points of reference were movies and architecture, both of which he cites when describing the "tactile dominance that governs the re-grouping of apperception."[12] Nevertheless, he had a good sense of what was happening, and of the coming cultural, socio-psychological, and even political impact of the telemedia. "Thus, technology subjected the human senses to a complex kind of training," wrote Benjamin in his study of Baudelaire, and that insight remained a kind of focal point in his work.[13] This line of inquiry, sustained by a critical insight into the hidden grounds of unnoticeable changes, convinced Benjamin that we must overcome the fatal and isolating "localized character of the arts and sciences," an idea that remains a central methodological issue in today's so-called evolutionary epistemology.[14]

Benjamin's approach strikes me as potentially more productive than the rather sterile debate—based on a somewhat anachronistic perspective—between Fascist aestheticization of politics and communist politicization of the arts. But this does not mean I want to depoliticize Benjamin; quite the contrary. If media theory is today in danger of neglecting the a prioris of power (at least in Germany, as we were recently reminded by Norbert Bolz, one of the few to acknowledge Ben-

11. McLuhan, "The TV Image," p. 287. See also McLuhan and Fiore, *War and Peace in the Global Village*, p. 77.

12. Taktile Dominanz, die die Umgruppierung der Apperzeption regiert (Benjamin, *Gesammelte Schriften*, I, 2, p. 466).

13. So unterwarf die Technik das menschliche Sensorium einem Training komplexer Art (ibid., I, 2, p. 630).

14. Wie Benedetto Croce durch Zerstrümmerung der Lehre von den Kunstformen den Weg zum einzelnen konkreten Kunstwerk freilegte, so sind meine bisherigen Versuche bemüht, *den Weg zum Kunstwerk durch Zerstrümmerung der Lehre vom Gebietscharakter der Kunst zu bahnen* [my emphasis] (Benjamin, "Lebenslauf III," circa 1928, ibid., VI, p. 218ff).

jamin as a pioneer of media-aesthetics), if media theory has no good answers to questions posed by media politics (witness the Berlusconi case in Italy or its Kirch-homologue, the new Hugenberg in Germany), then we might usefully recall that it was just this problem—the connection between media/technics and power politics—that constitutes the balance of Benjamin's aesthetic approach to technology. Indeed, the surrealist-like "probes" that Benjamin deploys in *One-Way Street* are an exemplary case of his approach in operation.

It may be that such an approach has not much new to say to Americans. In Germany, however, things are different: here the long shadows of cultural-critique-concepts, along with fraud-theories about media effects, continue to obscure the burning issues. Behind the walls of academic disciplinary fields—a kind of *compartimentos estancos*—most of the powerbrokers in the humanities spend (or waste) their time cherishing the never-ending illusion that they are the guard-dogs of a technically threatened aesthetic subject.

APPARATUS

The characteristics of the film lie not only in the manner in which man presents himself to mechanical equipment but also in the manner in which, by means of this apparatus, man can represent his environment (235)

As compared with painting, filmed behavior lends itself more readily to analysis because of its incomparably more precise statements of the situation. In comparison with the stage scene, the filmed behavior item lends itself more readily to analysis because it can be isolated more easily (236)

Mechanical reproduction of art changes the reaction of the masses toward art. The reactionary attitude toward a Picasso painting changes into the progressive reaction toward a Chaplin movie. The progressive reaction is characterized by the direct, intimate fusion of visual and emotional enjoyment with the orientation of the expert (234)

Under the concept of "apparatus," Benjamin brings together the ensemble of material conditions that, both on the side of the producers and on the side of the spectators, characterize the medium of "film." As film, more than any other medium, carried Benjamin's hopes and expectations about new and politically "progressive" functions that the artwork would fulfill in the age of its mechanical reproduction, the concept of "apparatus" turned into a discursive site where utopian dreams and utopian energies came together. Being more exclusively production-oriented (and more precise) than "apparatus," the notion of "montage" shares this affirmative and future-oriented connotation. On the other hand, "apparatus" is the more complex and the less well circumscribed of these two concepts. Which are its specific components?

Above all, Benjamin is convinced that all art forms based on mechanical reproduction—including film—"meet the beholder halfway" (220); in other words, he believes that they are particularly close to the recipients' everyday worlds. This is said as a—more or less—indirect

critique of the traditional concept of the artwork's "autonomy." The claim of film's greater closeness to the public also suggests that it can take over specific social functions—and Benjamin goes so far as to identify the world view of the camera with the spectator's world view: "[T]he audience takes the position of the camera; its approach is that of testing" (228ff). With the word "testing" Benjamin alludes to the capacity of the film to isolate certain objects (and certain aspects of these objects) through the close-up and related techniques, thus producing information that is not readily accessible to the human eye. Further, he seems to presuppose that an equation exists between such an increase of information and an intensification of the viewers' critical spirit. This idea leads to the discovery of a particularly interesting paradox—and of a comparatively trivial metaphor. The fascinating paradox suggests that the penetration of reality with the technical apparatus of the medium "film" (including the technique of "montage") produces an impression of "pure" reality: "[In] the studio the mechanical equipment has penetrated so deeply into reality that its pure aspect freed from the foreign substance of equipment is the result of a specific procedure, namely, the shooting by the specially adjusted camera and the mounting of the shot together with other similar ones. The equipment-free aspect of reality here has become the height of artifice; the sight of immediate reality has become an orchid in the land of technology" (233).

The conventional metaphor associated with film's analytic potential is that of the surgeon. It stands for higher analytic claims associated with the cameraman—as it had stood for similar claims pronounced in the name of new forms of "realistic" painting and of "realistic" literature throughout the nineteenth century. Benjamin uses this "analogy" between cameraman and surgeon to argue for a superior status of the cameraman in relation with the painter—whom he compares to the magician: "How does the cameraman compare with the painter? To answer this we take recourse to an analogy with a surgical operation. The surgeon represents the polar opposite of the magician. The magician heals a sick person by the laying on of hands; the surgeon cuts into the patient's body. The magician maintains the natural distance between the patient and himself. . . . The surgeon does exactly the reverse; he greatly diminishes the distance between himself and the patient by penetrating into the patient's body" (233). A similar contrast is established—or, rather, programmatically claimed—in the comparison

between the stage actor and the film actor: "The stage actor identifies himself with the character of the role. The film actor very often is denied this opportunity. His creation is by no means all of a piece; it is composed of many separate performances" (230). Once again—as in his discussion of the techniques of "montage"—Benjamin recurs to the principle of fragmentation with the intention of finding a reason for his claim that the film has a higher cognitive status. On the other hand, he also invokes the concept of "fragmentation" in order to explain how the "progressive" medium of film has developed—unfortunately, in his view—the cult of worshipping the movie star: "During the shooting [the film actor] has as little contact with his [labor] as any article produced in a factory. This may contribute to that oppression, that new anxiety which . . . grips the actor before the camera" (231).

These two contrasting evaluations of the principle of "fragmentation" seem to be symptomatic for some of Benjamin's conceptual problems. In his discussion of the "apparatus" of film—as opposed to other media, such as painting or theater—it is always clear where Benjamin's hopes and his Marxist(?) preferences lie. But he sometimes seems to fall short of sufficiently distinctive (and sufficiently coherent) critical concepts. "Fragmentation" is good (as a presupposition for "montage") and bad (as a condition for the film actor's alienation). "Closeness," he claims, is good (as leading to a specific level of analytic rigor), yet this concept is not really compatible with the attitude of (relaxed) "distraction" that Benjamin (again, not unlike Bertolt Brecht) expects from the new mass spectator (239). And how shall we imagine that ideal, new recipient who combines the "amateur's emotional fusion" with the film and the—distanced, one would have to think—orientation of the expert (239)?

Here, the problem seems to be that Benjamin's question concerning the function of the apparatus (not only) for the medium "film" does not yield those clear-cut, black-and-white distinctions and contrasts that he seems eager to suggest. We have meanwhile understood that technological innovations often unfold a complexity that cannot be conceptualized or evaluated with binary distinctions. In this sense, it is important, for example, to understand that both the assembly line that Henry Ford introduced into the production of cars and the medium "film" provide new positions and functions for the human body, and that both change the relations between the human "touch" and the world of material objects. But such convergences neither make these

two arrays into functional equivalents, nor do they explain why Benjamin criticizes some new fragmentations in the division of labor as "alienation" whereas he sees the fragmented and fragmenting medium of film as the "progressive" art of the future.

MONTAGE

The sequence of positional views which the editor composes from the material supplied him constitutes the completed film. It comprises certain factors of movement which are in reality those of the camera, not to mention special camera angles, close-ups, etc. Hence, the performance of the actor is subjected to a series of optical tests (228)

The directives which the captions give to those looking at pictures in illustrated magazines soon become even more explicit and more imperative in the film where the meaning of each single picture appears to be prescribed by the sequence of all preceding ones (226)

In the theater one is well aware of the place from which the play cannot immediately be detected as illusory. There is no such place for the movie scene that is being shot. Its illusionary nature is that of the second degree, the result of cutting (233)

[T]he work of art of the Dadaists became an instrument of ballistics. It hit the spectator like a bullet, it happened to him, thus acquiring a tactile quality. It promoted a demand for the film, the distinct element of which is also primarily tactile, being based on changes of place and focus which periodically assail the spectator (228)

From the "series of optical tests" performed by the movie camera to the "primarily tactile" effect of a finished film, Benjamin recognized that the cinema was a powerful force, able to shift the patterns of human perception in new ways. Standard theories of perception could account with difficulty for the ability of an optical phenomenon like film to produce the collective, visceral responses of a cinematic audience, and Benjamin seemed to view such a passage as difficult and sometimes violent, as his metaphor for Dadaist art makes clear. Later in the essay he sketches the difference as one of attention: "On the tactile side there is no counterpart to contemplation of the optical side. Tactile appropriation is accompanied not so much by attention as by habit" (280). Yet Benjamin was acutely aware that film seemed to challenge this distinction, and he was not alone in thinking this was due to the "changes of place and focus which periodically assail the spectator."

Ten years earlier, the Russian director Lev Kuleshov had concluded that "the fundamental source of the film's impact on the viewer—a source present only in cinema—was not simply to show the content of certain shots, but the organization of those shots among themselves, their combination and construction, that is, the interrelationship of shots, the replacement of one shot by another" (Kuleshov, "Art of the Cinema," 46). Kuleshov realized that the montage of individual shots into a chain of movements made it possible for filmic material to pass from purely optical rendering to tactile experience. Benjamin was surely familiar with contemporary thinking about montage, and much of what he writes about creating an illusion of episodes that never really occur depends directly on the idea that montage could actually transform cinematic material without using double exposures or other tricks of filming. Kuleshov cites the example of a short film about a woman at her toilette that was made by photographing four separate women: "[We] spliced the pieces together in a predetermined relationship and created a totally new person, still retaining the complete reality of the material" (ibid., 53). This is the kind of fabrication Benjamin describes as an illusion "of the second degree, the result of cutting," which he seems to find troubling because the spectator has no tools with which to test the truth-value of what is seen on the screen.

Indeed, Benjamin seems preoccupied with an aspect of montage that film theorists took for granted—namely, that the spectator plays an active and essential role in its operation. "With the correct montage," remarks Kuleshov, "even if one takes the performance of an actor directed at something quite different, it will still reach the viewer in the way intended by the editor, because the viewer himself will complete the sequence and see that which is suggested to him by the montage" (ibid., 54). Some years later, about the same time that Benjamin was writing the *Artwork* essay, Sergei Eisenstein pushed further the idea of a spectator's active participation in the effect of montage: "The strength of montage resided in this, that it includes in the creative process the emotions and mind of the spectator. . . . [T]he spectator is drawn into a creative act in which his personality is not subordinated to the author's individuality, but is opened up throughout the process of fusion with the author's intentions. . . . [E]very spectator, in correspondence with his individuality, and in his own way and out of his own experience . . . creates an image in accordance with the representational guidance suggested by the author" (Eisenstein, "Word and Image," 32–33).

Eisenstein recognized that a montage sequence must include a "guiding-shot which immediately 'christens' the *whole* sequence in one 'direction' or another," and he recommends that it be placed "as near as possible to the beginning of the sequence . . . sometimes it is even necessary to do this with a sub-title" (Eisenstein, "The Filmic Fourth Dimension," 65). Benjamin worries about this "soft spot" in the optimistic accounts of spectator freedom within contemporary theories of montage; he reads Eisenstein's freedom to create as a form of entrapment by drawing the parallel between "captions given to those looking at pictures in illustrated magazines" and the experience of viewing a film "where the meaning of each single picture appears to be prescribed by the sequence of all preceding ones."

Finally, Eisenstein's ideal of an emotionally engaged, thinking audience working in concert with the filmmaker's creative enterprise seems liquidated in the "distracted" and "absent-minded" film-going public of Benjamin. Benjamin draws a radical conclusion from Kuleshov's work by suggesting, since no amount of attention can unmask the illusion of a properly constructed montage, that it becomes pointless—even futile—to try. In Benjamin's account, the camera's optical testing is perversely transformed by montage into tactile experience: waves of images in orchestrated rhythms crash over a public unable to determine if their collective thrill derives from fact or fantasy. Should Benjamin's "take" on the power of montage surprise us? Writing in 1936 he could already see that "mass movements are usually discerned more clearly by a camera than the naked eye" (n. 21), and he knew full well that montage played a role in this disturbing truth.

History After Film

At the end of the *Artwork* essay, Walter Benjamin invokes the "politicization of art" as a measure directed against the "aesthetization of politics," which, in his assessment, corresponds to Fascism (1:508; 242).[1] The entire preceding argument, however, centers around the question of a new aesthetics initiated by the "advent of the first truly revolutionary means of reproduction, photography" (1:481; 224), and subsequently expanded by film. The argument's shift should make it clear that the relationship between politics and aesthetics cannot, for Benjamin, be reduced to a simple substitution of one for the other. At the same time, insisting on a complete separation of the spheres of aesthetic and political value would be equally inappropriate, for it would irrevocably commit aesthetics to the type of disinterested contemplation that, since Kant, has been synonymous with aesthetic perception. At the level of reception, such contemplation produces the "eternal value and mystery" of art; on the production side, this corresponds to the insistence on "creativity and genius." Benjamin views these as "outmoded" concepts in light of the technical innovations of photography and film (1:473; 218). The following remarks attempt to illuminate the interrelation of the political and the aesthetic in Benjamin's analysis of art under the conditions of reproducibility and, more specifically, of film. I will suggest that Benjamin undertakes not only an assessment of the historical importance—and thus the political potential—of film and

1. *Editors' Note:* Citations to Benjamin's text in this essay are generally double-referenced: the first is a page reference to the German text as published in Benjamin, "Das Kunstwerke" (*Gesammelte Schriften*, 1974); the second refers to the English version: Benjamin, "Work of Art." In some instances, for philological reasons, the author has substituted his own English translation, in which case one finds only a reference to the German original. References to other texts by Benjamin include volume and page numbers for *Gesammelte Schriften* with translations provided by the author, except for the citations from "Theses on the Philosophy of History," which are taken from Benjamin, "Theses."

photography, but also a redefinition of history in light of the simultaneity engendered by reproducibility.

Distracted reception, "the symptom of profound perceptual changes," writes Benjamin, "has its central place in the movie theaters" (1:466). The shock effect brought about by the quick succession of different images in the filmic sequence marks the intrusion of a strong tactile component into the arena of the visual. In the first version of his essay, film becomes "the currently most important object of that doctrine of perception, which the Greeks called aesthetics" (1: 466). Aesthetics, as this etymological allusion indicates, is properly treated within a discussion that encompasses general questions about perception, including an analysis of the epistemic shift that accompanies the advent of film and photography. Furthermore, although the Greek word *aisthesis* signifies perception of the senses in general, it assigns a special prevalence to the sense of feeling: by virtue of physical contact with the object, touch (and to a degree taste and smell) produces a much less dramatic transubstantiation of the object's material substance and form into a spiritual expression of boundless significance than do seeing or hearing.

The attachment, the interested—even erotic—adherence of touch to its object, corresponds to distracted perception: such tactile perception "*absorbs* the work of art"; in contrast, the disembodied, visual contemplation of a work amounts to being "absorbed by it" (1:504; 239). But this chiasmus does not mark an actual symmetry. "On the tactile side," as Benjamin points out, "there is no counterpart to contemplation on the optical side" (1:505; 240). Rather, tactile reception is determined by an absence—the absence of attention. In its place, habit governs interaction with the object which, for that reason, can no longer be understood as autonomous or independent. This shift in mode of attention from observation to operation is not absolute: the example of architecture illustrates that both modes might coexist, but they are activated for different purposes (not unlike Henri Bergson's independent recollections and mechanical memory). Only an aesthetics that leads to an habitual adaption of the "human apparatus of perception" can face the epistemological challenge posed by an epistemic change or, in Benjamin's own words, the "turning points of history." Film becomes "the true means of exercise" (1:505; 240) of an habitual aesthetics for several reasons: because its quick changes of place and focus "periodically assail" the audience (1:502; 238); because it shapes and addresses a mass audience in the first place, thus preventing the in-

dividual from evading the new epistemological task; finally, because the filmic "shock effect"—a consequence of montage—is perfectly suited to a distracted reception (1:505; 240).

It should be noted that Benjamin's concept of distraction is by no means synonymous with mindlessness. In fact, as a passage at the end of the fourteenth chapter makes clear, exactly the opposite is true: in order to be absorbed, the filmic shock effect needs to "be caught and cushioned by heightened presence of mind" (1:503; 238). Distraction is a sort of dispersed attention that can register anything that enters its wide radar screen. It is the constant presence of attentiveness without attention, of intentionality (in the phenomenological sense) without intention. In this way it is presence of mind, the potential for actualization at any point in time.

Such potential validates Benjamin's claim that film contains of necessity "a revolutionary criticism of traditional concepts of art" (1:492; 231). On the level of filmic images, heterogeneous and even contradictory elements from a variety of mutually independent semiotic systems can be assembled into new meanings, as no combination of words or elements of one specific semiotic system could. This process is, at least in theory, unlimited, since any additional frame can add new meaning—at times even to the surprise of director and editor—and thus revise the meaning created up to that point. This frame-by-frame process is not perceived on the level of individual frames, however, but in quick succession,[2] so that within the sequence in its totality "the apprehension of each single picture appears to be prescribed by the sequence of all preceding ones" (1:485; 226).[3]

The power and the distinction of film lies precisely in this sequenc-

2. The discussion and treatment of the incriminating video in the Rodney King case demonstrated impressively how filmed evidence is perceived differently when it is viewed frame by frame. While it seemed clear to almost everyone watching the nationally televised video that the police, from a certain point on, used unnecessary force to subdue the uncooperative but seemingly disoriented and defenseless suspect, an entirely different reaction resulted from the jury's frame-by-frame viewing. The jury in suburban Simi Valley was unable to decide when, or even whether, a point of unnecessary force was reached, and they acquitted all four officers accused of misconduct in April 1992.

3. Where Zohn uses "meaning," I put "apprehension" as a more accurate rendering of the German *Auffassung*, which for Kant designates a progressive perception (of a space, for example) that only subsequently leads to comprehension—that is, a combination of these data under one concept (*Critique of Judgement* §§ 26ff). In addition to and independent of the Kantian definition, the term suggests that the process in question is linked to the recipient's mode of perception (that is, to the audience) and is not, as Zohn's translation implies, derived from the qualities of the perceived filmic sequence (ibid., p. 99).

ing. The viewer does not have time to contemplate individual frames, but instead—as in a dream—is carried along by a stream of images that creates something like a rebus that can only be grasped through presence of mind qua distraction. The viewer is necessarily "distracted," for this state is the condition of film and of viewing films. In order to "read" individual frames as continuous motion, audience attention must slide along the succession of images and synthesize the series in a constellation of simultaneous presences that are continuously reconfigured, since the aesthetic object "film" (if it is indeed an object) can at no point in time be perceived in its entirety and thus cannot be subject to direct contemplation.

A precursor of the distractive effects of film can be found in the juxtaposition—or rather, the integration—of photograph and "caption" in picture magazines.[4] The combination of image and caption amounts to an intellectual stereoscopic effect: the image gains in profile through the verbal information conveyed in the caption; from the accompanying image this information gains persuasive power. Indeed, the relationship between image and caption is one of a certain mutual critique, in which the heteronomous element of the caption safeguards against a possible revival of auratic effects in the photographic image. Instead of encouraging the free play of the spectator's faculties and thus an attitude of "free-floating contemplation," the written word provides concrete "directives" that inform the viewer of the exact temporal and spatial distance that lies between him/her and the depicted scene. And while captions serve to bridge this spatio-temporal gap by actualizing the historicity of the image, they simultaneously mark it as irreducible. By means of the caption, the viewer is given "signposts" that point to the historical place of a particular image and infuse it with the reality of history by marking it as "evidence in the historical process" (1:485; 226). Rather than instigating a dialogue between itself as aesthetic object and the spectator within an eschatology of meaning, the photograph and its framing caption disclose their historical moment. Such a picture cannot be engaged in dialogue and needs no interlocutor: mute,

4. Benjamin's optimistic assessment of the medium's possibilities, while somewhat belated, is not uncommon in the Weimar Republic, as indicated by Tucholsky's statement that "the photographs are there, dynamite and detonators in the psychological struggle [of the workers]" (cited in Willett, *Art and Politics*, p. 142). These words are remarkably similar to Benjamin's description of the filmic unconscious in chapter thirteen of the *Artwork* essay.

it is evidence; it shows the dark corners, deserted places, and ephemera of an unwritten history.

While the caption gives "directives" for reception of the photograph, film provides not only images but also corresponding "directives" generated by the series of preceding images. Like the revolutionary concept of art criticism in German Romanticism, about which Benjamin wrote his dissertation, film is an ideal form of critique that takes its medium as its own object. But this object is not a specific work of art; rather, each individual image within the movie is such an object, and the movie in its entirety constitutes the critical commentary on any one of these objects. Whereas the romantic conception of the work insisted on its incompleteness vis-à-vis the aesthetic absolute— that is, its own absolute idea⁵—film, in contrast, is incomplete vis-à-vis its own absolute practice, a practice in which individual images are no longer perceived as complete in themselves.

Benjamin's observation that "the apprehension of each single picture appears to be prescribed by the sequence of all preceding ones" has a double edge, however. Not only is a specific image apprehended in terms of the preceding sequence, but all the preceding images are redefined and reorganized so that the emerging prescription fits the newly added picture. In other words, the perception of a whole film consists of an unfolding that is tentative at any given point and comes to a standstill only at the end of the movie. Such an unfolding is the absolute opposite of linear progress or development; instead, it should be thought of as either an incessant reappraisal that leaves no element untouched, or as a restless balance wheel within the filmic signifying machine. The produced meanings (which are, in fact, effects of the superimposition of images on the screen) are subjected to revisions with every addition of a new image. No hermeneutic reference to a stable whole is possible, since the whole itself is a continuously changing and unknown factor. While the same holds true for the reading of certain books that reflect the contingency of textual production,⁶ any textual discourse can nevertheless be located within the confines of a specific

5. "Jedes Werk ist dem Absoluten der Kunst gegenüber mit Notwendigkeit unvollständig, oder—was dasselbe bedeutet—es ist unvollständig gegenüber seiner eigenen absoluten Idee" (1:70).

6. Not coincidentally, numerous examples could be found within the discourse network of 1900, to which film also belongs. The definitive study is Kittler, *Discourse Networks*.

langue. This does not apply to film, however, because the language of film (if this metaphor is even permissible) can be reduced neither to convention nor to a specific semiotic system. Notwithstanding attempts to infuse it with another, conventionalized meaning (witness Sergei Eisenstein's intellectual cinema), a filmic image represents precisely that which it represents. There is no sharp distinction between signifier and signified. Due to the reproductive perfection of photographic technologies, the signifier adapts to the signified with such iconic precision that instead of denoting a particular situation within which certain objects or persons are possibly assigned a prominent place, it reproduces this situation as a whole. The lack of representational distance in the filmic image pushes film to the brink of collapsing into sheer simulation.

Film is a recording of the real, no matter what imaginary worlds it constructs.[7] It becomes "palpable [*handgreiflich*]" that a different nature opens itself to the camera than opens to the naked eye." It is a different nature, because the space filled with human consciousness gives way to a space filled by the unconscious (1:500; 236). This does not—as Zohn's translation suggests—become "evident" (a word derived from the Latin *videre*, which refers to visual perception). Rather, Benjamin's point is that the matter can be "grasped by the hand" [*handgreiflich*], and he offers some examples to establish a strong correlation between the "visual unconscious" and tactile reception: "With the close-up, space expands; with slow motion, movement is extended" (1:500; 236). Enlargement and slow motion do not just improve the perception of specific phenomena, they also uncover "entirely new structural formations of matter" and "entirely unknown" elements within familiar movements. These perceptions become possible precisely because "the camera intervenes with the resources of its lowerings and liftings, its interruptions and isolations, its extensions and accelerations, its enlargements and reductions" (1:500; 236)—that is, because they become palpable through the rhythm of the camera work.

Film supplements the anatomy of the body, which accompanied painting from the Renaissance onward, with an anatomy of behavior. Through film it becomes possible to isolate and dissect a specific behavioral pattern "like a muscle of a body" (1:499; 236). From its inception, cinema relied on close-ups to capture, as Siegfried Kracauer

7. In Benjamin's own words: "Film is the first art form capable of demonstrating how matter plays tricks on man" (1:490, n. 19; 247, n. 11).

observes, "an endless succession of unobtrusive phenomena" that, however, "provide clues to hidden mental processes."[8] Normally neglected details, individual body parts, and stage props—all these small, ephemeral things among the waste of history—attract the camera's attention and appear to the audience infused with new meaning. Thus in film, as in psychoanalysis, a total redistribution of distinctions takes place. Unlike subjects and objects, those paradigmatic units of bourgeois culture, elements on a superunit and a subunit level gain importance and become distinguished. On one hand, traditional units, especially the units of individual consciousness, are dissolved into bigger units (the totality of images in a filmic sequence or the constitution of the modern masses come to mind); on the other hand, they are fragmented to the point where their constituent elements are so emancipated as to become "organs without a body," an effect most strikingly illustrated by the tactile involvement in viewing a movie.[9]

If the work of art has been stripped of its aura, the human subject has not been spared: in a memorable comparison between surgeon and camera, Benjamin suggests that the physical cutting of the one, and the fragmentary "shooting" of the other, both treat the body as material devoid of aura. The effect of film, he writes, is that "man has to operate with his whole living person, yet forgoing its aura" (1:489; 229). In other words, and leaving behind Benjamin's last nostalgic attachment to humanism, filming a movie requires that all of man's living organs operate in a structural coupling with an apparatus that tests and records their performance. While the actor's body and, at times, just some of its parts act for the camera, the eyes of the audience assume the camera's perspective and test what they see. Directed by the constantly and abruptly changing unifying perspective of the filmic apparatus, the eyes of all viewers perceive movements and gestures that do not amount to the actions of an autonomous subject. Only under this condition can man's "other" become the focus of analysis: collectively as the modern mass, individually as the unconscious. For—to speak with Foucauldian rigor—there is no mass and no unconscious unrelated to

8. Kracauer, *From Caligari to Hitler*, p. 7.

9. Arthur Kroker and Michael A. Weinstein use this pun on the schizoid "body without organs" of Deleuze and Guattari to describe the "seduction to be code versus the dead-hand code of the body of flesh and blood." In the new electronic media, the will to virtuality (of which Benjamin's utopian assessment of film is an early stage) has reached a point where "bodily organs drift away, then reappear as pure cybernetic code" (Kroker and Weinstein, *Data Trash*, p. 59).

the arrival of film, nor to those parallel technologies belonging to the discourse network of 1900, such as the gramophone, the telephone, and the typewriter.

Benjamin states in a posthumous fragment that the dialectical image "justifies the bursting asunder of the continuum" of history (1:1242). Film occupies a structurally homologous position: "Then [after industrialized environments had enclosed and devoured modern human subjects] came the film and burst this prison-world asunder by the dynamite of the tenth of a second, so that now, in the midst of its far-flung ruins and debris, we calmly and adventurously go traveling" (1:499ff; 236). In this opening the "waste of history" (5:575–76) can be retrieved as evidence for another, previously discarded history yet to be (re)constructed.

Within the recognition that history "is subject to a construction whose site is not homogeneous and empty time, but time filled by the presence of the now" (1:701; 261), lies the political importance of the new epistemology for which film is the "true means of exercise" (1:505; 240). This presence of the now—or *time* of the now—should not be misconstrued as an exaltation of the present at the cost of the past. Rather, the time of the now, "as a model of Messianic time, comprises the entire history of mankind in an enormous abridgment" (1:703; 263); in a simultaneity exemplified by Benjamin's "dialectical image," thinking "comes to a standstill in a constellation that is saturated with tensions" (5:595).

The dialectical image as a mode of thinking depends, for its technology, on film. Furthermore, it relies on and expands the notion of "actualization" (5:574) as it is practiced in the mass reception of film— namely, as a distraction that, in the final analysis, always refers the superimposition of images back to the audience and its presence of mind. The idea of a history that is arrested in the standstill of an image refers neither to an abstract contextuality nor to a linear unfolding; rather, an image "is that in which the past comes together with the present in a constellation." But whereas "the relation of 'once upon a time' and 'now' is of a (continuous) purely temporal kind, the relation of past and present is dialectical and moves by leaps and bounds" (1:1242ff). A dialectical image flares up only momentarily like a lightning flash, a metaphor Benjamin uses repeatedly in this context to suggest that the recollection comprising the dialectical image is entirely involuntary. It is an image "that, in the instant [*Augenblick*] of danger, comes to the subject of history all of a sudden" as a disclosure of history (1:1243).

The viewpoint of this subject is occupied by the most endangered, most oppressed class—presumably in the configuration of a distracted mass—due to its exposed situation in the movie theater of history (that is, its affinity with the dehumanized perceptual mode brought about by film and required by the dialectical image). Neither a safe vantage point (perhaps the ivory tower from whence the old philosopher of history takes stock?) nor a linear narrative can capture "historical knowledge." It is accessible only in the "historical instant [Augenblick]" (1:1243). In a presence conceived along these historical concepts, "[e]very instant is one of passing judgment on certain instants that preceded it" (1:1245). Here, the linguistic fossilization of Augenblick as purely temporal equivalent of "instant" falls apart; what is required is a testing gaze, an Augen-Blick. The history Benjamin has in mind relies on both the visuality and the tactility of a filmic image rather than the discursivity of narrative which, of necessity, would depend on voluntary—that is, willful, selective, and purely subjective—memory.

Perhaps Benjamin's dialectical image, not unlike the combination of image and caption or the inherent tension in film between spatially defined images and a temporally unfolding linearity, could best be described in terms of the simultaneity of image and narrative: in other words, temporalization, historicization, and actualization of the spatial dimension of the image and of its synchronicity. At the same time, the dialectical image spatializes its story and history, and connects with the present (new in each case), by actualizing the diachronic range of its narrative.[10]

Only if the temporal distance between a past era and the present can reassert itself in the moment of actualizing the past, can past histories and their waste be redeemed. Therefore, reliving an era, in Benjamin's sense, means precisely not to empathize, for empathy "despairs of grasping and holding the genuine historical image as it flares up briefly" (1:696; 256). Empathy obliterates the distance between then

10. This would also explain the problem of the frame-by-frame viewing in the case of the Rodney King video: by effectively bracketing the temporal unfolding of the sequence (to the point where its linearity is dispersed), individual frames lost their relation to the real event of which they are both a record and a depiction. And slow-motion? Would it tend to aestheticize the beating? In other words, would slow-motion unveil the complicity between tactile aesthetics and violence? Demonstrate that between a tactile aesthetics (as in film) and violence there is only a difference of degree? After all, the shock effect of filmic montage bears the traits of violence, since the quick changes of place and focus "periodically assail" the audience (1:502; 238). Perhaps for this reason, the depiction of violence—to say nothing of the erotic—has a particular affinity to film.

and now, focusing only on a timeless present. It applies the hermeneutic mode of contemplation, which immerses the subject in the (presumably timeless) aesthetic object, on the level of history. Such treatment sublimates the ephemera and all that is palpable [*handgreiflich*] of history. Just as contemplation denies the materiality of the aesthetic object, so does empathy disregard the question concerning the ontological status of the historical. In contrast, Benjamin recommends that the historical materialist "brush history against the grain," a hands-on enterprise, to be sure (1:696ff; 256ff). The experience of film, and the reproducibility of the work of art in general, might well have become the best preparation for a materialist history, but only from the point of view of a future yet to come. Benjamin locates his own discourse in such a future, a projected "position for which no factual ground exists as yet."[11] But the contemporary mediasphere, determined by progressive impassivity, may have already surpassed Benjamin's proleptic viewpoint and assigned to it, literally, the status of a *futur antérieur*: it will not have been.

11. Geulen, "Zeit zur Darstellung," p. 598. Geulen's whole essay is a meditation on the problems of representation related to this projected epistemological vantage point from which Benjamin observes history.

Digitized Analogies

> In order for a part of the past to be touched by actuality, there
> must be no continuity between them.
>
> —Walter Benjamin, "N"

During the mid-1920s, Walter Benjamin and his friend Franz Hessel
prepared a German translation of *Within a Budding Grove*, the second
volume of Marcel Proust's *Remembrance of Things Past*. Proust's text
contains this account of young Marcel viewing a stage performance:

> I told my grandmother that I could not see very well; she handed me her
> [opera] glasses. But when one believes in the reality of things, making
> them visible by artificial means is not quite the same as feeling that they
> are close at hand. I thought that it was no longer Berma [the actress] but
> her image that I was seeing in the magnifying lenses. I put the glasses
> down. But perhaps the image that my eye received of her, diminished by
> distance, was no more exact; which of the two Bermas was the real one?[1]

Proust evokes an effect of simulation particularly familiar to postmod-
ern critics, a condition of reciprocal resemblance that undermines the
authority of the original. Young Marcel has experienced a simple case
of technological enhancement. Viewing through opera glasses offers the
advantages of increased size and apparent proximity, but once this
abrupt transformation of the experience has occurred, the observer is
left with a puzzle: does the glass actually distort the reality of the ob-
ject or, alternatively, has the truth of the unaided view been somehow
diminished, never to regain its former stature and status? The optical
exchange between large and small, near and far, seems to cloud the es-
sential character and effect of the actress and her performance, without
having lessened the boy's desire to experience this living object "close
at hand," endowed with all its unique qualities.

Curiously, Proust introduces the term "aura" in his next paragraph
when he refers to the "'aura' which surrounds momentous happenings,

1. Proust, "Within a Budding Grove" pp. 485–86. I thank Katy Siegel for calling
Proust's passage on aura to my attention. For the Benjamin and Hessel translation of
Proust, published in 1927, see Benjamin, "Marcel Proust," pp. 25–26.

and which may be visible hundreds of miles away." Placed within quotation marks in the French original, presumably because it derives from a technical medical discourse, the word extends the narrator's thoughts on observing those things of importance that must appear both near and far: near because the effect is overwhelming and inescapable; far because the reality can never be fully grasped. Proust's example of such an auratic event is the distant military engagement about which "vague and conflicting reports" circulate, but which nevertheless produces some coherent, collective emotion among members of the crowd. It is as if—to use a Benjaminian metaphor—the reality of the event was borne on the wind and passed to the crowd like the effect of a gentle breeze. Proust draws a comparison between this mass reaction to newsworthy events and the applause of a theater audience; the latter is surely a response to the genius of Berma, but it often erupts at inappropriate moments during her presentation. Ironically, this applause becomes self-generative by producing a simulation of itself in the form of ever more enthusiastic applause, and a correspondingly ever greater estimation of Berma's performance. Given such spontaneous magnification, what level of audience response is true to the situation? How attentive to the reality of Berma is this mass reaction to her aura? With these questions we drift from Proust toward Benjamin.

Benjamin's "A Short History of Photography" of 1931 defines aura with a phrase he repeats in the *Artwork* essay (composed 1935–39): "[T]he unique manifestation of a distance, however close at hand."[2] The word "aura" connotes qualities accessible to vision (brilliance, luminosity, glow) and phenomena that can be sensed from afar.[3] Aura collects such associations because it derives from the Greek and Latin words for breeze or air in motion, something ethereal that extends itself and permeates the environment.[4] Although the eye cannot see its substance, a breeze (like the air of emotion surrounding an event) can be visualized as luminous emanation; thus, with the concept of aura, Benjamin could conflate atmospheric inhalation with visible halation:

2. Compare, for example, Benjamin, "Short History of Photography," p. 49, to Benjamin, "Work of Art," p. 222.

3. Nevertheless, it can be argued that aura has an especially significant tactile dimension. See the discussion in Shiff, "Handling Shocks."

4. In medicine, *aura* signifies the sensory hallucinations immediately preceding certain epileptic seizures. According to ancient Greek physicians, the sensation of aura would originate in the hand or foot and seem to rise to the head, feeling like a cold vapor. Such vapor could pass up the body's vessels because it was believed they contained air—hence, the association of aura with breezes or currents of air. See Sacks, *Migraine*, p. 56.

"[To] let your eyes follow a mountain range on the horizon . . . until the moment or the hour partakes of its appearance—this is to breathe the aura of these mountains."[5] Such experience establishes unmediated bodily contact; you breathe the object, like the air, in and out. You assimilate bodily the medium that allows vision to operate (because the atmosphere is translucent), but which also conveys something of the object's physicality: the distance between you and the object dissipates, yet it remains distinctly separated from you, however immaterial its physical presence might seem to be.

To develop his theme of loss of aura in an age of mechanical reproduction—more specifically, the age of sound film and its ability to replicate both news events and theatrical performances—Benjamin invokes the screen actor. This performer faces the camera, not an audience. The actor in front of a camera is not in a position to share a medium (the air, the distance) with the members of his audience; he is not a living auratic object for them, nor can he engage them in reciprocity. Benjamin writes:

> For the first time—and this is the effect of film—man has to operate with his whole living person, yet forgoing its aura. For aura is tied to his presence; there can be no replica of it. The aura which, on the stage, emanates from Macbeth, cannot be separated for the spectators from that of the actor. However, [in film] the camera is substituted for the public. Consequently, the aura that envelops the actor vanishes, and with it the aura of the figure he portrays. (229)[6]

Recall that the optical magnification of the actress Berma's image—the simplest of mechanical transformations—began to interfere with her aura and to fragment her reality, albeit in a relatively minor way. With greater insistence, Benjamin argues that in film the camera "need not respect the performance as an integral whole" (228). Given the editing process, which constitutes a testing of various possibilities, certain of the performer's movements and effects "are in reality those of the camera" (228). Cinematic technology intervenes to a significant degree: disjoining actor from audience; eliminating the reciprocity of human contact; cutting the image off or away from the living flesh of the per-

5. Benjamin, "Short History of Photography," p. 49; Benjamin, "Work of Art," pp. 222–23.

6. *Editors' Note*: Parenthetical references in the text and notes of this essay are keyed to the edition listed in the Bibliography as: Benjamin, "Work of Art." However, in some cases the author has modified the published translations of Benjamin's text so as to preserve a metaphor or an effect of syntax.

former. Like a glass house ("things made of glass have no 'aura'"), the actor before the camera becomes visible and even palpable inside and out.[7] The cameraman, Benjamin states famously, operates like a surgeon (233 and n. 14).

It is in the nature of technology to operate. But what degree of technological probing, fragmentation, and recombination becomes revolutionary, given the conditions of a modern industrial economy and its social order? Benjamin's essays suggest several realms of investigation, one of which centers on the speed at which an image is transformed or reproduced. Despite the shift to a postindustrial economy, Benjamin's concern for the rate and quality of change seems particularly relevant to problems currently raised by digital photography and other forms of electronic imagery and recording. His arguments also speak to the environment of interactive simulation known as virtual reality, and to its remarkable capacity for counteracting a viewer's resistance to illusion.

In "A Short History of Photography," Benjamin notes that the first daguerreotypes required a relatively long exposure. Because of this, he implies, early portraiture did not fully realize photography's potential: it failed to still the breeze or breath of its object, or to detach the image from a person's aura. Photography's earliest portrait subjects lived "not *out of* the instant, but *into* it; during the long exposure they grew, as it were, into the image."[8] Benjamin's description suggests the encounter between subject and photographic apparatus is a mutual effort, analogous to the mutual responsiveness of actor and audience. Here, camera technology merely substitutes for skills of the hand, since the speed of the picturing—although vastly accelerated when compared with a process of drawing or painting—is still not fast enough to render outmoded the sitter's conventional behavior and habits of perception. Just as a theater audience participates in the actress's performance by applauding her, the sitter for a daguerreotype collaborates with the camera, as if the apparatus were a responsive individual. The sitter becomes a stage actor adjusting and effectively improving his or her performance, and that of the camera, by living "into it." The result is a certain confusion between the reality created by the device and that created by the living person, analogous to Proust's hesitation between the two images of Berma: one magnified by lenses, the other by applause.

7. "Die Dinge aus Glas haben keine 'Aura'" (Benjamin, "Erfahrung und Armut," p. 217).

8. Benjamin, "Short History of Photography," p. 48.

Benjamin's *Artwork* essay follows the argument of his "Short History" and repeats many of its sentences; but he eliminated the notion of living "into" images during lengthy portrait sittings, and simply alludes to the aura of a human presence seen "for the last time" in early photographs. Eugène Atget's images of "deserted Paris streets" become, in contrast, the paradigm of photography fully realized—isolated views cut out of history, rather than living faces that record a lifetime of slowly evolving experience (226). Benjamin's virtually contemporaneous essay on Baudelaire puts the matter of early portrait photography in a somewhat different, less auratic light: "In daguerreotypy [as opposed to the faster paper-print photography such as Atget's], what had to be experienced as the inhuman, one might even say the deathlike, was the continuous looking into the camera, since the camera takes a person's picture without returning his gaze."[9] This, Benjamin argues, runs counter to the experience of aura and the allied act of contemplative concentration, the living "into," the empathy.

Atget's strangely defamiliarizing images of early modern Paris realize the camera's capacity to strip the layering or history of human exchange, a source of aura. Since the camera fails to enter into active human exchange, the image it produces (the reproduction) becomes a thing unrecognizable save by an optics of the unconscious: if there is any recognition at all, it can only be uncanny. Benjamin compares facing the camera to the "estrangement felt before one's own image in the mirror" (230). He remarks elsewhere that "a man does not recognize his own walk on the screen."[10] Film disconnects a body from its life history and any collective social evolution, even before the material fragmentation of montage or editing.

Benjamin claims that modern cinema (sound film) is the medium in natural correspondence with the new, revolutionary urban masses. Cinema allows the masses to recognize their own proper mode of perception—distracted and perhaps shocked, as opposed to contemplative and empathic.[11] The history of media and modes of perception that Benjamin himself composes in the *Artwork* essay moves quickly; it jumps from one critical observation to another, often bringing disparate facts together through surprising and even shocking analogies.

9. Benjamin, *Charles Baudelaire*, p. 147.

10. Benjamin, "Franz Kafka," p. 137. Compare Benjamin, "Short History of Photography," p. 47, and Benjamin, "Work of Art," p. 237.

11. See Benjamin, "What Is Epic Theatre?" p. 150; and Shiff, "Handling Shocks," p. 102, n. 60.

Benjamin's argument may well appear to lack continuity. This is, however, one way it becomes "completely useless for the purposes of fascism" (218). Like photography, it breaks the chain of tradition, violating the systems of auratic authority and orders of historical evolution that have set a Fascist society in place; systems that have allowed bourgeois Europeans to contemplate and live "into" Fascism instead of being shocked by its very existence.

Consider the play of continuity and discontinuity in the following passage:

> With photography, for the first time in the process of pictorial reproduction, the hand was unburdened of the most important artistic duties, which henceforth devolved solely upon the eye looking into a lens. Since the eye comprehends faster than the hand draws, the process of pictorial reproduction was accelerated so exceedingly that it could keep pace with speech. A film operator shooting a scene in the studio captures the images at the speed the actor speaks. Just as the illustrated newspaper was virtually concealed within lithography, so within photography the sound film. (219)

Photography removes from the hand functions that the eye can perform faster—the scanning of a view, the composition of an image—but only the later development of sound films reveals photography's hidden potential: to reproduce the human image at the speed of the event; to establish an intimate closeness that breaks down the distance barrier of aura. A conventional historian would emphasize the continuity of technological development from photography to film, but Benjamin stresses a discontinuity, one that—because it depends on concealment—paradoxically has an aura of its own. He argues that the early modern innovation of photography could only acquire its full historical significance when a late modern society experienced the shock of filmic representation, an unforeseeable or "concealed" moment of photography's future. Photography touches the present through cinema when the sound film bursts from photography's own historical shell.

Note that Benjamin's final sentence in the passage cited above constitutes an analogy: lithography is to the illustrated newspaper as photography is to the sound film. Analogy is the most common form of Benjamin's argumentation, really more a rhetorical device than a matter of logic, more poetic metaphor than arithmetic ratio. If Benjamin was seeking to defeat Fascist readings by denying them the appearance of inevitable closure (a kind of historical and evolutionary determinism), then analogy had a way of working to his advantage. It appears

to uncover relationships of continuity, but they can only be deceptive: like a sentence composed of discrete words, or a film composed of discrete shots (to use two analogies), analogy merely combines disparate particulars according to some structure or pattern, one equally well suited to any number of other sets of particulars. Analogy works like computer-generated, digitized imagery in which pixels are composed into pictures. Each analogy represents a structure or algorithm applied to discontinuous digital elements, and seems to convert them into a higher, analog order of argument. Benjamin's "argument" startles because he resists conventional pacing; he prefers, like a Dadaist, that his work "hit the spectator like a bullet" (238). His analogies move cinematically to create ungraspable, illusory continuities from fragments. His phrases move faster than a reader's thought. Benjamin is a filmmaker, not a painter: "A painting invites the spectator to contemplation; before it he can abandon himself to his associations. Before the movie frame he cannot. No sooner has his eye grasped a scene than it has already changed" (238). Accelerated speed, the rate of change, is much of the problem.

As in fast-cut film editing, so in electronic computer technology. With enough time and energy, a conventional animator—either by flipping hand-rendered images in front of a film camera or converting individual photographs into film frame by frame—can create the elements that will perform any number of metamorphic and anamorphic transformations, equaling any specific product of computerized animation. But the computer and its animator-operator use electronically coded algorithms to perform such transformations incomparably faster than any user of handpower. Furthermore, the computer's basic template for an image is a set of electronic switches or digits; unlike conventional photography's negative, the computer's generative template remains independent of the characteristics of any particular material component or ground. The template or pattern can be reproduced in any physical form and, although it may have been derived by scanning an object or pre-existing image, it could have been derived by scanning any other source using a suitably different algorithmic operation. Digitization shows little respect for the integrity of objects, and so takes perception ever further from the experience of aura.

Perhaps I have become too familiar with Benjamin's abrupt analogies: to my mind they quite effectively identify the implications of recent technological change and only now reveal the greater historical significance of his argument. Just as photography's potential for speed

conceals film within, so film's potential for unlimited cutting and pasting conceals digitization within itself. The electronic computer adds unprecedented degrees of speed and dematerialization, not only freeing the hand but also releasing the mind from laboriously mapping out a sequential set of changing images. Computer technology, for better or worse, allows the testing of images to proceed at such a pace that there may be no time to contemplate their selection. As Benjamin said of the movies, "No sooner has [the] eye grasped a scene than it has already changed" (238).

Cinema is to the masses what the newspapers were to the bourgeoisie. "It began with the daily press opening to its readers space for 'letters to the editor,'" writes Benjamin, noting that middle-class Europeans enjoy more than ample opportunity to comment publicly on everyday matters that may concern them; "thus, the distinction between author and public is losing its basic character" (232). Benjamin's simple observation now seems to predict what can be said regarding virtual reality: "In multisensorial interactive VR, we are all authors and joint authors, broadcasters, writers, and consumers of data. . . . We are all responsible, to some extent, for the mutation of data. But because we do not completely control and cannot predict any change in data, none of us is the identifiable author of any creation."[12] The interactiveness of VR, a kind of simulated reciprocity, not only recalls Benjamin but also evokes once again Proust's Berma. The interaction of her audience—not with her, but with her aura—produced an improved performance; or, rather, the simulated appearance and experience of improvement for both parties to the exchange. Because the computer can generate a rapid succession of algorithmic transformations, it is conceivable (in practice as well as theory) that any image might be a reproduction or pirated copy of any other image. Being original becomes the luck of the draw—a de-auraticized originality. Just as Benjamin recognized the senselessness of searching for "the 'authentic' print" among photographic copies (224), so it now becomes pointless to devalue one image merely because it appears to derive from another. To select the one that will be "original" from among countless, interchangeable, yet different copies has become all the more obviously an act of politics.

12. Karnow, "Data Morphing," p. 121.

The *Photomonteur* Recycled

A Benjaminian Epilogue to Heartfield's 1991 Berlin Retrospective

In 1991, in the immediate aftermath of German Reunification, the Akademie der Künste of Berlin organized a monumental retrospective of John Heartfield's work. I have no hesitation in calling this cultural event, with its strong political undertones, a museal and national recycling of the great *photomonteur* of the 1920s and 1930s. I propose to analyze certain aspects of this event in interaction with the 1936 version of Benjamin's essay on the work of art that is at stake in this volume.[1] While trying to avoid attitudes toward Benjamin such as monumentalization, fetishization, or, in the opposite, iconoclasm, I should like to show that Benjamin's text can still help us to formulate complex questions in the cultural sphere. If we use this text as a tool for thinking, and do not classify it as a historical truth, it may still today prove to be extremely helpful.

There are some good reasons for using this specific text to analyze the Heartfield retrospective. First of all, John Heartfield, a contemporary of Walter Benjamin, was—together with Hannah Höch—one of the pioneers of photomontage in the first decades of our century. Although film was the new reproductive medium that most attracted Benjamin, photography and photomontage too are among the technical reproductions he dealt with in his text.[2] Finally, his notion of "exhibition value" may reveal itself to be very useful in our attempt to understand an exhibition as a cultural event.

It is indeed interesting to observe that there is a long-standing de-

1. *Editors' Note*: Parenthetical references in the text and notes of this essay are keyed to the edition listed in the Bibliography as: Benjamin, "Work of Art."

2. Thus Benjamin remarks that of the two processes of detaching the reproduced object from the domain of tradition and reactivating the object reproduced, "their most powerful agent is the film" (221).

bate on how to exhibit objects of photomontage, and that this apparently technical question of museology contains and entails a more basic question on the nature of photomontage:

> To be sure, what you see in this exhibition are so-called "originals." However, no matter how irreverent it may sound, I claim that the reproductions are the originals. Already in front of a photograph you cannot pose the question: Is this photograph the original or not? And it would be snobbish if one intended to hang up a negative as the original in one's room. The manner in which the images hang in front of you, here, does not correspond to Heartfield's intention.[3]

This text was written by Günther Anders for the Heartfield exhibition that took place in 1938 in New York. It could have been written in 1991. As a matter of fact it was included, in the form of a quoted fragment, in the catalogue of the retrospective in which we find analogous commentaries.

What should be exhibited: the unique *cliché*, the photographic negative, or the printed photo that has already been made public in as many copies as the circulation of the *AIZ*, one of the papers Heartfield had been working for, permitted? It is quite evident that in the two cases the exhibition value is extremely different. But is the negative really an original, or the equivalent of what an original is in painting for instance? Couldn't the photo itself, although made public at once in a great number of copies, claim the status of an original? This is what Rolf Sachsse seems to suggest, while carefully avoiding the term "original": "In the final analysis, the finished work exists solely in its realization through the mass media by means of printing and distribution which efface the traces of production."[4] If we thus declare the printed copy to be the original, what would the museal exhibition value of such a copy be, besides its documentary value?

Even if we do not push the argument ad absurdum as Anders does by stating that "the reproductions are the originals," we clearly have a problem with the dichotomy original/copy if we try to apply it to Heartfield's photomontage. The very nature of photomontage seems to render it highly problematic, if not inapplicable any more.

There might be a way out, if we take things in chronological order. Going back to the 1920 Dada Fair, the specialist Helen Adkins gives us the following account:

3. Anders, reprinted in Berlin Akademie der Künste, *Heartfield*, p. 181.
4. Cited in ibid., p. 268.

The "Monteur" shows us his original collage "The Pneuma Travels around the World" as well as its printed version which served as a cover illustration for "dada 3." This is not meant as a demonstration of the collage-printing process; both pieces were shown entirely independently of each other. Rather, [Heartfield] was concerned with illustrating the Dadaist claim of integrating concrete "material" into the works and with documenting this by means of "evidence." In the case of later photomontages the actual process of montage was only a production model, a means to an end and, being merely a technical necessity, it was no longer shown in public.[5]

According to Adkins, in 1920 the author himself made a distinction between the "original collage" and the printed photomontage, exhibiting both as different objects. In her biographical account of Heartfield's workings, this difference takes the narrative form of an evolution. In an early stage, among the Dadaists, Heartfield still produced collages from original pieces of heterogeneous materials, among which photographic material is only one kind. These pieces were assembled into a work that did have the status of an original, like a painting. The photograph taken of the collage could logically be treated as a mechanically produced copy.[6] This technique of collage, of which a picture was taken, was characterized by the diversity and number of its materials, by strong contrasts and hard cuts between the elements. In the later stage of production, what could be called the photomontage proper used exclusively photographic materials and avoided hard cuts and contrasts by a very subtle use of retouch. It also became more and more economical in its variety and number of materials.

It is only in this second stage of evolution that Heartfield's work truly belongs to mass-media photomontage. Consequently, its mode of exhibition doesn't seem to leave any doubt: what has to be shown is the mass-media product in the form of the printed photograph, one out of many that were produced of the same "work." The project of the 1991 retrospective was to revoke this widely agreed upon practice and to come back to the earlier exhibition technique: "In contrast to the practice that has prevailed hitherto, namely, to show Heartfield's works in the form of large photographic reproductions, original montages ought to be exhibited, now."[7]

This very sketchy look at the history of Heartfield exhibitions

5. Ibid., p. 262.
6. As opposed by Benjamin to the "manual copy."
7. Berlin Akademie der Künste, *Heartfield*, p. 295.

shows us that it was not clear what the visitor of such an exhibition should be offered to see. This question contains the more fundamental one about the specificity of photomontage. Very often the issue has been formulated as an alternative: is photomontage an art or a (mass) medium? This question returns us to Benjamin, who followed the long debate on this alternative and echoed it in the following terms: "The nineteenth-century dispute as to the artistic value of painting versus photography today seems devious and confused" (226). If the debate was deemed "devious and confused" to Benjamin in 1936, it is not because it was already obsolete, but because the potential of radical change in the realm of art brought about by the new media photography, could not be accepted by artists and photographers, but only registered and made explicit with great delay and many detours. Art life in its many dimensions—sociological, economical, aesthetic, self-reflective, and so on—did not change abruptly for those working at the border-line between painting and photography, which was Heartfield's case. This can be shown in two series of documents that were produced or activated in relation with the Heartfield Retrospective. The first concerns John Heartfield's biography, the second concerns reception of his work around 1990.

The first series, abundantly produced and reproduced in the catalogue of the retrospective, shows how difficult it was in the first half of our century for a specialist in photomontage not to fall back into the sociogram of the artist, into the discourse of art, or into the habits of an artist's life as the nineteenth century had developed them. "When Helmut Harzfeld arrived in Berlin in 1913, he still wanted to become a painter"—this sounds like the beginning of a typical novel about an artist.[8] In fact, Heartfield's life story rather became the antithesis of such a novel, because, once he had given up on painting, he constantly had to fight against the professional mold of the artist as painter. Here are a few, rather symbolical, details documenting his effort to construct a different professional identity and thereby to indicate the different social function of the photomonteur—that is, the producer of photomontages.

Since Heartfield participated in the invention of photomontage, he had to invent for himself the image and identity of "Monteur" as being different from those of "artist." His brother Wieland talks about the early stages of this effort: "As a matter of fact, John had already been

8. Adkins, cited in ibid., p. 256.

called 'Monteur' during the war, not because of his working style, but rather because he used to wear an overall. He did not want to look like an artist, but neither did he want to look like a PR-specialist."[9] In accordance with his special outfit, he insisted on calling himself a "Monteur," which became "Monteurdada" during his short association with the Dadaist group in Berlin around 1920.[10] It was in this context that he established a close collaboration with Georg Grosz. The two of them identified their common production with the stamp "Grosz-Heartfield mont.," which performs a triple rejection of the painter's signature: first, the stamp replaces the artist's personal, handwritten signature; second, the double name replaces the individual artist; and third, "mont." replaces the "pinxit" of the painter. Altogether this small gesture symbolizes an important move away from the paradigm of the individual artist toward that of the collective industrial producer of a mass-product.

In the light of Heartfield's effort to establish a professional identity that would express the cultural novelty of his activity as a photomonteur, it is surprising to observe how much the most recent reception of his work still insists on its painterly qualities. The photomontages are still looked at and analyzed as if they were paintings. I am referring to a second series of documents, produced in connection with the retrospective—many of them found their way into the Berlin catalogue—that cannot be given the benefit of the doubt due to an ongoing "dispute . . . that seems devious and confused." Rather, we are witnessing a conspiracy aimed at turning back the historical wheel by reducing photomontage, and especially photomontage used as a political weapon, to an artistic form and by treating it like a painting.

Not all critics participate in this conspiracy, and especially not to the same degree. But there is a general tendency that has the effect of suppressing the novelty of photomontage for which Heartfield was fighting—that is, the impact of a new technology on modes of cultural production and consumption. What is suppressed is its participation in industrial mass media production, the efficiency of its political use, the

9. Wieland Herzfeld, cited in ibid., p. 123.

10. Such a denomination had strong connotational links with Tatlin's "machine-art" and more generally with the Russian constructivists who were trying to bring about a new social function and symbolical identity of the artist. Rolf Sachsse, who insists on Heartfield's professional training as a "PR specialist," seems not to consider these implications when he talks about Heartfield's "manifold flirtation with the name of a profession: 'Monteur'" (ibid., p. 267).

necessity to rethink the relation man-machine on the production side, and the relation product-public on the reception side. In other words, what is actively forgotten is Benjamin's invitation to think through those aspects and relations, and his pioneering contribution to this task.

I am not suggesting that the artistic value, the aesthetic novelty of Heartfield's work, should not be discussed, or that his allusions to specific paintings and recycling of some should not be taken into account. My criticism aims at the implicit assumption that his photomontages can be analyzed with a terminology that turns them into paintings and forgets about their modes of production, their material conditions, their circulation, and their use in the society in which they where produced.

Invited to participate in the rethinking of Benjamin's work by adapting its potential to a new cultural situation brought about by the "digital age," I find myself in the situation of dealing with a development that points in the opposite direction. Indeed the Heartfield retrospective dealt with the issue of new technologies in cultural practices in a somewhat backward way. Not only were the specificity and the historical novelty of photomontage not seriously considered, but they were even somehow revoked. There are reasons for this; I shall try, later on, to explain some of them.

At this moment my awkward situation provokes me to reflect upon the "wrong" historical direction my object is taking as compared to the project proposed by the editors of this volume. This project seems to imply that what Benjamin did in 1936—in fact elaboration of his essay ran over a long period of time—was only the beginning of a theoretical and analytical task we must carry on today. As older technologies are made obsolete by new ones, so are theories; both must be adapted to the pace of history. Somehow the good old metanarrative of modernity shines through this schema. The case I have chosen to analyze shows that historical reality is more complex: the digital age, by its mere existence, has not done away with the debate on the artistic value of photomontage, even if the digitizing of photographs has revolutionized their treatment. Yet the technological progress that will undoubtedly bring about changes in cultural practices coexists with a retrograde handling of John Heartfield's work. Schematically, we have the choice between two attitudes. On one hand, holding on to some kind of historical metanarrative and imposing an order that implies rejecting what is unorderly and goes against historical progress: for instance, reducing Heartfield's photomontages to the conceptual status of oil paintings.

Or, on the other hand, taking noncontemporaneity seriously as part of our historical reality and trying to describe and analyze its complexity. This second choice is more appealing to me, although it obliges us to renounce neat explanatory devices and clear-cut historical ordering.

Benjamin might be partly to blame for a continuation of the art-or-medium debate. His essay, in fact, contains a certain ambiguity. Although the general title proposes the category of "work of art" as englobing all the phenomena that concern the author, the text of the essay clearly distinguishes two types of reproductive procedures: "Around 1900 technical reproduction had reached a standard that not only permitted it to reproduce all transmitted works of art and thus to cause the most profound change in their impact upon the public; it also had captured a place of its own among the artistic processes" (219–20). The first type consists in the reproduction of an already existing work of art. In this case the reproduction intervenes after a first moment of production that has brought forward what can be considered an original. The original and its copies are different in many respects, as this was the case with Heartfield's Dadaist collage, which was reproduced by taking pictures of it. This type allows for manual as well as mechanical reproduction.

In the second type, the impact of mechanical reproduction becomes much more radical, because "the work of art reproduced becomes the work of art designed for reproducibility" (Benjamin, 224). This means that the production takes place through a procedure of reproduction, or that the original is already a copy. Benjamin gives two examples:

> From a photographic negative, for example, one can make any number of prints; to ask for the "authentic" print makes no sense. (224)

> In the case of film, mechanical reproduction is not, as with literature and painting, an external condition for mass distribution. Mechanical reproduction is inherent in the very technique of film production. (244)

Photography and film are the examples here. They have in common a technical condition that makes it impossible to produce without reproducing. Thus, the dichotomy that makes it possible to talk about reproduction collapses. Analogously, the opposition between original and copy implodes. It is quite clear that this type of reproduction brings about a much more radical change in art (re)production than the first one. Yet, are we still dealing with art, with works of art? Photographs and films, by virtue of their technical conditions, can never enjoy the auratic status of an original.

The distinction of these two types of reproduction is most important in Benjamin's essay, although he seems to have blurred it by deciding to include both types into the category of art. The radicality of the second type is such that, in practice and in theory, it tends to be reduced to the first one. This helps to explain the difficulty we have observed in Heartfield's life decision not to be an "artist" when making photomontages, and it also sheds light on the debate about how to make an exhibition of photomontages.

With regard to the Heartfield retrospective, we are now in a better position to explain what happened. The exhibition was dominated by the tendency to reduce the second to the first type: to deal with a mass media in terms of an art; to restore artistic as well as aesthetic values to objects whose conditions of production had necessarily excluded the production of such values. In exchange for this museological aesthetization of Heartfield's photomontages, other aspects that were essential to their status as mass media—their political dimension—were forgotten or neutralized.

It is well known that Heartfield used the new reproductive technique he was developing quite effectively in the fight against rising Fascism in Germany during the 1920s and 1930s. It is also known that, because of his views and his outspoken style of fighting for them, he had become a problematic figure both in prewar Germany and in the postwar GDR. Therefore, the anachronical aestheticizing of the photomontage medium in the Berlin Retrospective of 1991 served a political purpose: while erasing Heartfield's primary political use of photomontage, the public event of the exhibition switched his work from one political agenda to another one in the immediate aftermath of German Reunification. Thus the work of the photomonteur underwent a double process of recycling: aesthetically the process produced an artistic opus magnum and politically it produced a great national artist.

From Aura-Loss to Cyberspace

Further Thoughts on Walter Benjamin

1.

> The shooting of a film, especially of a sound film, affords a spectacle unimaginable anywhere at any time before this. It presents a process in which it is impossible to assign to a spectator a viewpoint which would exclude from the actual scene such extraneous accessories as camera equipment, lighting machinery, staff assistants, etc.—unless his eye were on a line parallel with the lens. . . . In the theater one is well aware of the place from which the play cannot immediately be detected as illusionary. There is no such place for the movie scene that is being shot. Its illusionary nature is that of a second degree, the result of cutting. *That is to say, in the studio the mechanical equipment has penetrated so deeply into reality that its pure aspect freed from foreign substance of equipment is the result of a special procedure, namely, the shooting by the specially adjusted camera and the mounting of the shot together with other similar ones.* The equipment-free aspect of reality has become the height of artifice; the sight of immediate reality has become an orchid in the land of technology (232–33)[1]

What Walter Benjamin describes here occupies media theory time and time again: observation and its blind spot, staging and simulation count as the relevant headlines today. The disappearance of observers and the instruments of observation; the film editor's montage, which lends the sequence of little puzzle pieces an identical finish; the covering up of selection and production through faith in the image as reality fetish; the effort to collapse the visibility and the comprehensibility of reality: everything that Benjamin sees in film can be applied to the diverse audio-visual media of today, leaving no room for the innocence of the media. More important, if our gaze falls on reality, if our gaze

1. My emphasis. *Editors' Note*: Parenthetical references in the text of this essay are keyed to the edition listed in the Bibliography as: Benjamin, "Work of Art."

falls on media-reality, if our media-gaze falls on media-reality, then—occasionally—an insight dawns on us, an insight into the complexity of the staging of reality in our society that becomes ever more questionable the greater its claim to authenticity grows. The great construction-machine called "World society" works on the construction of realities. The billions of people it busies are each hardly less complex constructing machines, each having a reality-builder for her- or himself: "Being is a delirium of the many" (Robert Musil). And so, as each individual construction machine successfully evades its recognizability, the great world machine becomes more and more opaque. And we need more and more stories, blueprints, and theoretical fictions to fabricate the gigantic plurality of reality, which the media washes unquestioned into our lives, into manageable pluralities, which no longer allow us the defiant certainty of "it must be so," but instead the comforting maxim "it goes on." Art is no exception. Today, no one surveys more than fragments—which become smaller and smaller—of a plurality that has not been a whole for anyone in a long time. But the media stage each small fragment for a few minutes as totality, which for this fleeting moment excludes the understanding that has become abstract—that is, that it could all also be different. And so we explain, one for all and all for one, a little piece of the unending history—and then it goes on.

2.

> During long periods of history, the mode of human sense perception changes with humanity's entire mode of existence. The manner in which human sense perception is organized, the medium in which it is accomplished, is determined not only by nature but by historical circumstances as well (222)

Walter Benjamin describes in his essay that the media belong to these historical conditions: slow motion and close-ups make visible a new structural formation in film, and the "optical unconscious" becomes clear (237).

Today even the pedagogues know that socialization became media-socialization a long time ago. That the most relevant, base dichotomy between real and unreal for European societies in the last few years has begun to change, however, is an insight that is only gradually gaining a foothold. As early as 1972, Edmund Carpenter was reporting interesting observations of the media-behavior of American adolescents: "They regard media as self-contained environments, having little correspon-

dence with other realities or environments. TV is its own reality, radio its reality, film still another reality. Each creates its own space, its own time. . . . They regard press and TV, in fact all media, the way they regard LP records: as separate worlds. They don't relate recorded music back to the performance."[2] Thus, they do not take exception when, for example, reports from different media contradict one another, because they form from each medium its own separate "world," and they no longer appear to suggest coherence among the different realities.

Those socialized in a print culture are accustomed both to searching automatically for the "reference" of a chain of signs and to assigning each media offering the most coherent meaning possible. In contrast, those socialized in the audio-visual media appear to have developed another cognitive strategy for the use and thematization of media, a strategy apparently more appropriate to technological developments. Blue-box and paint-box techniques and computer simulation have merely accelerated the development that was imposed technologically, in terms of reference-semantics, from the beginning of the medium of television: the origin of the images, their emergence and, correspondingly, their possible reception and assessment were from the beginning precarious. The digital nature of electronically produced texts, images, and music, which makes possible their fundamental communicability, forces altered reference-semantic strategies. While texts and photos were and are pragmatically interpreted as bivalent mimesis, computer simulation is monovalent. From the image of reality came the reality of the image.

Virtual worlds, just as they open technical cyberspaces, embody thereby an instructive paradox: they strive, on one hand, for the most complete reproduction possible and, on the other hand, for a complete liquidation of the real. Purely audio-visual surfaces have beginnings and ends only coincidentally, for they are detached from the meaning of objects and from history; indifference or aesthetic fascination correspond to them as modes of perception, but not a processing of reference. This tendency will extend itself even further if the laser-micro-scanner enters civilian life—that is, the laser-micro scanner developed as a military technology that projects virtual images directly into the eye without a go-between monitor.

2. Carpenter, *Oh, What a Blow that Phantom Gave Me!* pp. 42ff.

3.

> "Every day the urge grows stronger to get hold of an object at very close range by way of its likeness, its reproduction" (223)

Benjamin still grants aura to the faces on the old portrait photos. First in film, then even more in television, this aura seems completely gone. The need for the shameless proximity of celebrities, of suffering and death, of fear and tears in horrified faces as image is both fulfilled and generated on a huge scale by info-tainment, Reality TV, and simulation. Media psychologists fear the final loss of aura, bodilessness, and anonymity of participants in the communications networks of interactive media. On the other hand, the collective, playful deployment of technical media apparently also leads to new forms of tele-sociability, which permit modes of para-social (anonymous and abstract) relations to arise. Networked international mailboxes (like Green.net or Fido.net or interactive systems like Habitat) open up new forms of communication and identity. Specialized cultures with discourse universes, in which their own norms and preferences are valid, expand the self-selectable patterns for self-representation and raise the degree of specialization of avocational, personal, and private identities. In this way, computers and data networks not only destroy communication, but they also provoke it in nonlocal and specialized forms. An observation of such developments cannot be satisfied with the conclusion that problems of social isolation are trying to be solved indirectly through technically mediated interactions or pseudo-interactions. Beyond that, we have to recognize that the further perfection of new forms of tele-sociability can permit the development of actual hybrid forms of the constitution and management of psychological as well as social problems. Already the mere availability and accessibility of elaborate interactive systems—Minitel and BTX have shown that implicitly—afford at least the potential of other forms of experiencing reality, right up to cyber-sex. The presence, availability, and observability of processes of technical simulation and interaction parallel to well-known and proven (or failed) interactions and communications forms will cognitively and communicatively change our concepts of society, person, and individuality. Cyber-researchers should, as soon and seriously as possible, begin with the observation of such changes—changes that will certainly dissolve the interplay between Cyberspace and *Oikos*. It is a question of serious games, because they play with the re-entry shock of crossing the borders between Oikos and Cyberspace.

AURA

The concept of the aura which was proposed . . . with reference to historical objects may usefully be illustrated with reference to the aura of natural ones. We define the aura of the latter as the unique phenomenon of a distance, however close it may be (222)

Originally the contextual integration of art in tradition found its expression in the cult. We know that the earliest art work originated in the service of a ritual—first the magical, then the religious kind. It is significant that the existence of the work of art with reference to its aura is never entirely separated from its ritual function (223ff)

[T]hat which withers in the age of mechanical reproduction is the aura of the work of art (221)

[F]or the first time—and this is the effect of the film—man has to operate with his whole living person, yet forgoing his aura (229)

The cult of the movie star, fostered by the money of the film industry, preserves not the unique aura of the person but the "spell of the personality," the phony spell of a commodity (231)

As a concept of cultural analysis, "aura" is Walter Benjamin's invention. But if we rely on his famous definition of aura as "the unique phenomenon of a distance, however close it may be," it is indeed plausible to suggest that he would better have chosen, for this purpose, the theological concept of aureole ("a halo around the entire body," especially the body of the saint), rather than the medical concept of aura. For in its nonmetaphorical use aura refers to "a curious sensation of a cool or warm breeze (aura eliptica), which, starting from one end of the body, passes through the same, and ends in the head or the hollow of the heart." Such a critique is all the more convincing as aura, in Benjamin's use, not only stands for a "distance, however close it may be"—but also for what he believes is left of the artwork's originally religious cult functions. In Catholic and in Christian orthodox culture, the aureole marks that dimension where the cult function sets the distance which it both requires and imposes.

On the explicit level of Benjamin's argument, the two semantic components of "aureole" (which he had transferred to "aura") bear negative connotations. The distance that the aura establishes between the artwork and those who admire it (or, if they manage to do so, "use" it), seems to relate to Benjamin and his contemporaries' obsession with blaming art for the lack of a clearly established social function. A religious function, on the other hand, is precisely what an Enlightenment and a modernist worldview would not want to attribute to any practice subsumed under their own projects. It is thus not surprising that the aura, within Benjamin's thought, became a candidate for elimination through modernity's effects of disenchantment. "Mechanical reproduction" is supposed to do the job, together "with the desire of contemporary masses to bring things 'closer' spatially and humanly" (223). This view with its double implication helps Benjamin to present himself as a materialist and as a politically progressive intellectual. Nevertheless, the question remains why, in the context of this argument and this evaluation, he relies so strongly on historical progress and on a teleological narrative frame; the question remains why he relies so strongly on a discursive orientation that he had given up in earlier texts—instead of making aura the subject of a more detailed (and perhaps more devastating) critique of his own. The answer is that his very thesis about the future "decay" of the aura gives Benjamin the possibility to have the material development of a technology, more precisely: the development of the reproduction technology embodies the movement of historical progress. It is indeed hard to imagine a more appropriate narrative frame for an author who, like Benjamin, took the programmatic concepts of "progress" and "materialism" very seriously.

What is more painful for Benjamin's unconditional admirers in the present-day situation to admit than his adherence to teleology, is the meanwhile long obvious—we might indeed say: empirical—fact that his prognosis about the disappearance of the aura has not come true. On the contrary, if they don't find themselves in a relationship of mutual enhancement, mechanical reproduction and the aura can exist side by side quite happily. There is no doubt that Benjamin was aware of certain cultural developments in his own time that made it difficult to maintain his bet about its decay. For example, as he related the concept of "aura" to presence, and as the projection of the movie actor's body onto the screen could not be identified—at least not at first

glance—as a phenomenon of presence, it seemed easy to argue that the movie actor had to "forgo his aura." It must have been disappointing, therefore, for Benjamin to observe that a "cult of the movie star had long emerged"—however hard he had tried to separate this cult from the concept of "aura" by describing it as the "phony spell of a commodity." Regardless of whether we want to subsume the cult of the movie star under the concept of aura or whether we stick to Benjamin's alternative characterization, this phenomenon, in his view, had prevented the film medium from living up to its most progressive potential: "So long as the movie-makers capital sets the fashion, as a rule no other revolutionary merit can be accredited to today's film than the promotion of a revolutionary criticism of traditional concepts of art" (231).

Is there a specific flaw in Benjamin's analytical and conceptual apparatus, a flaw that would help us understand why his prognosis failed (if we don't think that such prognoses are impossible anyhow)? If the closeness between the artwork and its recipient is a clearly positive value for him, a value that he thinks is produced and enhanced by mechanical reproduction, then the distance-setting aura is the opposite principle. What Benjamin neglects here, however, is the elementary dialectic (and the complexity) of the sacred. Sacred objects are not only objects at a distance from our everyday lives; by establishing that distance they also attract and intensify a desire to touch. We might then say that the aura works both against and for that closeness between the artwork and its recipient in which Benjamin is so interested. And we should also mention that Benjamin himself seems to have felt a strong—albeit secret—fascination for aura; that is, he came under the spell of a phenomenon for whose termination he was arguing at the same time, on the more explicit level of his essay.

Probably no other critic in Benjamin's generation felt a desire as irresistible as he did to touch the objects of his admiration—and this desire was enhanced, rather than mitigated, by the (quasi-)religious taboo that aura established around them. If, like Bertolt Brecht, Benjamin criticized art for what he took to be its distance from society and its lack of a social function, his position was also different from Brecht's inasmuch as he did not have much to say about possible social functions of the artwork—beyond the touch. In this he resembled some of the great protagonists of surrealist and Dadaist art. The more they complained about art's alienation from society, the more they contrib-

uted, through their very protest, to art's auratization. As every religious person—especially every secretly religious person—has experienced: blasphemy can be a most efficient way to promote and to increase sacralization. However unintentionally, Benjamin played this dialectic with perfection.

TECHNOLOGY

> The expansion of the field of the testable which mechanical equipment brings about for the actor corresponds to the extraordinary expansion of the field of the testable brought about for the individual through economic conditions. Thus, vocational aptitude tests become increasingly important. What matters in these tests are segmental performances of the individual (246, n. 10)

> The sportsman only knows natural tests, so to speak. He measures himself by the trials that nature sets for him, not those of any machine. . . . Meanwhile, the work process, especially since its normalization by the assembly line, submits innumerable workers to innumerable trials by mechanized test every day. The trials are established automatically; those who cannot stand up to them are eliminated ("L'Oeuvre d'art," 722)

> It is necessary to emphasize as strongly as possible that film, in that it makes the possibility of exhibition into the most important object of testing, measures the whole domain of human behavior through an array of equipment, in exactly the same way as is the case with the output of industrial workers at factories (Benjamin, *Gesammelte Schriften*, I, 3, 1048)

It is relatively easy to say that Benjamin had strong opinions about certain forms of technical reproduction: lithography, photography, film, and sound recording all appear in his essay as affronts to tradition, cult value, and aura. But beyond opinions about a handful of technical processes, did Benjamin confront technology? Did he have a theory of how technical processes intersect with the scientific culture that develops them, with the economic culture that fosters their spread, and with the political culture that endorses—at least implicitly—their proliferation? That Benjamin struggled with such issues is clear; whether he had a coherent position is of interest to those who ask his essay to speak to life in the digital age.

Among the three extant versions of Benjamin's text, no passage was more profoundly reworked than the section that introduces the notion of test: the movie camera tests an actor's performance; the film audi-

ence adopts an attitude of testing. In a note attached to the final version of this section (n. 10), Benjamin moves his argument laterally to draw a parallel between filming an actor and "vocational aptitude tests" that evaluate "segmental performances of the individual." Today we might pass easily over this comparison, thinking of those tests we took in grade school to determine if we were better suited to study mathematics than literature. But this is not the kind of "aptitude test" Benjamin had in mind: his intent emerges clearly from a *brouillon* for the second version of his essay, where he explicitly joins a movie camera's "test" of an actor's performance to the way factory machines "test" the performance of those who work them. The French version (for which the German original is lost) draws the distinction more dramatically: an athlete "tests" himself against the natural physical limits of his body's structure; a worker's body is constantly "tested" against the machinery of an assembly line, and failing the test means losing one's job.

Anyone with a rudimentary understanding of twentieth-century industrial history will recognize that Benjamin was writing within—and responding to—a practice of industrial management dominated by the principles of the American engineer Frederick Taylor. The basic premise of "Taylorism" was simple: maximize efficiency by radically rationalizing every moment of a worker's day and every aspect of the work environment. Widespread adoption of the assembly line—the most visible effect of Taylorism in the workplace—brought a steady stream of materials to the worker and his machine so as to minimize nonproductive "down" time. Workers in "Taylorized" factories were subjected to "tests" against bench-mark times established for each task, and even rest periods were programmed at intervals determined by studies of muscle fatigue, hunger, attention span, and so on. An essential part of employee recruiting in these factories included tests to determine the physical agility, mental stability, threshold of stress, and general docility of a potential worker: these are the kinds of man-versus-machine confrontations invoked by Benjamin when he equates the tests faced by the film actor with those of the factory worker. Indeed, the latter were sometimes filmed while working, and their movements were analyzed—in slow motion and frame by frame—so that repetitive moves, wasted gestures, and other kinds of nonproductive intervals might be eliminated.

It is no surprise that a cultural critic committed to materialist his-

tory—and at least marginally a Marxist—would frame Taylorism as a struggle between man and machine. Taylor's program to enlist science and medicine in the project of rationalizing industrial production and maximizing profits seemed to fulfill Marx's claim—cited by Benjamin in another essay—that "every kind of capitalist production has this in common, that it is not the workman that employs the instruments of labor, but the instruments of labor that employ the workman. But it is only in the factory system that this inversion for the first time acquires technical and palpable reality" (*Charles Baudelaire*, 132). What is of interest, however, is the way Benjamin gradually erased this strict reading of Taylorism from the *Artwork* essay: the third version (basis for the English translation) makes no mention of assembly lines or industrial testing, and his rather laconic development of "test" is relegated to a footnote. What might these revisions tell us about Benjamin's concept of technology?

First of all, his conflictual rendering of the meeting between man and machine—or actor and camera—made sense when the machinery involved was essentially mechanical: the gears, pulleys, power sources, and ratchets of 1930s factories do seem crude when compared with the subtlety and suppleness of human movement. Consequently, it was easy to figure this meeting as a loss for mankind: "[W]hat is important for dialectical consideration," wrote Benjamin about pre- and post-mechanized cultures, "is not the mechanical inferiority of this technique, but its difference in tendency from ours—the first engaging man as much as possible, the second as little as possible ("L'Oeuvre d'art," 716). Benjamin lived in a mechanized age, but we cannot fault him for not predicting the agility of today's machines, the complexity of electronic controls, or the development of feedback loops—characteristic of advanced servo-mechanisms—where machinery adjusts and adapts to the physical input of its operator.

Nonetheless, Benjamin's manner of confronting man with machine fixes not only his historical milieu but also his theory of contemporary technology: Benjamin was a rationalist and, however reluctantly, a Taylorist. Since later versions of his text downplay this conflict, we could say his Taylorism was not iron-clad—in contrast to his more avowedly Marxist colleagues—and his decision to revisit its most extreme articulation suggests a genuine questioning of its premises. Perhaps Benjamin was affected by Georges Friedmann's influential book of 1936, *La Crise du progrès* (cited in *Charles Baudelaire*): Friedmann

exposed Taylorism as neither scientific nor efficient, criticized its crude system of measurements, and showed that it failed to recognize the extemporaneous learning and self-adjustments that workers of different sizes, strengths, and temperaments developed for their tasks. Perhaps Benjamin was affected by the 1936 "Matignon accords" of Léon Blum, which accorded French factory workers some control of their work rules. Whatever the reason, Benjamin backed away from Taylorism—and, by extension, from Marxism—but nothing took its place in his thinking: the final version of the *Artwork* essay sidesteps a theory of technology, and we might remember this silence when trying to freight his text with predictive value for our own time.

ANTOINE HENNION
BRUNO LATOUR

How to Make Mistakes on So Many Things at Once—and Become Famous for It

Once upon a time, when people believed in structures and power, Walter Benjamin's famous *Artwork* essay exerted a powerful influence.[1] The task, in those remote times, was to escape a disregard for technical devices that characterized Marxist and other critical traditions, in spite of their much-vaunted materialism. Before the arrival of Benjamin and other Frankfurters, such devices were thought to be purely neutral instruments that could become good or bad depending on the interests they served. Benjamin and his colleagues taught us otherwise. Their point was that technique makes power, and they used the arts as an example. There, a simple change in the means of reproduction produced an astounding transformation, both in the content of the works and in their audience. Jesus had made a mistake: multiplying the loaves of bread also transubstantiated the host. This was a strong message, and it did not escape notice.

Today, after rereading Benjamin's essay, our "spontaneous" reaction is quite different. Once homage has been paid to the essay's originality, once one acknowledges that the present critique of Benjamin owes much to Benjamin himself, we are amazed by the number of mistakes cheerfully gathered by the essay, and by the deep misunderstandings of most phenomena, both modern and historical, which it reveals. Taking a somewhat provocative tack, we will suggest that these mistakes are not merely weak components of a strong text that fail to prevent the essay's many qualities from achieving a deserved success, but are, in fact, the main source of the fascination which the essay has exerted and, it appears, continues to exert. In a collage that few authors have dared to make with so much ingenuity, every aspect of the modern

1. *Editors' Note*: Parenthetical references in the text and notes of this essay are keyed to the edition listed in the Bibliography as: Benjamin, "Work of Art."

world is briefly portrayed in the *Artwork* essay: art, culture, architecture, science, technique, religion, economics, politics, even war and psychoanalysis. And, we believe, in each instance a mistake in category leads Benjamin to take one for another.

A repetitive dichotomy organizes the whole argument: singularity, contemplation, concentration, and aura, on one side; masses, distraction, immersion, and loss of the aura, on the other. But the status of "aura" is the most ambivalent, and it deserves closer scrutiny, for it organizes not only Benjamin's argument but also most contemporary discourses on modernity and the past. The appeal to "aura" provides Benjamin with a very efficient means of being always correct. When Benjamin looks at the modern epoch, aura becomes a kind of Lost Paradise, a negative foil to what he describes as the new effects of mechanically reproducing works of art, and to the new seduction of the masses that has replaced the former beauty of art. But, when he turns to the past, Benjamin sees a nostalgia for the aura as an illusion, a relic or residue of a cult value. Hence, critics of modern art can, in turn, be criticized as reactionaries who long for a lost, bourgeois, and elitist concept of art. According to Benjamin, modern standardized copies of art have lost the authenticity of the real presence, but he also argues that this now-absent real presence was itself an old religious artifact.[2]

With this collage between art and religion comes what we will bluntly call Benjamin's first mistake: the ritual cult rendered to the hidden image of God may be a good definition of idolatry, but surely not of religion. One cannot simultaneously use religion to denounce modernity and modernity to denounce religion. Of course, our good modern rationalist might honestly mistake aura for religion, but this entails renouncing any argument concerning the desacralization of art for at least two reasons. First, one assumes that religion has already been buried by Benjamin's tools of modern rational discourse, even if they have failed to recognize the difference between fetishism, against which religion has always fought, and religion itself. Second, to claim that modernism has desacralized art says nothing about sacred meaning, if one frames this loss only in terms of fetish value. Losing fetish value is simply to lose something that has never been held sacred, for religion has never maintained that God is in the image but, rather, exists at some remove from it. Our good modern rationalist seems to re-

2. This is a standard rhetorical tool of Marxist and post-Marxist literature; Pierre Bourdieu, for instance, constantly manipulates this double-edged sword.

ply by investing aura with something real, thus reanimating his argument by suggesting that a modernist fetishism replaces God by idols. This may be so, but how does Benjamin's response legitimate his consideration of movies, new techniques, and modern masses? Doing so tells us nothing new about modernity for, like the prophets of old, Benjamin simply re-enacts the Biblical story of Moses by destroying the idols and fetish objects of the masses![3]

The real touchstone of Benjamin's essay is technique itself. The argument is barely presented as such, but he takes for granted, as an obvious statement, that the main function of technique is to reproduce mechanically an original. This common-sense definition constitutes, in our view, the second major mistake in Benjamin's categories. By connecting this incorrect definition of technique as mechanical reproduction to his mistaken definition of religious aura as the irreproducible presence of the original, Benjamin is able to reach his desired conclusion: any copy is a weak counterfeit of the original. The history of art, which Benjamin briskly sums up in two pages to support his argument, actually offers material evidence to make several general points that lead to a conclusion exactly opposite of Benjamin's own. The first is that technique is identical to mechanical reproduction. Second, there is no such a thing as an original that can be copied afterward. Finally, there is no reason to believe that multiplication is an impoverishment—unless, of course, you have accepted this hypothesis as a solid empirical fact from the outset.

Let us follow Francis Haskell and Nicholas Penny as they trace the formation of modern taste for antique statues.[4] When Italian archaeologists pay attention to old statues, they take them both as evidence of the perfection of antiquity and as tools for reconstructing an Italian identity. They do not much care for the aesthetic value of individual statues, nor do they pay much attention to the sculptors; rather, they insist on a continuity between a past and a present, and they use the statues as active performers to connect themselves with the idea of Beauty. With little concern for a pretended aura, they restore statues, move them and copy them. Art is anything but a cult of pure originals for these Italian antiquarians. On the contrary, Haskell and Penny

3. The ambiguity of the argument is very striking when Benjamin quotes Georges Duhamel (238–39) or Aldous Huxley (248, n. 13), first assuming their critique of movies or modern technology, and then briefly denouncing it as reactionary: "This mode of observation is obviously not progressive."

4. Haskell and Penny, *Taste and the Antique*, passim.

demonstrate how, little by little, copies came to define the originals. It took three centuries to transform these lively touchstones to the past and to one another into fixed and untouchable "originals," and it took another century to push these Roman statues—once thought to be originals—into the waiting-room of an even more originary art, those Greek statues that the Romans had copied so avidly.

In fact, the concept of authenticity is a late by-product of the constant activity of reproduction by every technical means that could be invented. Moreover, the common sense view of art, in the name of which Benjamin predicts its transformation into mechanical reproduction, is itself the result of a continuous technical reproduction. *Ars* means technique, and this sense is much more consonant with the constant obsession of artists for their technical means than is the opposition between art and mechanical reproduction invented by Benjamin. The early history of photography demonstrates that photographers were far more concerned to aesthetize the myriad technical choices of making prints—the quality of paper, the optics, the framing, and so on—than to make their images more realistic.[5] Benjamin's account of film is as mistaken as his take on photography, for there is nothing mechanical about it. His stereotype of the movie actor as an immediate "personality" delivered to the public is patently false (231). The movie camera adds another mediation to an already long chain, but it does not cut it; an actor's presence in the studio is neither more nor less real than on stage, and there is as much technique in both kinds of acting. Every sound engineer knows that his techniques produce music; they do not *re-produce* anything. Technique has always been the means of producing art; it is not a modern perversion of some prior, disembodied creativity. Paradoxically, Benjamin appears to be a prisoner of the Romantic idea of the artist he set out to critique.

If reproduction is an active re-creation, and if technique is anything but mechanical, then multiplication cannot be defined as the passive dissolution of original authenticity into a reified consumption of fetishes. On the contrary, originality and authenticity presuppose, as sine qua non, the existence of an intense technical reproduction, a point that music illustrates very clearly: first come infinite repetitions, standards, schemes, variations; the works come later. There is no such a thing as a composer of unique works prior to our modern times. As late as 1750, each time Rameau presented a new series of one of his operas,

5. Moulin, "La genèse de la rareté artistique," passim.

he rewrote it for the occasion: it was only in the middle of the twentieth century, to serve the interests of the record industry, that the question of selecting and establishing a stable version of *Hippolyte* or *Dardanus* acquired any sense or meaning. Prior to this, music was written to be played rather than recorded, and composers copied, transcribed, repeated, corrected, and adapted scores in a continuous web of themes and variations. Considerable time and effort on the part of many publishers and two or three generations of musicologists have been required to transform scores from being merely tools for amateurs, who often mixed many transcriptions for the sake of playing together, into "exact" *Urtext* copies of an original piece written by a particular composer.[6] A second long-term transformation, carried out by the record industry, was needed to produce a new market of amateurs able to recognize Bach and Schubert as original creators. Svetlana Alpers has provided a similar example from the history of art, by showing how much work and strategic perspicacity was needed by Rembrandt to transform himself into the author of his paintings, a model for all the painters after him.[7]

Discussions of the "author" and "authorship" are a commonplace since Michel Foucault's famous article.[8] Even if Benjamin could not be expected to know this new history of art or sociology of authorship, it is nonetheless strange what little use he makes of books to illustrate the issue. Perhaps it is not so surprising: while admitting that "the enormous changes which printing . . . has brought about in literature are a familiar story" (218–19), Benjamin fails to recognize that the story is not about the loss of aura, but the birth of the author and a new extension of readership. The example of printing would have shown most clearly Benjamin's confusion of the mechanical reproduction of a text's material support with the multiplication of its readings: the former does not prevent a variety of unique experiences, but is precisely what fosters them. If I can read *Othello*—a particular piece of "original" Shakespeare—in a unique way, hic et nunc, it is because of the billions of printed copies everywhere in the world, not in spite of them.

We can now see more clearly the paradox upon which Benjamin's argument about technique turns: he wants to give back to technique an

6. Hennion, *La passion musicale*, passim.

7. Alpers, *Rembrandt's Enterprise*, passim.

8. Foucault, "What is an author?" Martha Woodmansee, Mark Rose, Carla Hesse, and Jane C. Ginsburg, among others, have subsequently studied the history of eighteenth-century copyright issues, notably in France, England, and Germany.

active role, as if it had been lost. He adopts a seemingly anti-idealist position by underscoring the profound impact of the means of reproduction upon the works that are produced. But, like the idealists with whom he pretends to differ, Benjamin fails to accord a positive role either to the materiality of the support, or to the continuous work of technical repetition that is of special interest to artists and audiences. Hence the success of his text, for it flatters both camps: materialists, because he claims to reveal a hidden infrastructural base supporting the idealist theory of art; idealists (or the hidden idealist sleeping inside every materialist), because he presents a technologizing of the world as the new, mechanized loss of some former state of art that ought to be regretted. By contrast, a genuinely materialist story would not demonize technique as the modern perversion of art, but strive to return technique to its role as the active producer of art.

The format of this paper does not allow us to extend our demonstration to all the category mistakes cumulated by Benjamin's strange text. But we would like to conclude briefly with a few remarks on economics and politics, as a way of generalizing our comments about Benjamin to the Frankfurt School as a whole. Their mistake is the same: German theorists of modernity, who were also Benjamin's contemporaries, systematically pictured the modern masses, completely dominated by technical devices, as if they were coterminus with the crowd.[9] Their fear—and they had good reasons to fear at the time—of the uncontrolled fusion and immediacy of the crowd led them to conflate the crowd with the technical and economic production of the masses. This conflation was a dramatic representation that attracted attention to the Frankfurt School, but it also assumed that two enemies would coexist—the masses of American culture and the Nuremberg crowds. In spite of Adorno's apocalyptic vision of the mass market, the American masses stopped the Nazi crowd. Nothing could be more sociologically unlike the technico-economic diversification of goods and consumers exemplified in the mass market, and represented in its mass media, than the "hot" crowd losing its differences in the common crucible of an immediately shared space and time.

Technique does not suppress distance: it creates distance. Economy is about the production of an isolated consumption, one that limits the responsibility of both buyer and supplier to a precise transaction. It is not about the totalitarian fusion of every facet of our activity into the

9. Yonnet, *Jeux, modes et masses,* passim.

unmediated, collective crowd that Frankfurt theorists claimed to have found hidden behind the quiet masses watching their televisions and shopping in supermarkets. In that sense, Benjamin was certainly Marxist: he tried to reduce every order of reality to a unique vocabulary that, in spite of his frugality, was borrowed from a political model.

A truly novel materialist analysis of the work of art in the age of mechanical reproduction would try to avoid category mistakes and would attempt to rework the ever-changing definition of modernity. Contrary to Benjamin's analysis, it would try to distinguish between the various modes of delegation in economics, religion, art, technique, and politics, and it would follow empirically the proliferation of mediations. Such an analysis would probably not have the lasting appeal of Benjamin's *Artwork* essay—an appeal largely due, as we have shown, to its mistakes and confusions, and to the complacent denunciation of modernity it allows.

Between Goethe's and Spielberg's "Aura"
On the Utility of a Nonoperational Concept

Benjamin's category of "aura" is not operational.[1] Not only does the term force together theological, spiritistic, psychiatric, and aesthetic connotations in a contradictory and self-conscious "hard" montage, but it is also used in a hopelessly disparate manner.[2] "Resting on a summer afternoon, following a mountain range on the horizon or a branch that casts its shadow on one" is an impression that resembles those of Proust, and continues—in spite of Benjamin's prognoses—to be suggested by a particular type of film, notably those of Resnais, Visconti, or Wenders. But what does this impression have to do with cult images, especially because Benjamin tosses into this concept an indiscriminate heap of cave paintings, ancient statues of Venus, and medieval table paintings? What does aura have to do with early portrait photographs, an actor playing Hamlet, the paintings of Derain, or the poems of Rilke (to cite a few of the concrete examples offered by Benjamin)? Conversely, both the photographs taken by Atget around 1900 of Parisian streets and today's black-and-white films—that is, mechanically reproduced forms of representation—seem to approach what Benjamin meant by the melancholic combination of momentariness, mysterious attraction, and insurmountable distance of aura (at the end of this paper I return to the "auratic" effect of black-and-white films in the age of color).

Perhaps, in light of the term's apparent lack of operationality we

1. *Editors' Note:* Parenthetical references in the text of this essay labeled *GW* are keyed to the text listed in the Bibliography as: Benjamin, "Goethes Wahlverwandtschaften." Unlabeled references are keyed to the edition of the *Artwork* essay listed in the Bibliography as: Benjamin, "Das Kunstwerk" (*Illuminationem*). All English translations are the author's own.

2. See the contribution by Ulla Link-Herr in the present volume. Also see Didi-Hubermann, *L'invention de l'hystérie*, esp. the section on "auras," pp. 84ff, with explicit reference to Benjamin on pp. 89ff.

should move on to the next order of business and simply "forget" Benjamin. But the broad reception of "aura" as a category cautions against settling accounts with Benjamin too soon, as does his unique historical-aesthetic position and, more important, his aesthetic-technical sensibility. It is highly unlikely that the category of "aura" was merely a phantasm with no operative or historically concrete correlates. Nonetheless, contradictions in the term's connotations or in its analytic uses do not necessarily rule out the possibility of reconstructing its rationale. Benjamin was certainly aware of such contradictions, and it is possible that he consciously took them into consideration. The following attempt to produce such a reconstruction starts with the evidence of contradiction, and goes on to isolate a concrete connotation of the "aura-concept" that has been largely overlooked: the connection between "aura" as "cloak" and Benjamin's critique of Goethe's concept of the "symbol."[3]

The "destruction of the aura" (154) which, according to Benjamin's theses, follows upon the mass reproduction of images and their mass consumption, is synonymously called "unwrapping an object from its cloak." As a "cloak" the "aura" apparently creates that distance which, along with uniqueness (momentariness), provides the most important characteristics of the category. Benjamin is concerned with a nonmaterial "cloak" that is generally not photographable—as when he writes that "there exists no depiction of it" (162)—in spite of Baraduc's photos of aura waves.[4] The "aura" as "cloak" prevents a direct grasp (designated by Benjamin as both "tactile" and "tactical") of the "auratic" object, removes it from material consumption, and constitutes it as "pure" image. Because the "auratic" object is wrapped in this impermeable, distancing cloak, beholders must resign themselves to never obtaining it, sublimating instead their sensual, consumer desire into "contemplation." Thus, the function of "aura" is the beholder's sacrifice of pleasure in consumption. Moreover, we must read Benjamin's concept of consumption intensively, for it is no coincidence that the erotically desired female body is equated in many contexts with the "auratic" object par excellence. The prohibition issued by "auratic" distance actually pertains to erotic contact with the body.

3. This connection was already discussed by Adorno and presupposed as obvious in his "cut up" letter of 18 March 1936 to Benjamin (see Benjamin, *Gesammelte Schriften*, 1974, vol. I, 3, p. 1001).

4. Didi-Hubermann, *L'invention de l'hystérie*, pp. 90ff, notably the reproductions of Baraduc's photographs with "aura" waves.

One of the most important connotations of the category "cloak" (in the same constellation as "sacrifice") is Goethe's concept of the "symbol," treated in detail by Benjamin in the essay *Elective Affinities*,[5] and in the book on the origins of German tragedy.[6] In the essay, Benjamin cites a well-known letter of 16 August 1797, in which Goethe writes to Schiller about "symbol."[7] Benjamin accepts Gervinus' critical commentary on the concept and he transcribes a long passage of it, including the following lines:

> Already this fully sets the stage for the significance, later developed into complete ridiculousness, with which he held notebooks and journals in highest esteem and regarded every miserable thing with the pathetic mien of wisdom. Since then, every medal presented him and every block of granite he presents is an object of greatest importance; and when he digs up rock salt, which Friedrich the Great, despite his commands, was unable to find, he sees therein I know not what wonder and sends off a symbolic knife edge full to his friend Zelter in Berlin. (*GW* 153)

Later, Benjamin would characterize Gervinus' polemic as an effort to "destroy" the "aura" that Goethe tried to impart to objects by means of "symbolism" and "significance."

What is striking here is the relative affinity between Goethe's symbolic objects and those privileged by the aura-destroying medium of film as described by Benjamin: "Insofar as film—through an inventory of close-ups, emphasis on the hidden details of our familiar requisites, and exploration of banal environments under the genial guidance of the camera lens—on the one hand increases our insight into the compulsory way in which our existence is governed, while, on the other hand, it comes to secure for us a terrible and unsuspected margin of free play!" (169). In retrospect, it must have seemed symptomatic to Benjamin that Goethe, the extreme "auraticist," remained so concerned with the "auraticization" of precisely those banal things and details by which film was supposed to destroy "aura." The concrete symbolic object of Goethe's letter of 16 August 1797 to Schiller—the Frankfurt Market—enters ex post, so to speak, into competition with the photographs of Atget:

5. *Editors' Note:* An English translation of "Goethe's Elective Affinities" is now available in Benjamin, *Selected Writings,* I, pp. 297–360.

6. Benjamin, "Ursprung des deutschen Trauerspiels," notably the beginning of the chapter called "Allegory and Tragedy."

7. The entire text is reproduced and discussed in the context of other canonical remarks by Goethe on "symbol" in Sörensen, *Allegorie und Symbol,* pp. 126ff.

Following the calm, collected path of observation, indeed mere sight, I quickly noticed that the account I had given myself of certain objects had a sort of sentimentality that struck me with such force I was immediately drawn to reflect on the reason. . . . I thus observed very exactly the objects that brought forth such an effect and to my astonishment noticed that they are actually symbolic. That means, as I scarcely need to say, they are eminent cases which, in their characteristic diversity, stand in as representative of many others, harbor in themselves a certain totality, demand a certain sequentiality, excite similar and different things in my spirit, and so, from both outside and inside, make a claim upon a certain unity and completeness. . . . Up until now I have only found two such objects: the square I live in, which, in view of its layout and all that happens in it, is symbolic in each and every moment; and the space of my grandfather's house, court and gardens, which has been transformed by clever and enterprising men from the parochial and patriarchal quarters of an old Frankfurt councilor into the most useful marketplace for goods and wares. During the bombardment the establishment was destroyed in an unusual coincidence, and is still, though largely a rubble heap, worth more than twice what my family was paid for it 11 years ago by the present owners. Insofar as one can imagine the whole thing being bought again and rebuilt by a new entrepreneur, it is easy to see that, in more than one sense, it must stand there as a symbol for many thousands of other cases in this trade-rich city, and especially so in my intuitions.[8]

Even if "aura" seems to resist an operative reformulation, such is not the case with one of its most important connotations, the "symbolic cloak" of objects formulated by Goethe. From the example of the Frankfurt Market one can reconstruct with complete clarity what Goethe understood by this concept: a real and, in particular, cultural object whose "apperception" constitutes the object as a "case" in a "sequence," as a "representative"—that is, as synecdoche and *pars pro toto* of a "meaning" based almost on natural law. Both the market and the ruins of his paternal house are seen by Goethe as "images" of a "meaning" originally hidden, as "cases" of a growth in wealth (in every sense) succeeding one another almost by nature in the face of historical contingencies ("unusual coincidences"). The synecdoche is thus joined to a (connotative, hidden) metaphor: growth of wealth is like natural growth. One recognizes that this concept of the "symbol" remained extremely important for the aesthetic of Lukács.

Obviously this conception depends on (subjective) "apperception,"

8. Letter from Goethe to Schiller, dated 16 August 1797, in Goethe, *Goethes Briefe*, II, pp. 297–99.

something Goethe was less ready to admit than was Schiller, but which he basically could not deny, "especially so in my intuitions." Even before actual artistic treatment, the "symbolic" object is semantically "prepared" and "woven into" a "cloak" of synecdochic and metaphoric relations that lend it a "depth" that has the effect of a mysterious and fascinating "aura" because, and so long as, its structure remains opaque. This semantic web—fed to the brain by culture as a form of "apperception"—isolates and particularizes the "symbolic" object over and against its environment and this, in turn, produces the effect of "auratic" distance.

When Benjamin campaigns against the "evident symbolism" of "myth" in Goethe and Gundolf he adds nothing to this critical scheme (GW 158). Yet he views the structure of a "representative" symbol as at one with a ravenous transcendence when he writes that "all representation in the moral realm is of mythical nature, from the patriotic 'one for all' to the sacrificial death of the redeemer" (GW 157). Only by considering this larger context does Benjamin's thesis illuminate how Goethe's symbolic structure, "anxiety of life" (GW 152), and even "lack in erotic life" (GW 154), are supposed to correspond narrowly with each other. In Benjamin's view, the structure of the representative symbol "binds" the object "back" [religio] to the suggested phantasm of a transcendental meaning and thereby withdraws it from the grasp of the beholder. The "cloak" (later "aura") consists of just this "binding-back" and withdrawal. The "cloak" creates "auratic" distance— the noli me tangere that the "auratic" object seems to speak—and gives it the appearance of participating in an eternal, transcendental subjectivity.

Benjamin's insight was to recognize a highly ambivalent constellation of Eros and Thanatos in the "religious" effect of "depth" produced by Goethe's symbolism. If both death and renunciation of the "sacrificial victim" move the desired object into an insurmountable distance, then the "auratic" object might be said to acquire paradoxically, through a union and exchange of the powers of Eros and Thanatos, a paracultic "eternal" life. The ruins of Goethe's paternal house—that "rubble heap"—acquire an "aura" of incommensurable "wealth." According to Benjamin, this mechanism is revealed even more clearly in certain of Goethe's female figures, such as Ottilie in *Elective Affinities*.[9] Indeed, Goethe explicitly attributed to such female figures an "aura" or

9. Benjamin, "Goethes Wahlverwandtschaften," esp. pp. 175ff.

an "auratic" veil, episodes that Benjamin surely recalled when arriving at his own concept of aura. For example, at the end of chapter 6 in book 4 of *Wilhelm Meisters Lehrjahren*, Goethe describes Natalie "as if her head were surrounded by rays, and over her entire image there gradually spread a glimmering light." Mignon dies in an "auratic" white dress—described as a "pure cloak" in her farewell song—that she leaves behind with her body.[10] Goethe bundled together all these forms of "aura" in the symbol of the "veil" that the ghost of Hamlet's father leaves behind for the hero: this veil symbolizes poetry in general, transforms all objects into "auratic" ones, and lends them a form of "eternal life" whose flip side, following Benjamin's polemical analysis, is renunciation, sacrifice, and death.

In his polemic against the category "creation," Benjamin confronted indirectly another aspect of Goethe's concept of the symbol, the one formulated in *Maxims and Reflections*:

> There is a great difference whether a poet is looking for the particular that goes with the general, or sees the general in the particular. The first gives rise to allegory where the particular only counts as an example, an illustration of the particular; but the latter in fact constitutes the nature of poetry, expressing something particular without any thought of the general, and without indicating it. Now whoever has this living grasp of the particular is at the same time in possession of the general, without realizing it, or else only realizing it later.[11]

In a similar vein, Goethe wrote that "allegory transforms an object of perception into a concept, the concept into an image, but in such a way that the concept continues to remain circumscribed and completely available and expressible within the image. Symbolism transforms an object of perception into an idea, the idea into an image, and does it in such a way that the idea always remains infinitely operative and unattainable so that even if it is put into words in all languages, it still remains inexpressible."[12] It has been overlooked (even by Benjamin, for whom this formula is of great import for his positive view of "allegory") that this canonical formula conjures up not only an ideology of

10. Ibid., p. 197, where he cites and comments upon Mignon's death song, and also establishes the connection with Ottilie by noting: "There is nothing mortal that cannot be unveiled."

11. Goethe, *Maxims and Reflections*, no. 279, pp. 33–34. Cited by Benjamin in "Ursprung des deutschen Trauerspiels," although without analysis or commentary.

12. Goethe, *Maxims and Reflections*, nos. 1112–13, p. 141. Cited and discussed in Sörensen, *Allegorie und Symbol*, pp. 134–35.

the "symbol" we have discussed, but also (albeit in passing) generative recipes—tricks—by which one produces certain effects.

Such formulas give both generative rules and hints for how to detect their traces.[13] Following Goethe, we could summarize the generative process of the "symbol" in the following manner. First, one must eschew all reflection so as to be led to "auratic" objects by "pure sight." Next, the culturally available deep meanings of these objects are roughly and intuitively identified: the whole from the part, and the metaphoric analogy, as with Goethe's example of the Frankfurt Market. Finally, there is an attempt to repress this "idea" into semiconsciousness, and to narrativize the object with as much autonomy as possible, scattering sparingly here and there mysterious connotative allusions (synecdochic and metaphoric) to the level of meaning. A symbolic story is thereby produced (a "mythos" in Benjamin's terminology) whose "motifs" form the model case of "symbolic" ("auratic") objects.

Goethe's "symbol"-theory is both a generative concept and a recipe that describes and teaches a process for producing as well as detecting its traces. The active, discursive production of a symbolic-"cloak" (an "aura") should have the effect of merely uncovering its previous "natural" existence. If this is true, then "aura" would be the result of a successfully "repressed" discursive production process, and the nucleus of auratic "destruction" must consist of "peeling" this production process out of its "cloak." Even in Goethe, this "cloak" constitutes a self-referential symbolic complex (the "veil"),[14] which symbolizes the process of repressing production as a spontaneous and mysterious presence. The "cloak" of the "veil" symbolizes that which is easily "detected" amid the overlapping of many images; it symbolizes the effect of a semantic union of "image" and "meaning" in "symbol" by means of synecdoche and metaphor. Seen in this way, Goethe's symbolism of the "veil" becomes one of the constitutive connotations of Benjamin's category of "aura."

If we agree that an important and constitutive component of "aura" derives from Goethe's "symbolic skin" of cultural-historical objects, it is clear that Benjamin erred in assuming that the strength or "decay" of this "symbolic skin" could be analyzed as a function of media. Symp-

13. See Benjamin, "Goethes Wahlverwandtschaften," p. 146, where he emphasizes that Goethe destroyed all his studies and drafts in order to cloak the generative process in mystery so that the result seems "to emerge from nothing" (Schiller). Here Benjamin explicitly stipulates a connection between "auratic" form and antigenerativism.

14. Emrich, Die Symbolik von Faust II, pp. 44ff.

toms of this error are already apparent in Benjamin's failure to mention literature in the *Artwork* essay, apart from a brief reference to Rilke. Technical reproducibility has been the norm in literature since Gutenberg, and Goethe's work, in particular, was reproduced on a mass scale without an apparent loss of aura. Why should film differ from literature? In the *Artwork* essay Benjamin made the mistake of deriving "forms of apperception" from a technological analysis of media and simultaneously equating them with media. In fact, "forms of apperception" are always intermedial and, even more, interdiscursive. Whether a film is "apperceived" with or without a "symbolic cloak" depends less on the medium of film, than on the image and language forms that combine with the medium and—above all—on the a priori stored in the heads of beholders.[15]

If the "decay of aura" cannot be caused by the technical reproducibility of each exemplar as such—a claim that would implicate book printing as well as the modern media of photographs, films, and records—then Benjamin's observations and theses may be aimed at a target other than mass reproduction, although perhaps a related one. The simultaneous "apperception" of many identical exemplars of a serially reproduced object does tend to destroy aura—the "Warhol-effect" of viewing a pile of mechanically reproduced Brillo boxes is a familiar example. Indeed, simultaneous viewing of a series of identical exemplars (copies) approximates the representation of a producing machine, or of the production apparatus itself. The same applies to every perceptible instance of "digitized" imagery: if there is no overview of the computer as generative source, an initial "auratic" effect must be counteracted, although this does not exclude the possibility that a computer might be covered by a "symbolic" skin.

What if Benjamin's "decay of the aura" is really a plea for a productive *levée en masse* of art beholders, a call for overcoming the ascetic denial of an unlimited sensual-material consumption of art? Benjamin's narrow reliance in much of the *Artwork* essay on Brecht's notion of transforming reception into production suggests this might be the case and, if true, shifts the core of his argument: destruction of "aura" through technical reproducibility would no longer be located in repro-

15. Meaning "historical a priori" in the Foucauldian sense—that is, as culturally specific, interdiscursive, and especially collective symbol-systems (see Link, "Literaturanalyse als Interdiskursanalyse," pp. 284–307). These networks of collective symbolism, already stored in the brain, led Goethe's "pure seeing" to "correct" objects, whose "aura" it seems to *find there* as already pre-existing.

ducibility as such, nor in a "theory of media," but in a theory of generativism. Aspects of technical reproducibility have a destructive effect on aura only insofar as they selectively direct one's attention to the generative processes of art. By no means *must* they have such an effect. Unfortunately, we know today how much Brecht and Benjamin overestimated the "testing" and "professional" (that is, generative) attitude of the masses with respect to new media, but then Marx had also overestimated the proletariat's "education" by means of technical production process as such. Even if the enjoyment of art—meaning by this not resigned contemplation but, especially for the "masses," an unlimited sensuality and materiality—presupposes "unwrapping" the aura (that is, replacing passive reception by generative and "participatory" reception), such a transformation cannot be expected to follow from the development of the media as such. Rather, it must be coupled to a generatively oriented, cultural-revolutionary tendency to which computer technologies might be in a good position to contribute.

No doubt both Goethe and Proust saw production of aura as a productive process (Proust more clearly than Goethe), and this productive process was already partially revealed for Proust (though not for Goethe): in both cases the process was highly individualized and, in principle, could not be technically implemented. By contrast, certain fabrications of aura today, en masse and for the masses, represent a fundamentally new development that demonstrates the usefulness of Benjamin's categorical instrumentarium (with all necessary criticisms and modifications). To sketch the contours of this new development, I will use the example of Steven Spielberg's film *Schindler's List*. Neither the structure nor the effect of this film can be understood without an analysis that sees it as manufacturing (in part unconsciously) an "aura" for the event of the Holocaust. This becomes immediately apparent by comparison with Claude Lanzmann's *Shoah*. A film of the "crime scene," the "inventory," and the "world of perception" fully consonant with Benjamin's use of these terms, *Shoah* had to be set in the bright light of contemporary technology and realized as a color film. Symptomatically, *Shoah* is also a "generativistic" film: it narrates the filming and making of the film itself. By contrast, *Schindler's List* begins with muted, already "auratic" colors and ends with bright ones, although the two films do intersect: the gas chamber scene of *Schindler's List*, which corresponds structurally with the barber's story in *Shoah*, is shot in the brightest and most banal colors. Between these two instances of color imagery, the narrative of *Schindler's List* is rendered in black and

white. This recourse to a technologically "outdated" medium places the connotative symbolism of the medium above its technology: against a background of linear technological progress, this "outdated" technology symbolizes the irreversible momentariness of a past time. A symbolic "cloak" of melancholic distance envelops the "anachronism."

The mixed deployment of black-and-white and color footage in modern films—other examples might be Edgar Reitz's *Heimat* and *Die zweite Heimat*—establishes a symbolic resonance: although black-and-white imagery is often used for supposedly "documentary" purposes, it tends to generate a "spontaneous auratization" that—like the ruins of Goethe's family home—issues from connotations of memories, of loved ones who have died, of irretrievable distances, and of nostalgia. Reitz was very aware of this tendency, and he attempted, through a consciously contrastive and "auratic" treatment of color—for example, blurred or overexposed images—to give back to black and white the hard documentary value and "aura destroying" effect Benjamin found in Atget. Reitz was not consistently successful; despite his best efforts viewers tended to see the black-and-white sequences "auratically"— draped in a spontaneous "aura of nostalgia" similar to album photos of the dearly departed that are a leitmotif of the film. Their resistance to the intentions of Reitz demonstrates clearly that the "apperception forms" in the minds of the public are complex intersections of both media and discourse developments, especially that of symbols.

In his film *Wings of Desire*, Wim Wenders refers explicitly to Benjamin by treating black-and-white imagery as possessing an aura that stems from Goethe's symbolic style of "eternal" distance, noli me tangere, death, sacrifice, and denial of bodily contact and lived Eros. When the "angel" (according to Benjamin an allegory of Goethe's artist) risks stepping into "life," the film switches suddenly to color. Especially interesting, in the context of discussing *Schindler's List*, is the sequence in which a Jewish-American actor in Berlin cooperates on the script of a holocaust film. He eventually reveals himself to be another former angel who has crossed over into life. Within the black-and-white sequences, this figure serves to prepare for the film's transition to color—a transition achieved mainly through humor and comedy with echoes of Chaplin.

Spielberg was probably not aware of the Benjaminian problematic when he accepted the risky venture of dealing with the Holocaust graphically, including the gas chambers, in a big film intended for a broad public. Piety and documentary intent might explain why Spiel-

berg renounced the technologies of animation and simulation that are his preferred modes, and why he chose to film mainly in black and white. But independent of those concerns, it is quite clear that the entire constellation of Benjaminian concerns were reasserted symptomatically in Spielberg's film. He did not reluctantly embrace the spontaneous tendency of black-and-white film to become "auratically nostalgic," but welcomed it whole-heartedly: for example, his use of vaporous white clouds in most of the Auschwitz sequences, including the gas chamber scene. It is astonishing that all the characteristics worked out in Benjamin's discussion of Goethe reappear in the "symbolic skin" of Spielberg's film: the proxy-roles of sacrificial victims (paradoxically saved) and hero who are immortalized in death, or the hero's subliminal melancholy that corresponds to the passively resigned melancholy of the viewer. Indeed, the viewer's distance from the hero remains constant and insurmountable because an aura, produced by the irretrievable medium of black-and-white imagery and the recurring white haze, separates the two and draws the hero into the depths of transcendence: metaphoric symbolism marches in step with synecdochic allusion when the gas chamber dissolves (metaphorically) into the biblical scene of a child in the oven. Suffocation is "redeemed" connotatively and mythically in song.

Within the overall aura of black-and-white imagery, faces and individual objects—stolen Jewish ritual objects, jewelry, and even the steam engine—are additionally "auraticized" in a manner akin to what Benjamin noted in Goethe's symbolic narrations. In short, Spielberg has proven that aura can be effectively fabricated for the masses and en masse. My comments are fully aware of the fact that a film like *Schindler's List*, by confronting many people from many lands with the destruction of European Jews, is in itself an event of some importance. It is unlikely that so many people would have clamored to see *Shoah*, for the "generativistic" structure of that film would have repelled a mass audience; by contrast, Spielberg's disinterest in producing even the slightest bit of generativistic alienation was welcomed. We need look no further for evidence that Benjamin's worry about the "aura-destroying" characteristics of the filmic medium as such was an illusion. We might also find in the comparison a clear guide to the possibilities of a generative art. Nonetheless, if we want to determine the artistic hour struck when *Shoah* is juxtaposed to *Schindler's List*, we cannot ignore Benjamin's "clock."

From Mechanical Reproduction to Electronic Representation

More than fifty years after the publication of Walter Benjamin's *Artwork* essay, we are still struck by the pertinence of its interrogation, for Benjamin links transformations that dramatically affected the modes of naming and classifying artworks, their legal status, and the criteria for their perception to mutations in modes of reproducing and representing aesthetic creations. Engraving, in all its forms, followed by photography and then cinema, gradually blurred the boundary between false and original by bringing the artwork closer to the spectator and by substituting a circulating ubiquity for a unique localization.

Among the several consequences highlighted by Benjamin, three seem to merit particular attention. First is the strong relationship he establishes between mass reproduction—regarded as that which destroys the aura of the work—and the contrasting production of a new aesthetic position, that of *l'art pour l'art*:

> With the advent of the first truly revolutionary means of reproduction, photography, simultaneously with the rise of socialism, art senses the approaching crisis which has become evident a century later. At the time, art reacted with the doctrine of *l'art pour l'art*, that is, with a theology of art. This gave rise to what might be called a negative theology in the form of the idea of "pure" art, which not only denied any social function of art but also any categorizing by subject matter. (In poetry, Mallarmé was the first to take this position.) (224)[1]

1. *Editors' Note:* Parenthetical references in the text and notes of this essay are keyed to the edition listed in the Bibliography as: Benjamin, "Work of Art."

For the complex history of the editing and publication of the *Artwork* essay, see Benjamin, *Ecrits Français*, pp. 115–92. This text reprints Pierre Klossowski's translation of the first version of the essay, entitled "L'oeuvre d'art à l'époque de sa reproduction mécanisée," which includes a number of cuts and modifications made without Benjamin's approval.

The demand for a pure (or purified) culture situated at a distance from popular taste, removed from the laws of economic production, and maintained by aesthetic complicity between the creators and a chosen public, arises alongside the triumph of a commercial culture dominated by capitalist enterprise and projected to the greatest number. Benjamin's proposition can be restated in slightly different terms: the construction of a separate aesthetic field—based on autonomy, disinterestedness, and the absolute liberty of the creative process—results directly from the refusal of certain creators to serve the industrial arts or popular preferences that might assure their success.[2]

Benjamin's second consequence concerns progressive obliteration of the difference between artist and spectator, producer and consumer: "The distinction between author and public is about to lose its basic character. The difference becomes merely functional; it may vary from case to case. At any moment the reader is ready to turn into a writer" (232). Benjamin situates this mutation within a particular historical moment ("the end of the last century"), and connects it to a mutation that occurs within print culture ("the extension of the press") and to a new practice of writing (the "reader's column"), where "an increasing number of readers became writers—at first, occasional ones" (232). Cinema, by making ordinary viewers into potential protagonists, further reinforced an indistinguishability between the positions and practices of producer and consumer that previously had been entirely separate.

The age of electronic media certainly marks a further step in this direction, for the economy of electronic writing makes possible the simultaneous production, transmission, and reception of text that unites—as never before—the tasks of author, editor, and distributor within one person. The ancient distinction of roles between intellectuals and everyone else, and all the categories that were founded on precisely this division, are suddenly stripped of meaning. In particular, the categories that gave the author-function a legal status (copyright, literary property, authors' rights, etc.) are gone, along with the categories of aesthetic status that Benjamin recalls at the beginning of his essay: "creativity and genius, eternal value and mystery" (218).[3] In short, the set of markers that organizes our relationship to writing must now be re-

2. See Bourdieu, *Les règles de l'art*, p. 89.

3. On the issues of copyright and authorship see: Woodmansee and Jaszi, *Construction of Authorship*; Rose, *Authors and Owners*; and Chartier, "Figures of the Author." The classic work on the category of genius is Zilsel, *Die Entstehung des Geniebegriffes*.

defined, for the technology of electronic writing has brought us to the radical endpoint of the evolution outlined by Benjamin's essay.

The third axis of Benjamin's reflection concerns a transformation in our modes of perceiving the work of art. He designates two kinds of causes: on one hand, the new techniques of photographic and cinematographic production and reproduction make it possible for us to see things not visible to the naked eye; on the other, changes in the size and composition of the public, and especially "the greatly increased mass of participants," have "produced a change in the mode of participation" (239). Such a schema strongly suggests that a history of the variations in our relationships to works of art can be constructed by paying attention to the relationship between *conventions* governing the rules of production or forms of representation and *categories* that organize the patterns of perception and judgment of specific publics.[4]

Relative to the electronic revolution of text production, Benjamin's perspective obliges us to ponder the relationship between a new "materiality" of the text and the intellectual categories that this materiality both presupposes and induces. Electronic representation of writing radically modifies the notion of contextualization, because it substitutes distribution in a logical architecture—the software that organizes a database, electronic files or key words—for the physical contiguity among texts put together in the same printed object. Electronic representation redefines the "materiality" of the work by suppressing the physical tie between text and book (or any other printed object or manuscript) and by making the reader—rather than the author or the editor—master of the cutting and appearance of the text. The entire system of perceiving and manipulating texts is thus overturned, and the contemporary reader before a computer screen reassumes somewhat the posture of an ancient reader handling a *volumen*, a scroll. There is, of course, a significant difference, for the computer's scroll unrolls vertically and is equipped with all the indicators necessary for *codex*: pagination, indexes, tables, and so on. In earlier forms of support for writing (volumen, codex) these two logics worked independently of one another; their junction in electronic representation defines an entirely new kind of reader-text relationship. In the same way that "reception in a state of distraction [cinema] is symptomatic of profound changes in apperception" (240), textual practice (including images) in an elec-

4. Baxandall, *Painting and Experience*, is an exemplary study. For a reading of Benjamin's essay that stresses the relationship between the "mode of perceiving and the mode of depiction," see Snyder, "Benjamin on Reproducibility and Aura."

tronic format necessarily produces a fundamental modification of the categories that structure a reader's manner of perceiving and understanding.

Published in 1936, Benjamin's essay was inscribed in the frontal opposition between European fascisms (Italian and German) and revolutionary or communist anti-Fascism. This context helps to explain his somewhat ambivalent prognosis for the political effects of mechanical reproduction. On one hand, mechanical reproduction assures a manipulation of the masses on a previously unknown scale, establishes dictatorial powers, and renders politics "aesthetic" (242). Benjamin notes somewhat pessimistically:

> Since the innovations of camera and recording equipment make it possible for the orator to become audible and visible to an unlimited number of persons, the presentation of the man of politics before camera and recording equipment becomes paramount. Parliaments, as much as theaters, are deserted. . . . This results in a new selection, a selection before the equipment from which the star and the dictator emerge victorious. (247)

On the other hand, erasure of the distinction between creator and public ("Literary license is now founded on polytechnic rather than specialized training and thus becomes common property" [232]), destruction of idealist concepts traditionally wielded to indicate what art is, and, finally, transformations in the "modes of apperception" that make critical practice compatible with the *jouissance* of entertainment ("The public is an examiner, but an absent-minded one" [241]) all tend to open the possibility of a more optimistic alternative: a politicizing of the aesthetic by which it might become a tool for emancipating the masses.

Pertinent or not as an historical description, these observations highlight the fact that any given technique can be put to a plurality of uses. In Benjamin's essay, we do not find a technical determinism that ascribes a univocal political meaning to the apparatus itself; rather, he writes that "violation of the masses, whom Fascism, with its *Führer* cult, forces to their knees, has its counterpart in the violation of an apparatus *which is pressed into the production of ritual values*" (241, my emphasis). This remark has a certain pertinence to contemporary debates about the effects of electronic dissemination of discourse—debates that have affected (and will no doubt continue to affect) both the conceptual definition and the social reality of public space.[5] The

5. See Nunberg, "Place of Books."

digital age, even more than the age of printing, is traversed by a major tension between the juxtaposition of particular communities (delimited and concretized by the circulation of texts among its unique members) and the construction of an abstract public (defined by the possibility of universal participation in written discourse).[6] The unfettered and long-distance communications of electronic media simultaneously foster development of both potentialities. Autonomous, cloistered "scribal communities" that are defined by belonging to the same "network" of interests or preoccupations are exposed to the loss of any universal references. In contrast, and at the same time, a new public use of Reason without limits or exclusions becomes possible: a use that "man as *scholar*, makes of his reason before the *reading* public" in a celebration of the liberty to "publish his criticisms of the faults of existing institutions" by "addressing his public through his *writings.*"[7]

6. See Warner, *Letters of the Republic.*
7. Kant, "What Is Enlightenment?" pp. 384–89.

Aura Hysterica or the Lifted Gaze of the Object

"Everything mystical, with an anti-mystical attitude," Brecht noted in his *Arbeitsjournal* (7.25.38) about Benjamin's auratic "spleen." The entry has become famous as an example of Brechtian lack of understanding and materialist banality, but it seems that what most disturbed Brecht still needs to be explained. "Benjamin is here," wrote Brecht, "he starts from something he calls *aura*, which is related to dreaming (daydreaming). He says: if one feels a gaze on oneself, even on one's back, one returns it(!). The expectation that what looks at one, one also looks back at creates the aura."[1] This mysterious, aura-constituting gaze (look, exchange of glances) stands at the center of my paper, even if it is not the focus of the *Artwork* essay.

Benjamin's mysterious formulations concerning the fascination of the "gaze" are found in texts that were written or published both before and after the *Artwork* essay. There is, for example, the dumbfounding formulation at the end of his Surrealism essay, "where proximity sees itself through its own eyes."[2] The Baudelaire essay contains an oft-cited sentence, itself auratic and apparently immune to closer examination: "The one seen or believing oneself to be seen gazes up. Experiencing the aura of an appearance means lending it the ability to lift one's gaze."[3] Most commentators have neither investigated nor really considered such sentences, and even Brecht fell short of them when he explained aura as a kind of hallucination.[4] There is surely something right about that explanation, especially since Benjamin es-

1. Brecht, *Arbeitsjournal*, I, p. 16.
2. Benjamin, "Der Sürrealismus," p. 309.
3. Benjamin, "Über einige Motive bei Baudelaire," p. 646.
4. There is no space for a full discussion of the literature on Benjamin's aura, but I want to mention the intellectual historical explorations of Werner Fuld, "Die Aura," and the close readings of Marleen Stoessel, *Aura, das vergessene Menschliche.*

tablished a contextual link between aura and dreams, as well as between aura and experiments with hashish and opium. Nonetheless, there would be no need for so many strained and unusual formulations of aura, if it were simply congruent with hallucination. For Benjamin, the act of "lending an appearance the ability to lift one's gaze" stands in a conceptual context alongside the definition of the aura as "a unique appearance of distance however near it might be."

According to Benjamin, "the work of art has always been in principle reproducible" (149), whereas in the case of the aura "there is no likeness [*Abbild*] of it" (162).[5] Thus Benjamin dissociates the work of art from aura, and deprives aura of access not only to technical reproducibility but also to "imitation" or, as the case may be, the general imitability that had distinguished art in pretechnological times—because, according to Benjamin, "what has been made by people can always be imitated by people" (149). If, however, there is no likeness of aura, how can its specific mode of reproduction even be thinkable? Consequently, its reproduction—or its nonreproduction—is variously described as "atrophy," "demolition," and "decay." Benjamin insists upon the nonmimetic character of aura; it is for him neither a mimetic nor a technologically implementable "unique appearance." This means, of course, that aura cannot be bound to a specific medium, nor to any specific art form, and that stipulation accounts for the great disparity of auratic experiences cited by Benjamin. Consider some of his examples: Proust's involuntary memory; the sight of "a mountain range on the horizon or a branch" that he takes up repeatedly and that must be understood as an experience of nature as well as an experience mediated textually, photographically, or cinematically; the art of storytelling, with its "ancient coordinates of soul, eye, and hand" indebted to oral memory;[6] early portrait photography; the "correspondences" of drug-addicts, and so on. If, however, aura is conceived as transcending media, and not technologically created, why should technological advances in the process of reproduction destroy it? In the following comments, I develop a view that I share with Jürgen Link—namely, that "forms of apperception" in the widest sense (perception, attention, and experience) cannot be derived technologically from media as such, but

5. *Editors' Note:* Parenthetical references in the text of this essay are keyed to the edition listed in the Bibliography as: Benjamin, "Das Kunstwerk" (*Illuminationem*). All English translations are the author's own.

6. Benjamin, "Der Erzähler," p. 464. Benjamin's fascination with aura is made clear in his letter of 4 June 1936 to Adorno (Benjamin, *Gesammelte Schriften*, II, 3, p. 1277).

are intermedially and interdiscursively constituted.[7] Link's attempt to see an aspect of the "cloak" in an intermedial-interdiscursive perspective will be expanded here to include aspects of the "gaze."

Naturally, fascination with the "gaze" has come to the fore in the context of photography and film. Benjamin's thesis that there is "no likeness" of aura, formulated with great confidence and conviction, appears to stem directly from his objection to photographic representations of it as practiced in France; for example, by the psychiatrist Hippolyte Baraduc.[8] The term "aura," introduced by Galen in late antiquity, was commonly used in medicine to indicate a respiration or breath that coursed through the body and caused it to tremble. The rising of this breath, and the patient's exceptional excitability and impressionability, were viewed as closely connected to each other. At some point Baraduc photographed his son holding a dead pheasant in his arms, and he was surprised to discover a cloak, a veil, or a fog on the photographic plate, which he explained as the "vital force attracted by the affected sentimental state of a child." Henceforth, Baraduc concentrated all his efforts on making visible this "aura" that was normally invisible to the naked eye. Baraduc called his auratic icons psychicônes, and, although he did not feel compelled to bare himself in the service of science (as did the slightly later Freud of the *Interpretation of Dreams*), he did pass to posterity his personal psychicônes, or *autographie auraculaire*. One can say of them, as does Georges Didi-Hubermann, that "his hystericized, impressionable cogito looked for itself as if a spectre, it portrayed itself as a phantom."[9] One could also point out that Baraduc was a materialist (of the sort that strikes us today as grotesque) who, in principle, wanted to submit psychic powers to the control of the positive experimental sciences: "Today, the photographic plate allows all of us to glimpse these hidden forces, and in this way it subjects the marvelous to an unimpeachable control, by making it enter the natural domain of experimental physics."[10]

Looking at what is portrayed in Baraduc's aura photographs—the *vapeurs* that let faces swim together like trains of clouds or fog—it becomes apparent that "aura" for Benjamin refers to something completely different. Baraduc's photographs cannot be experienced as aura;

7. See Jürgen Link's contribution to this volume.
8. Didi-Huberman, *L'invention de l'hystérie*, esp. the chapter "Auras" and accompanying illustrations, pp. 84ff.
9. Ibid., p. 97.
10. Baraduc, writing in 1897, cited in ibid., p. 93.

indeed, only on the basis of their written captions are they seen as auratic at all, and then not as aura, but as auratic *objects*. What they lack are those qualities with the "capacity to lift one's gaze." In this sense there can be no likeness of aura, since a likeness would make it into an object, into something that might be submitted to unconditional control, the way Baraduc formulated it. The aura to which Benjamin refers, by contrast, exists only as an image; moreover, he keeps image and likeness strictly distinct: "Every day the need inevitably makes itself felt to take possession of the most immediately proximate object through an image, or even more, through a likeness. And the likeness, as preserved in illustrated dailies and weekly tabloids, distinguishes itself unambiguously from the image. Singularity and permanence are as closely bound up in the one as ephemerality and duplicatability are in the other."[11] The linking in the image of singularity and permanence corresponds to the link between proximity and distance in aura. For Benjamin, the image—like aura—is not bound to a specific medium, whereas a likeness is always marked by the stamp of its medium. For that very reason, photography and film are not per se without aura, even though they participate in its decline.

Proof for a dwindling persistence of aura can be found everywhere, and we—contemporaries of the digital age—could effortlessly extend Benjamin's argument to the present. In the *Artwork* essay, when writing about early portrait photography, Benjamin sees the "final stronghold" of a diminishing "cult value" clinging to the auratic power of the human face: "In the cult of memory for the distant or lost beloved the cult value of the image finds its last refuge: the aura of early photographs functions for the last time in the fleeting expression of a human face" (158). Two strands of thought are intertwined in this passage. The first strand specifies the rules of production for the auratic object: the death of a loved one—absence in extremis—transfigures the medial likeness of the image into a *fascinosum*. Indeed, this rule of production makes it possible to explain why it is not the last time that aura functions in photography. Early photography, early film, early television all follow the same law: together with our memories, they touch on a distant era that is irrevocably lost. One has only to watch again television programs from thirty years ago—the family that competed for our weekend attention or the forever-unchanging newscaster—characters of

11. Benjamin, "Kleine Geschichte der Photographie," p. 379. In the *Artwork* essay one finds the same passage (154), except that "likeness" [*Abbild*] is elaborated—or replaced—by "reproduction" [*Reproduktion*].

a serious, impassive demeanor that never would have elicited the archaic equivalent of today's *zapping*. The second strand of thought in Benjamin's comment concerns his privileging of the "human face" with respect to the possibility of an auratic "mode of being" for photography. This privileging is clearly connected to the fascinosum of the "lifted gaze," and there actually exist famous early photographs in which a gaze is literally directed upward—namely, the gaze of "hysterical aura." The fact that *aura hysterica* was photographed compels us to pose once again the question already raised by Baraduc's later aura photography: is there a likeness of aura?

Keeping in mind the components of the medical meaning of aura—breath, respiration—we find that one of Benjamin's prominent examples becomes immediately more intelligible: "Resting on a summer afternoon, following a mountain range on the horizon or a branch that casts its shadow over oneself—that means breathing the aura of these mountains, this branch" (154). Benjamin's concern is not with the Romantics' "landscape of souls" but with the bodily stimulation due to contact with something distant. Admittedly, Benjamin qualifies the reach of his example, for he speaks explicitly of an illustration of aura "through the concept of the aura of natural objects." Might aura hysterica offer us an illustration of the aura of human objects? Perhaps it will help to clarify Benjamin's mysterious claim from the Baudelaire essay cited earlier: "The one seen or believing oneself to be seen gazes up. Experiencing the aura of an appearance means lending it the ability to lift one's gaze."

Beginning in 1886, the *Iconographie photographique de la Salpêtrière* originally served as a comprehensive synopsis of the regular developmental course of "Grand Hystérie" discovered, observed, or produced by Jean-Martin Charcot.[12] In this schema, aura hysterica designated the various precursors of a major attack, including pain in the region of the ovaries, the feeling of a ball or a knot climbing up the epigastrium, heart palpitations, constriction of the larynx, and headache. The aura appears (still following the commentary of the *Iconographie photographique*) "several minutes before the attack." Thus, the patient has a few moments to lie back, but she could also deceive herself into believing an attack was not imminent and, as a result of the deception, suffer a collapse. Transition to the attack is described as

12. I refer my readers to the selection of photographic reproductions and commentary in Didi-Huberman, *L'invention de l'hystérie*.

follows: the patient's speech becomes short and fragmented, movements become brusque, the eyes become cloudy and fixed, the pupils dilate and, without screaming, the attack erupts.[13]

In other words, aura hysterica forms an intermediate stage in the scientific will of the *Iconographie photographique de la Salpêtrière*, a latent stage between the patient's so-called normal state and the outbreak of the attack. However, this latency between normal and fundamentally pathological conditions greatly complexifies the configuration of expecting-a-gaze and responding-to-it. The configuration reflects the aporias of scientific observation that photography actually intensifies, even though it was intended to secure unequivocal proof for the correctness of observation. Photographs of hysterical women in the Salpêtrière—especially the photographs of Augustine, the *vedette* of hysterical iconography—refute the status of mere likeness or reproduction of a "stage" in the regular course of an hysterical attack by lifting the gaze, either literally or against the foil of psychoanalysis derived by Freud from Charcot's hysteria.

"The one seen or believing oneself to be seen gazes up." Let us forget for a moment the question of gender in Benjamin, even if Charcot had begun to study "masculine hysteria" as a clinical phenomenon in 1881 and published the first photographic portraits of hysterical men in 1888.[14] Benjamin writes on the relationship between expecting a gaze and responding to a gaze with reference to early daguerreotypes: "That which in the daguerreotypes could only be perceived as inhuman, even fatal, was the [moreover: sustained] gazing into the apparatus, since the apparatus takes up the image of the human being without returning the gaze. The expectation, however, is implicit in the gaze that it will be returned by that to which it was given."[15] Does this "inhumanity," not to say "fatality," allow for a greater specification of the clinical object in Charcot's studies of hysteria? In this case, the observing apparatus consists of a doubling of the hypersensitive retina of the camera by the exceptionally talented—albeit subjective—vision of the doctor. For Charcot's students, as for Freud, Charcot is the "seer" who directs his own gaze as well as that of the *Iconographie photographique de la Salpêtrière*. The book, edited by Bourneville and Régnard, effectively splits Charcot into the twin Dioscuri of doctor and photographer, and

13. I summarize from the second volume of the *Iconographie photographique* published in 1878, and excerpted in ibid., p. 282.

14. See Link-Heer, "'Male Hysteria': A Discourse Analysis."

15. Benjamin, "Über einige Motive bei Baudelaire," p. 646.

it doubles both the camera's eye and the photographic motif: the book's pictures are simultaneously concerned with portraits of individual faces (Benjamin's "human face" of the beloved), and the facial features or facets of illness.[16] Not just any illness, of course, but the clinically invisible illness par excellence, an illness without lesions or—as one says in the jargon—*sine materia*. But even this material invisibility, which one might later call an epistemological suffering, cannot mitigate the will or goal of making it visible, or objectifying it, by means of a hyperaesthetic apparatus.

To view Charcot's studies of hysteria only or primarily as Freud's pedagogical model is to adopt an unduly narrow perspective: they could have been a model for Benjamin. Although the "absent" hysteric is transformed into a somnambulant and hypnoid state, and subject to the complete accessibility demanded by clinical observation and the double retina medical photography, her submission evaporates—literally and symbolically—when she lifts her gaze. What becomes visible in the hysteric's answering gaze is a resistance to this objectification of the apparatus: the object lifts up its gaze and causes the observer to ask, whom or what does it see? The commentary of the *Iconographie photographique de la Salpêtrière* replies, almost in passing, to the photograph of a "love-struck supplication," which is attributed to a phase of *attitudes passionnelles*: "X . . . sees an imaginary lover whom she calls."[17] One possible interpretation would be that the subtext of the hysteric's pose are terms long rehearsed by theater and cultural iconography. Or, one could ascribe it to "transference" by suggesting that the "imaginary lover" is really the doctor who has induced everything: in this view, Charcot could have been Freud if he had only listened instead of wanting to see voyeuristically. Both interpretations have their existential justification, but I want to focus on something else by returning to the reproduction of aura hysterica, which I read as the veritable likeness of Benjaminian aura.

To reiterate: in the Salpêtrière hysterical aura is considered a brief state of latency that anticipates an attack. Dostoyevski, who describes the experience of an epileptic aura in his novels, shortens these few minutes to a few seconds. In the *Devils*, the suicide Kirilloff describes this brief interval:

16. For details, including reference to Galton's method of "composite" portraiture, see Didi-Huberman, *L'invention de l'hystérie*, pp. 51ff.

17. Ibid., p. 146.

It is nothing terrestrial; I don't mean to imply that it is anything divine, but only want to indicate that in his terrestrial form man would not be able to bear it. He must either physically alter himself or die. It is a clear and indisputable feeling. . . . If it lasted longer than five seconds the soul would not be able to endure it and would have to perish. In order to bear it for ten seconds one has to alter oneself.[18]

Obviously, such a moment could not be photographed with the limited means of artificial lighting available at the time. What concerns me, however, is not a fundamental doubt about producing likenesses of reality using photography or film, nor a suspicion that such images are manipulated. Rather, I am interested in a resistance to objectification that becomes, in the process of photographing aura hysterica, a gaze. An hysteric in the auratic state who lifts her gaze represents a moment of expectation that is, nonetheless, underscored by a duration—the very duration of the pose. The hysteric's gaze—whether directed inwardly, toward a mirror, or onto the doctor's retina—responds by representing simultaneously its retention and protention.[19] To paraphrase Husserl: the act of posing entwines, in a striking manner, the continuum of the Now that flows into the past with an expectation of the Now that is coming; lifting the gaze likewise "lifts up" this inward structure of time that reaches beyond the punctual Now. In other words, the representation of aura hysterica refutes both the patient's status as object and her "absence," in order to invest her with an hallucinatory subjectivity.

The particular qualities of this hallucinatory subjectivity can be clarified by comparing it to Lacan's well-known anecdote about the sardine tin.[20] In the course of a fishing excursion, the young fisherboy, Petit-Jean, draws Lacan's attention to a sardine tin floating on the waves and glinting in the rays of the sun: "You see that can? Do you see it? Well, it doesn't see you!" Lacan takes the observation rather more seriously than his companion: "To begin with, if what Petit-Jean said to me, namely, that the can did not see me, had any meaning, it was because in a sense it was looking at me, all the same. It was looking at me at the level of the point of light, the point at which every-

18. Cited from Vogel, "Von der Selbstwahrnehmung der Epilepsie," p. 440. I thank Walter Schindler (Hamburg) for this reference.
19. I refer here to the observations of Didi-Huberman, *L'invention de l'hystérie*, pp. 104ff, who nonetheless overlooks the coincidence between this configuration of expecting/answering a gaze and Benjamin's notion of aura.
20. For this suggestion, and for his careful reading of my manuscript, I thank Michael Marrinan.

thing that looks at me is situated—and I am not speaking metaphorically."[21] What is playfully staged in this anecdote—by means of a pun if not by metaphor—is the double sense of *regarder*, which can mean both "regarding" and "concerning." It makes sense (according to Lacan) to say that the sardine tin does not "see" me looking at it only if it *me regarde*: regards me, concerns me, interests me. When Lacan substitues *regarder* for Petit-Jean's *voir*, he gives a sense to the observation: "[It] was looking at me, all the same" [tout de même, elle me regard]. The language says "that concerns you," but it simultaneously implies that the Symbolic (or the world of objects constituted through the symbolic) gazes at you/concerns you as a subject. Lacan's reflections on the sardine tin clarify not only the meaning of his axiom "that we are beings who are looked at, in the spectacle of the world,"[22] but also why I believe the hallucinatory subjectivity of the object—made visible in the lifted gaze of the photographic iconography of the Salpêtrière—should be considered an extreme case of Lacan's psychological mechanism of the *regard*.

My second thesis is that a basic characteristic of the Benjaminian auratic *fascinosum* is a concern for extreme cases of an object's hallucinatory subjectivity. To make my point I want to return briefly to Marcel Proust, Benjamin's chief witness of auratic experience. It may not be immediately apparent what the "lifting of the gaze" described above has to do with Proust's freely arising "image structure of the *mémoire involuntaire*," once paraphrased by Benjamin as being "portraits that are for the most part isolated and only mysteriously present."[23] But let us read Proust. In *The Guermantes Way*, translated into German by Benjamin and Franz Hessel, Marcel visits his friend Saint-Loup in the garrison city of Doncières. Upon waking, he gazes out the window with curiosity at the unfamiliar landscape still swathed in mist: "In the meantime, I could see only a bare hill, raising its lean and rugged flanks, already swept clear of darkness, over the back of the barracks. Through the translucent screen of hoar-frost I could not take my eyes from this stranger who was looking at me for the first time."[24] Here is an example from Proust in which Benjamin's auratic impression (*following a mountain range on the horizon*) lifts the gaze: Marcel, the observer, anticipates the moment when the hills will offer them-

21. Lacan, *The Four Fundamental Concepts*, p. 95.
22. Ibid., p. 75.
23. Benjamin, "Proust-Papiere," *Gesammelte Schriften*, II, 3, p. 1053.
24. Proust, *Remembrance of Things Past*, II, pp. 78–79.

selves up to his gaze, and "this stranger"—a hill become woman—
watches him. Henceforth, consciousness of this hill's existence, even
when the ego of the *Remembrance* does not see it, guarantees that all
apperception in Doncières is permeated by the hill's profile and soaked
through with the mist from which it emerges:

> [I]ts reflected form, even without my realising it, was silhouetted against
> the slightest impressions that I formed at Doncières, and among them, to
> begin with this first morning, the pleasing impression of warmth given me
> by the cup of chocolate, prepared by Saint-Loup's batman in this comfort-
> able room, which seemed like a sort of optical centre from which to look
> out at the hill. . . . Imbued with the shape of the hill, associated with the
> taste of hot chocolate and with the whole web of my fancies at that par-
> ticular time, this mist, without my having given it the least thought, came
> to infuse all my thoughts of that time.[25]

It would require an extended analysis to describe all the sensual and
cognitive interconnections of proximity and distance, singularity and
permanence in the Proustian aethesiology of experiencing objects. Yet
the basic pattern of Proust's involuntary memory emerges clearly in the
eye contact between his observer and the hill. If the image of the hill's
form can be "associated" with the taste of chocolate and the concate-
nation of many thoughts, the opposite also occurs: physical contact
with the famous *madeleine*, and the response to it triggered by taste,
brings forth the entire visual world of a childhood in Combray. Neither
a subjective nor an objective point of view will completely describe
such experiences: the curving hill of an hallucinatory subjectivity de-
termines with its aura the entire time-space of a life. Here, in the hallu-
cinatory subjectivity of the object, lies the common denominator be-
tween aura hysterica and Proustian impression.

25. Ibid., II, p. 79.

AUTHENTICITY

The presence of the original is the prerequisite to the concept of authenticity. Chemical analyses of the patina of a bronze can help to establish this, as does the proof that a given manuscript of the Middle Ages stems from an archive of the fifteenth century (220)

The whole sphere of authenticity is outside technical—and, of course, not only technical—reproducibility. Confronted with its manual reproduction, which was usually branded as a forgery, the original preserved all its authority; not so *vis à vis* technical reproduction (220)

The authenticity of a thing is the essence of all that is transmissible from its beginning, ranging from its substantive duration to its testimony to the history which it has experienced. Since the historical testimony rests on the authenticity, the former, too, is jeopardized by reproduction when substantive duration ceases to matter. And what is really jeopardized when the historical testimony is affected is the authority of the object (221)

[T]he unique value of the "authentic" work of art has its basis in ritual, the location of its original use value. This ritualistic basis, however remote, is still recognizable as secularized ritual even in the most profane forms of the cult of beauty (224)

[T]he function of the concept of authenticity remains determinate in the evaluation of art; with the secularization of art, authenticity displaces the cult value of the work (244)

Authenticity, for Benjamin, is that which relates an artwork to its unique moment and place of origin. Authenticity produces an effect of ambiguity between the presence, the tangibility of art as an object, and the distance that separates this closeness from the moment (and often also from the place) of its origin. From a strictly formal point of view, we can say that the concept of "authenticity" shares with the concept of "aura" this tension between distance and closeness. But we must also understand that aura depends on authenticity, inasmuch as the aura is a remainder of the original cult value of the artwork and there-

fore needs the mediating function that we call "authenticity" in order to remain connected to the past.

Different in that from many (but certainly not all) other key concepts of Benjamin's essay, "authenticity" marks the discursive place of two different, diverging evaluations. Grounded on authenticity and uniqueness, the authority of the artwork is clearly threatened by technical reproduction—and as Benjamin wants to be so unambiguously committed to technical reproduction, this threat gives a negative connotation to authenticity. On the other hand, he explicitly states that "with the secularization, authenticity displaces the cult value of the work." In this view, authenticity is a "lesser evil" in comparison to the cult value. But is authenticity capable of being something more positive than a "lesser evil"? The answer to this question would depend on the answer to yet another question—that is, whether authenticity can be brought into relation of contiguity with the "exhibition value"—Benjamin's positive counterconcept to the unequivocally negative cult value. Unfortunately, the meaning of the word "exhibition value" never becomes sufficiently clear for us to resolve this problem on a purely semantic basis.

Yet it is interesting to see, on a more empirical level of observation, that art in the age of its technical reproduction has produced at least one phenomenon in which reproduction-based multiplicity and authenticity converge. These are the multiple originals of numbered and signed etchings or prints that have become so popular on the contemporary art market. Or should we say that, rather than multiple originals, they are authentified copies? Benjamin fails to make a distinction between copies that present themselves as authentified copies, and multiples that want to be originals. Copies that pretend to be originals are what we call fakes. But while it is true that high-quality fakes can make it difficult for the original to prove its privileged status (and thus become a danger for the original), it is also obvious that fakes do not put the category of the authentic into question. The opposite seems to be the case: what would be the point of authenticity if it were not for the danger of fakes—or, more precisely, there is no point to authenticity without copies that are not easily identifiable as copies.

Independent of their ambiguous status, there is at least one aspect in which multiple originals or authentified copies definitely depart from a more traditional conception of the artwork. They can no longer be located at the intersection of a unique place of origin and of a unique moment in time. Since the first decades of the twentieth century, the

word "authenticity" often adopted a meaning that is related to a map-ping—a meaning of high complexity and with an intense emotional charge. The word became thus associated to a—mostly nostalgic—worldview within which each phenomenon, due to its quasi-cosmologi-cal space/time-inscription, was expected to have a clear and identifiable meaning. This was a worldview that, quite obsessively, spotted phe-nomena of alienation and existential feelings of uncertainty everywhere in the modern world. It is not surprising that this meaning of authen-ticity (for which Heidegger's concept of *Eigentlichkeit* is an example) became a key value for the Conservative Revolution—that is, for those European intellectuals who felt the necessity, in a historical situation of transition and insecurity, to invent (to rediscover) a cosmological ground and order for the world. Had Benjamin been aware of this proximity, he would have gone out of his way to avoid the conceptual contiguity that made it possible. Perhaps his remark about the incom-patibility between authenticity and technical reproduction is an attempt in this direction: "From a photographic negative, for example, one can make any number of prints; to ask for the 'authentic' print makes no sense" (224).

But it is equally true (and more astonishing) that Benjamin appears hesitant in his efforts to break definitively with the concept of authen-ticity. He may have been attached to authenticity because the notion has to do with a double corporeal touch. Whatever is considered to be authentic has been in touch with the body of an author (this is true even for the "authentified" copies of an etching or of a photograph), and such a status triggers the desire of a potential buyer to touch what has been touched by the author. What the owner of an artwork or of a manuscript ends up buying is not so much the exclusive right to see the object in question (many art collectors make their collections accessible to the public)—but the right to touch it. Could we then say that Ben-jamin was among the first critics who changed—who perhaps even tried to "democratize"—this conception of the authentic? Despite his hope that a concern for aura and authenticity will disappear, it is clear that Benjamin was more fascinated with establishing a *material* rela-tion to the worlds of the past than even the most conservative among his critics. The kind of authenticity for which he longed was neither Heidegger's nostalgia for an orderly world, nor the quasi-erotic desire to come close to an author-genius. Benjamin was sensitive to the authenticity of the trivial object, to the authenticity of the object that had simply "been there," of the object which, despite its triviality,

could make the past materially present. This sensitivity of Benjamin, to use the language of historical teleology, was way ahead of—and certainly incompatible with—some of his most utopian critical concepts.

Although they are obviously not synonymous, it is difficult to distinguish "authenticity" from "aura." Both that which is considered to be authentic and that which is surrounded by an aura appear as being at a distance. Both authenticity and aura seem to be threatened by any kind of replication, especially by mechanical reproduction. From a historical point of view, authenticity becomes an issue—and authentification becomes a need—when artifacts begin to be related to a producer- (or a creator-) subject as a matter of custom. The act of authentification confirms that an object was indeed produced by the person to whom its existence has been attributed. This object thus becomes an *authenticum*—in distinction from its copies (*exemplaria*). It is safe to assume that this very association was reason enough for Benjamin to include authenticity on his list of negative concepts—and on the list of negative values that he wanted to see eliminated through the progress of history. But if it is doubtful whether technical reproduction, as Benjamin presupposed, will ever erode aura, there is no doubt that authenticity and mechanical reproduction, rather than being antagonistic principles, constitute a relation of complementarity. Only the production of copies—regardless of whether or not they are fakes (present themselves as originals)—generates the need for authentification and the desire for the authentic as a value. Copies, even if they are not produced by the author's hand, can still be "partially authentic" (the edition of a text, for example, can be authentic in its wording: it can be exactly the text an author wanted, without materially consisting of the very graphemes written by the author's hand). Finally, the art market has created—without any major logistic problem and with considerable economic profit—the phenomenon of the "authentified copy." Here, the artist's signature attributes a specific economic value and a specific dignity—should we say "aura"?—to a potentially infinite (but, for obvious economic reasons, never really infinite) number of copies.

REPLICATION

In principle a work of art has always been reproducible. Man-made artifacts could always be imitated by men. Replicas were made by pupils in practice of their craft, by masters for diffusing their works, and, finally, by third parties in pursuit of gain (218)

The whole sphere of authenticity is outside technical—and, of course, not only technical reproducibility. Confronted with its manual reproduction, which was usually branded as a forgery, the original preserved all its authority; not so *vis-à-vis* technical reproduction. The reason is twofold. First, process reproduction is more independent of the original than manual reproduction. . . . Secondly, technical reproduction can put the copy of the original into situations which would be out of reach for the original itself (220)

One might generalize by saying: the technique of reproduction detaches the reproduced object from the domain of tradition. By making many reproductions it substitutes a plurality of copies for a unique existence. And in permitting the reproduction to meet the beholder or listener in his own particular situation, it reactivates the object reproduced (221)

[F]or the first time in world history, mechanical reproduction emancipates the work of art from its parasitical dependence on ritual. To an ever greater degree the work of art reproduced becomes the work of art designed for reproducibility. From a photographic negative, for example, one can make any number of prints; to ask for the "authentic" print makes no sense (224)

What are the philosophical conditions of a replica, and how are they framed in the *Artwork* essay? Asking this basic question spotlights the fact that while Benjamin realized the advent of certain technical processes had wrought a change in replica-making, his manner of thinking about replicas could not keep pace with their proliferation. His opening remarks suggest a common-sense notion of replica: a model exists; a copy is made. But the philosophic issue is more complicated, for the ability to say "object-a is a replica of object-b" presupposes a sufficiently clear idea of what constitutes object-b that we can identify object-a *as a replica*. Benjamin invokes something on the order of "looks

like" as criteria, but when he couples reproducible with imitation he betrays the Platonism of his thinking: if object-a "is like" object-b the inverse must also hold; they have some quality or "idea" in common. To determine which is the copy means testing *authenticity*, and so Benjamin writes: "[E]ven the most perfect reproduction of a work of art is lacking in one element: its presence in time and space, its unique existence at the place it happens to be" (220).

A principal tension in the essay proceeds from a concern to inoculate this Neoplatonic concept of authenticity—manual reproductions are forgeries that leave the original's authority intact—from the effects of reproducibility, technical or otherwise. Benjamin marshals two kinds of arguments to achieve this goal. First, he suggests that process reproduction is more independent of the original, meaning it may "see" more intensely, more complexly, or more provocatively than "normal" vision: here we return to the threat of technically induced changes in our patterns of perception and the latent question as to whether "machines" experience art (Benjamin would probably say that machines "experience" art, but not the aura of art). However, his second argument is of special interest—namely, that technical reproduction can put replicas into situations that might be closed to the original itself. What are the philosophic stakes in this seemingly innocuous observation? What are the stakes of replication?

In the most Platonic of replica situations—where, for example, a copy might be said to "be like" a verified, authentic Rembrandt—a number of key constraints structure the space and time of our comparison. If the two are in a single room hanging side by side, we might not notice that the comparison depends upon a difference in *space* between the two. Or one could hang each picture in exactly the same space, under the same lighting conditions, but this could not happen at the same *time*. Or one could examine the Rembrandt in one gallery and then cross town to another gallery to see the copy, which is a crude—but crucial—way of extending experience of the two, and of the comparison, in *space and time*. Finally, it is logically possible—although physically improbable—that the two works could be experienced in the same space and at the same time: in which case—if they really "are like" one another—it would be hard to determine which was the original and which the replica: indeed, this most logically extended situation is where questions of authenticity give way to a hermeneutics of interpretation.

Benjamin sensed that if replicas can move freely to places an

"original" might never go, the otherwise stable categories of space and time essential to establishing the "likeness" of a replica and "authenticity" of an original begin to break down. Detachment from the "domain of tradition," which is nothing less than today's "challenging the canon," becomes possible when the *situation* of judgment—not merely the criteria deployed—is no longer stable. At the same time, proliferation of replicas able to "meet the beholder" so dramatically displaces the time-space conditions of viewing, and reception is so likely to be affected by factors unrelated to the task of verifying likeness, that the viewer's memory and experience of similar *situations*—rather than the original which may not be known first-hand—threaten to "reactivate" replicas with an entirely new set of values and appeal. In short, the "plurality of copies" engenders a whole range of new experiences that challenge the "unique experience" of the authentic original for a viewer's attention.

Benjamin's comment about freedom from ritual is related to the extended time-space continuum thus set in motion: not only the end of ritualized production (solitary artists working in sanctuaries called studios), but also of ritualized reception. In spite of the resources deployed by museums to keep the latter ritual alive (monumental buildings, security guards, hushed galleries, dramatic presentations), the growing number of "museum shops" that traffic in replicas tends to support Benjamin's basic insight. What he failed to see, and which becomes clear from his remark about photographic prints, is not that the question of an "authentic" print makes no sense because any number can be made, but that *all of them exist systemically as the original.* One can find hundreds of small, nearly invisible differences among prints made from a single negative, so that no print can claim "authenticity" over the others. Nor can the negative claim "authenticity" over the prints, for it only exists as a nonimage, a model that helps us to distribute and hierarchize the wealth of copies circulating simultaneously in culture: second-generation copies made from existing prints, for example, will exhibit a distribution of differences quite unlike the prints made from the model negative.

Gilles Deleuze describes how systemic representation displaces the identity of Platonism with an infinite play of differences: "*However small* the internal difference between the two series, the one story does not reproduce the other, one does not serve as model for the other: rather, resemblance and identity are only functional effects of that difference which alone is originary within the system. It is therefore

proper to say that the system excludes the assignation of an originary and a derived" (*Difference and Repetition*, 125). Today, we take for granted the "likeness" of a compact disc recording, but the sampling rate of recording, and the process of digital coding, produce a huge number of errors that are immediately "masked" by even the most simple CD player; in fact, we never actually "hear" a compact disc in exactly the same way more than once. In their thinking about originals and replicas, neither Plato nor Benjamin could tolerate the fact that *differences are always in play*; to allow for difference means decentering the entire chain of representation—a "shattering of tradition" (221)— so each in his turn made extravagant demands on the notion of authenticity: Plato barred artists from his ideal state; Benjamin invented aura.

"The Cameraman and Machine Are Now One"

Walter Benjamin's Frankenstein

The most advanced thought in contemporary cognitive science holds that "the proper understanding of human cognition"—Benjamin's main concern, what he calls human "apperception"—must acknowledge what Edwin Hutchins calls "the continual dynamic interconnectivity of functional elements inside with functional elements outside the boundary of the skin."[1] Only this way can we see the significance of the camera and all the practices of cinema.

Old-style works of art and old-style technologies such as printing exist safely outside the body. What is peculiar about the camera and the cinema is the way they dissolve the border between human and machine. Benjamin argues that the machine is in the loop of creativity. Human and machine form a hybrid that is the network that produces artworks. A whole network of agents—some human and some not— are the producers of the artwork, not the sovereign self of traditional art theory. Having rejected the ritualized account of art, Benjamin starts to account for art from the ground up, like a mechanic. Like Aristotle he dares to be a formalist, a technician. In his *Science in Action*, Bruno Latour lamented the lack of studies of the forms in which technical knowledge is concentrated. Some conclude that such studies are not possible, but not Latour:

> I draw a different conclusion; almost no one has had the courage to do a careful anthropological study of formalism. The reason for this lack of nerve is quite simple; a priori, before the study has even started, it is towards the mind and its cognitive abilities that one looks for the explanation of forms. Any study of mathematics, calculations, theories, and forms in general should do quite the contrary; first look at how the observers

1. Hutchins, *Cognition in the Wild*, p. 316.

move in space and time, how the mobility, stability and combinability of inscriptions are enhanced, how the networks are extended, how all the information are tied together in a cascade of re-representation, and if, by some extraordinary chance, there is something still unaccounted for, then, and only then, look for special cognitive abilities.[2]

Such exactly was Benjamin's procedure in studying cinema—to look at the behavior of all the human actors and all the machinery and to describe first of all how they move, how the inscriptions are combined and enhanced, how the networks are interlinked, and how they are tied together in the film itself, which is truly a cascade of re-representations. No skyhooks unless you have exhausted the possibility of formal explanation by means of cranes, the man-machine interface. Skyhooks are mind-first forces or powers whereas cranes are subprocesses or special features of a design process, says Dennett, who devises this dichotomy familiar to those studying evolutionary theory. One resorts to skyhook explanations when one has no earthly explanation. The history of Western thought about the arts offers a vast repertory of skyhook accounts of the beauties of art. "Skyhooks are miraculous lifters, unsupported and unsupportable. Cranes are no less excellent lifters, and they have the decided advantage of being real."[3] Benjamin gives us cranes.

The advent of the camera into the loop of artistic creativity causes a whole set of changes. Photography makes it possible for the human eye to take over from the hand, and the eye is much faster than the hand (219).[4] Photography has operating within it a certain negativity, a "destructive, cathartic aspect" (221). Photography makes salient in the practice of the arts the idea of human sense perception, apperception. Benjamin invokes Kant: "The organization of perception" is, it is clear, something historically variable. The camera has no respect for performance as "an integral whole" (228). In its stead we have a method that proceeds in an experimental way, testing each element in isolation as it goes along. All the pop arts are put together this way, feelingly, bit by bit in a constant negotiation among humans and machines testing the capacities and powers and limits of all the players, human and nonhuman, adapting to the resistances of all. When those who make

2. Latour, *Science in Action*, pp. 246–47.

3. Dennett, *Darwin's Dangerous Idea*, pp. 73–80, esp. p. 75.

4. *Editors' Note*: Unlabeled parenthetical references in the text of this essay are keyed to the edition listed in the Bibliography as: Benjamin, "Work of Art." Other parenthetic references marked *BU*, which refer to the text from which the film *Blow-up* was adapted, are keyed to the edition listed in the Bibliography as: Cortazar, "Blow-Up."

art have to learn to accommodate the inhuman and so to tap into the power of negation that inheres in the machine, then humans have to give up the wholeness and organic unity of the human body. The result, as Miriam Hansen writes about cinema, is that the "boundaries of the human body have been burst," and we have "the deliberate blurring of boundaries between human and nonhuman nature" thanks to the intervention of the apparatus into the making of art.[5] Although great fusses will be made by writers of fanzines about stars, and by writers of glossy magazines and scholarly journals about directors as "auteurs," all such talk is regressive, an effort to restore the humans to the driver's seat and to put Humpty Dumpty back together again upon the throne of control. But all the King's soldiers and all the King's men will never be able to put Humpty Dumpty together again. Benjamin scorns such efforts. Stage acting is out; and the directors, actors, and machines are all part of a new network or constellation that produces film. We have an art—if you want to hold on to the old, glorious, honorific title— which is saturated with materiality. The human subjects have been turned into objects. The tables are reversed. A new democracy is the order of the day.

The machine, the mediating artifact, links realms previously held separate. The machine makes possible an amalgamation, a blending, that the mind guided by tradition, the mind that the Great Wall of Tradition runs through (as it does through the mind of the narrator of Kafka's story), might not be able to contemplate without disgust. Such minds crave purity, since they themselves are abstractions from the ebb and flow of cultures. Humans have traditionally tried to keep subjectivity pure and objectivity pure so never the twain shall meet. The dominant accounts of sciences and arts have been made to conform to human desires, but the history of modern sciences and arts is quite another thing, as Steven Shapin and Simon Schaffer have shown in their analysis of how Robert Boyle's airpump functioned in his analysis of the vacuum.[6] Boyle's airpump, at least in Bruno Latour's description of it, is like Benjamin's camera. Latour writes that with the airpump we get "the intervention of a new actor" in science whose force we must recognize. Such actors are "inert bodies, incapable of will and bias but capable of showing, signing, writing, and scribbling on laboratory instruments before trustworthy witnesses." These nonhumans are "lack-

5. Hansen, "Of Mice and Ducks," pp. 44 and 47.
6. Shapin and Schaffer, *Leviathan and the Air-Pump*, passim.

ing souls but endowed with meaning" and "even more reliable than ordinary mortals, to whom will is attributed but who lack the capacity to indicate phenomena in a reliable way."[7]

Such actors, when joined with humans, make possible the emergence of hybrids. Benjamin's central subject is this hybrid, as when he writes that "the cameraman and machine are now one" (233), and adds that "we hardly know what really goes on between hand and metal" (237). Indeed, we hardly dare ask! What strange erotics must there be, this lascivious union of man and machine. Film, product of the union of the human and inhuman, is the monstrous progeny that I suspect many of us have feared to face at the heart of the labyrinth that is Benjamin's text. This produces the monster that can make a breach in the Wall. It is the story of King Kong assaulting the Empire State Building, a fundamental story from the movies.

I will not accuse other exegetes of timidity and revulsion in the face of Benjamin's monster when I ought to say that I speak for myself in saying that I—perhaps a typical *litterateur* who loves Tasso and Milton—have only now been able to contemplate this new Frankenstein. It is the emergence of this hybrid and its consequences that Benjamin was, I think, brave enough to face, overcoming the fears that all the traditionally minded must own up to and not deny. Understand your fear—as the self-help people say—so you can conquer it. It is for this sort of intellectual courage that Benjamin merits our admiration. Far easier to avert the eyes and pretend it was not the case, all the change these developments were bringing about. Surely not a one of his intellectual allies would have accused him of cowardice for failure to walk this mile. In fact, his closest allies positively discouraged him from doing it: the correspondence between Benjamin and Adorno is a sad record of Adorno's trying to bully Benjamin into taking the easier route.[8]

Does Latour exaggerate the difficulties involved for those who

7. Latour, *We Have Never Been Modern*, p. 23.

8. The correspondence is now available in Adorno and Benjamin, *Briefwechsel*. Raymond Geuss estimates that the underlying story told by the sequence of letters is of "Adorno gradually but persistently trying to take Benjamin and his project over and of Benjamin's repeated but increasingly feeble and demoralized attempts to resist this. . . . It is interesting to watch Benjamin use language as a means of escape from Adorno's sweaty embrace" (Personal letter of 4 February 1995 from Geuss to Lindsay Waters). Adorno accuses Benjamin of providing no more than a "wide-eyed presentation of mere facts" in his analyses of modern culture, and of failing to see how all the details are mediated through "the total social process." Benjamin defends himself and his fixation upon minute particulars as a form of "methodological caution" (see the exchange in Bloch, *Aesthetics and Politics*, pp. 100–141).

would give up the traditional purities? I think not. A long line of intel-
lects from Hobbes to Adorno—for whom knowledge and power are
one and the same—would happily have had Benjamin flinch from
analyzing the hybrid that film is. Benjamin sets before us the film stu-
dio, within which artificial machines, in league with humans, create
phenomena from a trash heap of objects that appear entirely natural—
sometimes even beautiful—to their viewers. Even though films are arti-
ficial, costly, and hard to produce, films represent nature. With Boyle
and his successors, and now with Benjamin, we begin to understand
what a natural force is: an object that is mute but endowed with
meaning. The great secret of the modern world, Latour argues, is the
paradox that although we crave purity, it is the hybrids, the mixtures
of nature and culture, that are our greatest achievements. Adorno per-
haps wanted his friend to let the secret remain a secret. If we could pre-
tend that the genie had never gotten out of the bottle, that Frankenstein
never arose from the casket and roamed the earth, perhaps Adorno's
wish that the mass arts never came into existence could serve as the
truth. But accepting that wish as true means living a lie greater than the
lie of cinema that it gives us nature unmediated. Such an act of denial
was never something Benjamin wanted to entertain. As his letter to
Rang suggested, he wanted to understand twentieth-century human
flourishing in terms of the emergence of long-term forces of nature. He
writes in "Konvolut K" of *The Arcades Project*: "One can characterize
the problem of the form of the new art straight on: when and how will
the worlds of form which, without our assistance, have arisen in me-
chanics, in film, in machine construction, in the new physics, etc., and
which have overpowered us, make it clear for us what in them is na-
ture?"[9] One of the paradoxes of Benjamin's *Artwork* essay is that in the
guise of an argument for radical discontinuity he has made the strong-
est case *for* change within continuity in artistic practices over millen-
nia.

But I should put aside talk of genies and Frankensteins and mon-
sters. It is not really helpful in the long run. Such talk conjures up a
mythology in whose frightful shadows we have cloaked the exact
physical operations Benjamin described so that we might justify avert-
ing our eyes from discerning exactly what is going on. But we need to
dispel those mists and myths, because Benjamin is not trafficking in
them. He has sharply attacked those who promote their views using

9. Benjamin, *The Arcades Project*, p. 396.

myth. "So let us not talk falsely now, the hour is getting late," runs the line in Bob Dylan's *All along the Watchtower*.[10] When Benjamin spoke of cinema, the hour was getting very late, the time of crisis *before* war was upon him and his contemporaries. Sand was running low in the hour glass.

Before getting to his notions of film reception, I want to discuss two aspects of Benjamin's ideas about the production of film. The first has to do with the interaction of human and machine and machine and nature. The second has to do with the nature of the social network for cognition composed of humans and machines, and the politics consequent upon the emergence of that network. Because Benjamin attends carefully to the agency of the machinery in the process, he notices two crucial and symmetrical things relative to human interaction with the machine. On the one hand, the advent of the machine permits an emerging awareness of how much human visuality is guided by the machine, so that the human subject takes on (as it were) aspects of the apparatus that was formerly thought to be a mere instrument and hence objectified. On the other hand, the machine's agency has the effect of turning human subjects—actors and actresses—into mere objects to be picked up and inscribed by the machine as agent. This shocking realization helps highlight the way film initiates a new form of human cognition. It renders incoherent the old subject-object dichotomy, the old epistemology. The system of person-in-interaction-with-technology exhibits a new form of expertise. The new machine does not just amplify the cognitive abilities of human beings, it transforms and reconstructs social relations. The cognitive properties of human groups interacting with technology differ from the cognitive properties of individual humans.

If the advent of film knocks the artwork cloaked in aura off its pedestal so that it tumbles and breaks, it also knocks individual human producers of such art out of their easy chairs. The double nature of this earthquake is best conveyed, I think, in Julio Cortazar's *Blow-Up*. Sections eight and nine of Benjamin's essay are devoted to an examination of the camera as actor, in Latour's sense of that word. The viewers of films are not invited up to some empyrean of first-class seats to enjoy the position of divine all-knowing subjects, as so often occurs in novels. Instead, the audience comes to feel that its real position is no better

10. Bob Dylan, *John Wesley Harding* (Columbia PC-9064).

than the machine that shot the film. "The audience's identification with the actor" of the film is not, in fact, with the actor, but with the camera filming the actor; what viewers are offered "is really an identification with the camera. Consequently the audience takes the position of the camera" (228). Cortazar's *Blow-Up* offers a gloss on Benjamin's point in the form of a fiction that eventually became a film. I would like to imagine that Cortazar read Klossowski's translation of Benjamin's essay but, in any case, his story helps illuminate Benjamin's thought.

Michel, the main human character of Cortazar's story, is obsessed with technologies, caught between his Remington typewriter and his Contax 1.1.2 camera. He is a comparatist, a happy explorer of icons and ambiguity in all the arts, who comes to realize what it is like to merge with steel and become the hybrid Benjamin writes about in the *Artwork* essay. When we first meet Michel, he is described as happiest "letting [him]self go in the letting go of objects, running immobile in the stream of time" (*BU* 118). But that was before the wind started blowing. He has that heightened consciousness shared by many of us—myself included—who were raised in a literary culture becoming a visual culture. He knows that "every looking oozes with mendacity, because it is that which expels us furthest outside ourselves, with the least guarantee" (*BU* 119). He goes to a park in Paris to take photos and begins to take shots of a corner of an island where an "uncommon couple" are talking animatedly. His mind races along ahead of the camera. He cannot control his mind. It leads him by the nose. He imagines stories that would make a whole narrative of what comes to his eyes in bits and pieces. He remarks: "Strange how the scene (almost nothing: two figures there mismatched in their youth) was taking on a disquieting aura. I thought it was I imposing it, and that my photo, if I shot it, would reconstitute things on their true stupidity" (*BU* 122). Cortazar uses the same term as Benjamin: aura. Michel, true humanist seeking unity even while apologizing for doing so, invokes the words for aura and negation (*nada*). He thinks his use of the machine will enhance his understanding of reality. The camera might allow him, he hopes, to get inside the minds of the individuals: "I would have liked to know what he was thinking." Old-fashioned humanist, he wants to get inside people's minds.

A conventional mistake in the way we think about our interactions with machines is to believe that using them will *amplify* our cognitive abilities. Tools certainly do allow people to do things they could not

otherwise do, but that's not all. As Edwin Hutchins reminds us, "Each tool presents the task to the user as a different sort of cognitive problem requiring a different set of cognitive abilities or a different organization of the same set of abilities."[11] Tools transform the task and all the actors. The plot of *Blow-Up* turns on Michel's coming to appreciate the nature of this transformation. He keeps taking pictures. He keeps imagining plots that would entwine the couple, but Cortazar refuses us the conventional tale that Michel imagines of the coupling of man and woman. Rather, we have an unconventional tale of the coupling of man and machine: *Las babas del diablo* is the early morning haze, the mist that is attractive but leaves everything unclear. Michel's mind is clouded. He projects movies of his own making, really home movies spun out of the interior of his mind with no constraints allowed by the world. But his fine mist is no better than drool. The story's narrator tolerates Michel's imaginings of neat stories until, suddenly, he comments acidly: "Michel is guilty of making literature, of indulging in fabricated unrealities" (*BU* 124). The artistic impulse must come up with something better, keener, sharper, cooler than capital-A Art! Several days later, Michel develops his photos, and the nothingness—the *nada* of photography—begins to operate. "Nothingness," the text says, is "the true solidifier of the scene" in all photography (*BU* 126). Michel realizes that it "had never occurred to [him] that when we look at a photo from the front, the eyes reproduce exactly the position and the vision of the lens; it's these things that are taken for granted and it never occurs to anyone to think about them" (*BU* 126–27). Never occurs to anyone, except that it had occurred to Walter Benjamin.

Working with his typewriter directly in front of his body, as we learn, it's a wonder that Michel even comes to this understanding. But even more transformations are in store for him: he abandons the translation upon which he had been working to explore what might emerge if he develops his photos to greater and greater resolution. He gradually sees a second man emerge from the woods and viewing the couple embracing. The camera has seen things he did not see. It has enhanced his vision. But while developing the photos in his apartment, he realizes that he is now cut off from those events. Obviously, Cortazar's story is far too rich for a quick gloss, but what is relevant to my reading of Benjamin is that Michel comes suddenly to realize that he is one with the camera: "All at once the order was inverted, they [the fig-

11. Hutchins, *Cognition in the Wild*, p. 154.

ures he photographed] were alive, moving, they were deciding and had decided, they were going to their future; and I on this side, prisoner of another time, in a room on the fifth floor, to not know who they were, that woman, that man, and that boy, to be only the lens of my camera, something fixed, rigid, incapable of intervention. It was horrible, their mocking me, deciding it before my impotent eye" (*BU* 129–30). Walter Benjamin does not tell us something impossible to know before the age of mechanical reproducibility: it could always be known. Art is an external storage system, and has a material reality that is a part of the story; a star role not a walk-on. Keats knew the scene, and he had felt Michel's pain. But, as he wrote in what might be considered his version of Benjamin's *Artwork* essay, Keats also believed that if we understand the materiality of the work of art it can "tease us out of thought"—out of thinking too much.[12]

Cortazar's story ends with Michel mingled with the camera, and he screams aloud when he realizes his restricted role. The narrator speaks for Michel: "[A]nd then I turned a bit, I mean the camera turned a little." They are one, and Michel begins to see more clearly into the eyes of the man he photographed; he realizes they are not filled with meaningful soulfulness ripe for the contemplation of the humanist, but rather that the man was looking at Michel "with the black holes he had in place of eyes" (*BU* 130). Like the aperture of a camera. In the end, Michel appreciates the nothingness that is in him, and in what he surveys, and he realizes it can be mobilized. He is capable of a great leap forward, provided he desists from humanist fantasies of control.

12. Keats, "Ode on a Grecian Urn," p. 210.

Concerning Two "Encounters" with Walter Benjamin

The Reproducibility of Art

It was almost forty-five years after Walter Benjamin wrote "The Work of Art in the Age of Mechanical Reproduction" that, on the advice of friends, I became acquainted with the essay. At the time I was finishing the editing of *Introduction à la poésie orale* (Seuil 1983), which in manuscript form I called *Présence de la voix*. I tried to work out the problem posed by the use of modern mechanical and electronic media in the transmission of oral traditions; in particular, its effect on the nature of vocality. I centered my analysis (pragmatically speaking) on the total event of "performance." Its "mediatization" had consequences on two levels, that of sensory perception (by the loss of tactility) and that of temporality (by the loss of uniqueness, of instantaneousness). I returned to these questions throughout my book.

The notions of aura and authenticity as defined by Benjamin applied convincingly to the phenomena I was considering; the idea (of secondary importance to him) that our mode of sensory perception is historically and culturally conditioned coincided with one of the assumptions with which I had begun. My argument, it is true, was based on phenomena relevant to poetic art and the voice, where, in relation to Benjamin's grander design, I found a certain ambiguity. Simply, in and by performance (rather than by virtue of some intrinsic grace) a work transmitted orally and directly finds its authenticity, deploys its aura; that is, it achieves its historicity—existing entirely within the double aspect it offers to reception—as an object perceived and as an object having intrinsic value within itself. In contemporary practice, mechanical mediatization (specifically audio recording and, even more appropriately, video) introduces an element of fiction which brings these varied performative aspects to a higher degree, beyond the dis-

tance of fictitiousness, without abolishing them. That is, the authenticity of a musical or vocal work heard on an audio recording is specific, but is no less authentic for it, because it is based upon its presence, its here-and-now. The amateur hears the piece, specifies it, and looks for it among the numerous versions furnished by the marketplace; he chooses the author, the label, and the type of playback equipment among the many existing and competing models—these are powerful factors of distanciation, in Benjamin's sense, at the very heart of the nearness between myself and the object brought about by industrialization. *Any* recording of the Ninth Symphony, *any* photograph by Robert Doisneau, is a unique work—repetitive by virtue of their mechanized aspect, yet profoundly and irreplaceably authentic.

It cannot be denied that industrial quantification (itself absurd) does lead to new forms of qualification, which are reserved less and less for a literary elite. The popular access of "youth" (that class raised in the 1960s and 1970s) to the so-called benefits of consumption highlights this process. Whoever spends time with this "youth" will notice the demand for quality (regardless of the sometimes laughable criteria) that dictates their choice.

Thus, I see no rupture in the continuity between direct performance and mediated performance; nor do I see a shifting of perspectives that would partially elide meaning and modes of production. The evolution of techniques of reproduction from the 1920s to the 1980s moved in the direction of a totalization (no doubt inaccessible in itself, but what do I know?), toward the founding of a synesthesia that puts into play the greatest possible number of perceptions. From the archaic camera used by my father, or the film masterpieces of Eisenstein, to our "virtual reality," the world around us is in the process of swinging completely into fiction; by entirely, I mean without losing any of its historicity, its presence, or its cruelty.

Perhaps Benjamin's essay owes its limitations to the fact that the author—fascinated by photography and cinema—thought of the problem in terms of visuality. The lack of any account of music, song, dance, or literary forms dramatically reduces the impact of his notion of reproduction, one that remains halfway between an antiquated mimesis and industrial fabrication. No doubt the state of photographic and filmic techniques around 1935 kept him from going beyond this stage of analysis: his references to Valéry, Duhamel, or Abel Gance are characteristic. It seems that Benjamin's personal tastes led him to prefer historical films—grand spectacles of a more or less epic tenor—in

which the intervention of montage techniques is most incisive. From this there emerges the idea of a splintering of the image, in contrast to painting, that Benjamin invokes in such a totalizing manner: an idea, it seems to me, that cannot be applied to "interiorized" films of which there are many examples in the history of cinema, especially in France and England of the last forty years, including Eric Rohmer and James Ivory.

On these grounds, it would be absurd to put Benjamin on trial when his essay contributed to denouncing the possible point of convergence between the *peste brune* and a particular modern art at the time of the rise of Nazism. Yet times have changed. Perils have assumed other masks: lies in advertising have replaced or merged with lies in politics; the "masses" have disintegrated, and their traditional designation—working-class, manual laborers, workers—progressively loses its historical meaning. The menaces threatening structural rupture that hung ponderously over the sociocultural situation in 1930 revealed themselves to be fruitful, and even positive. Similarly, the terms Benjamin uses to speak about Dadaism correspond to none of my memories. In the 1940s, Jean Arp and I were intimate friends, and I was introduced by him to several survivors of Dada, including Tristan Tzara. The conversations, the meetings, the daily interactions with the admirable sculptural work of Arp, no less than reading Hugo Ball, constituted for me—at thirty—the most intense experience of aura, of the artwork's here-and-now, its presence renewed at every moment: everything that Benjamin expressly refuses to accord to Arp's work!

My second encounter with Benjamin's essay was in the mid-1980s. I was preparing my book *La lettre et la voix* (1987) devoted to the study of the voice as a creative dynamism in medieval civilization. In rereading Benjamin's pages—old-fashioned but so dense—I was struck by another aspect of his argument. Benjamin affirms that mechanical reproduction detaches the artwork from tradition. This, in itself, is an incontestable claim, to the degree that tradition (as Benjamin understands it) is made up of incessant reprises, imitations, partial readjustments; the claim is a little less certain if one understands tradition (as I do) to be the accumulation over time of performances (expressions and receptions) of the artwork. If tradition is thus conceived, each work possesses a true uniqueness, its own here-and-now, its aura. Belonging to tradition constitutes and confirms the "distance" that objectivizes it relative to ourselves. Mechanical reproduction (at least the way it was

practiced in the 1970s) tended to abolish this distance and, in so doing, to erase any impression of ritual. Now, after a quarter-century, we observe everywhere in the practice of technologies of mass culture the emergence of new uses, that try—more or less clearly—to re-create the equivalent of ritual and, by extension, of a significant distance. The entire history of rock since the 1950s and 1960s illustrates such an effort on the part of contemporary mass culture.

I shall take another example, also borrowed from personal experience. Benjamin retraces, briefly but accurately, the history of engraved reproductions, from wood blocks of the fifteenth century to lithography, and he shows that the rupture with traditional art along this trajectory was produced three or four centuries after its first invention. By modifying the chronology a little, one can speak in identical terms about printing as the art of the book. This evolution, however, was accompanied by the not insignificant phenomenon of the *bibliophile*, which gave the product produced by presses its own uniqueness, a distance that isolated itself as a ritual object, an aura. To the extent that printing techniques were perfected, first in the nineteenth century and even more in the twentieth, manifestations of *bibliophilie* multiplied to the point of engendering an identifiable economic activity. At the same time, many editors tried to incite, in the eyes of potential buyers, the here-and-now of an original, of which any reproduction would be pure and simple plagiarism and thus merit punishment: limited press runs, numbered examples, printed text combined with manuscript, or text with illustrations are some of the strategies deployed. The beautiful volume entitled *Les riches heures de l'alphabet*, conceived by Henri Chopin and produced by the two of us in 1993 (Traversière, Paris), contributed to this situation and to this scheme an even more striking illustration that the proper objectness of a book is the graphic materiality of its printed text. In other words, "mechanical reproduction" is neither a uniform process nor even a homogenous technological ensemble: the idea we form of it includes an historical dimension, if not a deep-seated ambiguity, that always renders our idea of it more or less approximate.

But there is more. Benjamin's essay, after sixty years, has itself entered into history: in 1936 his argument seized the cultural situation that, emerging since the beginning of the century, seemed on the verge of imposing itself universally. Today, the prophetic aspect of this discourse no longer touches us: not only because some parts of the prophecy were not realized; but, if I may say so, the future is no longer what

it was. The prophecy was right for its moment; time has refuted certain terms to the point that the discourse lost is coherence as it aged. Whatever sociological, political, or aesthetic character of the object that seemed on the brink of a final disappearance in 1936 revived from about 1970 to 1990 under an unforeseen yet functionally analogous form. Its presumed disappearance permitted Benjamin to contrast an actual situation to a tradition that he identified with the forms of thought and action evidenced in Europe between the end of the Middle Ages and the nineteenth century. That, for him, was *yesterday*. He lived *today*. In relation to him, we are *the next day*. To read and interpret his text, we need a third term. I refuse to get involved in the quarrel about "postmodernity": words ultimately lose their meaning when they are abused. What remains certain is that we have not only emerged from the situation lived by Benjamin, but that various similarities (concealing, perhaps, their identities) seem to make us relive, here and there, prior situations. Thus, the fairly general practice, in all the arts since 1970, of techniques of citation and reuse gives an unexpected vigor to what begs to be called tradition. More than that, the simplifications and even puerilities of "mass" art—and the advertising that feeds off it—produce an unexpected ritualization of all the images projected around us: a distance that isolates them from our lived banality, and the desire that they are supposed to nourish in us.

—Translated by Melissa Goldman

ALEIDA ASSMANN
JAN ASSMANN

Air from Other Planets Blowing

The Logic of Authenticity and the Prophet of the Aura

"In a world where so much is imitation, people now value the original more and more. That's why people for so many years have enjoyed the wholesome goodness of Original NABISCO Shredded Wheat." This quotation comes from the package of a product that uses "The Original" as a prefix to its brand name. "The Original" figures as certificate of a particular quality supposedly aimed at but not reached by comparable products. Can these two simple sentences from the breakfast cereal of an American table neutralize fifty pages of Walter Benjamin's brilliant and sophisticated discourse? As is well known, Benjamin argues that new technical and industrial processes of imitation and multiplication (both aspects converging in what he calls "reproduction"), together with a change in social conditions (such as a demand for the homogeneous and ubiquitous that stems from the growth of mass culture), destroy the aura of the original, the only possible work of art. Our box of cereal makes exactly the opposite point: the conditions of mass production and reproduction do not diminish and destroy the original but—quite the contrary—set off and highlight its value.

Could it be possible that Benjamin overlooked the simple and convincing logic deployed by the box of cereal? Perhaps it is safer to assume that Benjamin had something altogether different in mind when addressing the problems of "original" art in an age of technical reproduction. To explore what he might have meant, we propose to take a rather meandering route: we shall start with an historical excursion to discuss the problems of technical reproduction in premodern societies, and proceed to a more systematic analysis of the concepts of original, fake, and copy, so as to sketch briefly the rules governing the dis-

courses in which such terms feature prominently. Finally, we will focus on Benjamin's concept of aura, and relate it to the negative theologies of art promulgated by Herbert Marcuse and others.

Looking Backward: Restriction and Authorization of Technical Reproduction in Premodern Societies

Technical reproduction was considered a serious problem long before Benjamin raised the issue in his famous essay, for tribal communities regularly forbid the unauthorized reproduction of a sacred object. Anthropologists and tourists are not allowed to photograph sacred images held to be infused with divine power, under the assumption that reproduction would not *destroy* the power inherent in the sacred object, but partake of it. For cultures in which signs are not arbitrary, any reproduction incorporates aspects of what it represents, and mobilizes a metonymic partaking of the sacred object, a kind of "spilling over" of its energy. Reproductions are thought to place this energy in the hands of those who may not be qualified to deal with it, and who may allow it to roam uncontrolled. Reproduction is forbidden in tribal societies because creating an unauthorized duplicate of the sacred object multiplies and disseminates its power in an uncontrollable manner.

The second commandment given to Moses is really the radicalization of this taboo. Although directed at the production (rather than reproduction) of sacred images, the second commandment assumes that *any* production of sacred images involves the technical imaging of that which cannot—and must not—be reproduced: God is *the* original, the sole source of life and power. Any image of God necessarily disseminates his presence—hence his power—in uncertain ways, and subverts the singularity and inaccessibility of the One. At the same time, the second commandment forbids images of the world and its creatures, since image-making is thought to be in essence a religious act of adoration and idolatry, one that sanctifies the merely profane and material. Image-making is thus doubly wrong: it profanes the holy by multiplying and visualizing the One, and it sanctifies his profane creation.

There are cultures, of course, known for their proliferation of images and techniques of mass production: ancient Egypt is a case in point. The collection of so-called Ushebtis or Shawabtis figurines found in the newly discovered tomb of the high-priest Parennefer-Wenennefer (end of fourteenth century B.C.), illustrates Egyptian ideas of mass pro-

duction. The Egyptians designed such figurines so as to be easily copied, not with the idea of "reproducing" an original, but of producing in series. They developed several techniques of mass production: *casting and founding* yielded the bronze statues of Osiris, reproduced in quantity to accompany the defunct to the netherworld; *stamping and minting* made it possible to imprint an individual's symbol of claim or property on a virtually endless number of objects. Stamping, in particular, was a form of technical reproduction closely associated with the rise of states and the dissemination of political power: Sumerian and Egyptian cylinder- and stamp-seals date from the fourth millennium, for example, and stamping was a common legal practice of the Roman empire. Yet these early forms of series production must be distinguished from modern phenomena of mass culture in at least three ways: first, the proliferated images are copies without an original; second, they are all based on a logic of nonarbitrary signs typical of premodern societies; third, they are always authorized reproductions, directly emanating from state authority and power.

Two Logics of the Original: Authenticity and Textuality

Obviously, the problems of technical reproduction mutate dramatically as we move from premodern to modern cultures, and engage different concepts of the sign, of value systems, and of media technologies. At least two logics define the potentials and limits of "originals" in modern cultures: we shall call them, respectively, the *logic of authenticity* and the *logic of textuality*. The logic of authenticity is based on the dichotomy original/fake and binds up both terms in a relationship of antagonistic tension and mutual exclusiveness; whenever the one is present, the other is logically absent. The fake never "represents" but rather displaces, represses, or substitutes for the original—it is a false usurper—and the original always unmasks and dissolves the fake.

The logic of textuality, on the other hand, is based on the distinction original/copy. In this case, the relationship is one of mutual implication: each term necessarily evokes and "constructs" the other, but neither is complete without the other; they are mutually constituted. Instead of an antagonistic tension, we have an ontological difference— an asymmetry between the two terms—rather like a complete manifestation and its shadow. The shadow is not, however, merely an impoverished version of the initial term, but a *new* term that highlights the

first and sets it off in more luminous colors. More than a simple linear movement of depravation from original to copy, there is a return loop, a cyclical movement of enrichment from the copy back to the original: the latter triggers the copy; the former, in return, valorizes the original.

Because the term "original" figures in both discourses, the distinctions in play are often not clearly articulated, and if we insist on making them here it is to enable a reassessment of the complexity of Benjamin's essay. With this in mind, we shall sketch some examples governed by the logic of authenticity (a brief phenomenology of fakes), followed by some examples of the logic of textuality (a brief phenomenology of copies).

A Brief Phenomenology of Fakes

Fake no. 1: Dissimulation of behavior is the most palpable pragmatic context for the logic of authenticity. Satan (in medieval plays) and papist monks (in Puritan epics) are represented as arch-dissemblers. Some later targets of suspicion include the Machiavellist, the Jew, and Woman in general; the last, according to Nietzsche, "continues her roleplaying even when she abandons herself in sexual intercourse."[1] Given the difficulty of reading the signs of the body, a whole range of special touchstones and techniques were devised to probe the truthfulness of a person, from the physical torture employed by the Spanish Inquisition (or the secret police of modern states), to the "soft" semiotic disciplines of physiognomy and psychoanalysis.

Fake no. 2: Dissimulation of self is not caused by intentional behavior, but by an obliteration of the true self behind the masks forced upon an individual by society. Recovery of the lost "original self" became a categorical imperative in bourgeois societies where the emerging conditions of life leveled differences and created ever greater pressures toward homogenization. "Born originals, how comes it to pass that men die copies?" asked Edward Young in an influential essay of the mid–eighteenth century.[2] The ethics of the original individual was eventually forced to yield and—as a kind of compensation—the notion of original genius was created: henceforth, collective attention looked to individual artists for vicarious fulfillment of the need to find originals in an ever more homogenized society.

1. Nietzsche, "Die fröhliche Wissenschaft," §361: "Vom Probleme des Schauspielers," p. 609.

2. Young, "Conjectures on Original Composition," p. 561.

Fake no. 3: Dissimulation of a text implies the notion of an "original text," an idea that emerged with the forefathers of philology in Alexandria who, rather than extending the authoritative integrity of old texts by copying them, embraced—for the first time—a break in tradition by *editing* the texts. Whenever the continuity of authority is shattered by a break in tradition, the concept of authenticity steps into the breach, which is why pseudepigraphic writings cannot be considered forgeries so long as they partake of and prolong the authority of a living tradition. In contrast, Renaissance humanists, who declared the document of Constantine's donation to be a forgery, shattered the tradition's authority by disproving the authenticity of an element. Their differentiation of two distinct values—namely, authority and authenticity, which had been seen as inextricably impacted—indirectly challenged the intellectual legitimacy of papal institutions.[3] Indeed, historical and critical philology created the concept of an Urtext, which turned out to be an efficient weapon of politics. As Leo Strauss has shown in his book on Spinoza's critique of religion, the historical consciousness of philology exploded traditional hierarchies and institutions and, in the last instance, the concept of God.[4]

Fake no. 4: Dissimulation of a work of art becomes possible when, with the shift to individualist culture, the label "original" was gradually transferred from the person of the artist to the work of art. The most important pragmatic effect of this shift in the discourse of authenticity is the rise of the art museum, which may be defined as a place where original works of art are collected and exhibited. The exhibition-value of these works depends solely upon their authenticity-value, both of which are relativized by monetary rates. The practical difference between an original and a fake—what determines a work's exposability—lies first and foremost in their respective price-tags. In a commercial society, where prices achieved at auction are to the art world what stock rates are to the world of commerce, awe and aura are to no small extent created by high monetary value. Because the reputation of a museum (or private collector) and considerable sums of money are at risk when distinguishing originals from fakes, it is no surprise that the process regularly makes use of techniques adopted from police criminal investigators, such as chemical analyses or the attentive study of defining physiognomic traits (Morelli's method).[5]

3. Burke, *Renaissance Sense*, pp. 50–69.
4. Strauss, *Religionskritik Spinozas*, passim.
5. Ginzburg, *Spurensicherungen*, passim.

A Brief Phenomenology of Copies

Copy no. 1: Technical reproductions are copies of a work of art that can be easily distinguished from a fake. While the fake may be defined as a copy designed to usurp the place of the original, the technical reproduction is subservient to the original and openly coexists with it. If the original is exactly located in time and place, the reproduction is like a mobile and multiple shadow, traveling in numbers across time and space. An interesting paradox is that the museum is the birthplace of both the original and the reproduction: Renaissance collectors, who laid the foundation of what later became museums, were also the first to publish engravings of their holdings.

Copy no. 2: The commentary provides a frame in which the original text is set off as such and encouraged to display its particular luminosity. In the language of Renaissance humanists, *textus* and *commentarius* were interrelated terms: a poem, a narrative, or some other piece of writing was called a "text" when it was referred to by a commentary, and "commentary" was defined as the genre of exegetical writing that referred to a text. Like a title of nobility, commentary "bestows" the status of "text" upon a piece of writing, much like the way a "reproduction" bestows upon an object the status of "original."

Copy no. 3: The translation is another way for a text to acquire the status of "original." Like commentary, the creation of a second text intimately related to the first produces a difference of status between the two. Benjamin pointed out that translation is really a kind of commentary upon an original text, one that underscores the most essential parts of its object exactly when it *fails* to produce an adequate translation.

The preceding examples can help us to clarify the two types of discourse on originality by distinguishing more precisely their respective aims. The logic of authenticity is concerned with "truth" in an absolute sense: the truth of a person, a text, or a work of art. The logic of textuality is concerned with relations among texts and their relative status: the original and unique is highlighted, valorized, and actually *constructed* by a secondary text, which may be a copy of a painting, a replica of a sculpture, a commentary or translation of a text. Separating the discursive threads and concepts in this way makes it clear that Benjamin's text is not concerned with the fake as inscribed by a logic of authenticity, but rather with the copy and its logic of textuality. The problem, however, is that while writing within the logic of textuality, his text continuously "crosses over" to evoke the logic of authenticity:

for example, when he evokes nostalgia in his discussion of aura, Benjamin clearly slips from the technical logic of textuality into the domain of a value- and emotion-laden logic of authenticity. In the third part of our comments, we shall follow up on this point so as to indicate his mixed investment in the issue of the original, and his analysis of its fate in the era of technical reproduction.

Walter Benjamin: Retrospective Prophet of Aura

What is Benjamin's primary concern in this essay? It is to account for the work of art's loss of aura under the social, industrial, and technical conditions of the early twentieth century. Benjamin's argument mobilizes the logic of authenticity without, however, using its central term—namely, dissimulation. Dissimulation in his text gives way to words such as destruction, dissolution, loss. His task is not how to discover the original and develop methods to distinguish it from a fake, but how to preserve the magic of the original in a world of fakes. To put it somewhat paradoxically: Benjamin becomes the retrospective prophet of aura when he speaks of values that are irredeemably lost and gone, values that find their last shrine in his very words. It is as difficult to describe what Benjamin means by aura as it is easy to memorize his "concise" definition of it as "the experience of a distance, however far that may be which brought it about." The problem with aura is that one is trying to describe something lost and absent rather than something extant to which one can refer indexically. In fact, Benjamin is not really describing it at all, but rather constructing it in the moment of its supposed vanishing. Hence, the nostalgia of his concept that struggles to capture a loss, one rather loosely defined as that element of art "which is not reproducible." This vanishing element, supposedly the "truth" of a work of art, is what Benjamin calls its aura.

Benjamin's name for this vanishing soul of art is itself a metaphor, because αυρα is the Greek and Latin word for a light breeze. "Aura" has an established usage in the history of Roman art, where it denotes a specific iconographic convention. It first appears in representations of *Aurae*, personifications of the sweet breeze, such as those found on the Ara Pacis Augustae at Rome. The veil of the deity hovers behind and above her head to form a circle that graciously sets off her face. This iconographic formula is called *aura velificans* (veil-moving breeze). A mysterious breeze, blowing either from outside or perhaps even from within, lifts and floats the arabesque veil to suggest some kind of aerial

radiation of the woman herself.[6] Later uses of this motif include not only personifications of the breeze itself but also deities, nymphs, and even noble ladies, and eventually developed (or degenerated) into a stable convention, a kind of "pathos-formula" in the words of Aby Warburg.[7] What originally denoted simply "a sweet breeze" came to connote divinity, nobility, and the remoteness of persons belonging to a superior sphere. Another connotation was revelation: a breeze that blows from either without or from within lifts the veil to reveal the face of an otherwise invisible being. In short, the invisible, mysterious, and sacred manifests itself by its aura, but unlike similar terms—such as "nimbus" or "aureola"—aura is an *aerial*, rather than luminary, metaphor. The sacred is revealed not by its luminous radiation but by the breeze that it exhales. Benjamin's use of "aura" reminds one of *Angelus Nova*, a drawing by Paul Klee, and of Benjamin's interpretation of that drawing: the angel, a modern variant of the Roman goddess Aura, is "auratized" by a storm blowing from behind—from paradise—but the angel's revelation also blocks the path of any possible return.

Benjamin and Marcuse: Negative Theologies of Art

Benjamin's analysis of the relationship between original and reproduction is really about the loss of a specific quality in art, a loss directly linked to the phenomenon of technical reproduction in modern mass culture. His critique of technical contemporary art harks back to the critique of material representation of the spiritual in the Hebrew Bible. In fact, his point could be cast as a variant of the second commandment: "Thou shalt not technically reproduce a work of art!" For Benjamin, this founding commandment of a religion of art is grossly trespassed by modern mass culture.

To spell out in detail the implications of such a religion of art, we turn to Herbert Marcuse, who was also deeply concerned with the damage incurred by art in the environment of contemporary mass culture. According to Marcuse, technical reproduction and commercialization have deprived art of its particular magic, its "alienating force which had once been its very substance," by turning "the alien and al-

6. Simon, *Ara Pacis Augustae*, I, passim.
7. Warburg, "Dürer und die italienische Antike," p. 446.

ienated works of spiritual culture into familiar goods and mercantile services."[8] Marcuse seems to have taken a cue from the poet Stefan George when he writes: "Text and tone are still there, but their distance through which they were experienced as 'air from other planets blowing' is overcome."[9] Indeed, Marcuse writes about art in a semireligious manner as "the very other" and, like Benjamin, he insists that art produces a magic by its power of negation. For Marcuse, the particular essence of art lies in an "antagonistic power," which means that art relates to the world in a negative rather than affirmative manner. Art is subversive and liberating, the apocalyptic negation of what is given; it presents "images of fulfillment which would dissolve the society which suppresses it."[10]

Marcuse characterizes art by its distance from everyday reality. Art transcends that reality and, by stressing its transcendence and negativity, Marcuse closely links aesthetic and religious experience. This semireligious quality is dissolved by the familiarization of art, by its integration into society, and by its inclusion in the commercial cycle of standardized products. Benjamin's definition of aura as "the experience of a distance, however far that may be which brought it about" similarly stresses the absolute alterity of art. This alterity continues to mark a metaphysical borderline in a world where the distinctions between holy and profane, transcendence and immanence have been lost. For both Marcuse and Benjamin, art is the last holdout of transcendent experience in an ever more secular world. Marcuse and Benjamin both write about this religious quality of art as constituting its very essence; they both testify to its "magic" at the moment of its irretrievable vanishing. The magic of an original is its alterity; its aura a "more-than-madeness" that comes from afar like a breeze from other planets blowing. Technical reproduction destroys this magic of the original by appropriating it into a world of "mades" and remakes. Marcuse blames the loss of aura on the one-dimensional character of the industrialized world. For him, to use Bach as background music in the kitchen is a profanation that has less to do with the technical equip-

8. Marcuse, *One-Dimensional Man*, p. 61.

9. Ibid., p. 65. The line comes from the poem "Entrueckung" published in George's *Der Siebte Ring*. Marcuse could have read the original, or found the line in either Arnold Schoenberg's string quartet for F sharp minor (op. 11) or Theodor W. Adorno's *Philosophie der Neuen Musik*.

10. Marcuse, *One-Dimensional Man*, p. 60.

ment of transistors and Walkmen than with the leveling character of mass culture. Benjamin, to the contrary, blames technical processes for the erosion of the magic, the alterity, and the uncontrollable contingency of art.

The Original: The Future of an Illusion?

"In a world where so much is imitation, people now value the original more and more." We have tried to show that the original, according to the logic of textuality, is not displaced by its copies, but is constructed by them and can thrive with them. Benjamin clearly underestimated the original's market-value quality—whether the market of art or of breakfast cereals. His concern lies elsewhere: not in the dialectics and strategies of the market but in the disappearance of the magic of art in an industrial age. This magic resides in an emphatic Original (capitalized so as to distinguish it from its commercial counterpart), and in constructing it Benjamin slips from the logic of textuality to approach the logic of authenticity. An emphatic Original does not engage the circular process of mutual invigoration and valorization between copy and original that constitutes the logic of textuality. Indeed, Benjamin focuses on a process whereby the copy erodes the most valuable aspect of the Original, its aura-magic. By destroying aura in this way, the copy actually approaches the status of a fake, the aim of which is to suppress a sense of the authentic original and to reign in its place. Benjamin is careful not to abandon completely the differential logic of textuality for the dualistic logic of authenticity, but evoking overtones of the latter—while arguing within a framework of the former—forces his discourse to hobble between both.

Benjamin started his essay with a quest for a new terminology that could not be abused by Fascism. He dismissed questionably resonant terms—such as creative genius, eternal value, mystery, and immersion—to replace them with supposedly neutral and technical terms such as reproduction, singularity, multiplicity, ubiquity, and accessibility. The term "original," which in bourgeois art criticism was associated with original genius, was replaced by "the original" in a purely technical and textual sense. Benjamin rephrased the bourgeois discourse of authenticity in terms of social and industrial facts, by exchanging the old pairing of "natural genius/mechanical imitation" for the new pairing of "aura/technical reproduction." Yet to link technical original

with aura tends to let in through the back door what has just been kicked out the front: mystery.

Paradoxically, to discover the auratic Original is to register its loss, and it is no wonder that the tone of Benjamin's essay is pervaded by melancholy. To give up this melancholy would mean to give up the last refuge of the auratic Original. Rereading Benjamin's essay today, we cannot help but notice that this melancholy is precisely that from which we have come to be estranged. Although his essay still fascinates us, we feel out of tune with its melancholic tone. In hindsight, it seems that Benjamin's text had been the last instance of what has since disappeared altogether: a witness to the vanishing transcendence of art, and an awareness of losing the radical alterity of the Original. What we have lost entirely today is *the sense of a loss*.

We are thus doubly separated from Benjamin: not only because we have lost his sense of loss, but also because we have gained something of which he was unaware—namely, a sense of the constructedness of our own discourses and values. We are learning to see our discourses from within and from without, and are studying the discursive modes and logics by which our meanings are constructed. Which is to say: the air from other planets blowing is nothing but a discursive event; yet it also holds true, so long as we continue to think and to feel in the modality of the discourse. A last question can be raised in this context: is it even desirable that the logic of authenticity continue? By way of reply, we close with the words of Umberto Eco, who is describing the "palace of living art," a wax museum that displays three-dimensional reproductions of the world's great painted masterpieces: "The Palace's philosophy is not, 'We are giving you the reproduction so that you will want the original,' but rather, 'We are giving you the reproduction so you will no longer feel any need for the original.' But for the reproduction to be desired, the original has to be idolized."[11] The museum visited by Eco was closed in 1982. Could this be a clue that the Palace's philosophy is already a philosophy of the past?

11. Eco, "Travels in Hyperreality," p. 19. We owe this quotation to Louise A. Hitchcock, who kindly made accessible to us her unpublished manuscript "Virtual Discourse: Arthur Evans and the Reconstructions of the Minoan Palace at Knossos."

What Is Mechanical Reproduction?

As hands fish lovingly into purses, bags, and wallets the world over to conjure up the presence of someone absent, who could be convinced that the snapshot, that ghostly smear of emulsion, surrenders aura, the radiance of individuality hic et nunc, distant at any degree of closeness?[1] Tearing up the photo would bring tears, not disenchantment. And if plans were made publicly to draw and quarter a photocopy of the essay that makes this claim—Walter Benjamin's *The Work of Art in the Age of Mechanical Reproduction*—multitudes would gather on its behalf. The essay itself insists that what has been mass reproduced becomes inertly disjoint from its original, yet the rending of the pages would make the crowd gasp. However obvious these objections may be to the essay's theses on reproduction, they disappear in its penumbra. The essay prevaricates self-evidence, it guarantees its quotation and ready embrace by virtue of a force that goes beyond each particular assertion and assures that the false rings true however it is debunked. The essay is itself auratic and this aura has not been, and could not be, thinned away by mass reproduction. But the aura of Benjamin's essay can be discerned, and maybe it is not just fruitless to study it. This aura has a form. And though this form is apparent at every point in the essay it is most convincingly accessible in Benjamin's idea of "mechanical reproduction."

American and French readers of the essay are especially compelled to question the contents of this concept when they check back to the original because they will notice that Benjamin does not use the word "mechanical" at any point in the essay, not even in the renowned title, which would literally read, "The Work of Art in the Age of Its Techni-

1. *Editors' Note*: Robert Hullot-Kentor's essay was too long to be included in its entirety. The version published here has been abbreviated by the editors. Parenthetic references in the text and notes of this essay are keyed to the edition listed in the Bibliography as: Benjamin, "Work of Art."

cal Reproducibility [*technische Reproduzierbarkeit*]." Throughout the essay each occurrence of "mechanical" can be replaced by "technical." It is not that the English translator erred. The two concepts—mechanical and technical—broadly overlap; Benjamin's essay does assume a context of mechanical devices; and by implying the thematically germane antagonism of the distractedness of mechanism verses presence of mind, "mechanical reproduction" invokes a commonplace that must have been a source of the essay. And compellingly, as a translation of the original's many variations on the phrase *technische Reproduktion*, the self-evidence of "mechanical reproduction"—whatever it may mean—recommends itself over the literal "technical reproduction," whose weak semantic content oozes fruitlessly.[2] French poses almost exactly the same problems of translation, and it can be assumed that Benjamin did not hesitate to approve Pierre Klossowski's translation of his essay as "L'oeuvre d'art à l'époque de sa reproduction mecanisée," for its inaugural publication in the *Zeitschrift für Sozialforschung* (1936).

Still, Benjamin would have regretted the compromise made in these translations. It is not only that film is the work of chemical, not just mechanical engineers, and cannot accurately be characterized as mechanical reproduction. More important, from title to epilogue, "technic" in its various agglomerations, including "technical reproduction," threads an urgently avowed Leninism through an essay composed as an aesthetic pendant to Lenin's doctrine of the identity of industrial might and socialism. Benjamin chronicles, for instance, the rise of technical reproduction from the woodcut to lithography, moving in lock step with the rise of socialism as a variation on Lenin's thesis that "electricity plus Soviets equals socialism"; the essay's opposition to custom and craft in favor of standardization, automation, and the unequivocalness of scientific solutions, are all ideals that Lenin himself espoused in the Taylorism that he disastrously imported from American

2. At the several points where the English reverts to the literal out of a sense of responsibility to the original, the obvious indeterminateness of "technical reproduction" compels the translation to seek modifying expressions that would give the phrase some content. But the absence of any compact adequate English phrase instead drives the translation into greater obscurities. This is what happens in the following passage in which "process reproduction" is to somehow help elucidate "technical reproduction." "Confronted with its manual reproduction, which was usually branded as a forgery, the original preserved all its authority; not so vis-à-vis technical reproduction [technische Reproduktion]. The reason is twofold. First, process reproduction [technische Reproduktion] is more independent of the original than manual reproduction" (220).

managerial science and endorsed as Communism's only legitimate means. Benjamin exalts the ineluctability of the conveyor belt and ultimately a command economy when he praises the unrelenting gaplessness of film for dislodging the contemplative stance and private associations of the individual in front of a canvas; it is scientific precision that he extols in the surgical instrumentarium of the camera for its power to dissect life in contrast to the surface bound magic of the painter's handicraft (233); and it is to "technic" per se that Benjamin looks for leadership when he deplores the fact that society is not "mature enough to incorporate technic as its organ" and that "technic has not been sufficiently developed to cope with the elemental forces of society" (242).

It is likewise to Leninist productivism that the essay owes a key aporia. For just as the insistence that technic is an absolute good prohibited Leninism from understanding why the forces of production, however ripe, did not compel society to take the necessary next step to a better world, so Leninism left Benjamin in the lurch when his theses came face to face with the reality of the movies of his own age, which he describes as "illusion-promoting spectacles" bearing a "phony spell" (231). The problem that arises from this confrontation is obvious: if technic automatically withers aura, why does a "phony spell" prevail in film as it exists? Benjamin solves this aporia programmatically by situating the "phony spell" external to technic. He might as well blame foreign powers when he inculpates "the movie makers' capital" for producing this spell by "an artificial build-up of 'personality' outside of the studio" (231).

The "phony spell" is clearly aura once removed, a residual technic-resistant ghost hopefully made unrecognizable as aura when lodged under other vocables. This ruse, however, maintains the purity of technic only at a price: it prohibits any investigation into the technics of mass culture in film. Thus Benjamin cut himself off from such insights as are contained in his earlier study of aura, "A Short History of Photography," in which he distinguishes not between aura and "phony spell" but between true and false aura, between the concentrated gaze of early photographic portraits and the *gommage* of pseudo-spirit instilled into faces and sunsets by the use of an erasure on the negative. This technical critique of pseudo-aura could have become the source for a more profound aesthetics, and not just of film. Instead, however, Benjamin practices conceptual gommage: the exclusion of any technical investigation of the "phony spell" redounds to the untouchable aura of

technic. Indeed the essay relies on the importation of indeterminateness to assert the self-evidence of the concept of technical reproduction. And it will be noticed that throughout the essay, however it extols technic, there is a minimum of genuinely technical analysis. It is a measure of the auratic power of the concept that it is possible to read this essay over decades without realizing that there is no technical analysis of "technical reproduction" as an overarching process that includes photography and film. The broad power of "technical reproduction" is known only by its effects, which are fourfold: (1) It results in many copies; (2) These copies are not dependent on the original to the same degree as are manual reproductions and therefore they can accent the original, regard it from various angles, and magnify what otherwise escapes the senses; (3) It brings the original into places where it could not otherwise be brought just as, to take Benjamin's example, a photo makes a cathedral portable; (4) By producing copies of this sort, it destroys aura. The auratic artwork bears the radiant authority of tradition, which it accumulates along the tether that it spans out from the moment of its unique inception. This uniqueness predicates its claim to authenticity, which is the evidence of all through which it has passed. By providing copies devoid of uniqueness, technical reproduction snaps this tether of tradition, thereby depriving the artwork of the authority of time that constitutes and shines through its untouchable presence hic et nunc. In these copies the work surrenders any claim to authenticity and any resistance to scrutiny (220–23).

Aura, then, is the aura of authenticity. It is evident that Benjamin, the collector, conceived it on the model of the authenticity with which antiques are charged by the nicks and divots they acquire as they change hands over the centuries. On this model artworks could be thought to forfeit their aura by being copied just as does a pressboard knockoff of a seventeenth-century armoire. But had Benjamin more concretely investigated technical reproduction in the arts, aura would have shown itself to be a more complex object, and he would have been obliged to conceive its relation to reproduction differently. Even a tango performed in the privacy of one's own bedroom, and only indistinctly executed, is not necessarily deprived of a degree of aura, an authoritative redolence of more than is there, simply because it is the trillionth rendition and authorized by no writ of habeas corpus for the primordial movers. And if the tango seems all too manual in a discussion of technical reproduction, neither do hammers, strings, and escapements necessarily deprive a piano performance of the authority of

its historical resonance hic et nunc. The piano is, in fact, an instrument of technical reproduction according to all of Benjamin's criteria: it produces a vast number of copies; these copies are indifferent to the factually original manuscript; and the performances can slow, magnify, expand, distort, test, analyze any section, and more than meet the listener halfway. A Beethoven sonata can even be performed at different places and with overlapping simultaneity without surrendering its uniqueness. But if the presence of the pianist's fingertips once again threaten to corrupt even this event with the manual, musical recordings of his own time—and even dance films of his own decades such as Mary Wigman's famous "Witch Dance"—were not and are not necessarily without the aura of their original, and this cannot simply be chalked up to the influence of foreign capital.

Perhaps it is unfair to Benjamin to cite these examples. In his correspondence he mentions a disdain for whatever made him tap his toes, an antipathy that also testifies to a limited interest in dance. And even challenging his arguments in the domain of painting might be foreign terrain because he could never have argued for photography as he does had he made himself familiar with modernism's critique of photography as the illusionistic, trompe l'oeil medium par excellence. But if music, dance, and painting were not his *terre natale*, this does not account for a literary critic of the first order urging that "from the perspective of world literature" the emergence of the printing press is "merely a special, though particularly important case" (219). Benjamin jettisons any consideration of the relation of the aura of literary works to their reproduction because literature is so obviously the result of technical reproduction as he describes it: it exists in any number of copies; even if it is a disturbingly human act, it eludes every narrow reification-hungry debate over the difference between the manual and the technical; it is separate from its origins, and so forth. And all the same, while meeting every condition of technical reproduction, the aura of *Absalom Absalom*, for instance, is not necessarily canceled.

On the contrary, the aura of the literary artwork depends on technical reproduction. Had Benjamin pursued this thread, he might have realized that his own insight that exhibition value is necessary to art implies that reproduction is not added into art but is inherent to it.[3] This is apparent in the fact that even before cathedrals became portable as photographs, masses of visitors were able to think back on what

3. Adorno, *Aesthetic Theory*, passim.

they had seen; and the inherency of reproduction to art is apparent again in the felt need to return in memory to a stanza to mumble through its syllables or to dredge up a song while G-forces drag the vocal cords their own way. Each artwork says, "Be like me," without necessarily surrendering its uniqueness. Thus Benjamin's key thesis that "even the most perfect reproduction of a work of art is lacking in one element: its presence in time and space, its unique existence at the place where it happens to be" (220) is compelling only by the potentials of its negation: even the most imperfect reproduction of an artwork is not necessarily lacking authoritative presence.

Benjamin requires that this implication be pursued when he writes that technical reproduction "enables the copy of the original" (220). By invoking the concept of the copy, he is compelled implicitly to admit that there is no true reproduction without the original: every copy is a copy of the original. But, if the weave and pigment of a painting ultimately constituted the original, Kandinsky—on discovering that his new acquaintance Schoenberg was not only a composer but also a painter—would not have requested photos of his works: "Actually, I can get along even without colors. Such a photo is a kind of piano reduction."[4] If a musical composition were ultimately the material acoustic event, musicians—who often enough spurn the distortion free gold-coupled stereolab—would not be heard to say, provokingly, that they are not "really interested in how it sounds." Historically, and especially in modern times, to the horror of art dealers and stirring public incredulity, artists like Giacometti and Francis Bacon have destroyed more artworks than they saved, effectively taking the side of what transpires in every artwork. Each artwork rejects its factuality, as the thing it is, by its form, which is the process by which it consumes its appearance and reveals what is more than this appearance.[5] The reality revealed in this process—however difficult it may be to specify that reality—is the original of the artwork, regardless of its material. Because the reality of an artwork is external to it, our eyes find it hard to locate the work precisely, even when looking at it directly. The most important artworks, by the power and sometimes violence with which they shed their appearance, may make themselves irrelevant, as if they stand superfluously in the way of their content, and no longer need to be seen, heard, or read.

4. Schoenberg and Kandinsky, *Letters, Pictures, Documents*, p. 26.
5. Adorno, *Aesthetic Theory*, passim.

If the original is not ultimately the factual work, then the copy is not necessarily deprived of the work's authoritative aura and authenticity. It is important to realize, however, that while this criticism goes to the core of Benjamin's argument, the critique actually comes from Benjamin. In *The Origin of German Tragic Drama*, he writes that "the function of artistic form is . . . to make historical content, such as provides the basis of every important work of art, into a philosophical truth."[6] The "origin" of an artwork is thus conceived as what wrests itself free by the power of form from the historical moment—not in the sense of becoming timeless, but as a sedimentation of time that seeks fulfillment in a process that consumes its own appearance and ultimately transcends the work. "Origin" then—to cite Benjamin's favorite Karl Kraus maxim—is not the historical beginnings of an artwork, but its goal; and what is original in the work goes beyond it.

These several ideas from Benjamin's own writings provide more than adequate resources to undermine the argument of the reproduction essay. They suggest that Benjamin could have refuted every thesis of the *Artwork* essay line by line, although that possibly means that his text becomes insuperably fishy. If we elect not to abandon it as such, the text must be studied for its fishiness. Indeed the essay asks to be studied in this way, for it schools disbelief in itself. The essay as a whole is a complex *credo quia absurdum est*, though without making obvious what is to be believed. On one hand, the essay claims that film motivates the revolutionary transformation of the masses, adapting a proletarianized world to collective, critical experience, and so forth. Yet, on the other hand, the essay recognizes that this is not the reality of film, and Benjamin writes at one point: "As a rule no revolutionary merit can be accredited to today's film" (231). In context, the disclaimer is a critique of the films of Western Europe. One assumes that his criticism must be more far-ranging, but against the acetate stock of the West he counterpoises no films from another cardinal direction. In fact, his accolade to the movies does not concretely reference or discuss a single movie and, completely contrary to the name-blabby genre of so-called film criticism, he hardly mentions a single film by title.

If it is evident that Benjamin must be far more critical of film than the essay seems to state, where is the criticism lodged? An instance of the essay's strategy is given by Benjamin's treatment of the film audience. It attracts attention by its uneasy stirrings. What Benjamin

6. Benjamin, *Origin of German Tragic Drama*, p. 182.

claimed to see in the movies through the eyes of its audience is not what the masses of that age or this ever saw or would be willing to see. The identity of Benjamin's audience is puzzling because the agog movie goer who marches out of the cinema feeling Bogart's trenchcoat dragging at the ankles cannot be recognized in Benjamin's figure of the distracted expert in the middle distance who presumably leaves the theater in cool self-possession. However, this paradoxically skimming—though erudite—gaze, which Benjamin casts as the model film viewer, is a familiar incarnation of the Baudelairian *flaneur*, Benjamin's own self-ideal. This is the viewer who is so remote from the proceedings that he identifies not with the actors but with the camera; attentive to works of the highest level of aesthetic density and tension he perceives nothing of the enthrallment of those on either side of him; even the opportunistic quarantine of the "phony spell" external to film probably pivots on a complete and learned lack of recognition of the auratic claims raised by the stars who stare at him from on high; the eye that translated Proust and habituated itself to the arcane Trauerspiel would not have struggled to see through the magic of movieland at the screen's bare factuality; his asceticism passes over the pornographic cornucopia without a twinge to admire instead the medium for its potential thinness.

With Benjamin's critical eye lodged in their otherwise diverse faces, his audience is an exotic hybrid population. It did not exist in his age, not before or since. Yet it is exclusively this nonexistent audience that Benjamin esteems as an inescapable fact, an automatic result of the movies themselves. Just how little Benjamin could have believed in the actuality of this revolutionary audience is implied by the fact that he only exalts film for what his essay fully acknowledges film was not: a proto-communist medium for the cognitive transformation of the masses. This is why anyone will notice that Benjamin's applause for his topic echoes strangely throughout the essay. It is the form in which criticism is sedimented: film, in all its aspects, audience included, is praised exclusively for what it is not. The eye that bestows admiration only where it finds nothing to admire is utterly at odds with what it sees. This is not to say that the "Work of Art in the Age of Its Technical Reproducibility" is a critique *à clef* of popular culture. It could not be a sly rhetoric stirring critique under admiration, for Benjamin's critical gaze is too disembodied, too unconsciously fixed in admiration, to be the work of a dinner guest furtively mocking a perfect evening.

If the audience in Benjamin's essay is an elite critical eye masked as the masses enjoying themselves in an aura-gutted vision, it may be nec-

essary for popular culture to revise its embrace of Benjamin. He is not a man of the people, but an elitist who in this essay—rather than setting his critical gaze in self-conscious opposition to the status quo—sought to inhabit the masses self-obliviously with his own elite contrarian gaze. When this is realized the essay becomes more comprehensible in its complexity, and its broad historical context is able to emerge. Benjamin made his way intellectually to the movie house in response to the same forces that shaped a long tradition of German cultural elites, beginning with Lessing and Schiller and on to Brecht. They—contrary to the American image of German intellectualism—have been far more isolated and culturally beleaguered than their counterparts this side of the Atlantic. Pursuing a Lutheran sense of the functionality of art, they hoped to overcome this isolation through the fulfillment of cultural aims by means of aesthetic praxis. Their various programs—for example, changing Germans into Greeks anno 400 B.C. by exhorting them to aesthetic play—were naive and myopic. By constantly exaggerating the idea of art as social praxis they made themselves unwitting theorists of, and sometimes—as when Benjamin insists that Fascism completed the aims of *l'art pour l'art* (242)—adamant participants in, the destruction of a hard won cultural realm. At least Benjamin's perceptions of film combine into so unlikely a portrayal of its reality that they deprive the essay of any evidence that he saw many films or was very interested in those he did see. He makes this plain when he asserts that the only merit that can be attributed to films as they exist is their "promotion of a revolutionary criticism of traditional concepts of art" (231). In other words, this flaneur sat still in the movies only by putting his wits into aesthetic reverie.

Something other than self-betrayal is involved in this essay. Invoking this moral optic would obscure that in these pages the continuity of his thinking is so rigorously pursued that the idea of "technical reproduction" gives unparalleled insight into his entire oeuvre. This becomes especially apparent in sections nine and ten, where Benjamin discusses film technic. The importance of these passages must be emphasized because, insofar as the essay seeks to establish film messianically as the art form to end all art, they provide a quintessential, although meager statement—missing from the rest of the essay—of how technical reproduction destroys aura. The key technical event is this: the camera severs the actors who appear in front of it from their own likeness. They step in front of the camera only to consign their image, and ultimately its unity, to the editing table. Benjamin claims a "feeling of strangeness

... overcomes the actor before the camera" because the actor's "reflected image has become separable, transportable" (230–31). Having left the presence of the actor behind, aura—which is presence—itself vanishes from the image.

Here Benjamin provides a statement of the form of technical reproduction: it produces an image that is not a reflection of the self. This image was the object of Benjamin's interest throughout his life, and on more than an intellectual level. Indeed, in the *Artwork* essay he gives evidence that his fascination with this image had preconceptual origins. When he elucidates the actor's experience of strangeness in front of the camera he tries to make his point credible by speaking from personal experience: the actor's estrangement, he writes, is "the estrangement felt before one's own image in the mirror" (230). Although the experience of the self split off from its likeness, and the beholding of this likeness as foreign, is for most people a potential yet rare late night event, Benjamin takes this depersonalization to be the norm. He insists that it is the constant condition of the reflection in the mirror, and by this exaggeration he implies that the experience of depersonalization is unavoidable. This implied claim cannot be taken at face value. Although it is possible to assume from his renowned physical standoffishness that he knew well the experience of depersonalization, he was too productive and his emotional life too complex to have constantly lived such a condition. Rather, his exaggeration has the quality of being just that and, as such, indicates an effort to cultivate an experience that was a spontaneous potential for him. Benjamin, in other words, sought to produce an image of himself that was severed from himself. "Technical reproduction" was, for him, an ideal. This does not have to be deduced from his one exaggerating comment of his experience in the mirror. On the contrary, it is repeatedly evident as the founding idea of his essay. At every point where Benjamin asserts theses that are so opposed to himself that those familiar with him are obliged to rub their eyes in disbelief, and to wonder whether this is actually Benjamin's own thought, he is not betraying himself but rather demonstrating "technical reproduction."

Benjamin's taste, in other words, was for an image of himself to which he was not present. This was his *parti pris* for the dead and it endowed him with an unrivaled capacity to immerse himself in the antiquarian. Benjamin was alleged to have this power. Dolf Sternberger, the author of *Panorama of the Nineteenth Century*, voiced a familiar admiration when he thanked Benjamin for sharpening "my eye for the

foreign and dead aspects" of historical documents.[7] Benjamin's affinity for the mortuary made it possible for him to sift through the breathtakingly inert documents of German Baroque drama and rediscover and decipher allegory as different from symbol. This distinction is complex, but it can be glossed as the difference between, on one hand, an image in which subjectivity withers away in the fragmentary form of a ruin, or a death's head, in the experience of time as painful duration; and on the other, a radiant image in which meaning is fulfilled in the mystical instant of the presence of spirit.[8] Benjamin developed this distinction in the *Trauerspiel* study in order to model a theological critique of subjective reflection on allegorical form.

If this distinction between symbol and allegory sounds familiar, it is because it is the same distinction made in the *Artwork* essay between the auratic presence of all time in the eternal moment hic et nunc, in which meaning appears as a totality, and the antiauratic, cinematic image of transience, in which the radiant presence of the actor's face is constantly stripped out of the image by the camera and deprived of wholeness by the ruin-making scissors of the editing shop. The theological critique of subjective reflection in the earlier study, built on the allegorical image, becomes a political critique built on technical reproduction. There is reason to be puzzled, therefore, when Benjamin writes in the later essay that "the technical reproduction of a work of art . . . represents something new" (218). How could it be something new if, after all, it was Benjamin's own research that dates the form of this image to four hundred years earlier and provides its seminal interpretation? But if no one knew better than Benjamin its antiquity and content, he least of all would have allowed that he was betraying his claim to his previous insight into the Baroque. Rather, he reproduces this earlier insight technically: he states it in a form that fascinated him, one deprived of self-recognition.

Benjamin did not want to know the content of his reflection. His writings, however magisterial and brilliant, are at the same time ineluctably sworn to rationalization. In the *Artwork* essay he decries Fascism for deceiving the masses with a "chance to express themselves" (241) without troubling to distinguish true from false expression. In the Ba-

7. Benjamin, *Correspondence*, p. 595.
8. Benjamin, *Origin of German Tragic Drama*, pp. 165–66.

roque study, he is similarly drawn to and deciphers the absence of sub-
jective expressiveness in allegory as a form of expression, but never crit-
icizes its actual inertness. He is rigorously antipsychological throughout
his oeuvre and draws on psychoanalysis only when it serves to avoid its
insights—as when he insists in the *Artwork* essay that "the camera in-
troduces us to unconscious optics as does psychoanalysis to uncon-
scious impulses" (237). This claim only holds if the preconscious—in
this case the world of gestures brought into consciousness only by being
attended to—is substituted for the unconscious, whose contents are ac-
cessible only by interpretation. Had Benjamin been able to make better
sense of psychoanalysis he would have had critical tools to avoid the
rationalizing kitsch of the Trauerspiel preface, where he epitomizes the
Idea as the mother's face that lights up when the constellation of her
children gather around her; he would not have made himself a spokes-
man of collective amnesia by evoking children as "messengers of para-
dise"; he would not have won a place on a recent West Coast *Story-
teller* calendar as one of a caste of New Age bards. It would also have
deprived Benjamin of the boundary of depersonalization, thus compel-
ling him to see that if looking into the mirror is an act of technical re-
production, then the camera is not all that austerely technical, nor all
that opposed to the manual. Rather, technic, as "technical reproduc-
tion," is a form of subjectivity that he relies on to defend himself from
knowing who he is while he seeks himself in absentia. Isn't this, after
all, the latent content of his argument in the *Artwork* essay? If, as he
asserts, the audience identifies with the camera, and if the audience can
be recognized as Benjamin's eyes, then it is Benjamin who is viewing
the figure who seemingly struggles with the loss of self-recognition in
the unreflexive mirror of the camera. This self-viewing is particular in
that it is predicated on a taboo of self-recognition.

Nowhere in the "Work of Art in the Age of Its Technical Repro-
ducibility" does Benjamin investigate the aura of mass culture. On the
contrary, he simply denies that it bears aura and explains why: techni-
cal reproduction makes presence wither by producing images that are
not reflections of the self. Of course, no investigation of mass culture is
needed to know that Benjamin's assessment of mass culture is wrong: it
glimmers with the presence of more than is factually there. But even if
Benjamin's idea of technical reproduction balks at understanding what
this aura is, his essay's urgently self-oblivious gestures inadvertently
give some clue: "technical reproduction" produces aura in the form of

fascination—that is, under the taboo of self-recognition. The essay lives from the same aura as does mass culture, which has the ability to glimmer only with what the audience can be enticed to put there without recognizing as its own. The tautology of this aura—which mass culture is constantly compelled to experience as its unsatisfying satisfactions—is a definition of its falseness.

CRITICAL DISCOURSE

[Theses] about the art of the proletariat after its assumption of power or about the art of a classless society would have less bearing . . . than theses about the developmental tendencies of art under present conditions of production. Their dialectic is no less noticeable in the superstructure than in the economy. It would therefore be wrong to underestimate the value of such theses as a weapon. They brush aside a number of outmoded concepts, such as creativity and genius, eternal value and mystery—concepts whose uncontrolled (and at present almost uncontrollable) application would lead to a processing of data in the Fascist sense (218)

The concepts which are introduced into the theory of art in what follows differ from the more familiar terms in that they are completely useless for the purposes of Fascism (218)

[The] film actor lacks the opportunity of the stage actor to adjust to the audience during his performance, since he does not present his performance to the audience in person. This permits the audience to take the position of a critic, without experiencing any personal contact with the actor (228)

Distraction and concentration form polar opposites which may be stated as follows: A man who concentrates before a work of art is absorbed by it. He enters into this work of art the way legend tells of the Chinese painter when he viewed his finished painting. In contrast, the distracted mass absorbs the work of art (239)

The film makes the cult value recede into the background not only by putting the public in the position of the critic, but also by the fact that at the movies this position requires no attention. The public is an examiner, but an absent-minded one (240ff)

For over two centuries now, the meaning and our uses of the words "critique," "critic," and "critical" have been informed by a very specific legacy from the age of Enlightenment. In their role as "critical judges," the intellectuals of that time made no separation between "critique" as analysis and discussion of the most diverse objects of reference, and "critique" as pointing to weaknesses, flaws, and contradictions uncovered in those objects of reference. A bifurcation between

these two meanings took place in the English language and in Anglo-American culture during the nineteenth century: what we have been calling, ever since, "critical writing" or "literary criticism" (mostly textual) analyses that do not necessarily lead to a value judgment, let alone to the uncovering of weaknesses on the side of their objects. But while criticism as analysis no longer necessarily entails criticism as judgment, we still expect any type of judgment (and any postulate for innovation) to be based on analysis. What is specific about the German situation (that is, Benjamin's situation)—or at least the academic situation in Germany and in those societies whose university systems were shaped under the influence of the German model—is the disappearance of the words "critique," "critic," and "critical" in relation to analysis without judgment. Rather than necessarily being critical, the academic analysis of literary texts in Germany tries to be *wissenschaftlich*—that is, dispassionate, distanced, objective (*Literaturwissenschaft* is the name of the academic discipline to which we are referring).

In other words, whenever Benjamin uses the concepts *Kritik* or *kritisch* he uses them in the sense of making obvious the flaws of an object of reference. An analysis that describes itself as *wissenschaftlich* may aim exclusively at the description of a text's content or of its form—whereas *Kritik* always tries to go beyond mere description (either in the direction of an aesthetic judgment or in the direction of a political attack). Benjamin's marked insistence on the convergence, on the complementarity between analytical work and a critical attitude motivated and informed by certain political goals, was, at least in Germany during the second quarter of the twentieth century, a gesture of self-reference characteristic of socialist and Marxist intellectuals. Within this context, Benjamin is a comparatively cautious intellectual and scholar. Instead of engaging in general speculations—for example, about the nature of a class-free society—he focused on his field of expertise: that is, on the history and on the present of European culture (with "culture" being subsumed under the Marxist concept of "superstructure"). Rather than relying on his own political actions, he preferred the evidence of truths that he had uncovered and the progress of history to undermine untenable concepts. Certain "theses," he expected, "will brush aside outmoded concepts," they will function as a "weapon." The concepts he offers to the reader, Benjamin hopes, will be "completely useless for the purposes of Fascism"—by virtue of their truth value, we might add. This is an even more optimistic position than Benjamin's claim that the "apparatus" of film will need to be

"violated" and "pressed" in order to produce "ritual values" (241)—as if the medium of film itself had the power to offer any political resistance.

Above all, Benjamin is eager to give important critical roles to those groups of readers whom he identifies with the "masses." His most surprising move in this relocation of critical capacities is his description—and his praise—of the spectator-masses as "distracted." Benjamin's spectator-masses, like the ideal recipients of Bertolt Brecht's "epic theater," will not let themselves be "absorbed" by what they see on the scene. Rather—like the masses attending sport-spectacles—Brecht's recipients are supposed to be wide awake; their attention is sharply focused. Benjamin's "public," in contrast, "is an examiner, but an absent-minded one," and the author insists that "at the movies this position requires no attention." We cannot help concluding—with a certain degree of astonishment—that Benjamin's fascination with the attitude (and the value) of "distraction" obliges us to rethink several implications of the classical concepts of "subjectivity" and of "agency." It used to be a basic premise of Western culture that, for any process of knowledge-production, the initial impulse had to come from the subject—and that the subject would then appropriate the object by transforming it into knowledge. A fundamental conviction of modern Western culture is that the more focused and more concentrated the subject/observer's performance of this approximation, the deeper and the more complex the knowledge that he/she produces will be.

Benjamin's praise of distraction implicitly challenges such traditional assumptions. It is therefore interesting to note that, over and again, we find passages in the *Artwork* essay where processes of knowledge production originate on the side of the object (and not in the subject)—and where it is the object that seems to advance toward an encounter with the subject: "The film with its shock effect meets this mode of reception halfway. The film makes the cult value recede into the background not only by putting the public in the position of the critic, but also by the fact that at the movies this position requires no attention" (240ff).

The epistemological outlines that underlie Benjamin's essay are surprisingly close—to say the least—to some features of Heidegger's epistemology. The "distraction" and "absent-mindedness" of Benjamin's spectator may not be completely identical with the attitude of *Gelassenheit* in Heidegger's philosophy, but both concepts presuppose a de-emphasizing of the classical subject-activity as a condition for the

emergence of truth effects on the object-side. Finally it is important—both for Benjamin's relation to the world of objects and for Heidegger's concept of "Being"—that they are not exclusively spiritual or conceptual. Being, as Heidegger wanted to see it unconcealing itself, shows substance, whereas Benjamin's Being is longing for a physical, for a tactile contact with the world, for a contact in which some not only conceptual truths will end up imposing themselves. In the end, relying on the absent-minded spectator as a potential source of truth is not completely incompatible with what Heidegger tried to express with his notorious "piety of thinking"—although Benjamin would have resented these words at least as much as Heidegger tried actively to ignore the intellectual obligation of being "critical." For Heidegger, as much as for Benjamin, engaging in the representation of the world is letting the world present itself.

REPRESENTATION

When the age of mechanical reproduction separated art from its basis in cult, the semblance of its autonomy disappeared forever (227)

[F]or contemporary man the representation of reality by the film is incomparably more significant than that of the painter, since it offers, precisely because of the thoroughgoing permeation of reality with mechanical equipment, an aspect of reality which is free of all equipment. And that is what one is entitled to ask from a work of art (234)

Before a painting of Arp's or a poem by August Stramm it is impossible to take time for contemplation and evaluation as one would before a canvas of Derain's or a poem by Rilke. In the decline of middle-class society, contemplation became a school for asocial behavior; it was countered by distraction as a variant of social conduct (238)

Distraction and concentration form polar opposites which may be stated as follows: A man who concentrates before a work of art is absorbed by it. . . . In contrast, the distracted mass absorbs the work of art (239)

To broach the concept of representation relative to the *Artwork* essay could simply incite us to summarize its argument, for Benjamin's point was to revisit the meaning of "represent" in light of new technology. Yet the axes and thrust of his thinking did not emerge in a void, and it might be useful to sketch the terrain onto which he ventured with this text. Three conditions describe Benjamin's understanding of the artwork in its new situation: it is no longer autonomous; it seems to be deeply embedded in contemporary reality; it is no longer an object of contemplation. While not exhaustive, these three are interconnected in complex ways, notably when Benjamin insists that mechanically reproduced works of art so become a part of the cultural matrix that a so-called higher order of existence becomes impossible. What were some of the forces behind Benjamin's thinking? Or, keeping in mind that "critical" thinking means generally "against the grain," we could ask: against *what* grain?

Of course, Benjamin's interest in representation was not unique: we can signal, for example, that Martin Heidegger lectured in Freiburg, Zurich, and Frankfurt during 1935–36 on the origins of the work of art, lectures later incorporated into *Holzwege*. We cannot know how closely Benjamin followed Heidegger's work, but he was surely aware of the latter's meteoric rise in German academe, and the few letters in which Heidegger is mentioned suggest the existence of an intellectual—not to mention personal—rivalry. In short, there would be grounds for Benjamin to mark his own analysis of the artwork as clearly *not* Heideggerian. We might, for example, set Benjamin's claim that mechanical reproduction has liquidated the autonomy of art against Heidegger's 1935 mapping of its origins as self-enclosed and circular:

> The *Way* of the asking about the origin of the work of art is a circular course. "*Origin*" means the ground that makes the work of art possible and necessary in its essence. The *starting point* of the question is found in the *workness of the work* and neither in its production by the artist nor in the object-being for the art market. (*De l'Origine*, 24)

Or, we could pit Benjamin's remark that painting can no longer match the immediate appeal of mechanically reproduced forms—so thoroughly are they part of everyday reality—against Heidegger's claim that works of art by nature both negotiate and instantiate a *rupture* in the world:

> World is against Earth and Earth against World. They are in strife, and this, *because* they belong to each other. This strife is opened—that is, conquered—in the work as such. The work should neither suppress nor overcome this strife. It must itself *be* this strife, perform it, that is, conquer it. The staying-in-itself of the work says nothing other than the *conquering of this strife*. And this is the *essential feature* of workness. (*De l'Origine*, 32)

And, finally, Benjamin's notion of distracted attention—the end of contemplation and evaluation—stands sharply opposed to Heidegger's gambit of "great art" and the metaphysical basis of its evaluation:

> Thus great art is never up-to-date art. Art is great when it brings its Being to full unfolding, that is, in its work sets *the* truth that shall become the measure for a time. The work can however not make itself up-to-date. There are of course such productions. But they are no *leap forward*, because they have no origin, but always only a supplement. In the wake of every real art is a supplemental art; it looks like the other, it often even succeeds better, and is yet different from great art by a leap—not only by degrees. (*De l'Origine*, 48)

Much has been written about Benjamin's use of *distraction* to describe the attention of "mass" audiences, where self-conscious "humanist" subjects give way to anonymous consumers of mechanically reproduced imagery. When joined to the idea that such images become an "aspect of reality" in and of themselves, we sense Benjamin's materialist bias, and usually ascribe it to his contact with Marxism, however odd that contact may be. There is, however, another figure whose work seems to have produced a creative resistance to Benjamin's thinking, a figure later described by Theodor Adorno as "the most influential French sociologist of the generation which is represented by names like Max Weber, Simmel, Troeltsch in Germany" ("Einleitung zu Emile Durkheim," 245). This person is Emile Durkheim, whose *Sociology and Philosophy* [*Sociologie et Philosophie*] (first published in 1924) seems pertinent to Benjamin's *Artwork* essay on three fronts. First is Durkheim's insistence on the materiality of representations: "[It] is not at all necessary to imagine representations as things having a separate existence; it is merely sufficient to admit that they are not non-entities, that they are phenomena but endowed with reality, with specific properties" (15). Second is the idea that "all representations from the moment that they come into being affect, apart from the organs, the mind itself. That is to say, they affect the present and past representations which constitute the mind" (17). Finally—and most important—is Durkheim's suggestion that this secondary effect may be subconscious because "we are always to a certain extent in a state of distraction . . . all distraction has the effect of withdrawing certain psychic states from the consciousness which do not cease to be real for all that, since they continue to function" (21). In short, representations cluster in unpredictable ways:

> If one can say that, to a certain extent, collective representations are exterior to individual minds, it means that they do not derive from them as such but from the association of minds, which is a very different thing. No doubt in the making of the whole each contributes his part, but private sentiments do not become social except by combination under the action of the sui generis forces developed in association. In such a combination, with the mutual alterations involved, *they become something else*. (26)

It seems clear that Durkheim was struggling to explain how a "mass" might emerge from a play of representations rather than, say, from a shared economic state. How this happens remained something of a mystery to him, for he admitted that "certainly we do not know exactly how these combined movements do give rise to a representa-

tion" (27). Ultimately Durkheim appealed to *spirituality*—which fuses individual thoughts into collective "social facts" the way individual brain cells "join" to become an organ capable of thought—and he suggested it operates as a spreading process over time: "The whole is only formed by the grouping of the parts, and this grouping does not take place instantly as a result of a sudden miracle. There is an infinite series of intermediaries between the state of pure isolation and the completed state of association" (30).

This is terrain where Benjamin could not travel, a weakness in Durkheim's otherwise attractive (anti-Heideggerian?) scheme he could not accept. But Benjamin *did* recognize that a "sudden miracle," which spreads representation like wildfire and in ways largely unconscious, now exists: mechanically reproduced images, especially film, whose technique "not only permits in the most direct way but virtually causes mass distribution" (n. 7). On opening day, thousands of viewers, in hundreds of nearly identical, darkened rooms, experience collectively the powerful "shock effect" of a new film, yet only partially (distractedly) understand what they have shared. Representations fully saturated with "reality," films become almost immediately social facts, "mass" phenomena that—as Durkheim predicted—"once a basic number of representations has been thus created, they become . . . partially autonomous realities with their own way of life. . . . [T]hey are immediately caused by other collective representations and not by this or that characteristic of the social structure" (31). Here we discover some of the conditions for representation "against the grain" of Heidegger: image-material that circulates and generates meaning, but which refuses to become a locus of "truth."

The Destruction of Representation

Walter Benjamin's Artwork Essay in the Present Age

The task of confronting Benjamin's *Artwork* essay today seems to require that we supersede his diagnosis in favor of new developments in the arts and their technical reproduction and that we regard the essay as a cult text, even if it is no longer representative.[1] Yet such a demand would overlook the fact that Benjamin's diagnosis is also a prognosis. Benjamin safeguarded his text against such a misreading by a double gesture, in epigraph and preface, toward the future. As the opening excerpt from Valéry announces, the growth of technical means "stellt uns in nahe Zukunft die eingreifendsten Veränderungen in der antiken Industrie des Schönen in Aussicht" [presents us in the near future with a view of the most intervening changes in the antique industry of the beautiful]. These changes affect not only the modes of technical reproduction of the work of art but also the possibility of its representation, thus opening the question of representation in the artwork essay and the question of representation of the essay as artwork.

The phrase "stellt . . . in Aussicht" points beyond itself toward a change in the present condition, a change where the distant immediacy of the eye [*Aus sicht*] is mediated by the penetrating hand [*ein greifend-sten*]. This change marks a loss of representation, effected by a replacing, by an "An-die-Stelle-setzen" (as Benjamin repeatedly formulates it) of the "Dar-" in "Darstellung" [representation] with an "in Aussicht" [prospect] that opens onto the future and indicates direction and mobility. The change also signifies a displacement of the artwork from its authentic location, a shift that destroys the condition of its representa-

1. *Editors' Note:* Parenthetical references in the text and notes of this essay are keyed to the edition listed in the Bibliography as: Benjamin, "Das Kunstwerk" (*Illuminationem*). All English translations are the author's own.

tion. What is thus "in Aussicht gestellt" and presented as a promise of the text, is a theory of representation that becomes visible in its very destruction, rescued from the ruin that the work undergoes in time. It therefore seems that a confrontation is not in order, but rather a critique that will complement and complete Benjamin's work. Such a critique, I will propose, must trace the constellation of "Stellen," "stellen," and "Stellung" in the text and indicate the directions in which they point.[2] Benjamin takes literally the etymological meaning of "Darstellung"—the bringing of an object before our eyes by making it stand up there and so remain or endure—by extending this image to its crisis: the shaking of the foundation (cf. 152, 155) which leads to its fall, to the "Ausfallen" (159, 161) of the aura. The representation of the destruction of representation, or representation as destruction, therefore *represents itself*—thereby doubling itself—and does so in a distracted fashion, scattered among the parts of the text.

Benjamin's text anticipates the charge that it is no longer valid by predicting its own destruction. Like Marx, Benjamin "directed his efforts in such a way as to give them prognostic value" (148). This prognosis by and about the text—its destruction—coincides with the development within the text—the destruction of representation. Benjamin's text is therefore no longer representative *of something* in the traditional sense: its object (destruction) does not precede representation but arises only in and through representation itself. The essay's representativeness lies in its exhibition value: it exhibits the destruction of representation, the representation of something that is no longer there—the representation of representation.

Prophetic with regard to both the text and the future, the *Artwork* essay's preface actualizes Benjamin's prognosis with the triad "Darstellung," "Herstellung," and "Abschaffung." Like Marx, Benjamin undertakes a representation of the "basic relations of capitalistic production"

2. Just how deliberately Benjamin has placed derivatives of "stellen" within his text becomes evident when he quotes an early film critic's contention that, from the point of view of film as art, it would "ein ganz unvergleichliches Ausdrucksmittel *darstellen*" [represent an incomparable means of expression] (159; my emphasis). Benjamin uses "darstellen" only when the prerequisites for representation are given. The critic's view reveals itself as inadequate, for he proceeded with his "voreilige Frage*stellung*" [rash posing of the question] and reached his conclusion "ohne die Vorfrage sich *gestellt* zu haben" [without having posed the preliminary question] (159; my emphasis) of whether the character of art has been fundamentally changed by the invention of film. Similarly, what Franz Werfel "stellt . . . fest" [ascertains] (160), is wrong in Benjamin's eyes, because it results from the same "voreilige Fragestellung."

to let emerge "the production of conditions which would make possible the abolition" (148) of capitalism itself. Likewise, "*Dar*stellung" [representation] is replaced by "*Her*stellung" [production], which brings about "die Abschaffung seiner selbst"—the abolition of "Darstellung" itself.

I

Benjamin begins his reflections on representation and its destruction from the perspective of the work of art. The characteristics required for an artwork to become representable display a unifying quality: the work is set apart by its uniqueness, its duration, its being a "Gegenstand" [object], its "Feststellung" [becoming fixed], and its distance from the observer. The work's uniqueness and unity are brought about by its singular location in space—its presence in the here and now—which also defines its aura (cf. 151). This static position in space [*Standort*] grounds the work's duration, making possible a "*Fest*stellung" (indispensable for "*Dar*stellung") that authenticates the work by determining and fixing it in space. The artwork is made complete by the phenomenon of its aura, "the unique appearance of a distance, however close it may be" (154). By granting a work its distance, aura lets it appear as a "Gegenstand" or "gegenständlichen Vorwurf," an objective pro-jection that stands opposite to [*Gegen-*] or before [*Vor-*] a subject (155–56).

If "Darstellung" is based on the uniqueness of the artwork, "Herstellung" for Benjamin, by contrast, is always "massenweise" [mass production] (149). Production in quantity (*re*production) suspends the possibility of traditional representation, for the singularity of its object gives way to a multiplicity that re-places it. An artwork is unique by dint of occupying a "Stelle"; in reproduction, however, the place of unique existence is taken by a plurality of copies (cf. 153). Moreover, Benjamin emphasizes that *technical* reproduction, having had no place of its own, has conquered a "place" for itself among the artistic processes and reached a "Standard" [standard], literally an upright position that indicates its newly won authority (151).

With reproduction, the work loses not only its place but also its duration and thus its "Feststellung." It is now subject to "*Her*stellung" [production], which gives it a direction and mobility. The duration or "Be-stehen" [ex-istence; my emphasis] of the work further contrasts with the quick appearance and disappearance of images and sounds in our homes that are produced instantly, for they are summoned by a

"movement of the hand" (151). Benjamin describes this arrival of sound and image with the verb "sich einstellen" [here: to present oneself], which also evokes its opposite, "ausstellen" [to turn off]—that is, the "movement of the hand" that terminates their presence. Furthermore, "sich einstellen" indicates that technically reproduced sounds and images—unlike representation—are changeable, for they adapt to the hand that adjusts them.

Technical reproduction dissolves the unity of the work of art and threatens its distance by subjecting it to a twofold mobility, each effected by an intervention of the hand. It exposes the original to an adjustable [verstellbaren] lens whose alterable focus[3] is able to manipulate the exposure (152). Not only can the lens be moved in the direction of the object, but the artwork itself—in the form of one of its reproductions—can be brought closer to the receiver and thus into a situation where it leaves its original place (152). Place defines the unity and uniqueness of the original, and its unique presence at a place is a prerequisite of its "Darstellung." Thus, re-presentation of the technically reproduced object becomes impossible, for its position has already been altered. With this increased mobility, the work's authority—its aura—begins to sway and finally recedes (152).

Works of art, for Benjamin, can acquire a third kind of mobility that threatens their representation. Apart from the movements by which lens and artwork approach each other, the artwork also becomes mobile when it begins to circulate in exhibitions. The possibility of exhibiting a portrait bust "that can be sent here and there," its "Ausstellbarkeit," dissolves the "festen Ort," the fixed place of the statue of a deity inside a temple (157). However, "Ausstellbarkeit" in itself does not seem to jeopardize representation; only *repeated* exhibitions dissolve the object's representability. Benjamin remarks that while a caveman might have exhibited his portrait of an elk to his fellow men, it was intended for the spirits (156): "Ausstellbarkeit" only undermines the possibility of representation when it affects the artwork's situatedness—that is, when it removes the object from its original location.

The cultic object—the artwork in the state of representation—is not exposed but concealed from view. Similarly, Benjamin has hidden a central aspect of his theory of representation in a footnote, namely the reason why situatedness is so crucial to representation.

3. Or "Einstellung," a word Benjamin uses later in the essay (cf. 160). The "Einstellung" of the camera corresponds to the film's "Ausstellung" (164) of the actor's performance.

II

The principle governing Benjamin's understanding of representation is buried in the fourth footnote of the *Artwork* essay. Here, the link that connects his examples—the artwork and the actor on stage or before the camera—is provided by a group of physicians who are represented as figures (actors) in a painting (artwork). These physicians do not only illustrate the principle of representation but also—as "Operateure" [surgeon, cameraman, projector] who cut—demonstrate the workings of technical reproduction (166). In the footnote, Benjamin draws attention to a sixteenth-century painter who is able to represent a group of physicians representatively (177). To effect such a double representation, the artist has to paint them on location—that is, present them in a scene where their profession and the place of its praxis coincide. The twofold character of representation is thus grounded in the duplicity of thing and location, in the object's situatedness in place.

The doubling of object and place generates the phenomenon of aura as a near distance. In the aura of an object, the distant "Erscheinung" [appearance] is coupled with its "Materie" [matter], its near physical presence, yet they do not coincide: rather, they keep a distance from each other which is crucial for representation (177, n. 5). Aura thus becomes representative of the object that gives rise to its appearance; they are coexistent. The doubling of the object into matter and appearance, which makes auratic representation possible, is a function of the object's "situatedness."

Of the two conceptions of "Darstellung" at stake here—the relation of representation to its object and representation as a self-reflexive act—Benjamin is concerned not with the question of whether the work of art is a representation *of something*, but whether the artwork and the actor are able to represent themselves to an audience. Thus, the crucial aspect of film is not "daß der Darsteller dem Publikum einen anderen als daß er der Apparatur sich selbst darstellt" [that the actor represents another to the audience but that he represents himself to the apparatus] (161). The artistic performance of the stage actor—"dem Publikum durch diesen selbst in eigener Person präsentiert" [presented to the audience by himself in person]—is a double representation (160). Being doubly present as person and performer, the actor is representative of himself as he acts "in eigener Person" [by himself in person].

The actor on stage is present with his entire being, and this full presence allows his aura to emerge. In film, however, the screen actor

loses his presence to the apparatus. His aura, too, vanishes before the apparatus, for it cannot be reproduced at a place different from that which gave rise to it. The screen actor's representation to the audience is mediated by the apparatus of the camera: "dagegen wird die Kunstleistung des Filmdarstellers dem Publikum durch eine Apparatur präsentiert" [the artistic performance of the screen actor, however, is presented to the audience through an apparatus] (160).[4] Filmic production generates a twofold *re*placement: it puts "an die *Stelle* des Publikums die Apparatur" [the apparatus in the place of the audience] (162; emphasis mine) and also places the actor in a new situation where the doubled nature of his appearance is lost (161). In short, the screen actor still represents someone, but without his aura.

Benjamin observes that film has thrown the theater into a crisis (cf. 162), which is a crisis of representation.[5] It is through the very loss of representation that its constitutive elements are brought into relief. Technical reproduction has shattered representation by dissolving its essential doubleness into sequence and seriality—into film as a series of images (cf. 158). The camera no longer serves as a means of analogical representation that faithfully transmits the image of the actor to the audience. Rather, it violates the totality of the actor's art, for the apparatus "nimmt . . . laufend . . . Stellung": it adopts a continually changing position vis-à-vis the work, which Benjamin describes as the camera's "Bewegungsmomente" [instants of movement] and "Spezialeinstellungen" [special takes]. It is thus a "*Folge*[6] von Stellungnahmen" (160; my emphasis), a series of partial takes whose multiplicity destroys the uniqueness of the actor's performance by splitting its unity into isolated frames that only later are combined into a montage.[7] This

4. The immediate relationship between art object and viewer can be interrupted by other devices besides the camera: witness how magazines have begun to put up [aufzustellen] textual directives that serve as signposts to the photographs (158).

5. In the form of a "Krise der bürgerlichen Demokratien" [crisis of the bourgeois democracies], this crisis of representation also enters the political arena. Politicians are exposed to the same "Veränderung der Ausstellungsweise durch die Reproduktionstechnik" [change in the mode of exhibition caused by the technique of reproduction] that affects an actor when his audience is no longer a public (or the parliament) but the camera (180, n. 12).

6. Benjamin regards "Folge" as consequence *and* as series. The way in which we perceive a single image in a film is the consequence [Folge] (160) of the series [Folge] (158, 160) of all the preceding images. Both meanings coincide in the statement "Die Folge von Stellungnahmen . . . bildet den fertig montierten Film" [The series/consequence of partial takes . . . forms the finished montage of the film] (160).

7. The film's montage character is manifest in the way the "Installation" of lighting breaks down the "Darstellung eines Vorgangs" [representation of a process] into a series

montage is created out of individual shots that were not necessarily filmed in the order they afterward assume. A representation of something that did not exist before, the finished film is "zusammengestellt" [put together] and thus takes on a totality that is no longer uniform (162).

The camera's "Stellungnahme" [partial take], Benjamin observes, is testing the screen actor's performance, and, as such, mediates between the actor and the audience (cf. 160).[8] With the direct contact to the actor thus blocked, the audience's desire to empathize with the actor is displaced onto the apparatus: the audience takes over the camera's attitude and, Benjamin argues, likewise begins to test the actor (cf. 161). Theatrical empathy—vicarious experience of an actor's feelings, thoughts, and so on through identification with him—is made impossible by technical reproduction.

In order to illustrate the difference between audience and apparatus, Benjamin suggests the analogy of a surgeon, who is an "Operateur" like the cameraman (166). His "Stellungnahme" is a physical "Einfühlung" [empathy] that literally involves his hand. Penetrating the sick person's body, the surgeon disregards three basic premises of representation: he violates that body's totality; he eliminates the physical distance between himself and the patient; and he thereby assumes a position where he is unable "seinem Kranken sich von Mensch zu Mensch gegenüberzu*stellen*" [to face his patient as man to man] (166; my emphasis). No longer opposite the surgeon, the patient ceases to be an object of representation. The figure of the surgeon appears in Benjamin's essay at both ends of representation: shown at his workplace in the painting, he constitutes a totality; when actually at work, he cuts into his patient's flesh and causes a loss of totality, thus destroying the possibility of representation.

of individual shots (162). The partial quality of the actor's performance is also illustrated by Rudolf Arnheim's remark, quoted by Benjamin, that the actor should be inserted "an der richtigen Stelle" [in the right place] (162).

8. See the entry "test" in Partridge, *Origins*, 708: "[He] who stands in the third part, he who stands by, a third party, as it were an intermediary between accuser and accused." The *Grimmsche Wörterbuch* makes an interesting semantic connection between witness, representation, and production by translating the Latin *productio testis* as "Zeugendarstellung" [representation by witnesses] (Grimm and Grimm, vol. 2, columns 791–92).

III

Benjamin approaches the concept of representation from two perspectives: on one hand, from the actor's point of view, the self-reflexive "Art, wie der Mensch sich der Aufnahmeapparatur [*darstellt*]" [the way in which man represents himself to the camera]; on the other, "wie er mit deren Hilfe die Umwelt sich darstellt" [how he represents the environment to himself with its help] (168). Screen actors are unable to represent themselves, for their aura dissolves before the camera. The requisite doubleness of representation, however, has "*stellen*weise" [partially; my emphasis] been regained through a "Verschiebung" [displacement] (165). Russian film, as Benjamin suggests, unites representation and production and thus allows representation and filmic *reproduction* to coincide. Like the physicians in the sixteenth-century painting, Russian workers are shown *at work*, so that some Russian "Darsteller sind nicht Darsteller in unserem Sinn, sondern Leute, die *sich*—und zwar in erster Linie in ihrem Arbeitsprozeß—darstellen" [actors are not actors in our sense but people who represent *themselves*—primarily in their work process] (165; Benjamin's emphasis). Human beings represent themselves as human beings by reproducing themselves through work.

The "filmic" or "artistic representation of reality" (167, 183) is an illusion,[9] however, for there is no "real" reality that corresponds to the artistic reality: it is based on the duplicity of representation—on its *deceptive* character—not on its reflexive doubleness. The finished film creates the illusion of a nature free of the camera that has penetrated it, while the artistic reality is in fact a reality-cum-apparatus (cf. 167). Furthermore, the "reality" that is displayed in a movie never occurred as such prior to the filming, but is created together with its representation. Composed of independent shots that are assembled into a whole,[10] film therefore both destroys the doubleness of (traditional) representation by splitting the composite of appearance/material presence, and it illustrates Benjamin's notion of representation as constellation—a constellation of things. Just as the arrangement of individual "Stellungnahmen" by the apparatus makes up the representation of the fin-

9. Thus, the film industry attempts to engage the masses by "illusionäre Vorstellungen" [illusionary representations] (165).

10. The crisis of traditional representation in film can be explained by the fact that its mode of production, which works from scattered pieces, does not correspond to its mode of representation, which is a unified whole.

ished film, the gathering together of "Stellen" [places, positions] creates a new configuration of materials that organize themselves into a "Darstellung." Benjamin "stellte sie so dar, daß sich aus ihnen ergab" [represented them in such a way that there resulted from them] (148) a "materialistische Darstellung" [materialist representation] (cf. 180, n. 11).

As argued above, the traditional form of representation presupposes a structural duplicity: the coincidence of object and place in the aura. This mode of representation is destroyed by a *re*placing that shatters the auratic unity of the object and installs a multiplicity in its stead. Scattering the parts of the whole into many places within itself, Benjamin's text enacts and represents the destruction of representation, and yet yields a constellation that is also a theory of representation—Benjamin's theory of representation. The essay is a "Zusammenstellung" [assemblage], a set of "Stellen" brought together, pieces of text about "Stellen." Together, they form a new doubleness: a representation of representation. It is in this sense that the text, a representation of the destruction of representation—representation *as* destruction—lets appear a constellation that is only *there* in destruction, arising only in and through the representation of something that no longer exists.

Text-Critical Remarks et Alia

Years ago, when we read the *Artwork* essay for the first time in the volume of *Illuminationem* with the brown binding, it embodied a fascination and plausibility innate to discoveries, even if one did not want to surrender oneself unconditionally.[1] The small yellow volume from Suhrkamp Verlag changed that impression very little, if I remember correctly, nor did the publication of Benjamin's collected works. Today, when I reread the text after many years, it appears to me as if written by many hands, the last one being Walter Benjamin's, under whose name it circulates. And I inadvertently find myself in the somewhat uncomfortable position of a text critic, trying to differentiate between the layers of transmission in the present text. At the very least, when the last writer produced a definitive version from the much-retouched draft, one imagines a situation not unlike that assumed by the old text critic Johannes Clericus before an edition of the Torah: "And it is not only a few words which one could suspect of having slipped from the margin into the text."[2]

"Aura" is one such word. Perhaps I only notice it because for a number of years I read many medical texts. Aura is a word that could only have been written in the margin by a doctor, and which then somehow managed to slip into the text. Aura (breath of wind) is what one called the precursor of a major epileptic attack, "a curious sensation of a cool or a warm breeze (*aura epileptica*), which, starting from one end of the body, passes through the same, and ends in the head or the hollow of the heart."[3] The reception of a work of art would then be the attack [grand mal] that follows the aura, and "is often ushered in by a loud and piercing scream" and is, in any case, associated "with a

1. *Editors' Note:* Parenthetical references in the text of this essay are keyed to the edition listed in the Bibliography as: Benjamin, "Das Kunstwerk" (*Gesammelte Schriften*). Translations have been approved by the author.

2. Le Clerc, *Sentimens de quelques théologiens de Hollande*, p. 125.

3. Brockhaus, *Brockhaus' Konversations-Lexikon*, VI, p. 207.

complete extinction of consciousness." I decided not to follow up this line of thought.

Seen from a text-critical point of view, we are dealing with a corrupt reading (*corruptela*), which was clearly occasioned by a passage that speaks of a mountain panorama and the branch of a tree on a summer afternoon: "that means, breathe the aura of these mountains, of this branch" (479). Here, and only here, the word "aura" (breath) fits better than any other, but elsewhere in the text it is strangely out of place: one cannot really speak of the "atrophy" (477), of the "decay" and "destruction" (479) of a breath of wind, nor of its "being around" someone (Macbeth, or an actor playing Macbeth) (489), and certainly not of its "shriveling up" (492).

A conjecture (*conjectura*) suggests itself. Instead of aura, one should read aureole—then the incompatibility with the other words largely disappears. One can quite well say of an aureole (a halo around an entire body) that it atrophies, decays, is around somebody, and shrivels up, or that it is destroyed when "the outer cover is peeled from an object" (479); nonetheless, to *inhale* an aureole would be a rather bold metaphor. In any case, the conjecture—one cannot demand more than that—makes the text more coherent, and the following passage further corroborates its justification: after art separated itself "from its cult basis, the appearance of its autonomy," its radiant aureole or—as it is later called—the "beautiful appearance," was "extinguished forever" (486). I do not wish to attempt to explain how the mix-up between aureole and aura came about, although the text itself proffers the psychoanalytic notion of "a slip of the tongue" (498).

Following this conjecture, and perhaps because of it, a question arises for which the text, in the state it has been passed down, provides only an answer filled with contradictions. Has the aureole now been extinguished "forever" (486), is the general process of its "atrophy" (477) and its "decay" still continuing (479), or is it shriveling in some places, while elsewhere remaining intact? Only the third part of the question seems to demand an affirmative reply: natural objects such as a branch or a range of mountains (479) apparently keep their aureole even now, as does Macbeth and the actor "who plays him" on the "stage" (489), whereas the aureole disappears as soon as something falls into the grasp of reproduction. Thus, speaking of a "decay" of the aureole retains some sort of intelligibility only as a statement of an average value, or as a reference to an increasingly prevalent tendency, and this, in turn, would further corroborate the fact that a "sense for

homogeneity in the world . . . makes itself noticeable in the realm of theory as the increasing importance of statistics" (480). In this view, Benjamin's theory becomes an exemplary instance of the tendency it wishes to describe, but this seems not to be a particularly satisfying reading.

A slightly revised conjecture promises a more satisfactory resolution of the difficulty: in those cases where one speaks of decay and so on, one might replace "aureole" with "concept of a work of art" (which contains the aureole as its essential determining factor). Everything said about alterations to the aureole can be applied to this traditional concept of a work of art and its supposed universal validity: it decays, it atrophies, it shrivels up to something of merely regional value. Moreover, it is destroyed by photography and film, and for those two media it dies "forever." According to Benjamin's text, in those cases that something is wearing, could wear, or has worn an aureole, the traditional concept of a work of art retains, at least for the moment, its validity—the word "aureole" need not be replaced. This is true for individual works of art—surely paintings above all—as well as "an antique statue of Venus" (480). It is also true for natural objects like a branch or range of mountains (479), for each person with "his entire living personage" (489), for the figure of Macbeth on stage as well as for the actor himself (489), for the artistic "production," and finally surely for human life as such, whose aureole is "gotten rid of" "in a new way" by chemical warfare (508). In any case, it makes good sense to define the aureole as a "unique appearance," as a visible mark of "the unique," of "uniqueness," of "singularity" (479). Indeed, the "ritual function" of the aureole is composed of this uniqueness, and that function remains "recognizable in the most profane forms of serving beauty as a secular ritual" (480): the aureole is the halo around the secular saint, around that which is simply unique, for which no equal can be found. The aureole is the visible component of uniqueness, which is worshiped in the profane cult as "ingenuity," "originality," or "authenticity" (476, 477, 482).

Our revised conjecture helps us to distinguish two processes from each other: one process is the advancement of multiplicity into the "world of art" (487), a domain that heretofore was (or seemed to be) reserved for uniqueness alone; the other process is a disintegration of the concept "work of art" as a consequence or corollary phenomenon of the first. The *Artwork* essay situates itself differently relative to each process: it is the description of the first (penetration of multiplicity),

and the achievement (performance) of the second (disintegration of the concept).

That the essay achieves a disintegration of the concept of "work of art" without mentioning it constitutes a large part of its not inconsiderable difficulty. It would have been easier to understand if, in accordance with Brecht's suggestion, Benjamin had completely omitted the concept—or, more properly, the term—"work of art" (484). From a text-critical perspective, "art" and "work of art" are terms that have slipped from a marginal notation (no doubt from the nineteenth century) into the main text and, to top it off, have dragged along the wild antonyms of "reality" and "actuality" (495ff). In all fairness, the exact consequence of omitting these terms remains unclear; keep in mind, however, that Jan Mukarovsky (also in 1936) did not disintegrate the concept "work of art" but, nonetheless, maintained a distinction between "artifact" and an "aesthetic object."

The description of the first process—the advancement and penetration of multiplicity—forms a coherent thematic framework from which we must eliminate another foreign body by means of renewed conjecture. The word "reproduction" must also be a marginal note of the twentieth century that slipped into the text where the word "likeness" [*Abbild*] had stood since the eighteenth century. This slippage occurs in a hasty correction, "in the picture, rather in the likeness, in the reproduction" (479), and a later consequence is the absurd formulation: "[T]he demand raised by today's man of being reproduced" (494). Clearly, Benjamin does not mean gene-controlled replication, but has in mind only the demand of "being filmed" (493)—that is, to have one's likeness made. Strictly speaking, the word "reproduction" should only be used to signify replication of a product; everywhere else it ought be replaced with the words recovered by our conjecture: "likeness" [*Abbild*] or "to make a likeness" [*abbilden*].

Once relieved of this excess baggage, Benjamin's essay refers, in the first instance, to a process that continues today: what I have called the advancement of multiplicity or, what amounts to the same thing, the propagation of the industrial means of production. To the degree that multiplicity is propagated, it fosters an unexpected sensibility for uniqueness. Unique things—different from all others—are surely becoming increasingly rare in the industrialized countries of the Western world; yet they are still produced, each with its own proud price. To possess something unique—for example, a custom-made suit, antique furniture, or a genuine oil painting—has become a luxury that many

people can and want to acquire: who would not love to have an old spinning wheel next to the chimney, or a somewhat dilapidated wagon wheel lying in the garden? Today, a heightened sensibility discovers in places it never before existed, such as scarce remnants of industrially manufactured lines of stamps, stock shares, cars, typewriters, and so on. Many of us travel to great exhibitions where unique objects might at last be seen first-hand. In short, the aureole radiates more strongly and preciously than ever before, which is a development that Benjamin obviously had not foreseen. He also seems not to have noticed that he, with his heightened sensibility, discovered uniqueness—ironically in the "ingenious guidance of the lens" (499)—and that he played an active role in the installation of aureole around film. This is not a reproach, especially because there are more even important aspects to his *Artwork* essay.

To my mind, the project of writing a twentieth-century sequel to the eighteenth-century's problem of the Laocoön (namely, expanding Lessing's comparison between painting and poetry to include photography and film), and of engaging social developments were central to the ambition of Benjamin's essay, and they are probably more important today than ever before. Unfortunately, rereading the text after so many years left me with an impression of how poorly that project was executed. The text-critical means at my disposal seem to be of little use, for I no longer know where to turn, and the comparison with Lessing breaks down from the very beginning. Consider Benjamin's use of the word "original" in his opening remarks, and the way he sets up the basic comparison between manual and technical reproduction (475–77): manual reproduction is a replica ("as a rule branded as a forgery"), its original the "genuine" work (a bronze, a manuscript); technical reproductions are photographs or phonograph records enjoyed in galleries or drawing rooms, whereas their originals—if you don't believe this, consult page 477—require the spaces of a cathedral, an auditorium, or the open air! The above-mentioned ambiguity around "reproduction" must be responsible for this disaster. Paradoxically, in the case of traditional hand-crafted arts, "reproduction" is used to mean "copy" [*Kopie*]; in the second case, that of modern technical arts, it is used to mean "likeness" [*Abbild*]. In light of such confusions, it is no wonder that text criticism is of little use.

Where Benjamin should have initiated the comparison becomes evident in several places: for example, with his observation of the "advent of the first truly revolutionary means of reproduction, photography"

(481). But even this goes astray at the critical moment when he writes: "It is possible, for example, to make numerous prints from a photographic plate; the question of a genuine print makes no sense." We can grant this point, but it circumvents the decisive and obvious question—namely, the relationship of all the prints to the photographic plate, and the status of the plate itself. Moreover, Benjamin never raises the general form of this question, which concerns the specifics of materiality and media in the "arts" and is where the comparison could and should become concrete. Photography—and this is what is revolutionary about it—undermines the familiar and, in prior times, fundamental distinction between original and copy. The photographic plate (the expression "photograph" is much too vague) is neither a copy of some original nor an original itself, although many copies can be made from it. The photographic plate is a *technologically produced medium*: this is exactly the quality it shares with a phonograph record or a canister of film, and exactly what distinguishes it from a painting or a statue. The new media have systematically nullified distinctions between original and copy or, one might say, they have settled terminologically the original's disappearance: amid the countless replicas of films, videotapes, CDs, or floppy disks, one no longer speaks of originals but, at best, only master copies. Copies are no longer valued because they are identical with some nonexistent original, but because they can be used to generate a new copy, ad infinitum: a diskette lacks uniqueness, and *for this very reason* it is highly likely that an aureole will form around it.

What the media *mediate* (hence the name) is fundamentally different from a painting, and not only because some of them—for example, audio recordings at least since the time of electric phonographs—require two types of machines, a recording device and a play-back device. This type of mediation is referenced somewhat cryptically by the phrase "shooting a spoken film," which to an innocent bystander offers a view "such as has never been conceivable before," thanks to the unavoidable disintegration of illusion that results when one sees simultaneously the scene being enacted and the movie cameras. There is no standpoint from which the spectator can avoid noting this disintegration, "unless the position of his pupil should happen to correspond with that of the camera" (495)—of course, this is exactly the point of view one assumes when watching a movie. The standpoint of the "camera" *is* our own eye, whether viewing a film, a video on television, or a flight simulator. A visual medium always communicates a picture *and* a view of the picture at the same time. The standpoint we

assume before a mediated picture is identical to the one familiar to us from reading a text (a script is also a medium): both entail a *point of view*, as narratology has called it with unwitting appropriateness.

The visual materiality of virtual reality appeals to the only set of eyes we possess, thereby forcing us to merge an essentially textual "point of view" with our ordinary habits of seeing the world of everyday experience. By confining us to the point of view of the recording device, visual media shape a way of looking that is foreign to us, but so direct and immediate that we willingly accept it as our own. But we are not alone, for every other observer also appears to accept this coercion. Consequently, there emerges a collective fictionalization of seeing: individual acts of seeing are pushed to become identical copies of one another, each supposedly modeled upon an original that does not exist. If we are allowed to intervene interactively in the mediated picture, we resemble figures in a novel—where lives are governed by the narrative thread—because the progress and functionality of every intervention in "virtual reality" is completely accounted for by the program. Interactive, and thus behaving without responsibility, what is supposed to hold us back if—unexpectedly one day—we are not answerable to a program?

—Translated by Anne Smith

FETISH

[The] concept of authenticity always transcends mere genuineness.
(This is particularly apparent in the collector who always retains
some traces of the fetishist and who, by owning the work of art,
shares in its ritual power.) Nevertheless, the function of the concept
of authenticity remains determinate in the evaluation of art; with
the secularization of art, authenticity displaces the cult value of the
work (244)

The film responds to the shriveling of the aura with an artificial
build-up of the "personality" outside the studio. The cult of the
movie star, fostered by the money of the film industry, preserves
not the unique aura of the person but the "spell of the personality,"
the phony spell of a commodity (231)

From an etymological point of view, "fetish" has everything to do with
the English word "fake." The word goes back to Portuguese *feitiço*,
which means "artificial," "nonnatural"—and the concept has been
used, since the mid–eighteenth century, to denounce the (fake) powers
attributed to statues of gods and goddesses in supposedly "primitive"
cultures. Whatever we call "a fetish," therefore, is supposed to look
alien to us. We associate such phenomena with archaic stages in his-
tory, with cultures outside the confines of Western civilization—and
with psychiatric pathology. And we assume that fetishists are driven by
forces and passions that are beyond (or, rather, below) their rational
control. Nobody in his or her right mind would want to be a fetishist.

In the *Artwork* essay, Walter Benjamin uses the word "fetishist"
only once, and that is in footnote 6, where he speaks of the "collector"
as "owner of the work of art." A first reading of this passage may pro-
duce the impression that fetishism manifests itself whenever the desire
of authenticity becomes excessive—or, referring to a different para-
graph (although Benjamin does not use the word "fetishism" in this
other context), that fetishism emerges when the aura that surrounded
an object of desire undergoes a somehow pathological transformation.
This exactly seems to be the central implication in Benjamin's discus-
sion of the phenomenon of the movie star. He sees the star as the result

of a double process in which the aura of the traditional figure of the actor is "shriveled"—which movement is followed by the "artificial build-up of the 'personality' outside the studio." The end product is "'the spell of the personality,' the phony spell of a commodity." Clearly, what makes these two cases into "problem cases"—or into pathologies—is the reduction of an object of desire to an (inferior?) level of sheer materiality. This reduction facilitates the association of both the possessions of the collector and the body of the star with the streams of capital (although we all know that, despite this metonymical association, there is no medium that is as immaterial as money).

While we may safely assume that Benjamin would have approved such a reading of his remarks on the collector and on the movie star, a second—and even closer—reading brings up a problem. For the author says that "the concept of authenticity always transcends mere genuineness"—which must mean that, if not necessarily fetishism, the desire for authenticity will always produce something that escapes our rational control. As a consequence of this observation, it is striking, as Benjamin explicitly states in the very same paragraph, that the value of authenticity has not disappeared "with the secularization" of art—and, according to Benjamin, will probably not disappear because he sees it as a replacement of the traditional "cult value of the work." In other words: according to Benjamin, the progress of history may well overcome the state of the religious cult and the state of its transformation into the cult of the artwork—but we seem to be stuck with a fixation on objectness and materiality that we can neither control nor definitively repress.

But are we obliged to evaluate this fixation and this loss of subject-control as pathological? Is it only bad that the film industry produces that "spell of the personality" in the movie star? Benjamin cared enough about his public (and private) image as an intellectual of the Left that he could never have made major concessions in this context. But, on the other hand, we know that he was a passionate collector of toys, old books, newspaper fragments, and other objects and products from past everyday life. An additional interesting symptom is his enthusiasm for the attitude of "distraction" that he hails as characteristic for a new type of mass-spectator. For distraction and absent-mindedness unavoidably entail a reduction of traditional subject-functions—converging thus with an enthusiasm for the materiality of artifacts. There are many more explicit and implicit details which, like a puzzle, end up producing the impression that Benjamin, beyond and below the

more programmatic levels of his discourse, may have been quite happily caught between the tangibility of many artifacts that were present to him and a desire to have those objects which (for the moment being or forever) had to remain absent. One of the reasons why he could afford to play—rather preconsciously, one would assume—with this very oscillation between the sensuality of the present and the desire for the absent was that the name of "Materialism" officially encouraged a closeness to whatever becomes tangible (although, in its philosophical core, the Marxist version of Materialism could not have been any further away from an affinity with the dimension of physical presence).

In this sense, the program of a "defetishizing criticism," as it was developed, decades later, by other members of the Frankfurt School, was much more faithful to the tradition of official Marxism as (a highly spiritual) "Materialism" than Benjamin's materialism (with its implicit desire for the touch). For "defetishizing criticism" set out to free (at least) us intellectuals from any kind of deplorable fixations on objects—whereas part of the fascination of Benjamin's work comes precisely from the contagious effects of his desire to touch things (and perhaps even to have these things in his possession).

RITUAL

We know that the earliest art works originated in the service of a ritual—first the magical, then the religious kind. It is significant that the existence of the work of art with reference to its aura is never entirely separated from its ritual function. In other words, the unique value of the "authentic" work of art has its basis in ritual, the location of its original use value. This ritualistic basis, however remote, is still recognizable as secularized ritual even in the most profane forms of the cult of beauty (223–24)

With the emancipation of the various art practices from ritual go increasing opportunities for the exhibition of their products (225)

This is comparable to the situation of the work of art in prehistoric times when, by the absolute emphasis on its cult value, it was, first and foremost, an instrument of magic. Only later did it come to be recognized as a work of art (224)

But the instant the criterion of authenticity ceases to be applicable to artistic production, the total function of art is reversed. Instead of being based on ritual, it begins to be based on another practice— politics (ibid.)

The *Artwork* essay does not dwell at length on the concept of ritual but, as the preceding quotations make clear, the idea of ritual is the armature of Benjamin's argument that links aura, authenticity, exhibition value, and politics. Ritual may be one of the most unarticulated elements at play in the text, but the threads that extend from its shadowy presence allow us to map the essay onto Benjamin's intellectual history, and thus to appreciate its pivotal position in the development of his thinking.

To begin our search, we must return to June 1917. Benjamin was preparing his dissertation on early Romantic criticism and, in the course of a long letter to his friend Gerhard Scholem, he reports that he is reading "primarily Friedrich Schlegel, then Novalis, August Wilhelm, even Tieck, and later, if possible, Schleiermacher" (*Correspondence of Walter Benjamin*, 88). Later in the same letter he sketches one of his goals: "In one sense, whose profundity would first have to be made

clear, romanticism seeks to accomplish for religion what Kant accomplished for theoretical subjects: to reveal its form. But does religion have a *form*?" Benjamin's question about the *form* of religion seems not, in fact, to have made its way into his thesis of 1919, but it does figure in an unpublished essay of 1918:

> The task of the coming philosophy can be conceived as the discovery or creation of that concept of knowledge which, by relating experience *exclusively* to the transcendental consciousness, makes not only mechanical but also religious experience logically possible. This should definitely be taken to mean not that knowledge makes God possible, but that it definitely does make the experience and doctrine of him possible in the first place. ("Coming Philosophy," 105)

In contrast, what did enter Benjamin's thesis was an admiration for the way early Romantics like Schlegel invented terms able to perform the logical gymnastics required by the "coming philosophy" but rooted in intuition. "Schegel's thinking is *absolutely conceptual*," remarks Benjamin, meaning

> it is linguistic thinking. Reflection is the intentional act of the absolute comprehension of the system, and the adequate form for this act is the concept. In this intuition lies the motive for Friedrich Schlegel's numerous terminological innovations and the deepest reason for the continually new names he devises for the absolute. ("Concept of Criticism," 140)

What does any of this have to do with "ritual" in the *Artwork* essay? Let us return to Benjamin's list of readings in 1917, a list that includes Friedrich Schleiermacher, whose *Über die Religion* had been republished in 1899 with an introduction and summation by Rudolf Otto. Did Benjamin read Otto's commentary? We shall never know for certain; what we do know, however, is that Otto wanted to push hard Schleiermacher's notion of intuition so that it might become a kind of knowledge—albeit based neither on experience nor reason—but rooted in the "sentiment" of a presence that launches in us an idea of our vulnerability. In a tremendously successful book of 1917 (the date seems eminently relevant), Otto coined the term *numinous [das Numinose]* for such a presence and described it in a thoroughly romantic manner:

> Rather, the "creature-feeling" is itself a first subjective concomitant and effect of another feeling-element, which casts it like a shadow, but which in itself indubitably has immediate and primary reference to an object outside the self. Now this object is just what we have already spoken of as "the numinous." For the "creature-feeling" and the sense of dependence

to arise in the mind the "numen" must be experienced as present, a *numen praesens*, as in the case of Abraham. There must be felt something "numinous," something bearing the character of a "numen," to which the mind turns spontaneously; or (which is the same thing in other words) these feelings can only arise in the mind as accompanying emotions when the category of "the numinous" is called into play. (Otto, *Idea of the Holy*, 10–11)

We shall return to Otto's image of the sentiment we experience as the shadow of another, but the point is—working with the same bibliography that Benjamin was reading—he invented a term (in the manner of Schlegel) for a category that is sui generis, "irreducible to any other; and, therefore, like every absolutely primary and elementary datum, while it admits of being discussed, it cannot be strictly defined" (ibid., 7).

Remarkably, Otto's book (*Das Heilige*) is still in print, for his concept of numinous is used by contemporary ethnographers to explain the most mysterious part of any ritual—namely, how and why it starts. Rituals do not spring spontaneously into being—their defining quality is repeated action—but rather develop, as Jean Cazeneuve suggests, when "man, anguished to feel that he is a mystery for himself, has been torn between the desire to define an unchanging human condition by rules, and, on the other hand, the temptation to remain more powerful than rules, to go beyond all limits" (*Sociologie du Rite*, 36). In the first case, rituals become framed as taboos, laws that must not be broken. In the second instance, rituals are shaped so as to transcend the threat: we call these magic. And yet there remains a third possibility, a kind of reconciliation between humans and the mystery they sense: here, the "human condition" is framed relative to a "transcendent power" in the form of the ritual we commonly call religion. Despite their functional differences, each ritual form springs from the sensation of being in the presence of an unknown force—a numinous.

The essential point to take away from this is that Benjamin worried not at all about how rituals begin: he suggests that magic was followed by religion, but is concerned with neither how they arose nor their functional differences. These are, after all, so-called prehistoric moments, and he simply states that the original cult value of artworks was connected to their use in rituals of magic. But Benjamin's text becomes rather more tortuous when facing the problem of how to describe secular appreciation for works of art. By some unknown process, an object of cult value—an "instrument of magic"—comes to be "rec-

ognized as a work of art." There are, to be sure, traces of its lost ritual value in the form of "authenticity," but this is gradually replaced by a new value—exhibition value—which begins to emerge when the work is "emancipated" from ritual. Eventually this decline crosses a threshold, the "total function of art is reversed," and it becomes a tool of politics.

Although certainly not a ritual of control (such as taboo or magic), exhibiting works of art can be placed among rituals of commemoration, which "insert into historical time (in diachrony) mythological models situated outside of time (in synchrony) in a sort of eternity" (*Sociologie du Rite*, 29). A "masterpiece" is an obvious example of synchronic intervention in the flux of time, the unchanging presence of what might be called "eternal value" amid the ephemera of everyday life. Benjamin is reluctant to admit this, however, so that his greatest problem in the *Artwork* essay becomes how to explain the rise of the cultural practice of exhibiting art without repeating the "theology of art" promulgated by those critics of *l'art pour l'art* with whom he is quite stern (224). "Aura" is the umbrella term he invents to carry forward through time the vestiges of ritual function that cling to works of art. How does he characterize it? His well-known formulation, "the unique phenomenon of a distance however close it may be," is only part of the story; we must also pay attention to his example: "[If], while resting on a summer afternoon, you follow with your eyes a mountain range on the horizon or a branch which casts its shadow over you, you experience the aura of those mountains, of that branch" (222). Is it mere coincidence that Benjamin's example uncannily resembles Rudolf Otto's description of the numinous object? "Aura" is an invented term (*pace* Schlegel) for the founding sensation of the ritual of art appreciation in a secular society—a ritual that refuses to speak its name.

If Benjamin had not insisted on the difference between "cult value" and "exhibition value" in his analysis, the messy issue of "authenticity"—and the need for "aura" to carry it through time—could have been avoided. Naturally, his whole argument about the historic watershed of mechanical reproducibility would also collapse. Our "archaeology" of ritual in the *Artwork* essay demonstrates that for all its appeal to materialist history and concern with technical processes, Benjamin's text springs from the same systematic thinking that he deeply admired in the early Romantics. Obviously, we have not "proven" that Benjamin read or endorsed the specific texts cited here, but we have sug-

gested—to bowdlerize his own comments—that his thinking "was de-
termined by systematic tendencies and contexts, which in any event
reached only partial clarity and maturity; or, to express it in the most
exact and incontrovertible form: that [his] thinking can be *set in rela-
tion* to systematic lines of thought" ("Concept of Criticism," 135).
Seeing this relation powerfully suggests that the *Artwork* essay *looks
back in time*—to Benjamin's early writings and interests—at least as
much as it claims to map the future.

Toward the *Artwork* Essay, Second Version

The epigraph of the second version of Walter Benjamin's *Artwork* essay provides an allusion to the entanglement in which the true and the false find themselves in this text: "The true is what it can be; the false is what it wants to be" (Madame de Duras). The author of this cryptic phrase belongs to the Parisian salons of the eighteenth century. Is the salon maxim intended as a hint that Benjamin's text undertakes a decisive venture into the region of the false, uninhibited by the poor truth, which is restricted to "what it can be"? In any case, Benjamin makes use of the voluntarism of the false. The epigraph could also indicate, however, that the concepts of true and false are altogether inappropriate here, and that the essay instead concerns itself with the authentic.

Benjamin promises "theses about the developmental tendencies of art under present conditions of production." These conditions, which he adduces emphatically at the very beginning of the essay—especially when he invokes Marx—are barely discussed in what follows. At best, they are mentioned in the global sense of industrial production, or in the very special sense of the conditions of the production of film. First and foremost they are introduced in order to prove how antiquated are the "outmoded concepts" of art. This, however, is entirely unnecessary, for these "outmoded concepts" have only a dubious use-value for the theory of art. To annul them requires no venture into the theory of photography or film, since "creativity and genius, eternal value and mystery" have their use in the apology for the conventional practice of art at best. If they are applied to new art forms at all, such as film or photography, it is solely for the purpose of convincing the most backward audience of the merits of these new forms. They are not aesthetic concepts. Rather, they belong to the polemics or apologetics of art.

Another theme that is forgotten in the course of the essay is the retrospective effect that techniques of reproduction have on "art in its traditional form." Benjamin's treatise is itself a choice example of such

a mentally constructed retrospective effect on the traditional conception of art. It speaks of art in its traditional form solely from viewpoints that testify to the enhanced value of photography and film. Furthermore, it turns the traditional arts into a mere contrasting phenomenon of mass art. Only on the basis of this method does the "aura" of traditional art acquire the meaning attributed to it.

It is already a mistake to state that the photographic illustration of an artwork is a reproduction. The photographic likeness [*Abbild*] is in no way a copy [*Nachbildung*]. Consequently, it does not make the artwork that it depicts [*abbildet*] reproducible. At most, it competes with a drawing of the artwork and differs from it only insofar as it is reproducible without a change in quality. Thus, the dissemination of likenesses of artworks is not a transformation of uniqueness into reproducibility. Such transformation only happens in the studio. Rodin inflicted more lasting damage on authenticity through the serial production of his sculptures than all the photographic or filmic depictions of artworks ever could have. He wanted all of the versions of his sculptures to be equally authentic. However, this procedure inflicts no more damage on the idea of authenticity as such than the existence of many replicas inflicts on the authenticity of a piece of Greek sculpture.

Furthermore, it is clearly not the case that a cathedral, when being reproduced, is no longer bound to its specific location, but instead finds entrance into the studio of an art-lover. Not only is the "actual work of art" left untouched, but also its "here and now" is not "always" devalued, as Benjamin thinks. Precisely the opposite is true: the "here and now" experiences an increase in value. Benjamin's treatise is the best proof of this, for this text illustrates—against its own explicit thesis—how in view of the progress of the technologies of reproduction, the "here and now" of the traditional work of art gains tremendously in importance. Under the sign of reproducibility, the bare "here and now" is uncovered as the distinguishing mark of the work of art for the first time.

Nevertheless, it is correct that the technology of reproduction removes its products from the realm of tradition. But this holds only for the likeness that is duplicated, disseminated, and made potentially omnipresent by the technology of reproduction. That of which it is a likeness is dragged into this course of events only insofar as its perception has been subjected to the optics of reproduction. Undoubtedly, reproductions bring about a hitherto unknown availability of the "cultural heritage," which before was disseminated only within restrictive confines.

Therein lies, of course, a moment of wear and tear. At the same time, however, this cultural heritage becomes all the more irreplaceable in the original. In fact, the claims to experiences of authenticity even increase in proportion to the degree of the dissemination of reproductions.

This newly initiated treatment of the authentic engenders a relationship to the work of art that is detached from the experience of authenticity. The isolated contemplation of the artwork qua authentic, by comparison, is aimed at the original as such. But even this experience can be gained only by means of a comparison, for the perception of the authentic is as impossible as an isolated perception of the "here and now." All that can be said is that getting used to reproductions burdens the perception of the authentic with claims that cannot be fulfilled in the realm of pure perception. The spread of mechanical reproduction leads to a cult of the original and authentic that bears the traits of mystification.

To this mystification corresponds the description of the aura which Benjamin gives: "If, while resting on a summer afternoon, you follow with your eyes a mountain range on the horizon or a branch which casts its shadow over you." If one follows this description, it is indeed "easy" to comprehend "the social bases of the contemporary decay of the aura." In contrast to the exquisite situation of being liberated from all social connections, the "decay of the aura" is evident in all possible social conditions. The social attitude, however, cannot be grasped more easily in one case than in the other. To distance things from oneself or to "bring things 'closer'"—both of these attitudes are socially indifferent to an equal degree; and yet, both of them can be socially conditioned.

According to Benjamin, the first film theorists, in an effort to annex film to art, read cultic elements into film. But Benjamin himself proceeds likewise when he explains the cultic element as mandatory for all art that preceded the invention of photography. He proceeds with as much exaggeration regarding the art of the past as any early film theorist proceeded regarding the cultic stylization of contemporary art. In the process, Benjamin overlooks the fact that a cultic foundation or moment of art is always postulated in a moment of crisis when art detaches itself from its well-known, habitual functions.

For Benjamin's generation, emphasizing the cultic was an answer to *l'art pour l'art*. But art for art's sake is as close to ritual as any traditional practice of art. However, the ritual of *l'art pour l'art* is directed against another ritual that has been overcome. But first and foremost "the cultic" is a postulate of the emerging mass culture. It is an expression of the self-deification of mass society. To describe it as a founda-

tion of all conventional art is a backward projection of the founding and legitimating needs of self-doubting contemporary art. Benjamin's idealistic exaggeration of the auratic quality of earlier art is directly proportional to his intention to give a strictly materialistic foundation of contemporary art. Benjamin's materialism is a (negative) copy of aesthetic idealism; it appears before the framework of idealism, which has been made invisible.

What is new with respect to film, according to Benjamin, is that the work comes into being only through editing and montage. Everything which precedes it is mere "artistic performance." But this also applies to painting, for a painting is not already a work of art in each one of its brush strokes. It comes into being no differently than a motion picture as a series of "artistic performances" to which, admittedly, the hand of the individual artist makes a greater and more direct contribution. Preliminary drawings, sketches, and outlines contribute to a painting no differently than camera movements or specific takes contribute to a movie. The painter accomplishes a series of "artistic performances" before the work of art actually appears.

Exactly as a movie, the work of art is assembled from "artistic performances" and not from other works of art. At best, the latter would apply, under certain circumstances, to the work of architecture. Among the artistic performances that emerge in the course of the creation of a work of art, one can find many that belong to traditional art, yet, at the same time, display techniques not unlike editing and montage. Admittedly, the panel painting [Tafelbild] is different from a movie since it is not, as a rule, a communal achievement. The idea of organic individual creation is inspired by the special case of panel painting. Judged from this point of view, it appears as the exact opposite of the communal achievement of film. But precisely the postmedieval history of the panel painting illustrates that the assumption of cultic restrictions has the least validity for it.

In film, Benjamin observes, a part is acted in a different way than ever before "for a mechanical contrivance." This observation is meant to support the analogy with the "mediated tests" in industrial production or with sports. A general reliance on the mechanical and on machines links all of these processes. Furthermore, as Benjamin states, all of these performances are observed by a panel of experts. That may be correct as an observation, but the comparison of the intertwined functionality of the performances of the actor in film with test performances in industrial production is nonetheless a mere postulate. Benja-

min nonetheless extends this parallel when he remarks that it is a shortcoming of mechanical test performances in industrial production that they cannot be displayed to the degree that would be desirable. Instead, industrial production is meant to produce itself as film.

Film in comparison has the advantage that it makes the "test performance" of the actors displayable. In other words: it turns "the displayability of the performance itself into a test." Chaplin's *Modern Times* could have given rise to this construction. This film relies, in fact, on a reflection of industrial technology in film technology, which accurately follows the movements in industrial production—especially the dissection and assembly of objects. By comparison, painted representations, for example Léger's paintings, can depict the technological world only symbolically.

Benjamin's thesis that film forgoes the "aura" of the human person is as idealistic as the valorizing of the human form in Hegel's aesthetics. Such similarity betrays the idealistic character of Benjamin's theses. Indeed, it is a type of negative idealism: by means of sharp contrasts an idealistic reminiscence of traditional and contemporary art is evoked—only to be thoroughly annihilated subsequently so that merely a sort of negative form of the idealistic view remains—that is, a negative idealism. "[F]or the first time—and this is the effect of film—man has to operate with his whole living person, yet forgoing its aura." The proof of the thesis is to be supplied by the dependence of the representational performances on the filmic equipment. This dependence is confirmed by a number of deficiencies that can occur during film production. But in the final analysis, they are indistinguishable from deficiencies and technical malfunctions of the play on the stage.

The violent rendering of film and industrial production as analogous is further sharpened when Benjamin introduces the claim of any "man today . . . to being filmed," which amounts to "modern man's legitimate claim to being reproduced." This claim seems to be a veiled form of the right to work. Here again, the fact that modern man is subject to processes of reproduction, processes that could not care less about man, is idealistically elevated: through the self-reproduction in film, man regains his claim to sovereignty—or so goes the argument. For Benjamin, the "original and legitimate interest of the masses in film" is an expression of the will to self-recognition, but he thinks it possible only as class-recognition.

After the emphasis on the technological aspect of filmic production, another truly idealistic motif makes its appearance in the thesis that the

entire technological aspect of film-making culminates in an "aspect freed from the foreign substance of equipment"—that is, in a sort of "second nature": "[T]he equipment-free aspect of reality here has become the height of artifice." Such a concept of a "second nature" is—besides the motif of steady increase and sudden change into the contrary—the central concept of idealistic philosophy.

An element of negative idealism can be discerned in Benjamin's interpretation of the "expert" stance of the masses with respect to film. In reality, the film audience might assume as much of an expert stance toward film as has every audience toward representations that take the audience itself into account and include it. The audience also takes an expert stance with regard to the teller of fairy-tales in the marketplace—a stance furthermore that it could not so easily display with regard to Hafis's poems. But for Benjamin the backward stance toward Picasso is only the flip side of its progressive stance with regard to Chaplin. Whether the judgment of an audience is perceived as backward or advanced depends solely on the critic's judgment concerning the backward or advanced state of the object in question. Every audience judges the art that "belongs" to it in an "expert" fashion. Benjamin's theses amount merely to the observation that the wide audience of popular genres and of "entertainment" in general brings an interest to these types of art that differs markedly from the one it brings to elitist art. That this insight does not immediately appear as trivial is due to the fact that modern art, defining itself as the authentic reworking of mass experiences, has raised the ideological claim to an understanding of the masses (although there is no concrete evidence for it). For this reason, Benjamin wanted to ascribe specific experiences of art to the masses to which the artistic practice of the avant-garde "corresponds."

Avant-garde art wanted to determine on its own the kind of art intended for the masses. Benjamin's error is a consequence of the ideology of the avant-garde. The avant-garde assumed an ideological position that it could no longer satisfy on the functional level. However, a division of the reactions of the audience into progressive and reactionary responses—"thus the same public which responds in a progressive manner toward a grotesque film is bound to respond in a reactionary manner to surrealism"—is not permissible. The audience applauds those representations that directly include it as their addressee, but it rejects representations that are imposed on it, against its will, because they are allegedly popular or advanced. Occasionally, however, it may

succumb to such representations for ideological reasons, as is the case with the agitational art of revolutionary periods.

In accordance with the self-definition of the avant-garde, Benjamin burdened film with functions that go far beyond a genuine effect on the masses; but they correspond to his purpose of proclaiming film as the legitimate successor of traditional art. For this reason, the doctrine of catharsis must not fall by the wayside. In Benjamin's view, film functions as a therapy for mass psychoses: "[T]he American grotesque films and the films of Disney bring about a therapeutic blowing-asunder of the unconscious." They do this in "collective laughter." Film becomes a sort of psychoanalysis for the people, by reacting to the "repressions that are a part of civilization" by means of a cathartic removal—a shock therapy brought about by a drastic intensification of the moments of danger inherent to civilization.

Benjamin describes a procedure here that can hardly be distinguished from the procedures of Fascist mass art. According to him, the difference lies in the fact that Fascism in these "revolutionary innovations" unearths the tendency "to accept—with ease—bestiality and acts of violence as side effects of existence." It is remarkable that this reproach is not directed against Fascist products, but rather against the "latest Disney movies." It is a type of reproach of Fascism that became customary in the postwar period. Clearly, it is generated by the disappointment about the disregard capitalism displays for the intentions of the avant-garde.

The theory of the aura could be plausibly derived from Dadaism. Indeed, Dadaism recklessly suppressed the auratic element of its creations in order to make them unusable as "objects of contemplation." Benjamin violently detached Dadaism from the exact polemical context of its creation within the history of art in order to interpret the Dadaist technique as an anticipation of film, which, for its part, in no way possessed the same destructive attitude toward the conventional character of art. The detour via Dadaism is necessary for the attribution of anti-auratic intentions to film.

Contemplation and distraction are not categories inherent to the work of art. Rather, they describe types of behavior toward a work of art. They are not tied to the materiality of the artwork. Indeed, it is precisely the condition of the tradition of art that it is capable of undergoing a series of different types of behavior toward the work of art. Nevertheless, these different types of behavior are linked in a meaningful way: from the cultic location up to the museum. The relative in-

dependence of artworks from the types of behavior they encounter as well as their functional indetermination and poly-functionality circumscribed the experience from which aesthetic idealism proceeded to create the museum as the corresponding polytheistic pantheon of art.

Furthermore, it is probably a question of habituation whether or not one is capable of reacting to a "new" medium in a contemplative manner. Distracted reception and distracted perception may rather be functions of newness than of the substance of specific works. The works of Dada are the best examples. Originally the instrument and organ of shocklike distraction, these works, in the meantime, have become objects of contemplation just as good as any classic work of art. Similarly, habituation to film erased the principal moments of Benjamin's theory. Today, the shock effect is hardly connected anymore with the medium itself, but rather is provided by the subject matter. A re-screened film by Eisenstein is as far removed from the political as the Nike of Samothrace is from ritual. If, as Benjamin thinks, conventional art parasitically partakes in ritual, mass art partakes just as parasitically in the political. This means, however, that mass art can detach itself from the political to the same degree to which traditional art managed to detach itself from ritual.

In his comparison of traditional art and mass art Benjamin follows a conception of traditional art that had first evolved as a reaction against the dawning industrial society and mass culture. This opposition, which Benjamin sees as constitutive for the entire history of art, is only possible within modern society itself. The distance by which he separates traditional art as such from contemporary art is a consequence of an imposition of traditional aesthetic expectations on contemporary ones. Benjamin replaces the idealistic conception of art by a conception that he calls materialistic and considers its opposite. But, in fact, it is nothing more than an idealistic conception made unrecognizable as such. This deliberate confusion illustrates Benjamin's intention to abandon the idealistic conception of art. In his setup the idealistic conception is dashed to pieces, as it were, by contemporary art—that is, by photography and film. But in this process he neglects a type of continuity between traditional and modern art that cannot be captured by idealistic means.

—Translated by Peter Gilgen

The Reverent Gaze

*Toward the Cultic Function of the Artwork in
the Premodern and the Postmodern Age*

Walter Benjamin's *Artwork* essay was a canonical text for a generation
of students and young assistant professors who detached themselves
from the idea-historical tradition and turned increasingly toward so-
cial-scientific questions. There is, therefore, a certain appeal to read
Benjamin's study once again in a situation characterized by another
paradigm shift, one we might characterize as opening new types of me-
dia-historical questions. This is no less true for medievalists who want
and must apply the *Artwork* essay to the particular conditions of their
discipline, even if relatively isolated from the complexities of special-
ized discussions about Benjamin.

In the essay, Benjamin develops an early media theory.[1] He begins
with casting and stamping, the processes of technical reproduction em-
ployed by the early Greeks; he then cites printing as the condition for
the "technical reproducibility of writing." Finally, he sketches the his-
tories of woodcutting, engraving, etching, lithography, and photogra-
phy as technologies of an increasingly dynamic self-developing image
reproduction: "[T]hrough lithography, graphic art became capable of
illustratively accompanying the everyday. It began to keep pace with
printing. In this enterprise, however, it was already outstripped by pho-
tography a few decades after the discovery of lithography" (12). Pho-
tographic technology so perfected the process of pictorial rendering,
especially by relieving the human hand of its role as principal tool, that
representation was able to accompany and to keep pace with speaking

1. This article refers to the last version of the *Artwork* essay revised by Benjamin, as
published in the most widely distributed and—in terms of its reception—most definitive
edition, *Drei Studien zur Kunstsoziologie*. *Editors' Note*: Parenthetic page references in the
text refer to this edition of 1963, which is listed in the Bibliography as: Benjamin, "Das
Kunstwerk" (*Drei Studien*).

itself: the sound film, as a medium of secondary audio-visuality, made possible the synchronous transmission of both image and speech in real time (12ff).

Nonetheless, according to Benjamin, even the "most highly perfected reproduction" is missing one thing: "the here and now of the artwork—its unique presence at the place where it is located. . . . The here and now of the original constitutes the concept of its authenticity. . . . The entire sphere of authenticity is beyond technical—and naturally not only technical—reproducibility" (13ff). By the "authenticity" of a thing Benjamin means the "embodiment of everything that is handed down from its origin on, from its material duration to its historical testimony. Since the latter [historical testimony] is founded upon the former [authenticity], in reproduction—when authenticity has withdrawn from mankind—the historical testimony of the thing becomes hesitant. Of course, scarcely this; what becomes hesitant in this manner is the authority of the object" (15ff). In this context Benjamin introduces the concept of aura: "One can subsume what gets lost here into the concept of aura and say: what atrophies in the age of the technical reproducibility of the artwork is the artwork's aura" (16).

The concept of aura, I would recapitulate, is bound up with an emphatic concept of "uniqueness"—the concept of "originals"—that is defined as artwork by means of its unique presence, its "here and now." The diagnosed change, the loss of aura, leads Benjamin back to new technologies of reproduction. Implicit in this statement is the auratic character of artworks before the saturation of new technologies. How do we regard such theses today from the viewpoint of an expanded concept of media, which extends from oral transmission (brain memory), through writing (script memory) and printing (print memory), right up to the electronic accumulation of data?[2]

The perspective of media history has prompted one to see even the writing and imagery of a pretechnical age as types of media, and to view their insertion into orally dominated communication communities as the implementation of new technologies. In this regard, discussion of scriptural economies has brought out more clearly than ever before the fact that the concept of "originals"—of "authenticity"—is only partially transferable to medieval art. The Middle Ages become increasingly explicable to us as a sequence of scriptural-oral cultures of mem-

2. McLuhan, *Gutenberg Galaxy*; Leroi-Gourhan, *Le geste et la parole*; Ong, *Orality and Literacy*; Luhmann, "Das Problem der Epochenbildung und die Evolutionstheorie"; Gumbrecht, "Beginn von 'Literatur'/Abschied vom Körper?"

ory, in which writing, imagery, and sculpture have, above all, a supporting function for bodily bound memory.[3] "Literature" lives in oral performance, and is preserved by writing, in order to be released again into orality.[4] The written form is a condition of latency, of potentiality, of stopped communication, whose preservation is directed toward reanimation, toward the resuscitation of bodily bound communication in the space of co-presence. At the same time, the supporting function of writing is guarantor for the success of a performance that adapts itself to changing situations; the instability of the text[5] is the expression of a mobility that results from the modifications of varying performance situations.[6] The ability to reshape texts by means of performance variations relativizes the concept of original and authentic texts: "We must reckon with unstable, mobile texts that can change without the modifications being understood as disturbances. Medieval texts are not fixed at first and then belatedly changed; rather, the text is in a changeable format from the outset."[7] We have both abridged versions and unabridged versions of great courtly epics—various continuations of *Tristan*, for example—and very different versions of the Nibelungen themes.[8] Therefore, the material consistency, the historical testimony of distinctive originals, becomes hesitant in the domain of older vernacular literatures, and with it Benjamin's concept of aura as characteristic of art in a pretechnological age.[9] In the medieval period, the literary

3. Wenzel, "Imaginato und Memoria."

4. Kuhn, "Minnesang als Aufführungsform"; Ortmann and Ragotzky, "Minnesang als 'Vollzugskunst'"; Strohschneider, "Aufführungssituation."

5. Zumthor, *Essai de poétique médiévale*, p. 507. Also see Bumke, *Die vier Fassungen,* passim.

6. "Medieval writing does not produce variants, it is variance" (Cerquiglini, *Éloge de la variante*, pp. 57ff).

7. Bumke, *Die vier Fassungen*, p. 54. Concerning the various working versions of lyrical texts, Karl Stackmann writes: "Every transcript represents a version in its own right and is regarded as autonomous with respect to all other transcriptions: the philologist must attend equally to all of them" (Stackmann, "Die Edition"). Also see Stackmann, "Neue Philologie?"; and Tervooren, "Die Frage nach dem Autor."

8. "In view of the conditions under which courtly epics were written down and circulated, it is not only possible, but also quite probable that many authors had produced various versions of their work" (Bumke, *Die vier Fassungen*, p. 45). Also see Strohschneider, "Höfische Romane in Kurzfassungen"; and Henkel, "Kurzfassungen höfischer Erzähltexte."

9. Once again citing Bumke: "The early multiple versions attest to the fact that the text was as yet unfixed in its proximity to an author and in its scriptural form, that various formulations could come into being. . . . On the basis of the prevailing orality of courtly literary enterprises, the early phase of handing down the work must reckon with partial publications, multiple editions, and changing performance and recording situations." Against

artwork had no "unique presence at the place where it is located" (13), nor the distinctive "here and now of the original" (14) that makes up the "concept of its authenticity" (ibid.).

Against the background of the scriptural-oral relationships of medieval literature, Benjamin's stipulation of identity between auratic works of art and the autonomous artwork seems adequate to the notion of distinctive individual artists, of great historical individuals. The art of medieval texts, however, does not lie in invention, but rather in shaping; "authenticity" is not lodged in originality, but in validity. In many cases, its status as art can be described as intertextual, and was explicitly formulated as such. Around 1215, Thomasin von Zirclaria, who wrote a book for courtly education called *Der Wälsche Gast*, spoke of the character of his work by using the metaphor of an architect:

> But he is a good carpenter who knows how to place stone and wood in his building where it should properly be placed. It is not a weakness if it also easily happens to me that I skillfully place in my poem's wall wood that another hand has crafted, so that it is exactly like the others. A wise man has once said of this: "Whoever can adroitly place into his poem an utterance which he did not make, he has done just as well (this no one should doubt) as he who invented it in the first place. The invention immediately became his own." It is my intention (desire) that one should reinforce one's speech with the teachings of other good people. It is honorable that one should despise no one.[10]

What does this metaphor express? It speaks of the bricks and beams of the text, of the "wall" of a poem that is assembled by the hand of a knowledgeable master, but is also divisible into its different components. In contrast to the literary concept of aesthetic genius, and to the notions of authenticity and originality, the category of handcraftsmanship dominates. The skillfulness of the act of joining together—the technical side of the process of production—is decisive here, not genuine invention. Intertextuality as a constitutive principle is made to depend upon the text-builder's assimilative energy, on the inner harmony of his textual construct, not upon the origin of the bricks and beams of his text. No aura protects the text; it is competently manufactured, but yet, at the same time "wall" and "quarry"—a whole harmoniously joined together and material for other craftsmen and architects. Al-

this, according to Bumke, "the later handing down of the work shows an astounding stability in written transmission" (Bumke, *Die vier Fassungen*, p. 67).

10. Thomasin von Zirclaria, *Der Wälsche Gast*, v. 105ff.

though the representation of the "wall" of a poem presupposes a written form—the idea of a written page or manuscripts—the laws of prescriptural cultural tradition still seem to be operative: cultural knowledge belongs to everyone; it is constantly reworked and refinished by talented specialists in a permanent process of unraveling and refabrication.[11] Postmodernity and premodernity join hands.

Nonetheless, it is also and precisely with regard to medieval texts that one must retain the concept of aura, and do so throughout with reference to Benjamin, who saw the origin of the auratic in cult—a correlation in which the work neither stands for itself nor is grounded in its own authority, but rather refers to some higher authority. This holds true not only for sacred texts but also for courtly literature.

If Thomasin speaks of courtly novels, which he recommends to young nobles as reading, he does not speak of authors or themes; indeed, on the contrary, he speaks of living or previously living persons:

> Young maidens should pay attention to Andromachae, from whom they can take a good example and good instruction, from which they will both profit and gain in reputation. They should hear about Enite, and they should follow her without reservation. They should also follow lady Penelope and Oenone, Galiena, and Blancheflor, . . . and Sordamor. If they aren't all queens by birth, they could be by virtue of their beautiful sensibilities.[12]

The stories are not transmitted in the name of their writer/author, but in the name of their heroines. The same holds for the exemplary male characters of epic, for Gawain, Erec, and Iwein, for Alexander the Great, Charlemagne, and Tristan.[13] Thomasin does not differentiate among the heroes of literature and history, subjects from antiquity [*matière de Rome*], narratives of the Charlemagne circle [*matière de France*], or Arthurian literature [*matière de Bretagne*]. In much the same way that a family can be experienced as a continuum of time and space in a gallery of ancestral portraits, the great names of collective memory are here united in an ensemble of binding prototypes. The narratives handed down offer visualization of a succinct line of exemplary bodies that are conveyed by writing, but should be contemplated by

11. This holds similarly for the cathedral or the pulpit of Aachen, in which prefabricated parts of vastly different origins and functions were joined together in an aesthetically balanced and functionally perfect creation (see Schmitz-Cliever-Lepie, *Die Domschatzkammer zu Aachen*).

12. Thomasin von Zirclaria, *Der Wälsche Gast*, v. 1029ff.

13. Ibid., v. 1041ff.

courtly nobles like a "mirror" for their self-maintenance: "[O]ne should cultivate each one / so that he fulfills with good deeds / all that he has read of goodness."[14]

Thomasin suggests that the scriptographic storage of information be used like the "old" media of oral communities—namely, by means of imitation and participation in the actions and postures of their exemplary representatives.[15] Thus, Luhmann's thesis of the reciprocal modification of medias holds up, in this case memory bound to bodies and to writing.[16] Meaning adheres even more to bodies—to visibility and audibility—even if these bodies are portrayed by the epic gaze of writing. One finds the following formulation in Benjamin's *Artwork* essay: "Now, however, the reflected image has become separable: it has become transportable. But where has it been transported? Before the public" (31). Benjamin speaks of the film actor and the camera before which he stands, but his description, from a media-historical perspective, can be applied to the function of books, to the severing of writing from its author, who delivers his book to his public as a "mirror."

The approach to this orally transmitted "body" is not one of aesthetic or historical distance, but rather a ratio of remoteness that is simultaneously one of proximity. The representative figures of courtly memoria are as present and as distant as the preeminent ancestors of a noble family: one knows of them, speaks of them, cites them as role-models for the next generation of young people, and links them to contemporary discussions of social values and norms. The historical space involved—marked by authority as well as familial intimacy—exists simultaneously in the present and in the past.

This particular form of aura, which binds itself to the represented carrier of action and not to the mode of its representation, not only applies to courtly literature but also to sacred art. Believers place themselves in an immediate relationship with the statues and frescoes of their saints and martyrs. This is not aesthetic contemplation, but rather an unmediated meeting, a situation that also applies to holy relics.[17] Holy shrines are treated as if the saints were immediately present and capable of unmediated communication; an exchange, therefore, not only characterized by religious devotion but also by a relationship between reward and achievement. The saint receives an offering for his

14. Ibid., v. 4ff.

15. Wenzel, "Partizipation und Mimesis"; and Wandhoff, *Der epische Blick.*

16. Luhmann, "Das Problem der Epochenbildung und die Evolutionstheorie," p. 20.

17. Wenzel, "Die Verkündigung an Maria."

intervention, but he is mocked and defamed if he fails to meet the believer's expectations.[18] The *damnatio memoriae*—the destruction of images of the ruler—corresponds to the destruction of the images of God in local, self-repeating iconoclasms.[19] One can describe the relationship to the ruler like the relationship to the saint by means of proximity and distance.[20] The double body of the king is, on one hand, a consequence of his (physical) absence and, on the other, an expression of his (symbolic) proximity: a coat of arms or sign of sovereign power, and a tight network of very diverse symbols, guarantee the ubiquity of the king's body. The immaterial body of God is made present for believers by means of rituals, images, and symbols. This doubling of proximity and distance constitutes an auratic defense of sovereign power in accord with Benjamin's stipulation of aura as the "unique phenomenon of a distance, no matter how far it may be" (18). The ruler is present in the sign, even if he is physically absent. This "suggestion system" remains tied to the legality of the established hierarchy of values. It can easily collapse as a result of political upheavals, religious reform movements, or the demise of a ruler or saint. Accordingly, no statue or panel is more secure than any other from mutilation or destruction. That is to say, the construction of aura as a social phenomenon depends upon the validity of a highly complex symbol system, a balance of expectation and experience, and the mutual protection of those who believe in the establishing and rectifying reflection of looks, voices, and gestures.

According to this hypothesis, the artwork in the age of its manual reproducibility would be furnished with an aura only so long as it is endowed with one by the assent of believers. Thus, the condition for auraticization would not be "authenticity," or the "here and now of the original," but rather the humility of believers, the cult, and the pious gaze. Taken together, these would be conditions for the possible destruction of aura, and Benjamin himself pointed in this direction with the explicit formulation: "The original form of embedding works of art in the context of tradition found its expression in the cult" (19). Therefore, what "withers in the age of the technical reproducibility of artworks" (16) would be their cultic function, "which is still recognizable as secularized ritual even in the most profane forms of the cult of

18. Brown, *Society and the Holy.*
19. Vittinghoff, *Der Staatsfeind in der römischen Kaiserzeit;* and Marchal, "Bildsturm im Mittelalter."
20. Kantorowicz, *Die zwei Körper des Königs,* passim.

beauty" (20). Benjamin's argument continues logically: "[T]echnical reproducibility of the work of art emancipates it, for the first time in world history, from its parasitical existence in ritual. The reproduced artwork becomes, to an ever greater degree, the reproduction of an artwork calculated for reproducibility" (21). Benjamin develops this thesis with respect to photography, but his concept of "copy" can also be transferred to a consideration of literature and printing: "From a photographic negative, for example, any number of prints can be made; the question of a genuine print makes no sense. But the instant that the standard of authenticity no longer applies to artistic production, the total function of art radically changes. In place of its foundation in ritual, its foundation is shifted to another practice, namely to its foundation in politics" (21). For the medieval historian, authenticity is not an important condition for the cultic function of the artwork, and the borders of politics and cult cannot be drawn so resolutely as Benjamin drew them under the conditions of the 1930s. For that reason, it is natural to investigate the function of old and new rituals, and to take up simultaneously the question of whether or not "copies" can receive a cultic function.[21] If aura is no longer sought in the work itself, but rather in the meaning-making frame, some examples suggest themselves: we will consider three different types.

The survival of old ritual functions is demonstrated by a picture of the Virgin Mary in an Italian mountain cabin (or in a streetcar in Lisbon, or in the cab of a crane operator in Spain) that, upon closer examination, proves to be a reproduction printed in an edition of ten thousand. It could have been cut out of a magazine but, when framed behind glass with the obligatory bouquet of flowers before it, the nearby image becomes a local icon, making present the distant mother of God. The technology of reproduction "detaches the reproduced object from the realm of tradition" (16); however, it does not do this definitely and everywhere, because this process of detachment can be abolished again and again by religious contemplation and cultic framing. Certainly, the auraticizing gaze can also be the individual gaze that moves a photograph into the position of an icon, and this photograph does not have to represent the Virgin Mary: it can also represent the popstar Madonna or simply Friederike B.[22]

21. Soeffner, "Rituale des Antiritualismus."
22. Braun, "Ce n'est pas une femme."

More complex to classify is the cult film, which brings together a community of initiates who celebrate, in a common, more or less fluctuating ceremony, the filmic revisualization of an event that is long known to all of them but which, in the collective gaze, is raised to the level of a cult event and retained as such. Benjamin postulates that the cinematographic apparatus, in contrast to the theater that connects actor and public, destroys aura: "The aura which envelops the actor must then disappear—and with it simultaneously the aura enveloping the character he plays" (29). But the public's grasping ignores the media-induced distance and auraticizes the actor in his mediated transmission; for example, Humphrey Bogart in *Casablanca*.[23] The cult does not satisfy itself with an "overview," with looking only at the surface of the media, but insists on closer inspection. The community of fans in no way identifies with the actor, "only insofar as they identify with the camera" (28); rather, the spectator "enters into this work the way legend tells of the Chinese painter when he views his finished work" (46), and this state of affairs has often been thematized in films, such as Woody Allen's *Play It Again, Sam* or *The Purple Rose of Cairo*.

The museum as cathedral of the present, as the architectonically exposed showroom of collective symbols, opens, via its own ritual passages (ticket-counter and coatroom), the space of another reality in which even the Readymade—Duchamp's bottle-stands or the bathtub of Joseph Beuys—are detached from their use function and become objects of a "secularized cult of beauty." The room of art contemplation is differentiated from the worldly hurly-burly of the cafeteria next door by hushed tones and a more or less pronounced reverence before the exhibited pictures.

We see then that new ritual and current forms of auraticization exist next to the remaining stock of old rituals and their secularized forms of expression. In discussion with Mary Douglas, Hans Georg Soeffner makes clear that we in no way live in a time of engaged antiritualism, but, on the contrary, we operate much more in the state of an *inscruta-*

23. This also still holds, in ironic refraction, for the community of those in Aachen who celebrate year-round the *Feuerzangenbowle* [flaming red wine punch]: decked out in frock coats and top hats, with a bottle of blueberry wine in an antique car, they pull up to the auditorium in numbers to enjoy the Rühmann film with like-minded people as in prior years: *same procedure as last year*.

ble ritualism.[24] The rituals of political protest movements, youth counterculture, and parareligious self-discovery groups have developed a fullness of symbolic forms of expression: from the bodily configurations of common ceremonies, from the clothing to the emblems, cult books, and music by which the "group soul" articulates itself. In a functionally differentiated society, the collective gaze is dispersed and robbed of its directional ability by the multiplicity of media. Precisely because of this, the resuscitation and re-establishment of collective and individual rituals promises an experience of authenticity, a secondary auraticization in a secondary performance culture that connects the cultically oriented, prebook age to the postbook age. Certainly these rituals are transient and are not permanently safeguarded by firm institutions, so that the processes and the objects of auraticization are themselves volatile.

24. Soeffner, "Rituale des Antiritualismus," p. 520.

Walter Benjamin in the Information Age?

On the Limited Possibilities for a Defetishizing Critique of Culture

Benjamin did not have a portable computer or hypertext program at his disposal for his work on the *Arcades* project, but he already thought of himself as living in an information age. He described the characteristics of this age in *The Storyteller* (which bears many resemblances to the *Artwork* essay and was also published in 1936), where he outlined a process within literature akin to that of the withering of aura in the visual arts.[1] Storytelling, he wrote, was disappearing because "experience has fallen in value. And it looks as if it is continuing to fall into bottomlessness" (S 83). Total war and inflation had been the immediate causes of this devaluation of experience, but, over the longer term, the "dissemination of information" had exerted a decisive influence and brought about a crisis in both storytelling and the novel. In the newspapers, "no event any longer comes to us without already being shot through with explanation" (S 89). Whereas the value of a story, deeply embedded in oral tradition, depends upon its leaving events unexplained and thus allowing readers to interpret it over time, "the value of information does not survive the moment in which it was new. It lives only at that moment; it has to surrender to it completely and explain itself to it without losing any time" (S 90). Like mechanically reproduced art, the information media shatter tradition and create new, mass-produced cultural forms that replace not only the old, premodern forms (storytelling as a craft, comparable to the work of art in the service of ritual) but also the modern forms characteristic of the age of the ascendant bourgeoisie (the novel, whose birthplace is the solitary

1. *Editors' Note:* Unlabeled parenthetic references in this essay are keyed to the edition listed in the Bibliography as: Benjamin, "Work of Art." References labeled (S) are keyed to the edition listed in the Bibliography as Benjamin, "Storyteller."

individual, comparable to putatively autonomous art). In both essays, Benjamin sees the present status of art or communication as a result of its emancipation from tradition, its increasingly abstract character (symbolized by the reduction of the role of the "hand" or craftsmanship in its production), and its mass audience.

These processes all seem to involve, for Benjamin, a form of demystification. In *The Storyteller*, Benjamin hints at a complex attitude vis-à-vis this demystification, but in the *Artwork* essay, he celebrates it outright as a form of "emancipation" closely related to the Marxist tradition of defetishizing critique.[2] The fetish, of course, is the object that people create but then endow with powers independent of themselves. The aim of "defetishizing critique" is to reveal to subjects that perceived objects (institutions, commodities, history, forms of consciousness) actually result from the activities of subjects, and thus are not inescapably "given" facts but processes open to change. Defetishizing critique relies in part on the assumption (today often contested) that if people understood the way in which the world and the social system they have inherited were products of prior generations, they would be in a better position to change that world and that system. Defetishizing critique arises from the Hegelian-Marxist historical schema that claims history is the history of Spirit's (or humanity's) self-objectification in the world and its coming to consciousness of its dual status as the constituting and constituted subject of history.[3] This historical schema has come under considerable scrutiny since 1936,[4] especially for its "unitary" model of subjectivity; that is, its subsumption of diverse subjects under the unitary category of "Spirit" or "humanity" (or "species being"). Nonetheless, defetishizing critique remains an important tool of cultural studies that claim to offer solutions to political problems. It often appears in the guise of the critique of the "social construction of reality," which suggests, in its most schematic form,

2. The starting point for my discussion of "defetishizing critique" in the context of Benjamin's essays has been the work of Seyla Benhabib, although it is impossible to give her analysis adequate attention within the limited scope of this essay. The discussion of plurality and finitude, and the distinctions communicative/objectifying activity and transfiguration/fulfillment in my comments also build on her work, although I use transfiguration and fulfillment in a rather different sense than she. See Benhabib, *Critique, Norm, and Utopia*, pp. 44–69, 114–23, 163–82, and 327–53, as well as Benhabib, "Critical Theory and Postmodernism." I wish to thank Morris Kaplan for discussing with me both Benhabib's work and certain of the problems posed here.

3. These and related assumptions are summarized under the rubric "philosophy of the subject" in Benhabib, *Critique, Norm, and Utopia*, p. 54.

4. Starting with Benjamin's own "Theses on the Philosophy of History."

that since society has constructed reality in a given way, it is up to society (or at least *possible* for society) to deconstruct and reconstruct it in a better way.[5] Benjamin frequently expresses sympathy for the view of the fetishist—as in the almost mystical powers he sometimes attributes to objects, or the positive role of the commodity as dream in the *Arcades* project—but his attitude in both of the 1936 essays is that of defetishizer. He reveals revered objects to be the result of historical processes, and both suggests and proclaims outright the possible transformation of these processes by the proletariat's self-realization.

The historical (or eschatological?) horizon of *The Storyteller* does not place the same emphasis on figures of the fetish as does the *Artwork* essay. If the aura of a work of art originates in its fetish character (its cult or ritual value), the story, in contrast, has no such fetishistic origin, but arises within the context of definite relations among people, and has a use value of its own—it communicates "intelligence from afar" (S 89). Storytelling, "an artisan form of communication," presents itself not as an objective fact but as a social process: "Thus traces of the storyteller cling to the story the way the handprints of the potter cling to the clay vessel" (S 91–92). In the fairy tale, the story's oldest form, fetishization is held in check by working against myth: "The fairy tale tells us of the earliest arrangements that mankind made to shake off the nightmare which the myth had placed upon its chest. . . . The liberating magic which the fairy tale has at its disposal does not bring nature into play in a mythical way, but points to its complicity with liberated man" (S 102). Benjamin's liberated man, in these concluding pages of the essay, is in harmony with the world of created things yet still maintains an autonomy that depends on recognizing his separation from the natural world. Benjamin can only conceive this utopia by appealing to a collective subject, an image of humanity, whose experience "even the deepest shock of every individual experience, death, constitutes no impediment or barrier" (ibid.). Because fairy tales and stories belong to the world of collective experience, they are capable of envisioning a redeemed world.

The Storyteller lays great emphasis on death, which suggests both human finitude and the close relationship of human existence to natural processes: "Dying was once a public process in the life of the individual and a most exemplary one. . . . Death is the sanction of every-

5. Obviously, this is an incomplete representation of the claims of various social constructionists. For an interesting recent elaboration and defense of a much more complex theory of social construction, see Butler, *Bodies that Matter*.

thing the storyteller can tell. He has borrowed his authority from death. In other words, it is natural history to which his stories refer back" (S 94). As the primary image of a redeemed world, Benjamin cites Leskov's interpretation of the Resurrection, "less as a transfiguration than as a disenchantment, in a sense akin to the fairy tale" (S 103). Disenchantment is, of course, an important metaphor for enlightenment; the redeemed world maintains its plurality and finitude, but in a disenchanted form. The essay presents two versions of utopia: the collective past of village life, and the redeemed (but not transfigured) future of the Resurrection. Here Benjamin may be accused of "nostalgia," but his utopias do leave open certain possibilities shut out by the *Artwork* essay, which seems to attribute an utterly false consciousness to all the believers and worshippers of art, and to condemn all aesthetic theories as priestly conspiracies. The logic of the fetish is the only logic Benjamin grants the work of art. In contrast, to the story he allows the possibility of an imagined world of noncompetitive human interaction, reconciliation with nature, and the creation of value in a social system relatively untouched by the division of labor. It seems that what gives Benjamin a sympathy for the story that he does not have for the work of art is his sense that the former belongs to a mode of intersubjective human interaction, whereas the latter belongs to a mode of objectifying action.[6]

Only with the rise of the novel, isolated from oral tradition, does the historical schema of *The Storyteller* converge with that of the *Artwork* essay, according to which from the Renaissance to the nineteenth century the defenders of art's autonomy "denied any social function of art" (224). The champions of *l'art pour l'art* thus seem to fall under the spell of the fetishism of commodities, described by Marx in the first chapter of *Capital*: "[The commodity] is nothing but the definite social relation between men themselves which assumes here, for them, the fantastic form of a relation between things."[7] The novel, unlike "all other forms of prose literature," depends essentially on the printed book (S 87). Only the conversion of the book into a commodity by the invention of the printing press made "dissemination" of the novel possible. The novel also effectively justifies the capitalist order by making the conditions of life in that order appear natural, the hallmark of the

6. Benhabib has noted a dependence in early critical theory on the "objectifying" model of action, and has proposed (following Habermas) a shift in emphasis toward "communicative" action (see n. 2).

7. Marx, *Capital*, I, p. 165.

fetish. What Benjamin describes in his analysis of the novel is the impossibility for the isolated individual to give counsel in the way that the storyteller could: "The birthplace of the novel is the solitary individual, who is no longer able to express himself by giving examples of his most important concerns, is himself uncounseled, and cannot counsel others" (ibid.). The other, closely related difference between the novel and the story implies the novel's acquiescence in the modern abandonment of plurality and finitude: the perpetuating remembrance of the novelist is dedicated to "*one* hero, *one* odyssey, *one* battle," while the "short-lived reminiscences of the storyteller" are dedicated to "*many* diffuse occurrences" (S 98). Whereas the storyteller envisioned a disenchantment that would also be redemption and allow integration of the individual in the community and in nature, the disenchantment actually offered by modernity consists in the individual's separation from community and nature. Benjamin borrows directly from Lukács when he writes that the novel is "the form of transcendental homelessness" (S 99).[8]

The modern age of *The Storyteller* resembles that of the *Artwork* essay in its essential alienation, but Benjamin is again kinder to the novelist and the novel-reader than to the artist and the aesthete. When Benjamin writes that "to write a novel means to carry the incommensurable to extremes in the representation of human life" (S 87), he appeals to the idealist language of Lukács's *Theory of the Novel*, but he also seems to point to the solution envisioned by Lukács in *History and Class Consciousness*: a revolutionary proletariat, the identical subject-object of history, able to resolve the contradictions inherent in the structure of modern experience.[9] The novelist describes these contradictions in good faith as it were, like the idealist philosophers analyzed by Lukács who cannot resolve the "antinomies of bourgeois thought" because only history—and the proletariat—will be able to do so. The artist merely continues to perpetrate the priestly fraud.[10]

When it comes to the information age, however, Benjamin sees a similar process at work in both communication and the visual arts. Experience, a positive value in *The Storyteller*, loses its relevance and its communicability and is replaced by a seemingly more objective and verifiable "information." The main criterion for knowledge in the age

8. The primary text is Lukács, *Theory of the Novel*.

9. Lukács, *History and Class Consciousness*, pp. 83–222.

10. To which we might add the poet, since Benjamin mentions Mallarmé in the *Artwork* essay.

of information, and one that seems to prepare the way for revolution, is verifiability: "It is no longer intelligence coming from afar, but the information which supplies a handle for what is nearest that gets the readiest hearing. . . . The prime requirement is that [information] appear 'understandable in itself'" (S 89). Similarly, mechanical reproduction "detaches the reproduced object from the domain of tradition" and brings it nearer to its audience (221). The *Artwork* essay specifies the political cause of this change: "[T]he desire of contemporary masses to bring things 'closer' spatially and humanly" (223). In *The Storyteller*, Benjamin sees this process of the shattering of tradition as a necessary stage in human progress: "Nothing would be more fatuous than to want to see in [the decline of storytelling and the dying-out of wisdom] merely a 'symptom of decay,' let alone a 'modern' symptom. It is, rather, only a concomitant symptom of the secular productive forces of history" (S 87). In a sense, the replacement of wisdom by information involves a type of defetishization, since it creates a verifiable, objective world. It entails, for Benjamin, a step in the fulfillment of the project of enlightenment and modernity, although it is a very incomplete fulfillment; another step is clearly necessary and is to be anticipated.

In the *Artwork* essay, this further step consists not in the fulfillment of the processes of enlightenment and secularization, but in their transformation, which the age of mechanical reproduction puts in motion. Benjamin's definition of the aura of a work of art and the conditions for its liquidation illustrate the essay's dependence on the Lukácsian Marxist theory of the reification of consciousness and its inherent logic of defetishization. The aura of a work of art resembles the aura of nature; both involve the "unique phenomenon of a distance, however close it may be" (222; 243, n. 5). The age of mechanical reproduction destroys the authenticity of the work of art but not that of nature (221). The work of art is, to use more recent jargon, "denaturalized." By "emancipat[ing] the work of art from its parasitic dependence on ritual," mechanical reproduction reveals the true basis of art in social forces: "Instead of being based on ritual, [the total function of art] begins to be based on another practice—politics" (224). That Benjamin sees this process as part of a Lukácsian schema of the defetishization of history becomes clear near the end of the essay, when he describes the process by which "the masses" (also referred to, in a significantly different register, as "the public") come to have a progressive, rather than a reactionary, relationship to mechanically reproduced art: "The pro-

gressive reaction is characterized by the direct, intimate fusion of visual and emotional enjoyment with the orientation of the expert" (234). This fusion of subjective and objective orientations to art suggests Benjamin's striving for a mode of art that would allow the proletariat (transformed into the public) to recognize its identity as the constituting and constituted subject of history, and thus to see in the artwork an objectification of its essence.

In the distracted form of reception that the essay envisions as a revolutionary mode of consciousness, the masses—while they may fuse subjective and objective attitudes—can hardly claim to be the constituting subject of the film that they are, after all, only watching and not producing. To illustrate that this possible fusion of subjectivity and objectivity motivates not only the progressive form of the reception of art but also the progressive form of art's production, Benjamin turns to an example from communication rather than the visual arts. After asserting that "any man today can lay claim to being filmed" (an activity that emphasizes the person as object before the camera), Benjamin goes on to suggest that "this claim can best be elucidated by a comparative look at the historical situation of contemporary literature" (231). Here, Benjamin draws conclusions excluded from *The Storyteller* that suggest some of the implications of the new information age: "Today there is hardly a gainfully employed European who could not, in principle, find an opportunity to publish somewhere or other comments on his work, grievances, documentary reports, or that sort of thing. Thus, the distinction between author and public is about to lose its basic character. . . . At any moment the reader is ready to turn into a writer" (232). Idealists of the Internet and desktop publishing continue to harbor such hopes, but the point is that Benjamin, in order to articulate the utopian potential of the revolution in the reproducibility of art, turns away from the visual arts, which he has tended to explain with an "objectification" model of action, toward communication, an explicitly intersubjective activity.

It seems to me that the distinction between these two models plays an important part in the very different constructions of history in these two essays. The *Artwork* essay foresees in the age of mechanical reproduction the radical transfiguration of the work of art from a fetish, an alienated creation of the human spirit, into a process in the service of humanity. The nature of this transformation, as Benjamin describes it, will be a radical "politicization" that involves essentially eliminating the specificity of the artwork and reappropriating the alienated objects

for the sake of the subject.[11] Yet the only meaningful example of such a transfiguration is the conversion of the visual arts into something like information, which serves the subject by communicating its needs. In *The Storyteller*, the story originates as an act of communication, not of objectification, and after passing through a period of noncommunication (the novel), it returns to its original function of communication, albeit in a secularized form for the masses. The trajectory of *The Storyteller* differs from that of the *Artwork* essay in one other respect. In the latter, Benjamin asserts (perhaps against hope) that the changing nature of the work of art will lead to a revolutionary transformation of consciousness among the "public," and he exemplifies this in his account of an Internetlike communicative network. In *The Storyteller*, an essay dedicated to forms of communication, Benjamin recognizes that the claim to objectivity made by the new media may itself be a type of fetish: "Often [information] is no more exact than the intelligence of earlier centuries was. But while the latter was inclined to borrow from the miraculous, it is indispensable for information to sound plausible" (S 89). Benjamin's near-failure to recognize that the products of film and photography could be just as fetishized as the earlier forms of painting and poetry has been the source of the most persistent and obvious criticism of the *Artwork* essay—namely, that aura has not disappeared. Even if mechanical reproducibility destroys the aura of some works of art, it apparently maintains it for others. In fact, old movies, the very subjects of Benjamin's essay, seem almost to monopolize aura, creating it for themselves at the expense of the older works of art that they have "denaturalized." Whether the auratic quality of old movies depends on their distance in time or on some aspects of the technical revolution Benjamin described is too complicated a question to discuss here. However, I would suggest that Benjamin's dependence on a radical logic of defetishization contributed to his misplaced hope in the mechanical reproduction of art.

Benjamin begins with a situation where a subject (humanity) alienates itself by objectifying itself in the creation of the work of art, and whose only solution is the radical transformation of the objectified essence, its liquidation into pure subjectivity. Where he perceives a more fragmentary (but still collective) group as the source of stories (which represent transmissible experience rather than objectified essence), he

11. For a discussion of the various criticisms of Benjamin's allegedly totalitarian logic, see Starkman, "Unaesthetic States."

can imagine—or, given his theory of history, at least predict—a ful-
filled, disenchanted version of a secular world, a this-worldly sort of
utopia within which individuality and plurality do not imply aliena-
tion. I am suggesting that Benjamin's thinking relies on a tacit distinc-
tion between communication in language—an intersubjective, nonal-
ienated activity—and artistic production—a form of objectifying, and
therefore alienating, activity. My own distinctions in this essay have
reproduced such an opposition, yet they clearly face a problem when
confronting the questions posed by contemporary philosophies of lan-
guage. Does not communication imply objectification and alienation,
and even *depend* on it? Is it not possible to understand artistic produc-
tion, and other forms of objectification, as variations of intersubjective
activity? as types of language games? To which a further question, di-
rected at understanding and evaluating the work of the Frankfurt
School, must be added: if an intersubjective, communicative model of
action replaces the objectifying model, how then can the project of re-
deeming nature, which cannot be considered simply as an intersubjec-
tive project, be kept alive? If the project of a defetishizing critique of
culture is to be relevant, it must consider a number of key issues: the
persistence of the fetish, which implies the utopian character of the
goal of the subject's transparency to itself; the plurality of subjects,
which implies the utopian character of the collective subject (human-
ity); the undecidability of objectifying and intersubjective modes of ac-
tivity; and, especially, the decidedly limited nature of any foreseeable
transformation by which the constituted subjects of history will be able
to recognize themselves as its constituting subjects. To paraphrase
Marx, but here with the emphasis on the often underestimated qualifi-
cation: people make their own history, but not under conditions of
their own choosing.

Media Theory After Benjamin and Brecht: Neo-Marxist?

"Being determines consciousness!" This ontological dualism expressed by Karl Marx appears to have been outdated for a long time. It is well known that Marx grasped this ominous *being* primarily in economic terms in order to deduce from this deep structure the surface of the "superstructure." Interestingly, Walter Benjamin's *Artwork* essay follows this tradition. The Preface tells us that the "present conditions of production" shape not only the "developments and trends in art" but also those in all other cultural spheres. This occurs, however, with a certain delay caused by the fact that a "radical change in the super-structure will take much longer than one in the substructure" (471).[1] But it is just this temporal difference between being and consciousness, between sub- and superstructure, that provides Marxist theory with its prognostic powers. Benjamin's futurology arises from the analysis of the actual conditions of production, which prompts him to make "certain prognoses" (WB35 435).

Paul Virilio, the media theorist, recently declared that "Marxism has become the expiatory sacrifice of high technology."[2] My argument against this point of view is based on the fact that the latest reflections on media theory—following Benjamin's *Artwork* essay—reformulate this specific Marxist distinction between being and consciousness, even if the radix of this model cannot always be identified easily. In order to be able to categorize "postmodern" media theorists such as Norbert Bolz or Friedrich Kittler (although, of course, entirely against the way

1. *Editors' Note*: Two versions of Benjamin's *Artwork* essay are discussed in this article: unmarked parenthetical references in the text are keyed to the 1936 edition listed in the Bibliography as: Benjamin, "Das Kunstwerk" (*Gesammelte Schriften*, 1974); parenthetical references marked (WB35) refer to the 1935 edition listed in the Bibliography as: Benjamin, "Das Kunstwerk (1935)."

2. Virilio, *Krieg und Fernsehen*, p. 70.

they see themselves), I will first examine the Benjaminian method of prognostication and the direction of its impact; then I will raise the question as to what the *new school* of contemporary media studies inherits from it.

I

Without a doubt, Bertolt Brecht also belongs to the *old school*. As early as 1931—that is, well before Benjamin—Brecht links the analysis of the new medium of film to utopian expectations. "A film must be the work of a collective," he demands.[3] Brecht goes on to add that a film could not be produced by anything but a collective, because technology forces financiers, directors, technicians, writers, and others to submit to the division of labor—implying modern sympoesis instead of individual authorship. This, according to Brecht, rules out "art" in the conventional sense, because art in a capitalist society implies the unique creation of an individual author usually estranged from his audience. The new technology, he says, has abolished bourgeois art: "These apparatuses are predestined to be used for the *surmounting* of the old untechnological, anti-technological 'auratic' art, which was closely related to religious practices. The socialization of these means of production is a vital matter for art."[4] The suitability of film for socialism lies not only in its collective production but also in a new mode of reception. Only a collective, Brecht explains, can "create works of art which transform the 'audience' into a collective as well."[5]

Benjamin takes off from this starting point in 1935, although without even mentioning Brecht. The original and unique, auratic, and autonomous work of art created by an individual author, he argues, has been liquidated by modern "means of reproduction" (WB35 441–42). The "illusion of autonomy . . . has ceased to exist forever" (WB35 447). Art as it has been known since the end of the eighteenth century becomes obsolete by a new technical medium. Like Brecht, Benjamin replaces the autonomous system of communication by the expected reorganization of society with the help of a collectivizing technology.

At the same time, Benjamin expects the abolition of the typically modern, quantitative and qualitative asymmetry between producer and

3. Brecht, "Der Dreigroschenprozeß," p. 172.
4. Ibid., p. 158.
5. Ibid., p. 173.

recipients, between sender and receivers. The differentiation of communication into these functional roles, he says, is abolished for two reasons. First, members of the audience assume the same attitude toward the actors in the film as an editor or a cameraman (488). They do not feel with the actors, as they once did while watching a play on stage, but copy the "perspective" of the "apparatus" (ibid.). The technical apparatus of film establishes a symmetry between the perceptions of the audience and those of the producers. Secondly, Benjamin does not forget to point out that film, as a matter of principle, gives "everyone a chance to be promoted from a mere passerby to a walk-on part. ... Today's people have every right to expect to be filmed" (493). Benjamin stresses that the newspaper industry had already leveled the centuries-old asymmetry between author and reader because, "with the expansion of the press . . . an ever-increasing part of the readership changed—at first cautiously—into writers" (493). He has already abandoned his hopes of 1929 concerning the surrealists, whose works were intended to lead to a collective "innervation" and, consequently, to a revolutionary eruption, because the audience received even the avant-garde both contemplatively and distinctly.[6] Yet the "most reactionary" viewer of pictures will be the "most advanced" cinema-goer (496). This is, Benjamin explains, because film inevitably gives rise to a "simultaneous collective reception" (497) and, therefore, to the progressive self-organization of the masses into a collective (498).

At this point, Benjamin again follows Brecht, whose "radio-theory" provided the essential motivation for Benjamin's essay on the work of art. At first (in 1927), Brecht merely smiled at the invention of the radio: "It was a gigantic triumph of technology to be, at last, able to open up both a Wiener waltz and a kitchen recipe to the whole world. ... A sensational affair, but what for?"[7] By 1932 he had discovered its revolutionary potential, and he hoped that art and radio would be capable of curing—therapeutically, so to speak—the deficit capitalist society, which he thought was based on the alienation and isolation of man.[8]

"Art must start work where something is defective."[9] Consequently, Brecht says art must oppose isolation and develop collective forms. For the radio, this means that it no longer be allowed to expose a host of

6. Benjamin, "Der Sürrealismus," p. 310.
7. Brecht, "Radio—eine vorsintflutliche Erfindung?" p. 119.
8. Brecht, "Der Rundfunk als Kommunikationsapparat."
9. Brecht, "Über Verwertungen," p. 124.

individuals to a constant stream of nonsense, but rather include all members of the audience and weld them together into a collective. In 1932, Brecht notes:

> [T]he radio has only *one* side where it should have *two*. It is an apparatus of distribution, it merely allocates. Now, in order to become positive— that is, to find out about the positive side of radio broadcasts—here is a suggestion for changing the function of the radio: transform it from an apparatus of distribution into an apparatus of communication. The radio could inarguably be the best apparatus of communication in public life, an enormous system of channels—provided it saw itself as not only a sender but also a receiver. This means making the listener not only listen but also speak; *not to isolate him but to place him in relation to others.*[10]

Today, the magic formula would be *interaction*. With the aid of this concept, Brecht wishes to abolish the gap between one single sender and numerous receivers. Such a symmetrization, he continues, is revolutionary and directly implemented in technology itself: "Being *unfeasible* in this particular social system but *feasible* in another, these suggestions, which are really a *natural* consequence of technological development, serve to propagate and form a *different* social system."[11] While other artistic media, such as literature, stand out due to the fact that they remained "without consequences" for the existing social system, the radio presses for its revolutionary change by means of a collectivization of senders and receivers.[12]

In the same year, Benjamin writes in his "Reflections on the Radio" ["Reflexionen zum Rundfunk"]: "Only the present time with its unrestrained development of a *consumer mentality* in the operetta-goer, the novel reader, the tourist, and similar types has created the mindless, inarticulate masses which form the audience in the narrow sense."[13] This passive and incapacitated attitude of the audience, he says, can be changed for the better by an adequate use of the radio. But, still, it is the "*crucial error of this institution to perpetuate in its work the fundamental split between performers and audience, which is belied by its technical foundations.* Any child could tell you [not to mention Brecht] that the aim and object of radio broadcasts is to put all kinds of people at any time in front of the microphone."[14] In the Soviet Union, Benja-

10. Brecht, "Der Rundfunk als Kommunikationsapparat," p. 129.
11. Ibid., p. 134.
12. Ibid., p. 130.
13. Benjamin, "Reflexionen zum Rundfunk," p. 1506.
14. Ibid.

min argues, people have for a long time drawn the "*natural* conclusions from the functioning of the apparatus" and installed an infinite, critical public discourse while the mindlessness of *one-way broadcasting* still dominates in Germany.[15] Benjamin follows Brecht exactly in his opinion that old media are responsible for the attitude of consumption that is replaced by interaction—treating consumers and producers as equals—fostered by new media (such as radio or film) as the natural and immediate consequence of technological development. The new technology and conditions of communication "change . . . the attitude of the masses," and it must be emphasized once more that meanings or messages are not important here.[16] Accordingly, it is "the technical and formal side alone that should be able to train listeners' expertise and make them grow out of barbarism."[17] The alternative between "socialisme ou barbarie" is decided by technology, which—by its very essence—influences the consciousness of the masses.

II

Anyone who looks into things more closely, cannot possibly overlook the most obvious matter, namely technology (Walter Benjamin, "Theatre and Radio," 1932)[18]

Media define our situation, which . . . deserves a description (Friedrich Kittler, *Grammophon, Film, Typewriter*, 1986)[19]

A person wishing to look into things closely will be unable to avoid technology, the most obvious matter. But it is precisely because technology is so close to us that we find it so difficult to analyze. Friedrich Kittler articulates the paradox: "Despite the title of McLuhan's book, *Understanding Media*, it remains impossible to understand media; on the contrary, it is precisely because, at any given time, the prevailing communications technology controls all understanding and creates illusions."[20] The technologies dominating us prevent us from understanding them because they themselves generate the modes of their own understanding.

In "Theatre and Radio," Benjamin speaks of a "re-transformation

15. Ibid.
16. Ibid.
17. Ibid., p. 1507.
18. Benjamin, "Theater und Rundfunk," p. 773.
19. Kittler, *Grammophon*, p. 1.
20. Ibid., p. 5.

of the methods of montage, so important in radio and film, from a merely technical event into a human one," so that "the individual eliminated by radio and cinema" is "in the way of the technology he himself invented."[21] Sixty-five years later, Norbert Bolz puts it this way: "In the technology-dominated reality of the new media, man is no longer the master of data but is himself installed into feedback loops." The astronaut functions, he says, as "*cyborg* of his capsule," the computer user has for a long time been turned into "the servo-assisted mechanism of his computer."[22] Technology is so closely related to our physical existence that it has become a part of our bodies. Bolz goes on to explain: "When Benjamin speaks of technology as an organ he means the same concept Ernst Jünger defined as organic construction, and what McLuhan called an *extension of man*: there is no longer any difference between the mechanical and organic world."[23] This new unity of body and media, continues Bolz, facilitates the reorganization of social life in the medium of a collective body: "In the same way, Marx has already connected the revolutionary abolition of private property to the formation of *social organs*, where interaction is thought to have been turned into the organ of the individual."[24] According to Bolz, an understanding of Benjamin is possible only against this background: he stresses the fact that Benjamin does not take the organization of the masses by the media to be a "revolutionary possibility" but a "necessity" taking place "with the elemental force of a second nature."[25] Social revolution naturally follows technical evolution, and that is why media theory proves to be a theory of society with prognostic powers.

Media theory examines technology, the "most obvious matter," and Benjamin's preference is also adopted by Friedrich Kittler: "Consequently, those messages or meanings with which communications technologies literally fit out so-called souls for the duration of a technical epoch do not count; all that counts, strictly according to McLuhan, is their switchings, this schematism of perception in general."[26] Our "situation becomes recognizable" if we "succeed in hearing the circuit diagram itself in the synthesizer sounds of a compact disc or in seeing the

21. Benjamin, "Theater und Rundfunk," p. 775.
22. Bolz, *Am Ende der Gutenberg-Galaxis*, pp. 114 and 117.
23. Bolz, *Theorie der neuen Medien*, p. 98. The Benjamin citation refers to the *Artwork* essay (507), while the Jünger reference is to *An der Zeitmauer*, pp. 134–35.
24. Bolz, *Theorie der neuen Medien*, p. 98.
25. Ibid., p. 99.
26. Kittler, *Grammophon*, p. 5.

circuit diagram itself in the laser storm of discotheques." Like Marx and Engels, who had to work through the ideologies of superstructure in order to find out about the basic structures of economic and technical conditions, the media theorist—over all the sounds and colorful images of semantics—must not forget "what is real"—namely, the media itself.[27] Of course, these are no longer just radio or film: by means of computerized and worldwide integrated data processing, the evolution of media technology has given us a multimedia system that integrates, and thus finally abolishes, "individual media."[28] Kittler writes of these new developments: "In the general digitalization of news and channels, distinctions between individual media disappear. Sound and image, voice and text exist only as a surface effect, also well-known to consumers under the pleasant name of the interface. Human senses and meanings become illusions."[29] All that remains of the "real" is a circuit diagram, and only the "illusions" created by those "surface effects" are able to distract from its analysis. If computers "remodel any algorithm you like into any interface effect you like," what is to become of a society consisting of "people who have lost their senses?"[30]

Brecht and Benjamin expected a new social system from the new media. Symptom and cause of this change was the conversion of the conditions of communication—forced by media-technologies—from asymmetrical broadcasting to symmetrical interaction. Recent media theory repeats these utopian hopes with surprising redundancy. Norbert Bolz, for instance, predicts that the asymmetry and distance between producer and recipients will be electronically liquidated in the hypermedium of the hypertext: "For the first time in history, it is technically possible to implement the *old utopia*, i.e. to do away with the difference between author and reader." The datanauts in the *docuverse* communicate interactively within a network to such an extent that "literary work becomes recognizable as a collective process." Hypermedia fulfill the old "dream" of media interaction through a "two-way cable network." The "fascist tendencies" in the "media reality of broadcasting" are replaced by the "new possibilities of a reversible, two-way communication inside a network." The aim of this development is an interactive paradise, in which participants are no longer alienated from themselves and their environment, but are quasi-organically interlocked

27. Ibid., p. 10; in this passage Kittler refers explicitly to Bolz.
28. Bolz, *Am Ende der Gutenberg-Galaxis*, p. 111.
29. Kittler, *Grammophon*, p. 7.
30. Ibid., p. 9.

in the medium of a new immediacy: "The limit of this obsession is electronic telepathy, the total *interface*." In the near future, biocybernetic systems of communication will directly network "the central nervous system and the computer" in order to carry out the medieval concept of "angels communicating without language."[31] If society and communication can solve the problem of mediating between *alter* and *ego* via media, then the development of the media is about to result in their own abolition. Angelic telepathy makes all mediating systems of symbols superfluous, and eliminates all differences between inside and outside, between self-reference and external reference; mind-reading permits no lie, no mask, no role, no hypocrisy, no illusion, and no distinction between information and message.[32] The very last medium abolishes the object of all media—that is, to mediate—and, at the same time, to preserve differences.

Already in 1990, Bolz wrote: "The media-technological demystification of man . . . provokes revolutionary, romantic, and immediate utopian dreams in collectives communicating in a reciprocal relationship. Baudrillard . . . has conjured up the revolutionary romanticism of immediate inscription: the very concept of the medium, he says, must disappear and give way to the *parole échangée*: only the destruction of a medium makes reciprocity possible."[33] At this point, Bolz himself crosses "the borderline which separates ages" when he writes: "Today, we say goodbye to linear writing systems, which were called culture or mind," in order to venture into the "age of algorithms."[34] New telematic technology "liberates the individual from his prison of subjectivity, and forces open the shield of the other. This may be called proximity: the prefix *tele-* implying intensity, closeness, and the intersubjectivity of a dense network. At last, we can recognize our neighbor behind the veil of otherness."[35] Now the eschatological note is unmis-

31. Bolz, *Am Ende der Gutenberg-Galaxis*, pp. 223, 226, 180, 118, 119.

32. Kittler, *Die Nacht der Substanz*, p. 34. Kittler refers to John von Neumann's *Automatentheorie* and draws the following conclusion: "Human beings as observers will become superfluous" because the computer neutralizes every distinction "between fact and observer." This is the abolition not only of the Old European difference between subject and object, but also—very explicitly—of the essential differences among "biologically inspired system theories"—namely, the difference between self-reference and external reference. It must also be emphasized that—according to Kittler—the "theory of mechanical self-reproduction" passes "*inevitably* into technical practice" (Kittler, *Die Nacht der Substanz*, p. 34).

33. Bolz, *Theorie der neuen Medien*, p. 111.

34. Bolz, *Am Ende der Gutenberg-Galaxis*, p. 180.

35. Ibid., p. 182.

takable, for the "telepathic perfection of telecommunication" creates a sympathetic neighbor out of the alienated other.[36] So, in the medium of immediacy, all human beings shall finally be brothers after all.

III

The media are new, the utopian dreams old. The fact that the structure of the hopes of Brecht and Benjamin are so exactly repeated can be seen to support our opening statement that the theory of new media inherits from its Marxist fathers not only the priority of technology as the motor of history but also its Messianic horizon. On no account do I insist on denouncing the capacities of media theory. Benjamin's proposition—that the interplay of technical conditions, human collectives, and their modes of perception determine history—is as convincing as ever. I would like to plead, however, for giving up this hierarchical relationship among media technology, social system, semantics, and sensuousness, and also giving up the primacy of technology. Anyone who believes the evolution of media technology is the key to an understanding of social processes risks being transformed from an analyst into a prophet. Even if the new conditions of communication greatly influence our perception of reality, they do not lead to an intelligible interactive, angel-like community, to man/machine couplings, or to the submission of "so-called human beings" to the power of "nameless Supreme Commands," hidden beneath interfaces.[37] In the best sense of info-tainment: the actual situation is far more boring.

—Translated by Almut Müller (Bochum)

36. Ibid., p. 119.
37. Kittler, *Grammophon*, p. 3.

HISTORY

During long periods of history, the mode of human sense perception changes with humanity's entire mode of existence. The manner in which human sense perception is organized, the medium in which it is accomplished, is determined not only by nature but by historical circumstances as well (222)

The film corresponds to profound changes in the apperceptive apparatus—changes that are experienced on an individual scale by the man in the street in big-city traffic, on a historical scale by every present-day citizen (250)

Mechanical reproduction of art changes the reaction of the masses toward art. The reactionary attitude toward a Picasso painting changes into the progressive reaction toward a Chaplin movie (234)

The extravagancies and crudities of art which thus appear, particularly in the so-called decadent epochs, actually arise from the nucleus of its richest historical energies (237)

The mass is a matrix from which all traditional behavior toward works of art issues today in a new form. Quantity has been transmuted into quality. The greatly increased mass of participants has produced a change in the mode of participation (239)

However hard Walter Benjamin tried to present himself as a Marxist (or as a "Materialist," as he preferred to say), his vision of history never completely adapted the Hegelian mood of tracing smooth—ascendant or descendent—lines of change through time. It has indeed been part of Benjamin's success, especially during the more recent stages of his work's reception history, that he seems to have favored forms of discontinuity in his ways of experiencing and representing history—which converges with an emphasis on and an enthusiasm for techniques of montage in his analysis of the medium "film" and its receptive apparatus. On the whole, Benjamin's option for discontinuity has given new intellectual appeal to our worn-out metaphors of redemption and revolution.

On the other hand—and this second aspect of his history writing is not necessarily in contradiction to its elements of discontinuity—Benja-

min's essay unfolds the full range of narrative forms and motifs from the then well-established tradition of writing history as a history of class struggles—that is, of class-struggles that take place in symmetrically ascending and descending movements. The "decline of middle-class society" (238), for example, is one strong vector in this context— a directionality so basic that it helps to define the dimension of all the other movements that are simultaneously taking place. If the middle-class is in decline, then one can associate whatever phenomena seem to be ascending with its class-antagonist—that is, with the proletarian masses. This associative context seems to be much more decisive than any empirical observations for Benjamin's claim that specific affinities exist between the new, technical media "photography" and "film" and the "masses." Indeed, the richness, the complexity, and the sheer speed of his associations—within a preexisting mold of narrative forms and ideological premises—are key features of Benjamin's intellectual style. Here is an example of his tendency to engage in associative crescendo:

> For the first time in the process of pictorial reproduction, photography freed the hand of the most important artistic functions which henceforth devolved only upon the eye looking into a lens. Since the eye perceives more swiftly than the hand can draw, the process of pictorial reproduction was accelerated so enormously that it could keep pace with speech. A film operator shooting a scene in the studio captures the pages at the speed of the actor's speech. Just as lithography virtually implied the illustrated newspaper, so did photography foreshadow the sound film. (219)

But the forces and phenomena that side with the rising class do not only foster and "foreshadow" each other (as photography is supposed to "have foreshadowed the sound film"), they also have a destructive impact on whatever seems to be opposed to the declared agents of historical progress. Particularly interesting in this context is a passage in which Benjamin quotes the French filmmaker Abel Gance with the intention to say that, once set into motion, the film medium will fulfill its historical mission in this sense—if necessary even contrary to Gance's program and intentions:

> In 1927 Abel Gance exclaimed enthusiastically: "Shakespeare, Rembrandt, Beethoven, will make films. . . . [A]ll legends, all mythologies and all myths, all founders of religion, and the very religions . . . await their exposed resurrection, and the heroes crowd each other at the gate." Presumably without intending it, he issued an invitation to a far-reaching liquidation. (221–22)

While Benjamin—unfortunately perhaps—never seemed to have much of a doubt about where to identify the "reactionary" and the "progressive" forces within the movements of historical change, he was masterful and subtle in the technique—Hegelians and Marxists used to call it "dialectics"—of uncovering positive energies in phenomena that seemed directed against the rhythms of ascent:

> The extravagancies and crudities of art which thus appear, particularly in the so-called decadent epochs, actually arise from the nucleus of its richest historical energies. In recent years, such barbarisms were abundant in Dadaism. It is only now that its impulse becomes discernible: Dadaism attempted to create by pictorial—and literary—means the effects which the public today seeks in the film. (237)

It may be the greatest merit—and the lasting legacy—of the historian Walter Benjamin that he took seriously and unfolded the one programmatic point in which Karl Marx's claim to "Materialism" was more than a symbolic tool that simply marked his distance from Hegel.

This programmatic point was Marx's invitation to view the history of humankind as history of the development of the five human senses. In Benjamin's words this means that during "long periods of human history, the mode of human sense perception changes with humanity's entire mode of existence. The manner in which human sense perception is organized, the medium in which it is accomplished, is determined not only by nature but by historical circumstances as well" (222). Increasingly, throughout the trajectory of his intellectual projection, this credo turned into Benjamin's most important question—that is, into the question of how different technologies had shaped and transformed the human senses in different ways, and how these transformations in the "apperceptive apparatus" were responsible for the different cultural styles and tonalities of different historical epochs. Until the present day, however, historiographical discourses that emerge—not only in Benjamin's work—from this very question have to leave one epistemological problem unresolved (and it may indeed be a problem without possible solution): this is the problem of whether a more than merely associative and improvised mediation is possible at all between the dimension of perception (the body, the senses, and so forth) and the dimension of experience (concepts, culture, and the like).

Being at least partly shaped, in this theoretically unresolved sense, by the new technical media and by their impact on the habits of perception (but being shaped, above all, by the history of their class struggles), the masses are connected to all the vectors of progress in Benja-

min's discourse (particularly of course to film). Above all, the masses appear as a principle of hope and as a collective agent of redemption. This may be the reason why Benjamin speaks of the masses as "a matrix" for new behaviors toward works of art. He seems to suggest and to promise that—as the agent of some higher necessity—the masses will end up producing solutions even for such problems which, in Benjamin's own time, still had the status of open problems. Based on a slightly different understanding of the noun "matrix," we might perhaps go so far as to postulate that Benjamin believed in the masses as nurturing the future of humankind. This is where we come to understand how much Walter Benjamin believed in—and relied upon—the play between those forces which, in his view, make up history. On the one hand, he never ceased to see and to analyze history from the angle of its "yield" for the well-being of humankind—and in this sense "politics" was the horizon of his historical research and writing. On the other hand, "politics," in his case, did not imply the obligation of actively intervening in the historical process (perhaps not even the obligation of using the opportunities that this process offered to him). Clearly (and this has been said over and again by many Benjamin scholars), there is a strong religious component in Benjamin's relation to history. It lies precisely in his willingness and in his patience—maybe even in a piety—to let the historical process fulfill itself.

Such willingness to let history fulfill itself (similar to the "millennarist" movements of Western history) may have fostered Benjamin's self-imposed obligation to keep his senses and his thought focused on the emerging innovations of each present—and on the requirements following from such innovations. "To be absolutely modern," in this sense, was a widely accepted imperative among European intellectuals during the first half of the twentieth century. In more dramatic fashion perhaps than any other of his major works, Benjamin's *Artwork* essay appears to be driven by the ambition to maintain—or, rather, to achieve—such a relation of contemporaneity between his thought and the present that surrounded him. Probably it would have been difficult—or, at least, unwelcome—for Benjamin to imagine that for us, his successors, thought appears to be always—and by definition—supplementary, retrospective, belated.

POLITICS

The concepts which are introduced into the theory of art in what follows differ from the more familiar terms in that they are completely useless for the purposes of Fascism. They are, on the other hand, useful for the formulation of revolutionary demands in the politics of art (218)

The logical result of Fascism is the introduction of aesthetics into political life. The violation of the masses, whom Fascism, with its *Führer* cult, forces to their knees, has its counterpart in the violation of an apparatus which is pressed into the service of ritual values (241)

We do not deny that in some cases today's films can also promote revolutionary criticism of social conditions, even of the distribution of property (231)

But the instant the criterion of authenticity ceases to be applicable to artistic production, the total function of art is reversed. Instead of being based on ritual, it begins to be based on another practice— politics (224)

To demonstrate the identity of the artistic and scientific uses of photography which heretofore usually were separated will be one of the revolutionary functions of the film (236)

Distraction as provided by art presents a covert control of the extent to which new tasks have become soluble by apperception. . . . [A]rt will tackle the most difficult and most important ones where it is able to mobilize the masses. Today it does so in the film (240)

The first and last sections of the *Artwork* essay frame Benjamin's argument with asides on the politics of contemporary life in 1936: the rise of Fascism. Advertising at the outset that the terms he will deploy are "useless for the purposes of Fascism," Benjamin insulates his comments from political appropriation. Near the end, he suggests that Fascism fosters a fusion of aesthetics and politics that violates the premises of a mechanical "apparatus" to construct ersatz ritual values; these, in turn, "violate" the masses. Thus, the essay's frame implies that aesthetics should be kept separate from politics, but Benjamin also keeps

the door open to formulating "revolutionary demands in the politics of art," and promoting "revolutionary criticism of social conditions, even the distribution of property." Is there hope for an alliance of aesthetics and politics without Fascism?

Benjamin's reference to the *Führer* cult reminds us of a long-standing interest in absolutism that figures importantly in his "Origin of German Tragic Drama" ["Ursprung des deutschen Trauerspiels"] of 1925 as a response to the crisis of Reformation: "Whereas the modern concept of sovereignty [*moderne Souveränitätsbegriff*] amounts to a supreme executive power on the part of the prince, the baroque concept emerges from a discussion of the state of emergency [*Ausnahmezustandes*], and makes it the most important function of the prince to avert this" (65). Apart from the irony that his characterization of Baroque absolutism would resonate ten years later in German political life, Benjamin's text refers explicitly to Carl Schmitt, an author who became a player in the politics of Nazism. Benjamin's analysis of absolutism was largely shaped by reading Schmitt's *Political Theology* [*Politische Theologie*] of 1922; indeed, the word *Ausnahmezustand* must allude to the notorious opening line of Schmitt's book: "Sovereign is he who decides on the exception [Souverän ist, wer über den Ausnahmezustand entscheidet]" (6).

Who is Carl Schmitt and why drag him into the story? He had rallied to the Nazi Party in May of 1933 and—as one of Germany's leading jurists—rose swiftly in official circles. Schmitt's fortunes took a dive in 1935, when his ideas were deemed incompatible with the party's racial policies and, in 1936, he was violently denounced in the pages of *Das Schwarze Korps*, the weekly newspaper of the SS. Schmitt saw the writing on the wall: by the end of 1936 he had resigned his academic chair and all official posts. Benjamin may or may not have followed the political rise and fall of Carl Schmitt while writing the *Artwork* essay, but in 1940 his work still bore the traces of Schmitt's thinking, for the term *Ausnahmezustand* reappears in "Über den Begriff der Geschichte" (697).

Benjamin's analysis of aesthetics, technology, and politics in the *Artwork* essay seems to parry, challenge, and track uncannily Schmitt's handling of parallel issues in *The Concept of the Political* [*Der Begriff des Politischen*]. Originally published in 1927, the text was reissued in 1932 with a key essay, "The Age of Neutralization and Re-Politicization" ["Das Zeitalter der Neutralisierungen und Entpolitisierung"], added as postface. If Benjamin wanted to ensure that his text would be

"useless" to Fascism, Schmitt's argument—eminently useful for Fascism—was the model against which he would have to write.

Benjamin sketches the complicated intertwining of aesthetics and politics at work in the 1930s with three interrelated observations. First, and perhaps most schematic, is the remark that loss of authenticity reverses the function of art by shifting it from a practice of ritual to politics. Obviously, this relates to the claim that a work of art drained of aura is severely and irrevocably impoverished, but Benjamin is reluctant to oversimplify the transformation. The photographs of Atget, for example, are cited as "standard evidence for historical occurrences" that acquire a "hidden political significance" and so pinpoint a "new stage" without being swallowed by the practice of politics (226). Benjamin adds that photo captions ultimately killed off Atget's mystery, but the point is that loss of authenticity need not lead *directly* to overt political instrumentality. Schmitt's handling of this transformation assumes a condition—naive ignorance of the masses—that Benjamin's Marxist leanings could not accept:

> Under the enormous suggestion of ever new, surprising discoveries and achievements emerges a religion of technological progress, for which all other problems simply solve themselves through technological progress. This belief was self-evident and natural to the great masses of industrialized countries. It cleared away all the intermediate steps that are characteristic of the ruling elite's way of thinking, and for them, the religion of wonder and belief in the hereafter became immediately, without intermediaries, a religion of technological wonder, human achievement, and domination over nature. A magical religiosity thus turns into an equally magical technicity. ("Zeitalter der Neutralisierungen," 84)

In short, the contrast highlights one of the unspoken political motives for Benjamin's need to keep terms like "authenticity" and "aura" in play.

Secondly, Benjamin sensed the emergence of an interesting and evermore complex social position for filmic imagery, so that it can be "difficult to say which is more fascinating, its artistic value or its value for science" (236). In a surprising move, he suggests that one of the "revolutionary functions" of film will be to demonstrate that photography can be useful for both the arts and sciences. A man of letters might marshal enthusiasm for unmotivated slippage across the frontier dividing these two huge spheres of human knowledge, but doing so assumes a rather innocent view of the politics surrounding deployment of technical processes. Here again, a contrast with Schmitt is revealing,

for the latter firmly believed that technology was never politically neu-
tral:

> Technology is always only an instrument and a weapon, and precisely be-
> cause it serves everyone, it is not neutral. From the immanence of the
> technological results not a single human or spiritual decision, least of all
> that of neutrality. Each kind of culture, each people and each religion,
> each war and each peace can use technology as a weapon. ("Zeitalter der
> Neutralisierungen," 90)

At stake in the difference between the two positions is the very idea of
revolution: Benjamin believes it will yield a utopia of common ground
across social practices; Schmitt's view—more cynical and instrumen-
tal—suggests that revolutions do not simply happen, but must be made.

Finally, Benjamin remarks that film tackles some of the most diffi-
cult and important tasks of modern life by mobilizing the masses under
cover of a distraction that "presents a covert control" of apperception:
people's habits are changed without their noticing it. Schmitt, in con-
trast, claims the essence of liberal democracies was a kind of status quo
where distraction might be a goal, not simply a symptom:

> Now, it is a noteworthy phenomenon that the European liberal state of
> the nineteenth century could designate itself as a *stato neutrale ed agnos-
> tico* and see the justification for its existence precisely in its neutrality. . . .
> Here, it is interesting above all as a symptom of a generalized cultural
> neutrality; as the teachings of the nineteenth-century neutral state take
> place in the framework of a general tendency toward spiritual neutralism
> that is characteristic of the history of Europe in the last century. (Ibid.,
> 87)

Obviously, there is deep disagreement here about political conscious-
ness: Schmitt locates its liquidation in the stasis of liberal politics;
Benjamin claims it results from proliferation of a specific media form.

Yet this is not the end of the story, for the two actually converge in
the way they position technical processes within the political arena.
Consider, for example, Benjamin's observation that political leaders are
increasingly selected (and self-selecting) by their ability to present
themselves to cameras and recording equipment: "The present crisis of
the bourgeois democracies comprises a crisis of the conditions which
determine the public presentation of the rulers. . . . The trend is toward
establishing controllable and transferable skills under certain social
conditions. This results in a new selection, a selection before the
equipment from which the star and the dictator emerge victorious" (n.

12). Schmitt deploys different terms, but suggests a parallel play of forces: "Interpreting the current century can thus only be a provisional arrangement. The ultimate meaning will only reveal itself when it shows which kind of politics is strong enough to take advantage of the new technology, and which are the real groups of friends and enemies that arise on this new ground" ("Zeitalter der Neutralisierungen," 94). We should not be surprised that Schmitt joined a political party committed to exploiting the potential of new media, but the point of our juxtaposition is to suggest that *both* writers understood technical changes were reshaping politics. Benjamin saw the rise of Fascism as a "violation" of the masses and of the filmic apparatus pressed into service. Schmitt might agree with Benjamin's first point, but would reply that technical processes could never be "violated" because they are never neutral:

> Today, technological discoveries are the means for an enormous control of the masses; the radio monopoly is a part of radio broadcasting, film censorship is a part of film. The decision about freedom and slavery does not lie in technology as technology. It can be revolutionary or reactionary, serving freedom and oppression, centralization and decentralization. Their merely technological principles and viewpoints yield neither a political question nor a political answer. (Ibid., 91–92)

Here again, Schmitt emphasizes an issue that Benjamin was unwilling to confront—namely, the means of technical reproduction are merely tools able to be used for good *or* evil. Benjamin wanted terms "useless for the purposes of Fascism," but this forced him to shift Schmitt's cynical world of mass appeal *into the processes*: their power became apparent, yet he was obliged to describe its politics internally, on technical grounds. Schmitt had shown this could cut either way; Benjamin responded with politically "soft" concepts—aura, authenticity, habit, distraction—to make his point.

Museums of the Present

Rimbaud Reads Benjamin

Loss of a Halo [*Perte d'auréole*], one of Baudelaire's "little prose poems," touches the heart of the problem faced by Walter Benjamin.[1] In this text, Baudelaire renders explicit the contradiction between the ordered rhymes of a classic poem and the random rhythm of a modern city. Always frightened by the chaotic traffic of the cities, Baudelaire's poet preserves his incomparable self by walking the streets with as much indifference to their teeming life as he can muster. The more detached he remains from the "moving chaos," the more "pure" will be his text. The poet's attitude assumes that the urban context is defined by an absence of correspondences—that is, it presents "forests of symbols" and precludes interpretation, since the randomness of everyday life seems hostile to hermeneutic activity. One day, the disparity between the poet and the rhythm of the streets causes his "halo, in a sudden movement, to slip from his head into the muck of the roadway." Recognizing himself "in a place of corruption" (obviously unhealthy for any "ambrosia-eater"), and deprived of his aura, the poet discovers a surprising consolation: "Now I can walk incognito."

If we read the vicissitude of Baudelaire's poet as representing the metamorphosis of a classical concept of art, we should keep in mind that few artists accepted such morphing with the witty ease that characterizes the modernity of Baudelaire's insight. Rather, most artists attached to a classic conception of art viewed any such proximity to the circumstances of everyday life as a threat to the core concept of aura that distinguished them from the ordinary world: Benjamin's famous "unique phenomenon of a distance, however close it may be" (222).[2]

I thank Bill Egginton for editing my original text.

1. Baudelaire, "Perte d'auréole," in *Oeuvres Complètes*, pp. 351–52.

2. *Editors' Note*: Parenthetical references in the text of this essay refer to the work listed in the Bibliography as: Benjamin, "Work of Art."

On one hand, the artist deprived of aura is no longer recognized as such; on the other, once deprived of that social identity, how to sustain a unique presence *as artist* amid the multitude and simultaneity of impressions offered by the new conditions of daily life in the nineteenth-century city?

The fever of/for museums characteristic of the time tried to provide an answer to this question: from the noisy silence of innumerable galleries to the invisible bodies that move as if not touching the ground; from the useless hands that could be forgotten at the entrance (since touching any of the works offered to abstract contemplation would be a sacrilege) to the voices that speak in whispers; from the eyes eager to be enlightened by unquestionable masterpieces to the minds that submit to the discipline of these spaces where the finest achievements of "Beauty" are put on display. The museum tries desperately to fulfill the promise of a site *apart from* the creeping homogenization of daily life. Paul Valéry expressed an attitude toward this "classic" concept of art that seems to echo the words and to mirror the behavior of Baudelaire's poet. In an essay dedicated to "the problem of museums," Valéry keenly identified a secret wish that inspires the bringing together of objects whose common characteristic, in most cases, is the fact that they belong to the institution where they are displayed: "They are rare objects whose authors would have wanted them to be unique."[3] Which gives rise to a kind of Platonic dilemma faced by any museum. If some constitutive essence of "Beauty" exists, why must there be so many pieces on display? In fact, why display anything? Would not the ideal of "eternal beauty" be better served if never seen, since it is mainly an idea anyway? The concrete materiality of any one object can only add to the incoherent multitude of different pieces that supposedly expresses a unique concept of art. If a single and definitive masterpiece is impossible, why not substitute objects by the mental apprehension of an idea (ideal Beauty)?

In a symptomatic reaction, Valéry resists with his own body the abstraction demanded by this concept of art: "How tiresome! I said to myself. What barbarism! All this is inhuman."[4] Analogous to the way Nietzsche responded to *Madame Bovary*—he suggested that Flaubert's heroine should be eaten, not read—Valéry deflates the museum's claim to nobility of spirit with an immediacy of the senses: "I don't much like

3. Valéry, "Problème des musées," p. 1292.
4. Ibid., p. 1291.

museums. There are too many *admirable* things there, but nothing *delicious*."[5] Valéry's reaction replaces intellectual observation and silent admiration with an imperative to reframe the question "what is art?" and to expand radically the field of possible meanings put into play by any single object. Films—cinematic "objects"—tend to increase the complexity of this problem by redrawing boundaries and reshaping concepts that once were taken for granted.

In 1931 René Clair produced *A Nous la liberté*, a subtle critique of industrialized society that focused on the dynamics of homogenization and the reification of both mass production and human relationships. Five years later, Charlie Chaplin worked the same themes in *Modern Times*, his last silent film. It seems clear that Chaplin drew inspiration from René Clair for what became the best-known sequence of his own film: the scene in which the Tramp ends up a part of the machine with which he cannot learn to interact. *Modern Times* immediately raised a "decisive" question: did Chaplin know *A Nous la liberté*? Predictably, French critics denounced the implied cultural imperialism of the similarity, since Chaplin was probably better known in France than René Clair! The same critics conveniently failed to remember that the theme was not "invented" by René Clair, for in *Metropolis* of 1926 Fritz Lang pictured with unforgettable strength and visual impact the (literal) consumption of workers by industrialized society, which he represented as a demoniac, living organism.

However, the whole question—who did what first?—is itself symptomatic of a concept of art out of synch with the new, cinematic perceptions of reality generated by the very process of shooting a film. Benjamin understood this situation perfectly when he wrote: "The shooting of a film . . . affords a spectacle unimaginable at any time before this" (232). The classic concept of aura demands the hic et nunc of the original work of art, one whose originality is inextricably bound up with authenticity; Benjamin would say, "its unique presence at the place where it happens to be" (220). This complex of requirements constitutes a metonymy for the prevailing paradigm of modernism, since the "necessary" individuality of a work of art evokes the presence of a human subject in his/her most "developed" feature—that is, a presence that constructs "authorship" as an ideological term of hermeneutic criticism.

The process of shooting a film challenges the basis of this paradigm.

5. Ibid., p. 1290 (my emphasis).

On one hand, making a movie subsumes individualistic notions of author under the empirical conditions of studio production. This is especially true in Hollywood, where the producer has always played a more important role than the director. The impasse faced by both D. W. Griffith and Erich von Stroheim in their respective careers is symptomatic of this new situation: they could not make the films they wanted because they never scaled their conceptions according to the "realistic" budgets managed by attentive producers. Griffith and Stroheim behaved as authors are supposed to behave, without realizing that the collective process of making studio movies strongly mitigates the whole idea of authorship.

On the other hand, the cinematic spectator is confronted with a new order of perception that produces an "intense frustration at never possessing, not even touching, those bodies that were so near."[6] Ultimately, this frustration is "bought off" by commodification of "the star." Just as one's desire to acquire the expensive goods "offered" by innumerable stores is fanned by the advertising industry and fulfilled by the system of credit, the "star system" and its media-hype make you "familiar" with your favorite actor/actress well before you see their latest film. They are portrayed as your closest friends, which compensates for the fact that you will never see them near enough to be touched. In other words, "[T]he public is an examiner, but an absentminded one" (241). This corollary is anathema to proponents of the hermeneutic paradigm, for whom interpretation presupposes a high order of purposeful attention: their ideal reader is the solitary interpreter of an author's intention, one who relentlessly seeks the hidden meaning of texts. Benjamin suggests that contemporary spectators of films (to whom we might add viewers of television) do not necessarily seek anything beyond an immediate satisfaction provided by the restless succession of images, and he seems to sense the significance of this perspective when he writes: "It would therefore be wrong to underestimate the value of such theses [the ones presented in his essay] as a weapon. They brush aside a number of outmoded concepts" (218).

One is thus tempted to distinguish the self-proclaimed usefulness of Benjamin's theses from a critical analysis of concepts of the hermeneutic paradigm. Although possible, such a distinction would obscure the originality of Benjamin's insight within the complex history of its moment. The steady growth of Fascism and, above all, its extraordinary

6. Gumbrecht, "It's Just a Game," p. 284.

ability to establish a direct link with the masses, challenged orthodox interpretations of the future of industrialized societies. It was already quite clear that the Revolution did not start in Germany (as Karl Marx had hoped), but rather that Fascism had acquired an unprecedented power there. In his essay, Benjamin rejects the prevailing position of European intellectuals who, like Ernst Bloch, believed the main task was to preserve a "true" European tradition in the face of conscious Nazi distortions, such as the party's "exegesis" of Nietzsche. Benjamin, along with Bertolt Brecht, proposed that mastery of the new techniques of communication—the same tools so successfully employed by Hitler and Mussolini—would be a much more effective response to Fascism. According to Benjamin, systematic use of these new techniques had been the decisive factor by which Fascism established its privileged contact with the masses, not the distortion of a "true" European intellectual tradition that was largely the domain of intellectuals and of only marginal interest to the masses. The *Artwork* essay attempts to produce a turning point in leftist thinking and political action: it assumes a political engagement that not only establishes the limits of Benjamin's interest, but also grounds the critical analysis of his argument.

Benjamin's call for a new attentiveness to the techniques of communication must first establish their emerging importance within the cultural field. To do so, he invokes notions that sustain the hermeneutic tradition: taken together, "outmoded concepts, such as creativity and genius, eternal value and mystery" (218), can be synthesized in the figure of the author. The corollary is that the author was central to interpretation, and interpretation was the defining act of mankind: in short, the author instituted the chain of human self-discovery. Benjamin wants to shift the focus radically, and to replace a classic conception of the work of art (vehicle of a previous essence—the author) to the concept of art as one specific discourse among all the other social constructions of meaning. This might be one reason why Benjamin was so drawn to Baudelaire, whose poet (as we have seen) does not regret the loss of his aura: indeed, for the poet to be unrecognizable amid common people already suggests that his art is but one strategy among many possible forms of discursive organization. For the visual arts, this means giving up the sanctuary of museums, and acknowledging their complicity in a defining now-ness [*jetztheit*].

However, the specific jetztheit of Benjamin's life in 1936 places a decisive constraint upon the scope of his thinking, for he seems com-

pelled to insist upon the role of art in the proletarian movement and, by extension, in the coming Revolution that was to be triggered by a newly self-conscious mass. Perhaps juxtaposing the first and the last statements of Benjamin's essay will clarify my point: "In principle a work of art has *always* been reproducible"; "Communism responds by politicizing art" (218, 242). When seen together, we suddenly realize that his whole argument about reproducibility, which seems to outline the emergence and diffusion of new technologies of communication as potential epistemological thresholds of innovative "life-worlds," is limited by the ambition to be a weapon "useful for the formulation of revolutionary demands in the politics of art" (218). The "always" of his first statement is the marker of a pale continuity that shrinks the scope of Benjamin's perspective and ultimately reveals in his essay a lingering residue of the hermeneutic paradigm.

In contrast, Friedrich Kittler criticizes the synchronism proposed by Benjamin between psychoanalysis and film, and he provides the grounds for a definitive caesura with the hermeneutic paradigm: "Technologies and sciences of media transposition do not simply extend human capacities; they determine recording thresholds. In the *physiology of the senses* these thresholds *cannot be determined too exactly*."[7] This quotation suggests an entirely different jetztheit. It is so different, in fact, that we can no longer consider it our *own*, since the most prominent feature of the technological, cultural, and social environment of our contemporary world is its unlimited *plurality*. Yet this plurality does not prevent a global sense of cultural integration: driven by the rapid and international distribution of technologies—especially those of communication—plurality is itself legitimized by the daily exposition in globalized media of a multitude of social organizations and a diversity of cultural options. Kittler's emphasis on a *physiology of the senses*, which recalls the strategy deployed by Paul Valéry against the bodiless experience of art, meets and tries to cope with some of the important changes that characterize a new jetztheit: the concept of *artistic performance*; the practices of *body art*; education programs promoted by some museums that encourage the physical touching of objects on display; other avenues of experiment—such as multimedia computing—that explore new states of consciousness.

Manifestations of this type are symptomatic of a very different historical moment, one in which thresholds cannot be determined exactly

7. Kittler, *Discourse Networks*, p. 284 (my emphasis).

because there is no telos to guide the flux of unforeseen events. The idealized continuity among epochs no longer finds shelter in the universal subject or reason, and the omniscient chain of causality cannot cope with the concept of *randomness*. In this context, I think we must regard contemporary interest in the epistemological issues of corporeality as a major symptom of our jetztheit: the body was obliterated during the hegemony of the *Geistesgeschichte* paradigm (whose denomination is already wishful thinking); the demise of that paradigm has brought the body back to life.

Finally, the lack of telos does not entail the end of history, but rather underscores the fact that History—conceived as a continuum progressing in a single direction—is simply a story told by unimaginative writers. Erich Auerbach pinpoints the paradox of this situation by suggesting that "the notion of *Weltliteratur* would be at once realized and destroyed."[8] The utopian notion of worldwide diffusion of an originally European literature illustrates the absurdity of the task, for to be everywhere is to be no longer *European*. Globalized communication technologies engender similar consequences: there is no way to provide one—and only one—base plane from which to describe homogeneity within the fundamentally different experiences of globally diffused media. We might say that the collapse of Communism represents the failure of totalitarian social constructions of meaning. Today, lacking any conceptual framework able to bracket change as a process of homogenization, we must confront the challenge of coping with difference itself. While it is true that the same globalized media hold out the nostalgic promise of homogenized closure—*we are the world*—it might be better to take the road that Benjamin opens at the start of his essay, and to reread Rimbaud: *je est un autre*.

8. Auerbach, "Philology and *Weltliteratur*," p. 3.

The End of Aura?

The expectation that what you look at looks back at you provides the aura. . . . [It] is mysticism, mysticism in a posture opposed to mysticism (Bertolt Brecht)

What is the sense of aura? Can one speak of a particular meaning for the term today?[1] Or has it come to the end of the line as a critical concept? Aura is arguably the most famous single notion advanced by Walter Benjamin in his *Artwork* essay of 1936, so it might be worthwhile to ponder these questions briefly in a larger critical context and then refer them to the needs of medieval criticism and theory.[2]

Benjamin himself proposed the concept of aura as a means of distinguishing the original artwork from technologically superlative reproductions. More exactly, it denoted a mystique emanating—in the experience of a viewer—from a natural or artistic object, a mystique that translated into the viewer's sense of a spatial or temporal distance interposing itself between the viewer and the object. Even if the artwork were only inches from the viewer's eyes, there would still be the feeling of a gulf separating viewer from object. It was this sense of distance, of otherness, that mechanical reproduction was thought to abolish by making the artwork readily available to domestic life.

At a moment when photo reproduction had made enormous progress, copies seemed to resemble originals without the effort or creative involvement of an individual struggling to reproduce a world view that had traditionally set the great work of art apart from other images. In one stroke the single canvas—witness to the vision of a master, to a world view frozen in time, remote from the public, priceless—became

1. Michael Jennings points out that Benjamin first used aura in "A Small History of Photography." Jennings comments on Werner Fuld's observation that Benjamin used "aura" rather than the more likely French *auréole*. Jennings also believes the term may have been suggested by Benjamin's reading of Léon Daudet's 1929 *Flambeaux: Rabelais, Montaigne, Victor Hugo, Baudelaire* (see Jennings, *Dialectical Images*, p. 168 and n. 3).

2. *Editors' Note*: Parenthetical references in the text and notes of this essay are keyed to the edition listed in the Bibliography as: Benjamin, "Work of Art."

mass-produced, inexpensive and thus available for everyday domestic consumption.

Benjamin drew a parallel between the industrial revolution, which replaced living artisans by machines and factories in the nineteenth century, and the mechanical reproduction of paintings, which abolished the sense of humans connecting across space, the sense of a bond between viewer and artist mediated by the artwork. This development also extracted the artwork from its special relation to time and the material process in time we call history. A machine that prints hundreds of copies an hour cannot be said to confer a special temporality on any one copy: instantaneity is not duration, and duration was increasingly an important component of artworks. An instantaneous copy, Benjamin felt, could hardly have "a history," a story to tell in the sense that an original Rembrandt or a Cézanne might be said to convey several levels of meaning: meaning about its subject; its historical moment; its way of making meaning; its voyage through time.[3] Benjamin thus found himself in the position of defending the significance of concepts like originality, authenticity, and uniqueness. In short, he perceived a crisis of art occasioned by technological innovation: aura was part of his theoretical response to this perceived crisis.

At first blush, a concept that juxtaposes tradition and technology, original and repetition, authentic and counterfeit, seems destined to figure the differences between premodern and modern modes of thought and production. In these oppositions, aura would appear consistently on the side of tradition, esthetics, and originality as part of a nostalgic historical order usually associated with the pre- and early-modern. It would appear to valorize all that had come to be associated with symbolic expression as the unique product of an individual laboriously striving to express a hard-won world view. It might even be construed as the quintessence of what is generally meant by high culture: the authentically complex, elite art form laboriously accessible to

3. "Even the most perfect reproduction of a work of art is lacking in one element: its presence in time and space, its unique existence at the place where it happens to be. This unique existence of the work of art determined the history to which it was subject throughout the time of its existence" (222). "The authenticity of a thing is the essence of all that is transmissible from its beginning, ranging from its substantive duration to its testimony to the history which it has experienced. Since the historical testimony rests on the authenticity, the former, too, is jeopardized by reproduction when substantive duration ceases to matter" (223). "The uniqueness of a work of art is inseparable from its being imbedded in the fabric of tradition. The tradition itself is thoroughly alive and extremely changeable" (225).

the initiate. Or, more catholically, it could be perceived as the nostalgia for the "authentic moment" of vision and consciousness associated with the creative process, the moment that has been described as "sealed with the uniqueness of the aura, imbued with the flash of the mutely revelatory symbol."[4]

The medieval (and, I think, early modern) scholar would instantly recognize in such dichotomies a modernist sensibility at work, one that knows little about the tradition evoked. In fact, the scenario could only be conceived at a time when reproduction technology, notably cinema in the 1930s, seemed to be sweeping aside traditional conceptions of art, reception, and audience. It could only have been the product of a reflection more focused on the immediate technologies in question, a reflection that superficially assumed a radical disjunction between them and traditional technologies of representation. We might well choose to question these presuppositions today.

First, however, there is the question of Benjamin's cathected relationship to the representational traditions he seems to be evoking with such nostalgia. How could a Marxist critic, however unorthodox, profess nostalgia for an esthetics of tradition? The answer tells us much about the layered meanings of aura, or at least Benjamin's layered use of the term. Other definitions (misconceptions?) have not been slow in accumulating. John McCole argued recently that what Benjamin called "the crisis in the structure of perception and experience" was, in fact, a crisis of tradition:

> "A shattering blow to all that has been handed down—a shattering of tradition, which is the obverse of the present crisis and renewal of humanity." What he [Benjamin] meant by "tradition" was less a particular canon of texts or values than the very coherence, communicability, and thus the *transmissibility* of experience. "For experience" [wrote Benjamin], "is a matter of tradition. . . . [It] is built up less out of individual facts firmly fixed in memory than of accumulated, often unconscious data that flow together in memory."[5]

Benjamin conceives experience in two contrasting senses, represented by two German words: *Erfahrung*, "the individual's ability to assimilate sensations, information, and events to an integrated stock of experience"; and *Erlebnis*, "atomized, unarticulated moments merely lived through." According to Benjamin, it was the disarticulated succession

4. The phrase is from Eagleton, *Walter Benjamin*, p. 26.
5. Cited from McCole, *Walter Benjamin*, p. 2.

of events simply experienced that prevents true ontological cognition of the kind necessary to perceive one's life as a learning experience. Erlebnis destroys Erfahrung. "The result was both a decay of tradition and the helpless perplexity of the isolated individual. It became 'a matter of chance whether the individual gets an image of himself, whether he can take hold of his experience.'"[6] For McCole, this contrast between Erfahrung and Erlebnis typifies Benjamin's conflicted attitude toward tradition. This was signaled, on the one hand, by a clear recognition of the responsibility of terms like "'creativity and genius, eternal value and mystery' which seemed to him destined to promote 'the processing of factual materials in the fascist sense.'"[7] On the other hand, Benjamin regretted the loss of an art like storytelling, destroyed by the novel (a phenomenon of postprint culture), that clearly fostered experiential knowledge, meaning individual and collective reflection/perception:

> Experience which is passed on from mouth to mouth is the source from which all storytellers have drawn. And among those who have written down the tales, it is the great ones whose written version differs least from the speech of the many nameless storytellers.
>
> An orientation towards practical interests is characteristic of many born storytellers. . . . Every real story . . . contains, openly or covertly, something useful. . . . [T]he storyteller is a man who has counsel for his readers. But if today "having counsel" is beginning to have an old-fashioned ring, this is because the communicability of experience is decreasing. . . . Counsel woven into the fabric of real life is wisdom. The art of storytelling is reaching its end because the epic side of truth, wisdom, is dying out. This is a process that has been going on for a long time. . . . It is a concomitant symptom of the secular productive forces of history, a concomitant that has quite gradually removed narrative from the realm of living speech and at the same time is making it possible to see a new beauty in what is vanishing.[8]

Aura stood as Benjamin's attempt to encompass the disparate, contradictory senses of tradition: what was regrettably lost or fading as well as what should be destroyed.[9] If historical materialism was the

6. Ibid.
7. Ibid.
8. Benjamin, "The Storyteller," pp. 84, 86–87.
9. "Benjamin's theory of the aura [of an object of perception] was first and foremost an aesthetic theory, but he was convinced that aesthetic phenomena provide especially sensitive anticipations of broader perceptual and social trends. For him the decay of the aura, a 'crisis of artistic reproduction,' exemplified a much more general 'crisis of perception.' . . . And the changing structure of perception—the 'formal signature' of an age, which the best

method by which to dismantle inherited cultural processes leading toward Fascism, aura could prove a dangerous idea. However hedged by caveats, aura still incorporated a nostalgia for the aestheticized conceptions of author and authenticity representative of a ritual moment, a unique cultic experience. It could not be otherwise, given Benjamin's belief in the uniqueness of the work of art as "inseparable from its being imbedded in the fabric of tradition" (225). In other words, from his concept that a work of art possesses "a quality of presence," copying could do nothing but depreciate its "most sensitive nucleus—its authenticity."[10]

Orthodox Marxism did not fail to see the implicit dangers in the ambivalence of aura. It set off alarm bells: from Bertolt Brecht's "abominable" mysticism,[11] to Terry Eagleton's ingenious gloss that predicates an evolution in Benjamin's thinking that leads from a retrograde temptation to aestheticize tradition in the concept of aura to a truly revolutionary criticism based on "trace" and "shock." Eagleton situates Benjamin's art criticism within a Marxist dialectic of commodity and exchange where the commodity is duplicitous, "a structure of ambiguity—an ambiguity that for Benjamin is 'the figurative appearance of the dialectic, the law of the dialectic at a standstill.'"[12] Eagleton's rhetoric inexorably recasts Benjamin's concerns as a theory of meaning-production via the artwork as commodity. In this interpretation, trace and aura become dialectical foils. Initially, trace belongs with aura as a "petrified physical residue" and the "unconscious track" that is aura's "very mechanism," but, ultimately, trace is the antithesis of aura, opposed to its aestheticizing pull. Trace reveals the elements of the productive process that defetishize the object and mark its historic-

art historians sometimes succeeded in portraying—could in turn be related to underlying social transformations" (McCole, *Walter Benjamin*, p. 3).

10. "The situations into which the product of mechanical reproduction can be brought may not touch the actual work of art, yet the quality of its presence is always depreciated. . . . In the art object, a most sensitive nucleus, namely, its authenticity—is interfered with" (223).

11. "[Benjamin] uses as his point of departure something he calls the *aura*, which is connected with dreaming (daydreams). he says: if you feel a gaze directed at you, even behind your back, you return it (!). the expectation that what you look at will look back at you creates the aura. this is supposed to be in decline of late, along with the cult element in life. b[enjamin] has discovered this while analysing the films, where the aura is decomposed by the reproducibility of the art-work. a load of mysticism, although his attitude is against mysticism. this is the way the materialistic understanding of history is adapted. it is abominable" (Brecht, *Journals*, I, p. 10).

12. Eagleton, *Walter Benjamin*, p. 29, where he cites Benjamin's essay on Charles Baudelaire.

ity: the scars it has accumulated at the hands of owners, the visible imprint of its variable functionality.[13]

Eagleton also builds upon Benjamin's ambivalent concept of experience as Erfahrung and Erlebnis to harness the different workings of trace and aura. The key component of trace in Eagleton's reading is shock, a concept developed from Benjamin's reading of Freud. Eagleton notes that Benjamin invoked Freud, in *Charles Baudelaire: A Lyric Poet in the Era of High Capitalism*, to juxtapose aura and shock: "In the process of perception, only those stimuli that consciousness does not vigilantly register will sink into the unconscious to lay memory traces there; and these traces, once revived, are at the root of the auratic experience."[14] Opposed to this contemplative resuscitation of memory from the unconscious was the intensity of directly lived experience—Erlebnis—which Eagleton glosses as "shock." Experience could thus be "taken to denote the directly lived (*Erlebnis*, 'shock') or privileged inwardness (*Erfahrung*, 'aura')."[15]

By developing the psychoanalytic dimensions of aura in this way, Eagleton attacks aura from two directions. First, he can argue that the auratic experience rewrites history to deny heterogeneity and rupture in favor of a homogenous narrative: "Just as the psychoanalytic subject designates itself as a homogeneous entity over time by repressing traces (shocks) of its unconscious desires, so the auratic object—whether cultural artefact or state apparatus—continually rewrites its own history to expel the traces of its ruptured heterogeneous past."[16] Then, he can show that aura, in the Lacanian schema he invokes, belongs to the imaginary unity of a homogeneous vision, a "fetishized," inauthentic concept of history because it seeks to exclude multiple visions, the awareness of difference that comes from recognizing the returned gaze of the other. "Trace" opposes aura by representing the possibility of alternative subject positions, the "staring back" of the returned gaze, the consciousness that we are not alone in a homogeneous world of seamless tradition. This space of consciousness of other subjects, difference, rupture is the "symbolic," the space of "ceaseless 'differencing' which results from smashing the aura and deploying the object in specific conjunctures."[17]

In a second, related movement, psychoanalysis allows Eagleton to

13. Ibid., pp. 31–32.
14. Ibid., p. 35.
15. Ibid., p. 35.
16. Ibid., p. 33.
17. Ibid., p. 40.

undermine the conceptual anchor of aura, which, as we have seen, was its vaunted relationship to a founding object, the authentic original:

> But the Law or "Name of the Father," which joins the subject to that place under threat of castration, at the same stroke opening up the unconscious, is in a sense operative also in the history of objects and artefacts. Its names in that history are "aura," "authority," "authenticity"—names which designate the object's persistence in its originary mode of being, its carving out of an organic identity for itself over time.[18]

Eagleton rejects the idea that origins persist in this way except speciously for ideological purposes. It is not necessarily a bad thing "if mechanical reproduction—which may figure here as a metonym for cultural revolution—destroys the authority of origins," for doing so "writes large a plurality that was there all along. It signifies the invasion of multiplicity into the object, shattering that illusory self-identity which one might risk calling the object's 'ego.' "[19]

One could continue at length to cite the various glosses given to the concept of aura by those who deplore it, as well as by its supporters. Although aura has inspired some heroic theoretical defenses, I cannot—on close consideration of the concept and its literature today—avoid a certain sympathy for Brecht's opinion (see n. 10). At least from the perspective of the medieval period, one of the most "traditional" in the eyes of modernists, it is not obvious that the concept has any relevance at all. I want to suggest that Benjamin's conception of history abolishes historical specificity and denies period alterity. His sense of historical continuum begins with the work itself; but precisely because aura proceeds from the work *itself*, the concept diminishes an object's ability to speak with its own voice from its specific historical context. Aura conceives the work as commodity, as object inserting itself into a transhistorical tradition consisting of a line of other artistic objects stretching across time and constantly affecting the work's meaning and identity. For Benjamin, the auratic work is, in fact, a kind of relic, betraying its theological relationship to a cultic past. How else to take his assertion, also true of a cult object, that "the uniqueness of a work of art is inseparable from its being imbedded in the fabric of tradition" (225)?

However medieval the comparison of an art object to a sacred relic might sound, Benjamin's notion of the artwork and its relationships to history and tradition do not correlate with medieval reality. As any

18. Ibid., p. 32.
19. Ibid., p. 33.

reader of Chaucer's "Pardoner's Tale" can attest, the relic hardly stands as an unequivocal representative of either uniqueness or authenticity. One might even argue that if the manufacture of relics had not reached Taylorist assembly line standards by the late Middle Ages, it was not far short of that goal. But even in the case of the individual artwork, can one really speak of it as a unique product of a single individual—not only the form in which we now possess it, but also as it first appeared in its own time? It is disingenuous to speak of the medieval cultural artifact, whatever its medium, as anything but a collaborative, even a collective production, which makes it a sociological as well as an artistic and historical artifact. A manuscript may showcase the brilliance of one or more of the artists—one thinks of the great illuminated manuscripts or the genius of specific poets, thinkers, or historians—but painters rarely if ever appear without an accompanying text produced by another artist and usually lettered by a scribe. As for the poet, historian, or philosopher, we seldom have their words exactly as they might have composed them, or written in their own hand. A manuscript may well represent a text composed years, decades, even centuries before.

Even more troubling to anyone seeking to apply Benjamin's criticism to medieval art and literature is an essential ahistoricism one finds there—perhaps modernocentrism might be a more appropriate term. Benjamin's dispensation seems *not* to allow for historical texts or artifacts to carry meanings determined by the symbolic language of the text, enriched by connotations, allusions, and/or references provided by historical context. He believes that the meaning of a work and its importance will be determined by the modern critic's historical, philosophical, and ideological exigencies. Consequently, he does not focus on the alterity of a past moment, the radical otherness of an historical work; rather, he seeks to show the work's prehistory as a function of establishing the nature of tradition and transmission as it applies to the work in question. As he writes in *The Arcades Project*:

> For the materialist historian, every epoch with which he occupies himself is only a prehistory of that which really concerns him. And that is precisely why the appearance of repetition doesn't exist for him in history, because the moments in the course of history which matter most to him become moments of the present through their index as "prehistory," and change their character according to a catastrophic or triumphant determination of that present.[20]

20. Cited from Jennings, *Dialectical Images*, p. 178.

With these caveats in mind and for the sake of argument, let us consider some aspects of medieval art where aura might seem cogent at first approximation. Let us look first at the formal aspects, since they were Benjamin's own starting point—that is, the relationship of an original to its copy, which in medieval studies means artifacts such as manuscripts, illuminations, paintings/fresco cycles, and so on. Unquestionably, mechanical reproduction has played an enormous role in the study and teaching of these artifacts, both by increasing their accessibility and widening the field of inquiry. Today, in fact, many students—dare one say most?—have probably not handled or studied the originals of the manuscripts and illuminations they know through facsimile reproductions, microfilms, photographs, and now computer imaging. If the curators of some manuscript repositories like the Bibliothèque Nationale in Paris have their way, access to manuscript materials will be primarily via reproductions; indeed, scholars are already told routinely to consult microfilms or photocopies.

Digital scanning of manuscripts and paintings, the newest and most promising reproduction technology yet devised, will—thanks to hypertext capabilities—enhance the ease of working from manuscripts and make possible more synoptic critical editions. All of these advances in mechanical reproduction facilitate the work of scholars, and are to be celebrated rather than deplored: celebrated not least of all because, in digitized and hypertext form, they more closely approximate the plurality and variability that was the condition of existence for so much medieval art, especially manuscripts.

Medievalists will feel no angst about using good-quality reproductions for their research, provided that one maintains access to the originals when necessary. For them, the original of the manuscript (we will look at the concept of origin in a moment) does not have the special status Benjamin assigned to his hypothetical original work of art. I am not suggesting that medievalists believe a properly executed photograph, facsimile, or digitized version fully captures the scholarly or even aesthetic value of the manuscript. Rather, most medieval scholars would be hard pressed to correlate the term "original" with any given manuscript. They might ask: original of *what*?

Text-editors would reject out-of-hand the notion of "original" applied to a specific manuscript because, in the editor's view, the "original" refers to a prior work of which the particular object in hand is already only a copy, perhaps many generations removed from a lost Ur-

text. The belief underlying most scholarly editions is that extant manuscripts are only imperfect signposts pointing to an original which one must attempt to recover, if possible, from a thorough study of all extant versions. At the very least, an editor must find a "best" manuscript whose lacunae and errors can be supplemented and corrected by other manuscripts. This process is driven by an idea that comes closest to the reification implied by Benjamin's concept of aura, in that it privileges authority, authenticity, and origins while the absent Urtext enjoys virtual auratic status.

Medievalists who do not believe in a lost original would have still less reason to impute auratic status to a given manuscript. For them, variability *was* the original mode of existence of the medieval work. A given manuscript testifies in a fascinating and important way to a particular version of a work, and it can assist immeasurably in recovering contextual meanings so crucial to an understanding of the work's historical materiality: for example, how it adapted to particular conditions and audiences at given moments in its trajectory through the Middle Ages. Variable representation—*not* reproduction—was a crucial fact of life of medieval works. Benjamin's notion of transmissibility simply does not hold for a medieval literary text that could be represented quite differently from one period of transmission to another. The innumerable manuscripts of the *Roman de la Rose*, especially the illuminated ones, manifest a wide variety of treatments, yet few scholars would be led to confuse a fifteenth-century manuscript of the *Rose* with one produced in the fourteenth.

One might object that individual manuscripts of the *Rose* (say Morgan 132, which once belonged to William Morris before its acquisition by J. Pierpont Morgan), would better fulfill the Benjaminian model. I would reply, after pointing out that bibliomania really belongs to a separate sociological category, in two ways. First, by arguing that although manuscript collecting undeniably sets a different priority and value on the manuscript as objet d'art—and no doubt some collectors invest individual manuscripts with auratic status—it is by no means certain that all collectors perceive their manuscripts auratically. Second, by noting that while auratic status demands one invest individual artworks with the values denoted by the term "aura," many collectors seem little concerned with originality or the authority of origin. Serious collectors tend to acquire many manuscripts—even multiple manuscripts—of the same work, as did J. P. Morgan with the *Roman de la*

Rose. How many of his manuscripts did Morgan ever handle more than once? From the first Valois (Philippe VI began the Bibliothèque Royale in the early fourteenth century with some "books" shelved in a tower stair of the Louvre) to Jean, duc de Berry of the late fourteenth century; from the J. P. Morgans to the William Gates of the twentieth century, wealthy collectors—whatever their various motives—would almost certainly not recognize their motives in Benjamin's theory of aura. Quiet satisfaction with possessing rare objects unavailable to those less well-off, the pleasure of owning what Sterling Clark (founder of the Clark Museum in Williamstown, Massachusetts) called "fancy" pictures; these, rather than intellectualized rationales, motivate the grand acquisitors.

Paradoxically, the question of origins suggests further reasons why medieval scholars today might do well to distance themselves from Benjamin's concept of aura. Aura presupposes high culture, whereas a good many medieval artifacts—certainly a good deal of monumental art and vernacular literature—were literally vulgar, in the medieval sense of vernacular expression. Indeed, their whole raison d'être lay in an ability to appeal to the ear and the eye of a lay populace. In the medieval period, aural and visual images were an important means of communicating a variety of edifying and pleasing messages, which may or may not have been written down, at least initially, and yet were an integral part of daily life. As John of Damascus says:

> [I]mages are of two kinds: either they are words written in books, as when God had the law engraved on tablets and desired the lives of holy men to be recorded, or else they are material things such as the jar of manna, or Aaron's staff. . . . [So] when we record events and good deeds of the past, we use images.
> We use our senses to produce worthy images of Him, and we sanctify the noblest of the senses, which is that of sight. For just as words edify the ear, so also the image stimulates the eye. What the book is to the literate, the image is to the illiterate. Just as words speak to the ear, so the image speaks to the sight; it brings us understanding.[21]

Among the early vernacular "words that spoke to the ear" were those of the nascent love lyric in Old Provençal. We know that the *cansos* of the troubadours circulated orally long before they were written down, and that the inspiration nurturing evolution of this most aural of medieval traditions—for the cansos were the first vernacular meeting

21. John of Damascus, *On the Divine Images*, pp. 21, 25.

ground of music and lyrics—derived from a synthesis of stimuli that formed part of the daily life of the eleventh-century *méridional*: Arabic *muwashshahat*, liturgical music, and folk songs.

Maria Menocal has written persuasively about the ways in which vernacular lyric in the twelfth century—muwashshahat and canso— informed and shaped one another through the ferment of everyday life. With felicitous intuition, she relates this medieval cultural *brassage* to the finding [*trobar*] that inspired a contemporary rock classic: Eric Clapton's "Layla," an adaptation of *Layla and Majnun*, a romance composed in 1188 by an Arabic poet named Nizami. Menocal's point is that, like rock music today, medieval lyric arose and flourished in a swirling context of stimuli—both written and oral—that could never be pinpointed. Indeed, just as we will never recover more than the adumbration of twelfth-century performance from extant musical notation, so we will never fully "fill in the blanks" surrounding the composition and intention of even the most historically referential troubadour songs. Instead of trying to locate lyric in an auratic experience, Menocal argues, we should undertake a "reimagination (if it is really and thoroughly done) of the medieval lyric as a cultural structure of songs far more like the rock tradition all around us than like the written literary traditions of which we normally, traditionally consider it a part."[22]

I have spoken primarily about what aura does *not* contribute to medieval critical practice. But in the end of aura, in the demise of the concept as originally adumbrated, there is an important lesson. Benjamin coined the term to explain a loss, an absence, or at least the fear of an absence. I would suggest that rather than seeking to fill that void, we make it the center of attention. If Terry Eagleton worked to establish aura and trace its antinomies in what he defined as Benjamin's revolutionary practice, we might more modestly propose adopting a revisionary practice of literary history. Such a practice will look closely at the whole question of absence: not as a problem to be solved, but as a condition that both defines the historical process and remains part of the dialogue between what can be known about an historical corpus and what cannot be recovered. Revisionist literary history focuses on the space of the word, the historical locus in which the poet inscribed his oeuvre. A major component of this locus cannot be represented in hard-edged terms, for it incorporates a level of social understanding

22. Menocal, *Shards of Love*, p. 156.

that Pierre Bourdieu calls the *habitus*.[23] Social understanding in this sense, as Charles Taylor has recently noted, manifests our awareness of the fact that all social interaction is interactive, involving us in mediated exchange with "the other," meaning those who surround us and to whom we must present ourselves in a wide variety of ways.[24] This "inanimate environment" (as Taylor calls it) determines much of our expression and many of our attitudes at a level below that of formal articulation. In troubadour lyric, for example, the habitus would less likely be found in the formal language of the poems than in the assumptions underlying the social mores they evoke, the dress or concepts of beauty they describe, or their historical and geographical references. Assumptions convey social understanding, so that what is actually said either explicitly accords with the social environment, or may be seen to be at variance with it. In either event, the ambient locus so evoked will appear as "the historical other" to our own habitus, our own social conventions. Revisionist literary history, in short, "must compare the conditions of the possibility of history to its condition of impossibility."[25]

23. Bourdieu, *Le sens pratique*, pp. 87–111.

24. Taylor, "To Follow a Rule," pp. 167–85, and esp. pp. 174–76 for the discussion of Bourdieu's *habitus*.

25. "Le révisionisme assimile la condition de possibilité de l'histoire à sa condition d'impossibilité" (Rancière, *Les noms de l'histoire*, p. 130).

A Commonplace in Walter Benjamin

The editors tell us that we inhabit a time-lag, one situated between technological innovation and our capacity to analyze it.[1] They invite us, with a somewhat apocalyptic tone, to assess Benjamin's essay in the framework of our "present thinking" about art and technology, to update our "cultural software." This appeal to the contemporary raises an initial question: how can thought, a thought or a thinking, be "present," contemporary, *cum tempore*, up to date? What has been important to us in the debates about "postmodernity" is exactly the refusal to make temporality the object of conceptual synthesis, an insistence on troubling consciousness by effects of deferred action [*Nachträglichkeit*] attendant on thinking. So, with the passing of another of those *fins de siècle* that Benjamin seems to have found so attractive, it is not a question of getting him right, not a question of seeing whether the *Arcades Project* will help us to read mall culture or the Internet. Thinking the contemporaneity of Benjamin's essay is not simply a matter of updating a stable body of knowledge, and we are not excused from the difficult task of reading: not excused, in other words, from that infinite attempt to acknowledge the untimeliness of any text, an untimeliness—the aphorism reminds us—with which it is impossible to come to terms.

We will begin by posing an alternate question: how does this text give itself to be read? Since the editors have wisely refused us the space for anything like a discussion of Benjamin's argument, we will focus on his celebrated conclusion: "This is the situation of politics which Fascism is rendering aesthetic. Communism responds by politicizing art" (242). Before we ask what this might mean—the phrase still resonates in our social imaginary well after the decline of Communism—it might be a good idea to ask what kind of phrase it is. We recognize that the

1. *Editors' Note*: Parenthetical references in the text of this essay are keyed to the edition listed in the Bibliography as: Benjamin, "Work of Art."

phrase is marked by the figure of chiasmus, and we wonder if this has something do with its "aura," the reverence with which it is still intoned today, even with Zhdanov dead and the politicization of art most vibrantly an issue in liberal-capitalist democracies. Indeed, the aura of Benjamin's phrase remains undiminished by its repeated and mechanized reproduction in subsequent commentaries, a fact that might provoke us to nuance our understanding of what "aura" means in his work.

Importantly, the politicization of art is not simply the opposite of the national-aesthetic cult of the Nazis, because the sense of art changes with the decay of aura and becomes a matter of "exhibition value." The politicization of art is not a sociological reduction, an explanation of art in terms of politics, but a recognition that art is fundamentally *exhibited*, and that its exhibition only takes on meaning in terms of the political work it performs in a community of mass spectators. Art becomes the object of a critical reflection that is disinterested by virtue of the fact that its objects are wholly exhibited in "the sense of the universal equality of things" (225) that arises from the decay of aura.

Ironically, the purity of Kantian aesthetics seems realized only with the decay of aura: the work of art—now defined in terms of universalized exhibition rather than cultic inaccessibility—shifts the masses into a position of *sensus communis* and a new possibility of community. A hitherto unthinkable entity brought about by media technology, the masses are not, for Benjamin, an empirical reality except when considered, in the Fascist sense, as something to be processed as data. Kant had assigned the sensus communis (the transcendent universal community) to the subject of aesthetics (taste); Benjamin assigns it to the subject of history (the proletariat). In this way, "politicizing art" does not produce a sociology of art (as in much maximizing Marxism) because its finality is not empirical society, but rather the transcendental possibility of the *idea* of the proletariat. This is why film and photography, with their pure exhibition value and critical distancing of the observer, are potentially (though not necessarily) progressive; they can "ultimately . . . create conditions which would make it possible to abolish capitalism itself" (219). Contrary to the maximizing particularity of judgment upon which cult depends, film and photography "present an object for simultaneous collective experience" (236), and are thus likely to evoke singular judgments that stand aphoristically in relation to the universal but empty [*aphoros*] possibility of mass-community.

What we do know about Benjamin's writing is that there is something at stake in the *phrase*: Adorno, one recalls, saw Benjamin's style as a montage of fragments, and was troubled. We, however, will not speak of fragments, since they implicitly appeal to the possibility of a wider totality—a form of aestheticization, insofar as this opens the redemptive horizon of a total work of art as ultimate reunification. At the most simple level, we will say that Benjamin's concluding phrase is not a fragment but a chiasmus. It speaks today, in the age of the sound-bite, despite the fact that its referents—Communism and Fascism—no longer seem to function as the poles of political activity, and it does so because of the way it seems to imbricate art and politics, to render the one unthinkable without the other. Quite what this means, however, is not so clear.

To return to the form of the phrase, which stands out the way minimalist sculpture stands before itself, we shall ask a rather banal question: what kind of phrase is this? Is it aphoristic, a mode to which Benjamin was inclined, or does it partake of the apocalyptic tone of the maxim? We must make a heuristic distinction here. On one hand, a maxim is a totality in miniature, the purely declarative enunciation of a universal law—a phrase that *maximizes* itself (Benjamin criticizes such tropes of authoritative discourse in *The Storyteller*). An aphorism, on the other hand, is somewhat more complex—a minor phrase. The Greek *aphorizo*, meaning to mark off by boundaries, to define, or to reject, implies a negativity that is perhaps linked to aphoros, meaning barren or lacking. The aphorism lacks a certain self-sufficiency that the maxim can claim, even if the two are sometimes proposed as synonyms. Whatever the aphorism's pretension to authority, its form is dispersed in time rather than all-encompassing. Put another way, the aphorism appeals to a *mise en série*: there are always aphorisms.

Thus, the aphorism is closer to the proverb than to the Law, for there are always many proverbs; the answer supplied by a proverb is undercut by the impression that another proverb could have given a different answer. The proverb is not a measure of absolute knowledge, for it exacts the exercise of prudence. Nor does it allow the user to ignore his or her act of practical application: it provides no alibis, merely a hint. In short, the aphorism, like the proverb, invokes both a performative and a declarative dimension of meaning: neither "contains" meaning, but each requires that some meaning be attributed to it by an act of practical application. The "Law" of aphorisms and proverbs is never absolute, for it necessarily rests upon the pragmatic context of invocation.

We will suggest that Benjamin's essay of 1936 is stuffed with aphorisms concerning reproducibility and the everyday in such phrases as "buildings have been man's companions since primeval times" (239). However, the essay's interpretative history has been dogged by the attempt to extract from it critical maxims concerning the nature of art, cinema, or politics. Indeed, the editors' provocation to write this essay might be understood as a request for an updating of maxims. However, Benjamin's essay engages our problematic contemporaneity by its demand that *aphorisms be read*. This reading, in turn, demands of us the recognition that critical activity is necessarily grounded in the appeal to communal (that is to say, practical) wisdom rather than absolute knowledge. Hence Benjamin does not tell us what the relation is or should be between art and politics, but proposes terms with which to think their inseparability. Just as full aestheticization cannot mean the end of politics, neither can full politicization mean the end of art—the end of aura perhaps, but not of art—at least not the rhetorical art of phrasing and applying aphorisms.

The politicization of which Benjamin speaks is thus not a sociological demystification of art (since it is already demystified by mechanical reproducibility), but a refusal to remystify art (as does Fascism). Instead, it equates the sensus communis with an indeterminate relation of concrete experience to collectivity. Technologizing the work of art means that instead of forming a community around a single object, the experience of "being-in-common" arises from reading an art whose sheer availability precludes determining judgment or the consolidation of a communal identity. Unwilling to respond to the technological decentering of community, Fascism attempts to recover community through ritual by submitting technology to cultic forms. "Communism"—the index in Benjamin of a collectivity which, we have argued, is neither clear nor can be—owes its being-in-common to the inherently collective force of exhibition value; it points to that indeterminate community of which Giorgio Agamben speaks in *The Coming Community*.[2] Politicizing aesthetics, for Benjamin, means determining the criterion of beauty in reference to the idea-in-process of the proletariat; but for us, even more than for Benjamin, this idea is strictly unrealizable, a differential or barren [aphoros] horizon, not a technocratic apocalypse. The politicization of art called for by Benjamin is thus perhaps best understood as keeping open the indeterminate question of

2. Agamben, "The Coming Community," passim.

community and practice that is the work of the aphorism: in other words, a *reading* community, which is not the same as an interpretative community of readers. Keeping these questions open is a task that obliges us to continue the work of reading—that is, reading Benjamin aphoristically rather than invoking him as Law.

JOSHUA FEINSTEIN

If It Were Only for Real

Since the Second World War, digital electronic technology has become ubiquitous.[1] Over the last two decades, personal computers have invaded the workplace and the home. More recently, interest in the so-called "information superhighway" has led some to declare the arrival of a brave new technological era. The question of art in the age of its digital reproduction pertains to the status of these innovations. Are they comparable in cultural impact to those described by Benjamin in his famous essay? While I do not want to trivialize the great significance of new computer-based technologies of communication, I remain somewhat skeptical of the often inflated claims made on their behalf. In my estimation, the technical shifts we are now experiencing represent a continuation of processes that have been underway for some time. The media revolution described by Benjamin strikes me as more significant if only because it came first. Sound recording, film, and radio all performed radically new functions. Before the end of the nineteenth century, it was simply impossible to register motion or to record and transmit sound, and the introduction of new media technologies like the camera or telephone, even if culturally foreshadowed, profoundly changed patterns of social interaction. In contrast, it seems at least an open question whether compact discs, video-games, the latest generation of Hollywood special effects, word-processing, or even "cyberspace" have or will effect such radical cultural changes. Surely, they are all significant innovations that are part and parcel of tangible social and economic displacements, but is the "information" revolution truly on a par with the "industrial" revolution? Or has the modern world simply found new toys and amusements to propel a never-ending spiral of rising expectations and inevitable disappointments?

1. I wish to thank Amir Alexander, Richard Heineman, and Patricia Mazón for their suggestions in preparing this essay. *Editors' Note*: Parenthetical references in the text of this essay are keyed to the edition listed in the Bibliography as: Benjamin, "Work of Art."

Benjamin saw a light at the end of this tunnel. Like Marx, who had argued that new means of industrial production would both alienate and elevate the consciousness of workers, Benjamin viewed optimistically the dialectic he saw at work in the production and circulation of artworks. The same technical processes that contributed to the decline of aura and the denigration of authenticity, also had the power to usher in a higher stage of cultural development. If, for Benjamin, the world political situation seemed nonetheless to bode evil, this was due to the asynchronicity of technical and cultural developments. Benjamin saw a kind of race between techniques of mimesis and more prosaic forms of social reproduction. Although recording technologies—notably film— had the potential to promote a "mutual penetration of art and science" (236), Fascism was wasting no time in applying them to the "production of ritual values." The inevitable outcome of this "violation" would be war, itself "proof that society has not been mature enough to incorporate technology as its organ, that technology has not been sufficiently developed to cope with the elemental forces of society" (241–42). Whether civilization would productively harness these forces, or erupt in a final Armageddon, depended on the ability of modern culture to come into its own right.

Six decades later, Benjamin seems both hopelessly outdated and very au courant. Veritable academic mini-industries continue to thrive by simply applying his pioneering use of Marxist terminology to cultural phenomena. Yet Benjamin's Marxist teleology has become almost touchingly quaint, and there is even a certain nostalgia for Benjamin's era when pure evil had a face and a name: Fascism. Today, the only acceptable take on history seems to be that the apocalypse is already upon us: the blessed denizens of the air-conditioned nightmare grow increasingly apprehensive about their privileges; the rest of the world struggles to dig itself out from the rubbish-heap left when producing the former's affluence.

One of Benjamin's most important points of departure—the possibility of universal progress—has almost lost its relevance. Who today expresses a confidence in the masses that we find in Benjamin's *Artwork* essay? About the most for which anyone still hopes is local improvement. Curiously enough, technology is the one realm where faith in enlightenment, in reason's ability to provide universal solutions, still seems to persist, even though there has been some obvious flagging of enthusiasm. Benjamin's brief allusion, at the end of his essay, to a future scenario of diverted rivers and seeds sown from airplanes now

strikes us as horrific as the alternative he wished to avoid: Marinetti's global battlefield. Even so, faith in the power of science to alter fundamentally society and culture has not diminished. Environmentalists, for example, still hope for technological miracles: a practical electric car (preferably biodegradable) or the achievement of viable nuclear fusion. The present volume of essays demonstrates that both popular and academic discourse remain obsessed by the question of how technology is changing the texture and quality of existence.

One of Benjamin's most compelling observations about technology concerns its ability to erase its own effects. Film, for example, unlike a traditional medium such as painting, "offers, precisely because of the thoroughgoing permeation of reality with mechanical equipment, an aspect of reality which is free of all equipment" (236). Even so, Benjamin was profoundly suspicious of the cinema's ability to obscure its technical basis. While mourning the loss of aura, he foresaw only one solution for the ills of capitalism: a head-long rush into modernity, a ruthless immersion in the asynchronous discordance of industrial life from which those most affected—the masses—would emerge self-conscious and triumphant. For this reason, Benjamin feared any attempt to harness the power of cinematic illusion to recapture what was irretrievably lost. For him, the cult of the movie star was a last-ditch effort by capitalist interests to preserve aura by means of a medium inherently destructive of that very quality (233). Fascism posed a parallel danger: rather than allowing a progressive development of new media to dissect with scientific precision the world and all forms of authority, Fascism transformed technology into the slave of a false god.

In the *Artwork* essay, Benjamin did not seriously consider the possibility that the unattainable ideal of total self-erasure is an intrinsic, driving force behind media innovation. Indeed, digital media now present themselves as antidotes to some of the very symptoms of modernity Benjamin associated with the decline of aura. Why switch from vinyl records to compact discs? because the sound is just like that of the concert hall. Why play Super-Nintendo rather than its competitors? because Nintendo is more like the real thing, even if the scenario is pure science fiction. Claims made in connection with the Internet often refer to some lost authentic realm that only technology can restore. The electronic network, it has been claimed, will revive true public discourse in a fragmented society. Ross Perot, that paragon of down-to-earth virtue, has gone even further by suggesting that interactive television, a miracle of electronic wizardry, will finally allow America to return to its

mythic origins and to become a genuine democracy. Why bother with Congress and the Constitution, if you can have one big town hall meeting with Ross Perot as showmaster?

If Benjamin's major source of anxiety was the power of Fascist myth to obscure the harsh truth of industrial society, today's media pundits and Internet boosters seem to be concerned with the opposite—namely, the intrusion of modern life into a heretofore pristine realm of illusion. The upsurge in Internet usage, so goes the argument, has left old-timers mourning the loss of what had been their personal stomping grounds. One incident that received major media coverage involved two Phoenix lawyers who hit upon the idea of using the system of electronic bulletin boards as a convenient means of free publicity. Targeted users were so enraged that the sheer volume of their "flames" (angry letters of protest) crashed the Internet service provider used by the offending lawyers. The sullying of scenic electronic byways by unsightly billboards is just one problem. Scam artists have gone on-line to proffer false investing tips in the hope of manipulating stock prices. Nor is the crime only white-collar, for we are now accustomed to cases of child molestation initiated on the Internet. Sorry, middle America! The Internet is no escape, for this virtual metropolis is as dangerous and confusing as actual city streets.

The sad fact of the matter is that cyberspace is not and never was a La-La land. The Internet's origins, far from innocent, can be traced to the U.S. Department of Defense, which initially developed the technology as a means of ensuring communications among government organizations and researchers in case of a nuclear attack. That people found useful applications for such an arcane project is enough to restore one's faith in human nature. Still, threading one's way through this virtual universe has never been easy. Internet bulletin boards devoted to general topics are filled with endless torrents of nonsense, and many mailing lists now have "moderators" screen messages. Other bulletin boards are policed by regulars ready to "flame" unwanted interlopers into submission. In short, the Internet tends to replicate rather than suspend the contradictions inherent in public discourse, and the degree to which it offers an "alternative" rather than merely a supplement to other types of communication is open to debate.

Is there then nothing "new" about the new electronic media? On the contrary, new media present themselves differently than the forms of communication discussed by Benjamin. Those older forms provided a means for accessing a remote time or place: radio, for example, made

it possible to follow a sporting event or political rally without being physically present. Epic film extravaganzas lured viewers with the promise of re-creating history, of making the past breathe again. By contrast, the claims made by today's technologies of digital communications are far bolder: cyberspace, interactive television, and virtual reality do not merely provide access to a distant time or place, but are themselves a form of authentic experience. An electronic universe displaces the prosaic world of direct sensation. Digital technology allows the imagination and spirit to run riot. The constraints of physical existence lose all relevance. As if to confirm such assertions, computer industry lore credits the immense fortune of its richest executive, Bill Gates, to a single profound insight: a computer's software is far more important than its hardware.

A true digital enthusiast might argue that the new media represent nothing less than the final triumph of art over life. Virtual reality will dominate concrete physical experience. Life will become an endless hypertext, allowing every opportunity for the free play of fantasy. Of course, there is another way of reading this scenario. Technology, grown weary of repeated failures in the practical world, now seeks refuge in the realm of aesthetic experience. The prophets of the digital future do not so much promise to save the world as to enrich the lives of the few. For all their horrendous shortcomings, old-fashioned technocrats still believed they could benefit everyone, not just the affluent and well-educated. The idea of a postindustrial age suffers from a strangely limited application: what does cyberspace hold for people who do not have enough to eat?

The Internet has already had a tremendous impact on the circulation of art. Users can participate in bulletin boards where original compositions in music, literature, and computer-generated visual art are posted and critiqued. In the near future, it is likely that the Internet will be a prime means of distributing films, music, and other forms of entertainment. Theoretically, the world's entire cultural legacy could be concentrated in central databases, from which individuals might summon whatever artwork or examples of literature they want, regardless of their geographical location. What such developments might mean for the general status of art in modern society is unclear. History seems not to have borne out Benjamin's dire prognosis concerning the status of artistic aura. If anything, his anxiety now looks like the symptom of a quite different phenomenon: art's increasing vitality at the debut of the twenty-first century. Not only have galleries and museums flour-

ished, but the realm of aesthetic experience has annexed with a vengeance whole new territories. Is it not ironic that works glorifying the ephemeral nature of modern existence have themselves been glorified as enduring masterpieces? By the same token, the "distractions" of Benjamin's age have attained the status of a cherished cultural legacy. A banal example: in Palo Alto, near the heart of California's Silicon Valley, David Packard, Jr., son of the computer tycoon, has dedicated millions of dollars to the loving reconstruction of a 1920s movie theater in which employees of the high-tech firms relentlessly pursuing the future try to recapture the feel and texture of a bygone era.

If modern culture's quest for authenticity has persisted, despite Benjamin's predictions, something whose demise he could not have imagined has not withstood the test of time. Class conflict is no longer the inescapable fact of modern existence it had seemed to Benjamin. During the first half of the last century, even political conservatives tended to accept the premise that the rise of industrial society inevitably dissolved social bonds and exacerbated social strife between haves and have-nots. Obviously, wealth still brings great advantages, but class has become merely one of several categories of social analysis, none of which can aspire to priority or even precision. Today one speaks of identity politics almost without invoking the notion of authenticity. There is a tendency to accept human differences as self-evident and irreducible rather than viewing them as curable pathologies of the universal subject. Popular discourse now emphasizes both the terrible power and the baffling nature of difference. Consider how often journalists averred that although Bosnian Serbs and Muslims shared virtually the same language and culture, they seemed to be locked in an almost timeless war of ruthless intensity.

In the *Artwork* essay, Benjamin recognized only one legitimate foundation for social and cultural analysis: the material circumstances of modern existence. His insistence that a medium like film dissected the world with the harshness and precision of science was an expression of faith in a common truth we might call the underlying unity of human experience. Today, the very goal of a harmony between consciousness and technology seems absurd. The power of science has grown, but so has an awareness of its limitations. Few people expect technology, even by some circuitous or dialectical route, to fulfill the millennial promise of utopia. Late-twentieth-century fears of cultural conformity and the uniform sterility of modern life have given way to anxieties about the shattered, ineluctably parochial nature of existence.

Perhaps this explains the enduring vitality of art. Something has to present the tangible premonition of what no technology can effect: a harmony of the universal and the particular, the triumph of Hegel's spirit, a higher meaning to it all. It appears increasingly unlikely that digital technology will provide the key to a more fulsome existence, so the culture surrounding it adopts an unapologetic lack of concern for the horrors of present-day life. Nonetheless, we have no reason to pretend that the new media are not exciting, for at the very least they represent change. It may be change without any particular direction, but it suggests an awesome and terrible power—above and beyond mortal experience—whose coattails might one dare to ride, if only for a fleeting instant.

PRESENCE

For the film, what matters primarily is that the actor represents himself to the public before the camera, rather than representing someone else (229)

With a vague sense of discomfort [the film actor] feels inexplicable emptiness: his body loses its corporeality, it evaporates, it is deprived of reality, life, voice, and the noises caused by his moving about, in order to be changed into a mute image, flickering an instant on the screen, then vanishing into silence (229)

Even the most perfect reproduction of a work of art is lacking in one element: its presence in time and space, its unique existence at the place where it happens to be (220)

For aura is tied to [the actor's] presence; there can be no replica of it. The aura which, on the stage, emanates from Macbeth, cannot be separated for the spectators from that of the actor (229)

The poorest provincial staging of *Faust* is superior to a Faust film in that, ideally, it competes with the first performance at Weimar (243)

Radio and film not only affect the function of the professional actor but likewise the function of those who also exhibit themselves before this mechanical equipment, those who govern. . . . The trend is toward establishing controllable and transferable skills under certain social conditions. This results in a new selection, a selection before the equipment from which the star and the dictator emerge victorious (247)

The philosophical pertinence of etymological speculations is—at best—relative. But it is certainly interesting to realize, by way of etymology, that the word "presence" implies a strong (if not predominant) spatial component. In Latin, *aliquid prae-est* means that "something is in front of us," and while it is true that the phrase can also mean that "something is temporally close," there is reason to believe that the spatial aspect used to be dominant. Martin Heidegger, Benjamin's contemporary, remarked (in *Sein und Zeit*) that Cartesian thought—and with it modern thought in general—has the double tendency of emphasizing

the temporal and of bracketing the spatial dimension. Before Heidegger, Henri Bergson had pursued the project of developing conceptions of time and space that would de-emphasize (if not undo) their modern penetration with numbers, measures, and mathematics, and thus allow for a return to matter and materiality as the dimension of the tangible. Indeed, if we manage to think of that which is present as that which is in front of us and which, therefore, we can touch, then it becomes difficult, all of a sudden (and perhaps only for a moment), to understand how something that is in front of us and therefore tangible can be perceived, at the same time, as "historical"—that is, as something that is temporally remote.

It is not the least among Walter Benjamin's intellectual merits—and it marks a difference that accounts, in part, for the continued fascination with his work—that he did not confuse the relation between presence and tactility with "representation"—that is, with the invocation, by ways of meaning, of something that has to remain absent. Being aware of this difference, Benjamin makes a distinction between, on the one side, an actor "representing" the idea of a role or even the body of a person that remains absent and, on the other side, an actor "representing" (perhaps we should better just say "presenting") his own body to an audience. The second meaning of "(re)presentation" explains in which sense Benjamin could speak of the "tactility" of film as a medium: for film produces an illusion of a spatial closeness (presence, tangibility) of bodies and of objects which—in physical reality—remain both spatially and temporally remote. As we can never completely bracket that illusion of spatial closeness which the film produces, we can never see an actor's body exclusively as a signifier for the meaning-construct of a role, or for another body. The actor's body is always present itself. Marlon Brando's screen-appearance is the Godfather and Marlon Brando; Elizabeth Taylor's face is Cleopatra's and her own. The techniques of montage that Benjamin so admired may well have contributed to producing this effect by undermining the continuity and coherence from which a totalizing sphere of meaning emerges, a sphere of meaning that turns every object into a signifier (and nothing but a signifier).

Clearly, Benjamin's intellectual passion and his aesthetic enthusiasm belonged to the dimensions of presence and tactility—but this preference was not easily reconciled with some other premises of the *Artwork* essay. He had a hard time, for example, overcoming the empirical fact that the presence of a movie actor's body on the screen was

only an *effect* of presence. He was hopeful that technical reproduction of the artwork, by making its presence impossible, would end by destroying the aura of the artwork—thereby making it more directly accessible to the masses. He claimed to prefer the medium of film over the live performances of theater—although the latter seemed to fulfill much better his desire for presence. He praised the closeness to the world of objects that film seems to offer, but he did not tackle the paradox that this closeness is achieved by a physical absence. While, in the main argument of the *Artwork* essay, Benjamin manages to distinguish between visual presence (e.g., the presence of the close-up) as "good presence" and tangible presence (e.g., the presence of cult objects) as (mainly) "bad presence," there are at least two footnotes in which he appears less cautious—and less obliged to his premises. One of these footnotes celebrates presence by stating that, in one sense, even the poorest theater performance is superior to a film of the same play "because it competes with the first performance," meaning that the poor "provincial performance" shares the effects of presence with the first performance and that it thus unavoidably makes the first performance present again. In the second of these footnotes, Benjamin admits—allowing for a contiguity of phenomena which he must have found quite unpleasant—that movie stars (on whose medium he set such high hopes) are thriving for the same reasons that make dictators the dominant political figures of his time.

Why Benjamin gets into such conceptual trouble is not so obvious, although conceptualizing a dialectic (or, more precisely, an oscillation) between presence and absence would have helped him to clear up some of these problems. For example: film produces an effect of a closeness between a spectator's body and that of an actor, but ultimately the two remain beyond any mutual reach. At the same time, however, this inescapable remoteness of one from the other produces a desire for physical closeness, for a closeness in space. As both collector and author Benjamin was a master practitioner of this very ambiguity that was so hard for him to conceptualize. "Historicization"—or, in less academic terms, getting the flavor of history—is, above all, the capacity to imagine an object close in space (an object that can only be familiar) in its original, in its "authentic" context, including all the defamiliarizing effects triggered by the discovery of such remoteness; to historicize is to gain a component of absence from an object that is physically present.

The museum is the one institution that caters to the desire—and to the talent—of discovering and appreciating such remoteness and ab-

sence in objects which, at first glance, may appear to be only close (the museum is also an institution that both elicits and sanctions the desire to touch). Could we then say—with mild irony (if with any irony at all)—that Walter Benjamin, whose ambition was to imagine and to conceptualize a politically revolutionary, a nonauratic, distracted way for the masses to appreciate works of art, was the prophet of customers in today's highly popular museum shops? Was he the forerunner of a cultural style whose state of development in the early twentieth century was barely embryonic, compared with the triumphant dimension that it has conquered today? The museum shop is the place of a smooth tradeoff, one that draws its claim to legitimacy from the claim that it happens in the name of democracy. What cannot be touched in the museum (much less owned) becomes tangible and turns into a possession—for a very moderate price—in the museum shop. The concession that I have to make, the trade-off to which I must agree for this touch to become possible—and exciting—is this: I must bracket my (inglorious) awareness that the "Ancient Egyptian" scarabaeus that I am buying for my daughter in the museum shop cannot "really" be transformed into temporal remoteness because it was produced only a few months ago in Taiwan. But what if we all behaved as if this partial transformation of closeness into remoteness was still possible? What if I simply didn't tell my daughter that her scarabaeus was produced a few months ago in Taiwan? Well, then I become a producer of second-hand auratic effects—which may be my métier anyway. Regarding the museum store, Walter Benjamin would probably have been less optimistic, for he could not have known how auratic Botticelli-posters (bought in the Uffizi) can be when hanging in my office or in my colleague's apartment.

ABSENCE

> Art reacted with the doctrine of *l'art pour l'art*, that is, with a the-
> ology of art. This gave rise to what might be called a negative the-
> ology in the idea of "pure" art, which not only denied any social
> function of art but also any categorizing by subject matter. (In po-
> etry, Mallarmé was the first to take this position) (224)

> It is no accident that the portrait was the focal point of early pho-
> tography. The cult of remembrance of loved ones, absent or dead,
> offers a last refuge for the cult value of the picture. For the last
> time the aura emanates from the early photographs in the fleeting
> expression of a human face. This is what institutes their melan-
> choly, incomparable beauty (226)

> Today the cult value would seem to demand that the work of art
> remain hidden (225)

> Even the most perfect reproduction of a work of art is lacking in
> one element: its presence in time and space, its unique existence at
> the place where it happens to be (220)

It is not surprising that a committed "materialist" like Benjamin speaks
almost never about "absence" as it is used in contemporary, postphe-
nomenological discourse. There is, in fact, one passing, elliptical refer-
ence to it in the *Artwork* essay—Mallarmé is cited as among the first
poets to deny "any social function of art"—but this comment only
makes sense if referred to a fragment on "taste," appended to the first
draft of Benjamin's Baudelaire text, written about the time of the *Art-
work* essay:

> In *l'art pour l'art* the poet for the first time faces language the way the
> buyer faces the commodity on the open market. He has lost familiarity
> with the process of its production to a particularly high degree. . . . The
> poet's taste guides him in his choice of words. But the choice is made only
> among words which have not been coined by the *object* itself—that is,
> which have not been included in the process of production. . . . At the end
> of this development may be found Mallarmé and the theory of *poésie
> pure*. There the cause of his own class has become so far removed from
> the poet that the problem of a literature without an object becomes the

center of discussion. This discussion takes place not least in Mallarmé's poems, which revolve around *blanc, absence, silence, vide. (Charles Baudelaire,* 105–6)

Benjamin rejects an art of pure invention whose forms respond only to the will of the solitary creator, far removed from—and relatively uninterested in—causes related to "the class to which he belongs."

Yet one of the continuing fascinations of the *Artwork* essay is its pivotal position within the movement and development of Benjamin's thought, and so we can contrast his disparaging remarks on the social detachment of *l'art pour l'art* to his suggestion—in an essay of 1931— that the mystery and enchantment of early portrait photographs was due in part to an "absence of contact between actuality and photography" that resisted journalism ("Small History," 244). He locates the power of these portraits in the technical demands of early photography, which "caused the subject to focus his life in the moment rather than hurrying on past it; during the considerable period of the exposure, the subject as it were grew into the picture, in the sharpest contrast with appearances in a snap-shot" (245). Four years later, in the *Artwork* essay, Benjamin radically "rereads" early portrait photographs: now aura emanates from these images "in the fleeting expression of a human face" and the "cult of remembrance" offers a last refuge for cult value before its mechanical liquidation. Benjamin's critical trajectory is played out in the 1939 version of his Baudelaire essay, where looking into the camera is given yet a third coloration: "What was inevitably felt to be inhuman, one might even say deadly, in daguerreotypy was the (prolonged) looking into the camera, since the camera records our likeness without returning our gaze" (*Charles Baudelaire,* 147). What might be the goal of Benjamin's critical journey? We could say: a theory of mechanical images devoid of "modernist" absence.

Benjamin's reading of old photographs moves steadily away from anything that might celebrate the charm of absence as he strives to reframe their attraction in positive, materialist terms. In 1931 he sees a "magical value" in early photographs, based on a difference between the wealth of data delivered by the camera image and our irresistible urge:

to search such a picture for the tiny spark of contingency, of the Here and Now, with which reality has so to speak seared the subject, to find the inconspicuous spot where in the immediacy of that long-forgotten moment the future subsists so eloquently that we, looking back, may rediscover it. For it is another nature that speaks to the camera than to the eye; other in

the sense that a space informed by human consciousness gives way to a space informed by the unconscious. ("Small History," 243)

If Benjamin's formulation reminds us vaguely of Proust's *mémoire involontaire*, we would be close to the mark because, in the second version of his Baudelaire essay (1939), Benjamin explicitly aligns what he means by "aura" and the Proustian idea:

> If we designate as aura the associations which, at home in the *mémoire involontaire*, tend to cluster around the object of a perception, then its analogue in the case of a utilitarian object is the experience which has left traces of the practised hand. The techniques based on the use of the camera and of subsequent analogous mechanical devices extend the range of the *mémoire involontaire*. (*Charles Baudelaire*, 145)

What does Benjamin achieve by this alignment? In at least one sense, his strategy banishes "absence" from his discourse by replacing an open-ended set of possible responses with a finite set rooted in lived experience. Nowhere is this shift more evident than in the comparison he draws between painting and photography:

> The painting we look at reflects back at us that of which our eyes will never have their fill. What it contains that fulfills the original desire would be the very same stuff on which the desire continuously feeds. What distinguishes photography from painting is therefore clear, and why there can be no encompassing principle of "creation" applicable to both: to the eyes that will never have their fill of a painting, photography is rather like food for the hungry or drink for the thirsty. (ibid., 146–47)

Benjamin introduced this comment with a quotation from Paul Valéry that suggests "we recognize a work of art by the fact that no idea it inspires in us, no mode of behaviour that it suggests we adopt could exhaust it or dispose of it" (cited in ibid., 146). But Benjamin seems to willfully misread Valéry; consider, for example, Valéry's description of Manet's portrait of Berthe Morisot that appears in the same collection of texts from which Benjamin drew the opening citation of the *Artwork* essay: "[T]he confusion of curls, tie strings and ribbon to each side of the face; the face itself with its great eyes whose vague fixity suggests the profoundest abstraction, a sort of *presence in absence*—the total effect adds up to a singular impression of . . . *poetry*" ("Triumph of Manet," 113). Benjamin reads Valéry on painting to see an image that feeds our impulsive *desire* for beauty; when he moves to photography, he sees an image of plenitude that feeds our *appetite* for things.

Benjamin's reading of Valéry exactly misses the force—the lack in

painting—that generates a desire to keep looking because it is unable to extinguish memory: an absence that Valéry could embrace for its poetry, but which Benjamin's materialism could not accept. Rather, he opts for distanciation and loss of memory wrapped in a different concept:

> To perceive the aura of an object we look at means to invest it with the ability to look at us in return. This experience corresponds to the data of the *mémoire involontaire*. (These data, incidentally, are unique; they are lost to the memory that seeks to retain them. Thus they lend support to a concept of the aura that comprises the 'unique manifestation of a distance.' This designation has the advantage of clarifying the ceremonial character of the phenomenon. The essentially distant is the inapproachable: inapproachability is in fact a primary quality of the ceremonial image.) Proust's great familiarity with the problem of the aura requires no emphasis. (*Charles Baudelaire*, 148)

All of which helps us to explain Benjamin's otherwise cryptic line in the *Artwork* essay: "[T]oday the cult value would seem to demand that the work of art remain hidden" (225). Distance, concealment, and loss are not the same as absence: to "save" his theory from the social estrangement he condemns in *l'art pour l'art*, Benjamin shifts the terms driving our desire to "see and be seen" from lack and absence to invisibility and distance. Aura is the concept that negotiates this shift. By the second Baudelaire essay (1939), much of its power has been usurped by the memory traces of Proust's *mémoire involontaire*, yet the asocial, open-ended void of absence has been kept at bay. So it is no surprise that "aura" in the *Artwork* essay stands poised between these two moments—between two kinds of memory—as the "unique phenomenon of a distance, however close it may be" (222).

Yet for all its materialist obsessions, a profound absence lurks deep within the logic of Benjamin's *Artwork* essay, one that becomes clear if we introduce Henri Bergson, a third author of great interest to Benjamin at this time. Benjamin writes at length on Bergson's *Matière et mémoire* in the 1939 Baudelaire essay, and the interesting part of his encounter with Bergson is the way Proust emerges as the poet who "put Bergson's theory to the test" and challenges the idea that "only a poet can be the adequate subject" of an experience in the *durée*. In short, Benjamin makes Proust do to Bergson what Benjamin did to proponents of *l'art pour l'art*. Given Benjamin's interest in Bergson, it is likely that he read the latter's *Creative Evolution* of 1907; given our sketch of Benjamin's project to banish "absence" from his discourse, it

is also likely he was not swayed by the book's argument, which is among the first to discuss "absence" in its modernist sense.

Revisiting Bergson's essay alerts us to the fact that when Benjamin suggests "even the most perfect reproduction of a work of art is lacking in one element: its presence in time and space, its unique existence at the place where it happens to be" (220), he initiates a logic of negation and absence in his discussion of mechanical reproductions. Bergson argues that such a logic will never produce new ideas, and he uses two kinds of statements—"the table is black" and "the table is not white"—to underscore the peculiar quality of the second: while the first speaks of the table, the second *may* speak of that object, but is essentially a judgment about some other opinion, one that has found it white (*Creative Evolution*, 287–88). What this means is that:

> When we deny, we give a lesson to others, or it may be to ourselves. We take to task an interlocutor, real or possible, whom we find mistaken and whom we put on his guard. He was affirming something: we tell him he ought to affirm something else (though not without specifying the affirmation which must be substituted). There is no longer then, simply, a person and an object; there is, in place of the object, a person speaking to a person, opposing him and aiding him at the same time; there is a beginning of society. Negation aims at some one, and not only, like a purely intellectual operation, at some thing. It is of a pedagogical and social nature. (288–89)

But there is more to Bergson's point, for an affirmation like "the table is not white"—or "a mechanically reproduced work of art lacks presence"—performs two simultaneous acts: first, it sets out what *ought* to interest the speaker and listener about the object of discussion without, however, forcing that interest on the listener; second, it announces that something else *should* be said without specifying what that might be. We might reply: "Well, the table is red," or "The mechanically reproduced work of art has glamour," but in neither case has the opening, negative comment framed what *can be* or *ought to be* the next observation. Bergson concludes: "It is in vain, then, that we attribute to negation the power of creating ideas sui generis, symmetrical with those that affirmation creates, and directed in a contrary sense. No idea will come forth from negation, for it has no other content than that of the affirmative judgment which it judges" (290).

Why is this important? First, because it is evident that the *Artwork* essay is a work "of a pedagogical and social nature," and Bergson's analysis helps us to see how Benjamin mapped the *situation* of our in-

struction. Second, when Benjamin slips his argument from lack of presence to lack of authenticity, from lack of authenticity to lack of historical testimony, from lack of historical testimony to lack of authority, and from lack of authority to lack of aura (220–21), we can recognize that his entire chain of reasoning springs from a negation incapable of founding an idea: behind a screen of smoke gently agitated by the breeze of aura is a nothingness—an absence that will not speak its name.

The Flip Side

"Rock and roll will never die" is one of the many charming anthemlike lines that rock uses to describe itself. It is, of course, a lie: rock could well die—and the urge to die, to become a "classical" tradition, in other words, is as strong in rock as in any other tradition. One of the best ways to describe what constitutes death for a song tradition is when it acquires the notion of an irreproducible "original": an authentic, perfect version that cannot be equaled, that cannot, in the parlance of music, be covered.[1] In this, as in so many other areas, the etymologically related concepts of "origins" and "originality" are crucially dependent on each other for any functional value: the very conceit of originality is strictly dependent on the existence of an original—that authentic form whose derivatives, whether they are perfect or imperfect copies, are necessarily secondary, derivative. (The word "copy" already carries within it the same disdain.) But before I talk about the death of a tradition, of an aesthetic form, let me talk first about the flip side, its life.

It is instinctive to react negatively to Benjamin's meditations on the supreme cultural value of authenticity from a backward-looking perspective—that is, as the editors of this volume suggest, "in the digital age." This would be, in essence, a narrative of how Benjamin precedes us and thus how he could not have known the many remarkable cultural phenomena that would flow from technological reproduction, the story of how we are now in a "radically changed technological, cultural, and social environment" to quote again the editors of this vol-

1. A cover in the rock tradition means a version of a song that is not merely an attempt to reproduce an earlier version (what might be an "original") but rather is intended to interpret the song differently. While there are occasional purely imitative covers (usually as part of some special occasion—one thinks, for instance of George Michael's extraordinary imitation of Freddi Mercury's recording of *Somebody to Love* at the "memorial" concert for Mercury), but these are rare.

ume. There is an even more instructive story, I believe, to be found in first reacting negatively from the opposite temporal perspective. Benjamin's cultural prejudices and dicta revolving around the issue of originality—which means, let us repeat it, a bedrock belief in the existence of an inimitable authentic original—are part of the profoundly antimedieval aesthetics that has characterized the definition of European high culture at least since Petrarch. Ironically, full institutionalization of the Petrarchan disdain for the culture of variation—which is the opposite of a culture of the authentic original—is dependent for its full historical fulfillment on the most remarkable of tools of mechanical reproduction, the printing press.

The first point I want to argue, then, is that Benjamin's position is extraordinarily Petrarchan in its denial of high cultural value to literary phenomena that are rooted in cultures that do not prize "originality" and thus have little or no concept of an authentic "origins" but instead value variation, "covers," and "coverability." Part of the historical irony involved here is that for Benjamin and almost all other modernists the conscious articulation of the distinction between one type of cultural value and another is implicitly that of a decline from the cultural achievements of the modern West. This prevalence owes much to the success of that paradigm in obscuring the radically antioriginarian basis of the most "authentic" (in terms of the same paradigm) European cultural moment—namely, the rise of vernacular cultural forms in the tenth through twelfth centuries.

One could adopt a very different narrative perspective from which the dynamic issue within Western culture is always the struggle between an aesthetics (and ethics—for it is, indeed, a highly ethical question) that values variation—and thus has no conscious belief in the supreme value of "authenticity," no historiography of "origins"—and its opposite, an aesthetics that values fixed forms, worships authenticity, and cultivates the search for origins as the ultimate intellectual and philosophical quest. This conflict, moreover, is both internal and external: it is not merely one powerful, consistent set of beliefs and believers pitted against another (even if it often looks that way from the outside) although, in any given historical moment, one vision of cultural value may be largely triumphant. The conflict is always, at a minimum, latent within either vision, even within any given individual in either mode: in a culture of variation the attractions of classicization are never very far; conversely, in classicizing moments the seductive allure of variation is often just barely repressed. The role of mechanical re-

production—I will focus on the advent of printing and the development of its aural equivalent, sound recording—is equally "conflicted" and manipulable. Printing and recording can serve, with equal efficacy, as agents of classicization by fixing forms and providing the basis for an aesthetics of originality and "authenticity" or, conversely, as precisely the agents that allow a culture of variation to flourish. Because I cannot develop the full complexities of this dialectic in this brief essay, and because I mean for this to be a reading that reveals the ahistoricity of Benjamin's views, I will dwell on only two of the "ironic" aspects of the problem—how, in essence, the relationship between mechanical reproduction and authenticity can be viewed exactly opposite to Benjamin's conception of it. The flip side.

First irony: the printing press and the development of a print culture is the form of mechanical reproduction that allows the ascendance of a concept of authentic original. In historical, developmental terms, it is simple enough to see the destruction of a medieval culture of variation—a culture whose two principal literary forms were the song (later called, in the age of mechanically reproduced written form, lyric and poem) and the story, principally the stories of what is called the framed-tale tradition. Framing, the specification of a person telling a story (usually a twice-told tale) is the narrative device that thematizes and makes central the oral nature of storytelling that would be largely replaced with the advent of a print culture. In both cases and in different ways—ways that have all too often been occluded by a literary historiography that participates in the value systems of print culture—the highest values are those of variation and participation, of reproducibility and covers. Speaking generally, authenticity and excellence in such traditions are necessarily keyed not to "uniqueness" but to something resembling the opposite, which I might state as how many versions— variants, of course—are produced.[2] Originality is not a function of uniqueness (a phenomenon that within this framework is actually a marker of sterility) but of performance of a known text (story, song).

2. Many of the easiest examples of this can be taken from the vernacular framed-tale tradition, to judge from manuscript evidence the most popular and influential of vernacular literary genres. In such a context, Boccaccio's *Griselda* story, itself a "cover" of the Job story (as Chaucer, in his cover, will point out) is immediately rewritten by Petrarch (who has the most difficulty with the issue of versions and covers, but who deals with it by doing his version in Latin, a complex gesture in the attempt to move into a classicized and fixed mode) and then by Chaucer, who further articulates the virtues of covers by giving, at the end, the possibility of a different way of telling the story.

Performance is, by definition, an interpretive act that involves the participation of both the performer and the audience.

At least two things need to be said about the fate of the vernacular song movement that can be called "troubadour" in a very inadequate shorthand. By most accounts (including my own) the movement is at the heart of a redefinition of culture at a crucial historical crossroads, with profound reverberations well into our own time and certainly in the late nineteenth and early twentieth centuries. First, it was a song tradition, powerfully attached to the introduction of a range of musical instruments (notably fiddles and percussion) and a mode of performance of those instruments, the whole ensemble called "secular monody." Second, of greatest importance, is that we have understood precious little about this song movement. Indeed, we have construed it in radically distorted ways because of its anteriority to any means of mechanical reproduction, and because we have seen it through a prism of the concepts of authenticity and originality for works of art in "high" culture that became virtually universal in the wake of the development of the printing press.

Let me reduce this complex point to a handful of basics. First, the lack of mechanical reproduction (in this case, recording) has meant a virtually complete loss of the vital musical aspect. Although some musical notation exists in manuscripts, what is ultimately undecipherable in this tradition—that is, secular monody as opposed, for example, to sacred polyphony—is its rhythmic component. This, in turn, has powerful implications for how we might reconstruct or reconceive the kind of music that was so transforming, so much the object of opprobrium by ecclesiastical authorities, and so central a part of the cultural revolution of the time. But the principal point is that we do not attempt to deal with this as a song tradition at all but have, instead, redefined it as "the lyric." The medieval lyric will come to have, in the vast majority of work done on it in the modern philological period, two crucial ontological features that are, in fact, diametrically opposed to the ethics of the "original" song tradition: it will be conceptualized of as a fixed-text tradition and, following that, it will have and be an authentic original. The establishment of each of these—the fixed texts that can be deduced from extraordinary variations in manuscript traditions, and origins that are transparently elusive—become the two principal philological projects in Romance studies from the mid-nineteenth century forward. In other words, the secular medieval song tradition has not been understood in terms of its own musical ethics of variation and

performance, but rather in terms of an ethics of fixed texts that, although masterfully prefigured and in part established by Petrarch in the *Canzoniere*,[3] would certainly not have become so universal without the mechanical written reproduction of the printing press. Even more significant for the argument at hand, this clearly anachronistic presentation of a foundational European lyric as a player in the culture of authenticity is exactly what allows Benjamin to articulate a kind of flip-side historical vision, one in which "originals" and "fixed forms" and "authenticity" (all dependent on each other for legitimacy) are features and values of the cultural landscape *until* the age of mechanical reproduction. The history I am suggesting reads the other way around.

Second irony: mechanical sound reproduction has been a *primum mobile* in the development of the ethics of "authenticity" and "originals" in music. Recording has played the most conspicuous role in transforming what we normatively call "classical" music from an art form rooted in the virtues of variation—performance—to one in which performance, as Edward Said has so felicitously put it, has become an "extreme occasion" in which achieving the reproduction of a perfect "original," rather than a variant personal interpretation, is the regnant ethic.[4] In rock, where the internal struggle between fixed forms and variant forms is still very much in progress (but which already has a period and style unironically called "classic rock"), recording still serves both purposes—thus revealing the complexity of the relationship between mechanical reproduction and the values of authenticity.

3. Petrarch is an extraordinary example of the inherent nature of the conflict between the vitality of vernacular variation, on the one hand, and, on the other, the urge to classicize and make fixed (grammatical, to use Dante's term in the *De vulgari eloquentia*). Petrarch's rejection of the variation and performance ethics of the song tradition is explicitly a rejection of the legitimacy of covers (see the extended discussion in Menocal, *Shards of Love*, esp. pp. 176–81).

4. See Said, *Musical Elaborations*, for an extended and highly nuanced discussion of the problem. His theoretical touchstone is not Benjamin—although he might have been—but rather Adorno. Of particular interest, in the key first chapter "Performance as an Extreme Occasion," is Said's discussion of the irony of Glenn Gould's now infamous abandonment of performance—described by Gould as "the last blood sport" because of the unattainable perfection of "authenticity" the audience had come to hear—rather than an interpretation with necessary variation. Gould's striking individuality of interpretation and performance, his attempt to recultivate and re-elevate interpretation and variation, was, in a further ironic twist, only achieved through turning to recording at the expense of live performance. In other words, the extreme classicization of the classical tradition in music has, among other things, fixed the notion of text so absolutely that live performance can no longer provide the space for interpretation and variation—only recording.

A few gross generalizations about the importance of performance and the ethics of variation in music—a crucial cultural practice that suffers from one of the most problematic dichotomies of "high" culture/"low" culture—are in order. First of all, there is a very general and powerful correlation in cultural evaluation between what I will call inaccessibility or "high" value, on the one hand, and accessibility or "low" value, on the other. In purely musical terms the correlation can be fruitfully seen by the way a Platonic or Neoplatonic prism views Dionysian music and its performance. Interestingly enough, this is the perspective of Allan Bloom's scathing denunciation of rock—a denunciation that logically (and correctly) taken to its ends would have included an equal abhorrence of (among others) Wagnerian performances in the nineteenth century and many performances of opera today. At the heart of Dionysian music is the ability to provoke profound (and widespread) emotional involvement that, in turn, depends in subtle but telling ways not only on the purely technical aspects of the music— does the rhythm, for example, make listeners get up and dance (or at least long to get up and dance)—but also on the listener's involvement in the performance or on the possibility (however openly illusory) that the individual and communal audience is able to *be* a performer—a participant intimately tied to the performer and to the very aura of the work of art.[5]

This, clearly, is a value system in which "authentic" and "original" are anathema—and in which performance must not be an extreme occasion but rather, as rock concerts largely continue to be, a fully participative occasion. Rock audiences do not just dance to the music but also sing the songs: no rock concert worth its name in the last two decades occurs without one or more audience "sing-alongs" orchestrated by the band. Most remarkable from the perspective of the utter unachievability of classical performance except by virtuosos—even the most unmusical member of the audience can pretend to be playing along with the band: a common sight at any rock concert is members of the audience playing imaginary guitars. Said rather forlornly describes the utter remoteness and formality of the classical-concert-going experience. He could have gone further and pointed out the remarkable

5. Incidentally, one can deduce from much secondary evidence as well as from the provenance of musical instruments in the tenth through twelfth centuries that the key features of the troubadour song tradition—immensely appealing to many but appalling to the clergies—was its highly moving rhythmic nature, and its ability to provoke emotional and physical movement in the audience.

material contrasts between the sheer physical and verbal involvement of audiences at rock concerts—in "live" recordings the many sounds, musical and otherwise, of the audience are a crucial part of the experience—versus the quietude and stillness of "classical" performances, in which the ideal audience is invisible and nonexistent. Ideally, there would be no way to tell the difference between a recording of a classical performance in front of a live audience and a studio recording. I am not suggesting that normative "classical" music is not profoundly moving: rather, the correct presumption is that listeners are moved "silently" and internally. I am as moved, in many ways more so, by Beethoven's Ninth as by any rock song, but public performance of the Ninth completely forbids my own participation—the aura of Beethoven's perfection depends on the utter banishment of my own performance (the singing along, conducting along, and dancing along that I do at home) and radically changes the nature of the artwork's aura, substantially depersonalizing it.

Rock, the culturally dominant vernacular song form of the last half of the twentieth century—and probably beyond—is at a historic crossroads. The role of recording and the mechanical reproduction of sound, which have undergone a remarkable revolution and progress hand in hand with the development of the genre (largely as a direct consequence of the vast economic power of the rock tradition) affects both sides of the conflict. On the one hand, recording and the cheap and universal dissemination of recorded songs have played crucial roles in the formation and preservation of a culture of variants. This is true in many complex ways, but I will single out two of the most conspicuous. First, recordings have been historically essential to exposing key early rockers to the otherwise inaccessible music of black American blues, which are a key formative strain. Without the recordings of Robert Johnson heard and subsequently interpreted by a whole generation of white British boys—Eric Clapton and Keith Richards, to name two of the most canonical—rock could not have developed as a culturally miscegenated variant form. Recordings in the formative period offered exposure to other sounds that were perceived as prestigious and became the basis for an interpretive and variant performance. Second, in a later period of cultural dominance and ascendancy, recording plays the seemingly paradoxical role of enabling the vitality of performance that in the rock concert, as I have suggested, is profoundly tied to both the possibility of a performer's necessarily variant performance and to the audience's active participation in the performance. One of the most dis-

tinctive phenomenological features of the rock concert is this extreme degree of audience involvement, which is, in the end, dependent on the audience's remarkable knowledge of the music performed—a knowledge acquired primarily or exclusively through recordings.

Anyone attending a rock concert for the first time—and used to the diametrically opposed aesthetics and ethics of a classical performance—will be astonished by the many overt markers of the audience's intimate role. There is no program, but audible reaction will indicate unambiguously the moment of recognition of an upcoming song, usually as the first few chords are sounded, sometimes (astonishingly) from the way the guitars are tuned.[6] Even more dramatically, as I have mentioned, not only does everyone sing along individually, but most concerts also include at least one or two songs in which the audience is specifically invited to sing with or even in lieu of the singers—everyone understands this is a vital part of the aura and value of the song.[7] Both of these vital features that make up the highly individual aura of the work of art that is a song—unique individual interpretation and intimate and necessary involvement of a live audience—are (the paradox should be self-evident) fully dependent on the existence and mass availability of the recording (first the single, then the album, now the CD). Moreover, the recording is not only a fixed form but also a form able to reproduce with increasing technical perfection.

The flip side (vinyl records, by the way, had flip sides, hence the expression; but CDs have only one playing side and this is beginning to affect how songwriters are structuring what we used to call "albums"—the linguistic effects of this is still an open question) is that recording—logically enough, inevitably perhaps—can and does serve the

6. Fredric Lieberman, an ethnomusicologist who has worked extensively with the Grateful Dead—arguably the most variation-and-performance oriented among the major classic rock bands—does a marvelous demonstration of the phenomenon of how quickly the Dead's audience can recognize any one of the over four hundred songs in their active repertoire. In an inaugural lecture delivered at UC Santa Cruz ("Fieldwork among the Dead," 1991, available as UCSC Media Center tape VT1659), Lieberman makes the point by having the band on stage (not the Grateful Dead, but a band there to play some of their music as demonstration) merely tune their guitars and play one or two opening chords— and then having the audience identify (quickly, invariably correctly) the song—a feat one would more likely expect from very experienced performers.

7. My own favorite example is from the early years of the development of this tradition: the performance by Country Joe and the Fish at Woodstock, of one of the most scathing antiwar songs, I-Feel-Like-I'm-Fixing-To-Die Rag, with an obscene spell-along "cheer" and the band's struggle, after each of the first two verses, to get the audience to sing the refrain; finally, the lead singer bursts out with: "Listen, people, I don't know how you expect to ever stop the war if you can't sing any better than that."

many profound urges to classicize, to fix an authentic version with an inimitable aura, to devaluate the cover in favor of the "original." I explicitly use "original" in quotes because the canonized form may, in fact, not be an original in strictly chronological or "authentic" terms, but merely in terms of what is assumed to be the perfect version—the perfect studio recording. Jimi Hendrix's version of Bob Dylan's *All Along the Watchtower*, for example, would be taken by most classic rock purists to be the perfect performance of that song, and thus the authentic, which cannot be covered without loss of aura. I recently discovered that in a large group of twenty- to twenty-two-year-olds, most assumed it *was* Hendrix's song, had no knowledge of Dylan's authorship, or of his "original" version—the one Hendrix heard, on a recording, and rather radically adapted.

Although one can argue all one wants—as I have just done briefly—that the very heart and soul of rock (or of any song tradition of the Dionysian variety) lies in its cultivation of the cover and interpretation, the inherently conflicting urge to establish a classic—and uncoverable—form is evident everywhere. It is not simply that a well-defined classic period exists (roughly speaking the decade from 1963 to 1973) in comparison to which all later material is necessarily belated (no matter how canonical in its own right), it is also that the freedom of performers to work outside the bounds of the classical norms is, at times, far more constrained by a concept of the aura of an original than it used to be. The complaints along these lines from all sorts of rock musicians are by now well known: the new guys don't get air-time or recognition unless they sound like they are a part of the classic tradition; the old guys can't do live performances with much new material because the audience has come to hear the classics, and to hear them as close as possible to their original sound. Almost invariably, the "original" is the precise and clean version, the "pure" perfection of the song recorded in a studio, the sort of sound—now we hear echoes of the sad fate of classical music—that cannot be matched in a live performance.

What is fascinating about rock is precisely that it has not yet cast its lot. It is driven by both the impulse to classicize and the urge to retain the aesthetics of variation. Recording, as I have tried to suggest, could and can serve either side. In a hundred years, recordings of rock will have either allowed the covers to continue (and will have provided a record of the many historical variants possible) or it will have set and fixed a perfect and immutable original version, with an aura of purity, which no one—by definition—will ever sing again. In the end, it is

more than possible that the effects of the superb sound reproduction techniques being developed today as part of the rock tradition will result in a complete flip-side effect both from what has until now defined rock as a vital song tradition and from what Benjamin had envisioned. The rock performance could become another blood sport through the use of technology to reaffirm the Petrarchan and Benjaminian notion of a pure and authentic aura. We can thus begin to imagine walking into a concert hall and sitting stiffly and in utter, reverential silence to a virtuoso guitarist attempting to reproduce that perfect version of Jimi Hendrix's *Purple Haze*.[8] One can only hope that will be followed by a Glenn Gould defiantly—but hopelessly—coming on stage to do his version of Neil Young's *My My, Hey Hey*, of which the final verse is:

> Hey hey, my my
> Rock and roll can never die
> There's more to the picture
> Than meets the eye

8. There is a stunning string quartet version of *Purple Haze* recorded by the Kronos Quartet in 1986, which I take to be a participant in the tradition of interpretive covers, but also a partially classicizing removal of the song from the audience-participative tradition into the silent concert-hall world (you listen quietly to it—you don't dance to it—and you can't sing along because it has been redone as an instrumental). An equally suggestive note: in playing various covers of *Purple Haze* to a group of undergraduates—none of whom were born while Hendrix was alive, by the way, and all of whom have known Hendrix only through recordings—there was not only rejection of all of the *rock* covers but indignation from many that anyone would try and do any cover (i.e., real interpretation) of that most classic of rock songs. The Kronos Quartet cover, it emerged, was the only one that met with any approval.

Post-Benjaminian

In *A Berlin Chronicle*, one reads: "The *déjà vu* effect has often been described. But I wonder whether the term is actually well chosen, and whether the metaphor appropriate to the process would not be far better taken from the realm of acoustics. One ought to speak of events that reach us like an echo awakened by a call, a sound that seems to have been heard somewhere in the darkness of past life."[1] Walter Benjamin raises this question in the context of a childhood experience that only revealed its secret sense many years later. An adult now, Benjamin discovers the reason for the elaborate story his father told him, one night, about the death of a cousin. The details of the story obscured the true reason for his death. I think Benjamin's observation may serve as a guide for the reading of his own texts. My experience with them has shown me that they open slowly through time like a fan (this is also Benjamin's image, also from *A Berlin Chronicle*),[2] and that we can read in them things that we had passed over before, occult places that we could not see or could not incorporate into memory until, years later, the same text by Benjamin activates them like an echo. I have put this idea to the test by writing down some of those echoes by way of a rereading of *The Work of Art in the Age of Mechanical Reproduction*.[3]

I. Trees in the Shopping Mall

"The sight of immediate reality has become an orchid in the land of technology" (233)

Shopping malls are a decisive chapter in the technologization of the city. The bluster of the streets allows fleeting visions of the sky, cascades of natural light between buildings, shadows inspired by light

1. Benjamin, "A Berlin Chronicle," p. 634.
2. Ibid., p. 597.
3. *Editors' Note*: Parenthetical references in the text of this essay are keyed to the edition listed in the Bibliography as: Benjamin, "Work of Art."

breaking against figures rising in relief from their facades, reverberations of light over the smooth curtain-walls of the modern architecture, *veduttas* connecting the buildings with trees in some park, nature invaded by cement, iron, and bricks. The streets remind us, though in an intermittent way, that storms exist: rain can soak us, heat smothers us, wind accosts us as we turn a corner. Not everything is under control. In the scenography of the streets, the architecture exhibits the historical temporality of its different aesthetics, even if passers-by consume it in a "state of distraction."

Shopping malls, on the other hand, are the most recent invention of a technology that is becoming definitively severed from both temporality and the intemperate. Like a spaceship, the shopping mall anticipates all the needs of its crew members: there exists neither cold nor heat, there is no random montage of mechanical and natural sounds, no improvised play of lights, no conflict between facades or styles. Above all, there exist no national differences. Shopping malls and Club Med unify their form on a planetary scale because they scrupulously repeat a typology that is a computer design and an allegory of the market. This can be proven in each of the assembled bits that form the shopping mall, but let us pause over one example: bushes and plants.

In Pentagon City, Washington, D.C., and in downtown Miami, in Sao Paulo and in Buenos Aires we are confronted with the same plants: shrubs that aren't quite miniature, but neither are they of the same size as "natural" species. Rather, they are characterized by an intermediate size, frankly artificial, unforeseen not only by nature but also by any gardener preceding the invention of the shopping mall. They are monstrous not because they differ from nature, but because they try to imitate it while hiding precisely the fact of their imitation. A Baroque garden works on nature as if it were meant to be destroyed and replaced by the garden's art. A shopping mall shrub, on the contrary, tries to intensify its "treeness" but in doing so transforms the "tree" into a monstrous plant, whose leaves are greener, brighter, and more perfect than those of any tree we have ever seen. The shopping mall's landscaping wants to reproduce the tree, adapting it to the scale of the commercial galleria.

In this it is responding perfectly to a spirit of the age that, in the midst of the most delirious technological expansion, feels a nostalgia for nature (a relationship that has probably been lost for good and, what's more, never existed as a "good" or spontaneous relationship).

This nostalgia is resolved in the quotation: the overly lustrous leaves of botanically engineered trees quote the "tree."

The shopping mall tells us that it doesn't renounce nature. Nevertheless, it separates itself from nature in a way that is both radical and completely new. In the shopping mall we breath recycled air, the lights are always artificial and never blend with atmospheric light, the sounds from outside, for architectonic reasons, must not transgress the fortified walls of the enclosure; the absence of windows denies all contact with the outside. Nevertheless, in an infantile way and with a will to an effect of "ecological" scenography, the shopping mall's courts cannot dispense with their trees, the same trees all over the planet, indifferent to the desert surrounding the shopping mall, or to the nineteenth-century city in which it has encrusted itself.

In the shopping mall, the landscaping isn't looking for the wonderment evoked by artifice, nor the romantic inspiration of a rustic countryside, nor the abstract culmination of the miniatures in a Japanese garden. Far from these examples, its originality is based on the sought-after incongruence of architecture and "natural" decor. In the midst of the visual pollution of billboards, ads, and signs, the shopping mall trees are there to prove that, if a shopping mall is the universe in the form of a market, nothing in the universe may be free from it. The technology of the shopping mall must, in order to accomplish its ends adequately, expulse all reminders of the outside world and transform itself into an abstract and universal space (there is no better metaphor for a market than a shopping mall). Nevertheless, since there prospers in hypertechnological society a "naturalist" ideology (a bland, romantic kind of ecologism) it needs the green of the trees as a guarantee, precisely, that technological universality leaves nothing outside it. Not even the trees that, crammed into their planters and arrested at half-growth, are a scenography of science fiction: emerald green leaves in a burlap landscape.

II. Film and Clip

> The spectator's process of association in view of these [film] images
> is indeed interrupted by their constant, sudden change (238)

Images need *time*: so that we can visually scan a fixed field of view; so that a shot-sequence can show us time in its narrative movement. There is a threshold of time that is indispensable to cinema; portions of

time that fall under this threshold destroy the possibility that, as much in classic films as in modern ones, in Eisenstein or Ford, in Godard, Jarmusch, or Chantal Ackerman, a meaning will emerge.

Filmic images have to follow one after another in order for a film to exist, and they have to follow one another while administering time in its duration. Cinema (including the most trivial products that the major studios distribute throughout the screens of the planet) requires that each shot be recognized as a shot: if the spectator didn't see John Wayne deciding whether or not to follow the caravan that was abandoning the threatened fort, s/he lost a precise clue as to the nature of the character. The shot wasn't complicated, but it required a viewing time to scan it and its meaning was not exhausted immediately. Rather, it had to be recuperated later, in the course of the film, where this meaning would eventually be complete. As "distracted" as the spectator may have been, s/he had to realize these operations when viewing great films like *She Wore a Yellow Ribbon* or *Río Bravo*, but also lesser productions. From this point of view, classic cinema (including action films) was *slow*. Equally slow might be a film by Jarmusch, wherein extremely long journeys over completely banal landscapes oblige us to withstand the *duration* of time. Cinema was time and presented time as its narrative material.

That *was* cinema, whose complex and temporal nature Benjamin was not able to see in its totality. His observations are prophetically applicable to postcinema, where things are different. Vision has been modified, because time no longer counts as a fundamental component and syntactic element. Naturally, postcinema uses time as a support and a medium, but it has abandoned the aesthetic and philosophical problematic of time that characterized cinema. Postcinema is not interested in the duration of shots, but in their accumulation, because the duration of the shot is something that is decided almost before the filming has begun. The shots should be between short and really short. Postcinema is a high-impact discourse, founded on the velocity with which one image replaces another. Each new image should supersede the one preceding it.

For this reason, the best works of postcinema are commercials and video-clips. These two genres based their aesthetic on erasure: image A should be erased when image B appears, which should be erased when image C appears, and so on. On the one hand, without erasure, the images would show in too obvious a way their nature as stock-shots. On the other, if there weren't an immediate erasure of image A with the

appearance of image B, there would be no possibility of reading, since the velocity of the succession of images is greater than any mental construction of meaning. Only a computer can read a video-clip the way film viewers used to read a Chaplin film. No one is that quick. Cinema was never seen with a totally "distracted" disposition: even the simplest plot of a thriller or a comedy required recuperation of images that had been experienced a half-hour or an hour before. In contrast, the art of the clip and the commercial demands that previous images be debilitated, compacted, superimposed, and that they leave open space for the images that follow.

The attraction of incessant novelty is displayed in the power of icons that anchor the novelty in a recognizable cultural space: Madonna or Bono suture the meaning of the hundreds of shots in a video that, because of the iconic force of Bono or Madonna, is not only a fleeing forward. The spectators can constantly erase images as if their eye lids were windshield wipers, because they know the icon will remain, reassuring them with the illusion of a continuity that the syntax of the video has fragmented infinitely.

III. Disloyal Syntax

> The public [of the film] is an examiner, but an absent-minded one (241)

Zapping is a procedure that the technology, relatively simple, of remote control has made possible. With zapping, an uncertain syntax threatens the syntax of any film or television program. It matters little how much one has thought about the relation between one image and another; zapping is capable of rupturing that relation and installing a new one, unforeseen in the moment when the film was edited. But zapping is possible not only for technical reasons, and its origin lies not only with a gadget like the remote control. Zapping also presupposes spectators accustomed to the high-impact velocity of television and video images. In the same instant that those spectators feel that the intensity of the impact is insufficient to maintain their interest, they press a button and organize a new syntax of images. The desire of the spectator, who flees from boredom and demands to be permanently entertained, organizes from the household remote control a technological usage that replaces both film editing and the on-off switch of the television camera in a studio.

With zapping, one pursues an intensity of images that will never be

sufficient, branded by a velocity of shot successions that will never be considered excessive. The attention span tolerates no delay, nor does it accept the idea of waiting for a meaning. On the contrary, distractedly, one pursues a meaning that is nowhere. The last technical recourse from the desperation inspired by the flow of time, zapping is the interactive invention that no engineer of the audio-visual industries intended to invent. The market, which needs a faithful audience, has found itself, paradoxically, with distracted but disloyal critics.

IV. *Jazz*

> The technique of reproduction detaches the reproduced object from the domain of tradition (221)

> The uniqueness of a work of art is inseparable from its being imbedded in the fabric of tradition (223)

Let's consider jazz. Technical reproduction of the session, almost contemporaneous with this music's first historical phase, made possible the transmission of a tradition: first within the black minority community, repressed and discriminated against; later, to white society, which took this music and, submitting it to aesthetic and marketing operations, converted it into the epitome of an "American sound" in the 1940s. It is impossible to listen to jazz (Louis Armstrong or Miles Davis, Charlie Parker or Ornette Coleman, Bill Evans or Cecil Taylor) without harkening back, in the act of listening, to the previous jazz tradition. That tradition is present even in the absences, in the silences of the tradition, in its gaps. The sound of the instruments in jazz, which is different from the sound of those instruments in all other music, is constructed in continuity or in debate, in homage or in criticism of this tradition. Every great jazz musician listens to all the previous sounds of his instrument before finding the one that will be uniquely his.

Jazz is, possibly, the music in which dialogue with tradition attains a *form*. Improvisation and quoting were the two procedures on which jazz imprinted its originality. Jazz is, therefore, a music against oblivion. One plays an instrument, one composes, one improvises on the indispensable assumption that the musicians as well as the public are capable of recognizing the quote, working with the memory of what is missing, and discerning the differences between the quote and the music quoted. On the other hand, the pleasure of jazz lies in recognizing the quote not as a dead fragment of the past, nor as an indifferent recurrence, but rather as a living element of the new composition. To lis-

ten to jazz is to remember jazz as it was listened to; to make jazz is to presuppose the aesthetic potential of this remembrance.

Technical reproduction, on disk or tape, of a session or of an original studio recording, laid the foundations of a cultural tradition: the disk or the tape reinforce the presence of the quote, communicate the present with the past of jazz, and allow us to see how a musician dialogues within that tradition, whether trying to affirm it or to destroy it. One truly revolutionary aspect of jazz is its disposition to give cultural continuity to a music which, in its origins, seemed to be destined by society to fragmentation or to mere entertainment.

The force with which jazz superseded the limits within which white society tried to enclose it forever (even by way of the "white" use of jazz in the great swing orchestras) was driven by an impulse to resist forgetting the cultural tradition from which it emerged. The sound of each great jazz musician is a personal mark of originality, a mark produced in his listening to the cultural tradition. Without a solid anchoring in that tradition there is neither innovation nor rupture. In this way, technical reproduction did not function as a solvent of cultural ties, but rather as an imaginary space of identification. The same occurs with the jazz public: to listen to jazz presupposes that we appropriate a few decisive moments of this century that would otherwise be irremediably silent: *happenings* befallen once and for all time, if technical reproduction had not made it possible to know the past of a music deprived, for many decades, of scores, conservatories, or academies.

V. Museum Shop

> Technical reproduction can put the copy of the original into situations which would be out of reach for the original itself. Above all, it enables the original to meet the beholder halfway, be it in the form of a photograph or a phonograph record (220–21)

Museum shops are a fundamental setting for investigating contemporary aesthetic practices. There, many people pass more time before the reproduction of a painting than in front of the original: a person heads for the poster display, selects a work, takes it in hand, moves it closer then farther from his or her eyes, looks at it from the side; s/he puts it aside, takes another work and repeats the same operation; returns to the first. Sometimes it's a question of a detail enlarged from the original work; with the estrangement that all blowups produce, this detail can be perceived "better" than in the original that hangs on the

walls of the same museum. Later, the visitor heads toward the stacks of postcards. In some museums, postcards reproduce virtually all of the important works hung on the walls, and many museums arrange their postcards by period or artist, so that the visitor finds, in miniature, the sequence of paintings that s/he found in the galleries. One can, literally, touch those paintings; the difference of size and their reduced scale makes them "familiar." A historical tableau several meters long, whose upper regions are barely visible, becomes a comic strip that can be read slowly and with no physical effort. The attributes of the characters in an allegory, which were irresolvable because of glare or darkness of the palette, are shown in the postcard to be clearly illuminated and flattened out by the flash.

Agendas, notebooks for collecting recipes, telephone books, private diaries, family date books, decks of cards, coasters, place mats, all permit one to handle those untouchable pieces one has just seen in the museum, or knows are there. The transiency of a direct vision of the original, the fugitive quality that always seems to threaten happiness, is trapped in reproductions. Visitors are comforted in the museum-shop because, through a clever intervention of the market, the originals convey the impression that they will never escape. The anxiety that the museum produces is quieted in the shop. The "aura" disappears, but, in some way, the object deformed by false lighting and false proportions remains in the hands of the visitor. While the museum can be a simply intolerable place for the conflictive copresence and overdetermination of originalities, the museum shop is a place ordered according to logics accessible to everyone: it has to do with ordering objects by use, by size, by known materials (printed paper, cardboard, plastic), and by exchange values.

The visitors are better acquainted with these logics (which are incorporated in their daily lives) than with those that organize the museum. They feel more comfortable when their vision is accompanied by other activities that are prohibited in the galleries where the originals hang: in the museum shop, the visitors may touch what they see, even when what they touch is not the surface upon which the hand of the painter left its mark, but rather the ultrasmooth surface of Bristol board. In any case, they are not condemned to view only from the distance that the same museum establishes (sometimes with an absurd lack of tact) in its galleries. The cultural terror that can assault the visitor in front of the originals that s/he knows to be irremediably remote,

is attenuated before the reproductions that might possibly become banal proximities.

The museum shop is a self-administered guided tour. The videos that museums produce from their collections, once they arrive at home, might become fodder for curious operations of homespun montage using the remote control: impressionists in *fast forward*, *freeze frame* for a Constable landscape, *close-ups* of Botticelli goddesses. Finally, it has also been said that the restoration of Michelangelo's murals in the Sistine Chapel responds to a tele-visual aesthetic (in the strictest sense of the word, hence the hyphen) that has little to do with aura.

Pietà

I arrived early, a few days later, for my mid-morning rendezvous with Owler. I usually would—arrive early, that is—whenever I had to meet him somewhere. For someone who gave the impression of having an ample margin of leisure in his life, he was awfully intolerant of tardiness. The first and only time I was late for an appointment with him he laid into me in an insidious fashion, accusing me of living in flight from my own death, of an unacknowledged and unresolved fear of it. When I protested that I didn't see what my being late had to do with my being-unto-death, he insisted that every appointment, however casual or insignificant, figures as an allegory of our ultimate *rendezvous*, or "self-rendering." When it comes to that last appointment some of us want to be there on time, ready and waiting, while others would prefer to delay the moment. Most people hope to cheat a little more time out of their existence. The problem is that death runs on its own schedule, not yours. It may come early, it may come late, but it's unlikely you can assure yourself of the latter alternative by making a habit of tardi-

Author's Note: The following is an abbreviated version of the second chapter of a book that appeared in French under the title *Rome, la pluie: A quoi bon la littérature?* (Paris: Flammarion, 1994). The book consists of five dialogues between the characters Leonard Ash and his enigmatic friend Owler. Although it contains only one explicit reference to Walter Benjamin earlier on, the dialogue is an extended meditation on certain aspects of Benjamin's *Artwork* essay. Owler, in his own idiosyncratic idiom, would seem to be arguing that art restoration is a form of mechanical reproduction, the irony of it being that it is undertaken on behalf of the "aura" of the original. Benjamin speaks of the aura in terms of a "phenomenon of distance," which in this dialogue comes to mean the manifestation of historical time that an artwork bears in the traces of its age, call it the aging process itself. Restoration, which presumes to preserve and enhance the aura, in fact seeks to abolish the "distance" disclosed by the aura and to bring the artwork's ideal iconographic content as near as possible to the viewer. But the aura is not in that (infinitely reproducible) iconographic content, but rather in what Heidegger called the "earth" dimension of the work, which I take to mean its embodied historicity and materiality. As for the motif of vandalism in the dialogue, the reader will have to decide for himself who are the vandalizers and who are the preservers of the artwork's originality.

ness. A habit of tardiness? I pointed out that, as far as I knew, I did not make a habit of tardiness, but Owler would hear nothing of it. I felt like, but refrained from, asking him what he could possibly know about the anxieties of death, he who did not share our ordinary limitations and who had prolonged his existence beyond all deadlines.

Waiting for him near the plexiglass barrier that keeps tourists at a safe distance from the Pietà, inside the Vatican basilica, I tried to remember the name of that high school classmate of mine from the Overseas School of Rome who got caught one night driving without a license and ended up spending it in the same jail cell with the Hungarian vandal who had just assaulted the statue with a hammer. His name wouldn't come to me. My thoughts drifted to Owler. As I spotted him walking down the aisle toward me, looking like a cross between a seaman, a dandy and a sage, I couldn't help but wonder what business my friend could possibly have with the Vatican. For this was not the first time that he had told me to meet him inside the basilica.

"Can't talk sense to anyone around here! Hello, Leonard. Am I intruding on your aesthetic pleasure?" He gestured toward the statue. "Bewitching simulacrum, n'est ce pas?" A tour guide was pontificating to a crowd of heads turned up toward the remote artwork, which the chapel's meticulous illumination failed to render more accessible. It seemed an ethereal, almost artificial thing, perched on its lofty base, shielded from us by a sheet of plexiglass. "I've gotten to the point where I don't even want to see it anymore, trapped in that cage like a wounded bird," Owler said. "I try to disregard it, pretend it's not there, but I reckon it has a pair of eyes of its own. I can feel them staring at me every time I walk out of this place."

"Which you do rather often, from what I can gather."

"Not that often, only every now and then. Curious of you to ask, though. Did I ever tell you I happened to be there when the statue was unveiled? No? I was, believe it or not. A small handful of us, select private guests and aesthetes. None of us had heard of the young Florentine before, but we were prepared to do some courteous murmuring, admiring, criticizing. You know, size it up. Instead, as the sheet came off, we were stunned, like a mouse by the smack of a falcon swooping down out of nowhere. We stood there, all muffled up. Then some of us started dropping to our knees, with our heads down, in an appeal for forgiveness. That was the immediate power of the thing—to force your eyes away from it toward some . . . darker image of the heart."

"What were you asking forgiveness for?"

"Now that's an insensate question to come from someone who used to be an altar boy. It's not like asking for a strawberry milkshake, is it? What do you ask forgiveness for if you're a Christian in a Christian epoch? For needing it, for needing to ask for it. . . . It's amazing how a work of stone could have drawn a cantankerous community together on that basis, if only for a moment, but that was the power of the thing. Of course at the time . . . I don't say the demise hadn't already started, we just weren't aware of it yet. Then the age that brought it forth gave way to another, and the thing turned into a relic. Now we can't even see it anymore—the testimony of it, I mean—no matter how many magnifying lenses we focus on it, or how many efforts we make to study it, analyze it, restore it, encase it."

I figured there was not much point in remarking that he seemed to be lamenting the loss of what Walter Benjamin called the "aura" of artworks in their original religious contexts, so I limited myself to a leading question: "You mean it's been divorced from its original context?"

"I mean the core of its coherence has disintegrated. It's visible to us only in fragments of perspectives pieced together as best we can. Better that way, I suppose—spares us its violence somehow. Every now and then it may suddenly reveal its crux to someone, shed the veils of notoriety which cover it up for us. If you happen to be visionary enough to get a glimpse of it, who knows what you'd be capable of—conversion, derangement, an act of vandalism."

The tourists had moved on and we were left to ourselves. There was a sinister resonance to his words in that hall. "I hope you're not insinuating that the Hungarian vandal who attacked it was a visionary, because if you are, that's downright absurd."

"Is that what I was insinuating? Well, who am I to judge?" He paused. "What makes you so sure he wasn't?"

"A classmate of mine from high school spent a night in jail with the man. He was no visionary, he was a quack. Do you remember what he shouted when he jumped the rail and assaulted the Virgin? 'I am Christ! I am Christ! You have murdered me!' Does that sound like a sane person to you?"

"I didn't say he was sane, did I? Again, who is to judge? I don't know what went on in the man's mind, but I reckon that when he went for the statue he was responding to something he saw in it, something which most of us don't see any longer, except only partially. I'll admit it intrigues me. Why not? It makes me want to ask what it was about

the thing that provoked him. Or do you think it's 'absurd' to raise such a question?"

"No, but I think a psychologist is more qualified to answer it than I am. I can't guess why he might have done it. Maybe he was desperate for attention and figured that hacking away at a masterpiece was a good way of getting it. Maybe he had an overdetermined relationship with his mother and took it out on the Virgin. Anything's possible. It's not the statue's fault that he chose to attack it."

"Are you sure of that?"

I asked him to give me one good reason why I should not be sure of it. "There you go," he said, pointing to the statue—"one good reason." I told him I didn't see it. "You don't see it, but maybe he did." I shook my head and repeated that the vandal hadn't seen anything in the statue except his own hallucinations. "So what *do* you see in it, if you don't mind my asking?" Owler asked.

"What I see," I said deliberately and polemically, "is a masterfully resolved harmony of proportions. I see a three-dimensional triangle, starting at the base of the statue and leading up to a point of convergence somewhere above the Virgin's head. I see, in the juxtaposition of the horizontal body of Christ and vertical posture of the mother, a figure of the cross—the crucifixion, the plastic realism of the Incarnation. In the figure of the Virgin, her gesture, her expression, I see something that calls to mind Eliot's words about 'an infinitely gentle, infinitely suffering thing.' In the abundance of her gown and its intricate folds I see the implications of the Virgin's mercy, her motherhood's capacity for universal containment—the sacred womb's involution, if you will. In the achieved image as a whole—a promise of the passion's redemption."

"Well, you always were a good reader," Owler remarked in what I took as a spirit of irony, as though I had rehearsed a passage from an art history book. "What about the prophylactic glass you see it through? You didn't describe that for me. Of course we can pretend it's not there. . . . Flippant? Well, you might be able to ignore it. I can't. Let me ask you another question, if you're up for it. Why do you suppose the vandal, in his moment of self-dispossession, struck mostly at the Virgin's eye?"

"I would say it's your turn to answer. You obviously have your own theory about that."

"We can only speculate," he said. "But the target suggests to me that there was something objectionable about her gaze; it suggests that

the statue may have eyes of its own which can suddenly open up and accuse you, trouble you, 'implicate' you, since you talked about implication. To me it suggests that he felt himself put into question by that look. Is that what he said?—'I am Christ! You have murdered me!' Strange. Very strange. It makes you wonder what there is in that gaze of hers that murders. You're right, there's a gentleness in it. But there's also a trace of incomprehensibility, wouldn't you say?—a suggestion of the absurdity, futility, unjustifiability of this body's lifeless weight on her lap. That's what she's looking at, that's what she's theorizing, after all—her stone dead son. It's scandalous, if you look at it coldly. In earlier lamentation scenes, the mother tends to be looking skyward, as if to remind us that she's receiving an explanation from above. Not here, though. Here she's looking down at the brutal fact of a murder. There's a hint in her gesture that no lofty answer could possibly allay the question."

Was he suggesting that the vandal saw in the Pietà a testimony of existential abandon, à la Jean-Paul Sartre? I asked the question cynically. Owler answered earnestly: "Again, I don't presume to know what offended or unnerved him about it, but I reckon that his act of aggression was responding to whatever it is we think of as the thing's appeal. When the artwork attains a degree of expressive power it elates you, but it can also oppress, even humiliate you. There's a sublime violence in certain images which we naively call their power, their beauty, their wonder. I would say that, more often than not, vandalism is an act of counter-violence directed against the threats emanating from the representation. Representation itself is a form of violence, isn't it? It begins and ends with cadavers—call them heroes, gods, victims, 'still life,' whatever. Art pledges allegiance to the dead. The cadaver is the basis of the first image, the first statue, the first commemoration in form. Or maybe the image is itself a kind of cadaverous thing. There are good reasons to fear the image. It's never innocent. A solemn terror lurks in the shadow it casts. Vandalism grapples with it, the shadow I mean. It strikes at something that you can't say is there yet can't say is not there. I reckon that few of us who have been deeply moved by an artwork have not also felt the trace of an urge to destroy it. Vandals and artists share something in common, as if their dialectically opposed modes of expression arose from the same impulse. And if I have to go all the way, I'd rather not, but if I have to, I would say that, yes, in some cases vandalism is a more genuine response to a

work of art than the self-satisfaction of our aesthetes and culture mongers."

We stepped out of the basilica into the blank glare of a winter noon, into the vulgar sunlight of a washed-out hour. The clamor of car traffic, the bustle of bodies, the frenzy of locomotion, gave the impression of a civic upheaval or mass panic, but it was just another day in downtown Rome. I looked down the magisterial Via della Conciliazone, extending rectilinearly toward the Tiber, and tried to imagine what that neighborhood had looked like before they cut open the grand perspectives. Owler had once claimed that before the transfiguration it had been the richest, most complex maze of streets and small squares in all of Rome. He would know. We walked toward the river as endangered pedestrians and headed for the Viale Trastevere. The Tiber glided past us like a sluggish beast of the mire, bearing its burden beneath the estranged repose of the bridges. All the stones of the city seemed oppressed by the weight of some invisible menace sinking down from the sky. A riotous traffic on the Lungotevere discouraged Owler and me from exchanging words as we made our way toward the Piazza Sonnino. In the piazza we caught a bus that contested its way up the Viale Trastever and eventually dropped us off near the Villa Doria Pamphili. As we gained the asylum of the park, we took up our conversation about the Pietà.

"That's the second time you used that word," I said. "Why are you calling it a simulacrum? I hope you're not implying that what's displayed in the cathedral is not the original Pietà."

"It depends on what you mean by 'original.' They didn't substitute a copy for the original, no, but by restoring the thing after it was damaged, they falsified it, gave us a mere likeness of what it looked like before the incident occurred."

"They've reconstructed it very faithfully."

"They've reconstructed *what* very faithfully?"

"What the work looked like before it was damaged or tarnished by the effects of time," I replied naively and straightforwardly.

"What it 'looked like'? What it looked like when? Exposure to the world changes the work's aspect day by day. Which day in its lifetime are we talking about when we talk about the original? The first? The seventh? The thousandth?"

"When it was intact, say when it left the artist's hand."

"Is *that* what we mean by the original? Something like a car with

zero miles on it? What about those cases where the artist took into account the effects of time on his artifact and dealt with his materials accordingly, anticipating the aging process? Artworks don't descend on us from some timeless realm of Platonic forms. They come to us from the earth, consigned to the fate of time and history. But for some reason we've got it into our heads that we should box them up, erase the traces of their historicity. I don't understand it. Why do we behave as if artworks aren't given over to mortality like the rest of us?"

"Restorers know full well that artworks are perishable, Owler," I said. "That's why they restore them."

"Which amounts to saying that because a woman knows there's such a thing as an ageing process she does everything she can to look twenty for the rest of her life."

"The analogy doesn't hold. The artwork's not eternal—no one's saying it is—it just hangs around longer than we do. We try to prolong its life as best we can so that future generations can see how the past saw the world."

"No, Leonard, we don't restore them so that we can see how the past saw the world. We never see how the past saw the world. What we see in the work that comes down to us from another age is the pathos of distance that separates us from its past—a distance revealed in the traces of its age and the tangible evidence of its having endured in the world. A sixteenth-century fresco that's made to look like it was painted yesterday is not a sixteenth-century fresco. It's a forgery, a simulacrum, an artwork vandalized in the name of false veneration."

I had to laugh. "So now it's the restorers who are the vandals!"

"Of course they're vandals. I'll take you on a visit one day so you can see for yourself. They're fine fellows, I'm sure, but most of them are scientifically trained technicians who may know a thing or two about chemistry but precious little about art. Most of our major museums now have their own restoration laboratories, with a permanent staff of these professionals, and I've seen them at work. Their first priority is to keep busy, to hold on to their jobs, which means that every newly purchased canvas, whatever its condition, whatever its age, passes through their hands, is stretched out on their operating floors, under bright lights, like a wounded patient. Then the surgeons go to work on it with their precision tools—remove the patina, the varnish, touch it up, accentuate the contours, homogenize the colors, revarnish—until they bring the thing into conformity with a uniform standard of newness, regardless of centuries, styles, manners. To hell with

age. There's no age left on these restored paintings, if not our own. Do you think it looks like the 'original' when it leaves their hands? It looks more like a precision photograph. That's what the contemporary public expects, you see, of a restored artwork. Every age has its own aesthetic prejudices which it's blind to, and ours happen to be dominated by the photograph—sharp outlines and a clear focus. When our present standards change, as eventually they will, only then will we truly see to what extent the restorers left indelible marks of their epoch's aesthetic taste on these paintings and frescos. But by then it will be too late. What am I saying? It's already too late for most of them—those the restorers have gotten their hands on. Let's destroy the heritage if we must, if that's what it takes to keep the fellows employed, but let's at least be honest with ourselves: this is not restoration, friend, this is systematic, institutionalized vandalism."

"So what are you proposing, that we don't touch them at all?"

"Leave them alone! They're meant to age, grow old, and eventually die—like everything else that has a life of its own. We can care for them, preserve them in appropriate environments, minimize to the best of our ability the decaying process, but to intervene in the materiality of an artwork—that's a breach of its originality."

"But where do you draw the line? What do you do with the Pietà, for example, after some quack has violently 'intervened in its materiality'? Do you just leave it the way it is, damaged and disfigured?"

"Leave it alone! Its place is in the world, in its history of interaction with it. That incident is part of its past now. Something in the thing provoked an attack. It happened. The original has been disfigured. If we were permitted to see the evidence of it with our own eyes, who knows, maybe that would open them to the scandal of the work. Isn't that what Christianity is at bottom—isn't that what the Pietà is—the revelation of a scandal? Instead we cover up the traces and call it restoration. What we see in that chapel is no more than a contrived image of what the statue 'looked like' at some prior point in its temporal duration. We've denied the thing's reality, its worldliness." He paused. "The argument I made at the time was that if people want to see a simulacrum of what the statue looked like before it was damaged, then let the restorers make a wholesale reproduction of it, leaving the disfigured original intact. Do you think anyone listened to me?"

Confronting Benjamin

I imagine that ideas have a life span similar to that of great fishes in the ocean. First of all, they play vigorously in the upper levels, often breaking the surface and following the waves in their flux and reflux. As they reach the end of their natural lives, they begin to sink lower and lower into the murky depths, and become prey to other, more predatory sea creatures. Piece by piece they are gobbled up, but enough flesh remains on the bones to turn rotten, and produce a phosphorescent glow. This diminishes gradually, and only a skeleton remains, which will in the long term be incorporated into the bedrock of the ocean in the form of a fossil.

Something of this sort seems to have happened, in the course of more than half a century, to Benjamin's extraordinary essay. It is not open to question that, in 1936, it was a formidably intelligent diagnosis of the current state of the arts: more than that, it was possibly the first attempt to think coherently about the comparative modes of visual art against a long-term history of visuality that still remains to be written. But Benjamin is not in need of further praise. What is more relevant to this inquiry is the fortune of the essay over the past twenty-five years or so, during which it has been picked over continuously—and begun to glow with a specious glamour. It will certainly be a long time before the essay is assimilated, as so much intellectual detritus, into the history of Western thought. But at present, I will argue, its effects are almost wholly fallacious. The light that it casts has ceased to reveal anything, and remains itself as a baleful glare, obstructing the possibility of vision.

Working through the stages of this particular analogy, I can perhaps allow myself a brief autobiographical moment to explain the stages of my antagonism to Benjamin's essay (though certainly not to Benjamin as a whole, since almost every other aspect of his work—on Proust, on photography, on German tragic drama, on Paris—continues to grow in

stature for me). The remarkably successful and widely diffused English edition of Benjamin's *Illuminations*, with its introduction by Hannah Arendt, was originally published in 1968. In 1972, British television published the book by John Berger, *Ways of Seeing*, which was the record of the immensely popular series of the same name: transferred from screen to the printed page, with an inexorable bold typeface that seemed to offer the statements up as tablets of the law, this text was indeed Walter Benjamin as *doxa*, the brilliant essay transformed into a mesmerizing assortment of half-truths and banalities.

I have no wish to write at greater length about *Ways of Seeing*, except to say that it represented, no doubt, a depressive stage in its author's movement from being a socialist realist critic unable to find the artists he required, to being a very fine commentator on the phenomenology of the photograph (among other things). It was also, unquestionably, the particular problem of the voice-over from the series translated to the printed page that gave the text its uniquely obnoxious authoritarian quality. But, apart from these reservations, there can be no doubt that *Ways of Seeing* succeeded in perpetuating a Benjaminian myth all the more misleading for being couched in such different terms. It was claimed that modern methods of reproduction entirely changed the status of the original work: a "process of mystification" was initiated whereby the art object no longer depended on "what it uniquely says" but on "what it uniquely is," its value guaranteed by a "market price" that was a measure of its rarity, and a "spiritual value" that simply upheld the market price. In relation to the word "spiritual," the text of *Ways of Seeing* worked itself into a paroxysm of sanctimonious disapproval: "The spiritual value of an object, as opposed to a message or an example, can only be explained in terms of magic or religion. And since in modern society neither of these is a living force, the art object, the 'work of art,' is enveloped in an atmosphere of entirely bogus religiosity. Works of art are discussed and presented as though they were holy relics."[1] This is Benjamin's notion of aura reduced to a dogma of frightening inadequacy. But why should it matter? Why should I be concerned about the inevitable process of popularization that greeted Benjamin's ideas in the period of the early 1970s? The point is (or was) that the popular diffusion of these versions of "Walter Benjamin for beginners" resulted in a systematic misrecognition of many of the most important transformations that were taking place, at

1. Berger, *Ways of Seeing*, p. 21.

that stage, in the realm of the visual arts. This inevitably reflects back on the validity of Benjamin's own prescriptions, offered more than thirty years before.

No amount of concentration on the fine detail of Benjamin's distinctions in the essay can obscure the fact that, for him, the conspectus of the visual arts needs to be interpreted according to an evolutionary pattern. The very fact of "mechanical reproduction" meant that certain newly developed art forms were equipped to surpass their more traditional fellows in the struggle for survival. Of course, this argument was not as simple as it sounds. For Benjamin, the fact that "the age of mechanical reproduction" decisively undercut the basis of the traditional work of art in cultic practices established it as an irreversible staging point in the history of image-making: "When the age of mechanical reproduction separated art from its basis in cult, the semblance of its autonomy disappeared forever."[2] But a problem remained—not so much for Benjamin, writing in 1936 when "autonomy" might indeed have seemed a hazardous claim for any artist, but for his disciples who greeted and popularized his concepts in the 1970s. What if the painters, and other plastic artists, refused to accept this irreversible development?

I should emphasize at this point that I am thinking back to my own activity as an art critic in this very period, and especially to my own attempts to make sense of what I saw before my eyes. By the end of the decade, it was obvious to me that Benjamin's essay indicated precisely the reverse of what was taking place. The operative word in that judgment is, of course, "precisely": it was not just that Benjamin seemed to have got it wrong, but that the form of his distinctions seemed to require inverting. Benjamin had predicted the withering away of the painting's aura. Yet aura, as far as I could see, was what at least some contemporary painters were trying to recover, after the existential heroics of Abstract Expressionism and the phenomenological reductivism of Minimal Art. Indeed, it was not simply that they were trying to recover aura, since that could legitimately have been interpreted as a nostalgic reversion to an obsolete form of practice. Rather, their paintings revealed or demonstrated aura, and a vocabulary had to be found for testifying to the strength of this effect.

The American artist Brice Marden, whose work I followed from the beginning of the decade, wrote in 1972: "The rectangle, the plane, the

2. Benjamin, "Work of Art," p. 226.

structure, the picture are but sounding boards for a spirit."[3] Coming in the same year as *Ways of Seeing*, one might have ascribed Marden's remark to the inveterate sentimentality of the artistic temperament, had it not been supported by a whole series of paintings that invited the critic to look again at the pertinence of that sort of statement. I tried initially to deal with its implications in a long essay published in 1976,[4] but it was only in 1980, in a catalogue introduction written to accompany Marden's first European retrospective, that I presented the issue as being integrally linked to Benjamin's prognosis. Quoting the passage from *Ways of Seeing* that has already been used here, I followed with a query that led right back to the essay of 1936:

> The whole argument rests on this carefree and unexplained assertion about "modern society" which is assumed to be a generally received truth. Yet it might not be so. It might, after all, be a flimsily based myth, at least as far as the profound interrelation between "religion" and "culture" goes. The argument of the preceding paragraph in fact brings to mind the proverb about closing the stable door after the horse has escaped. And the horse which emerges from Walter Benjamin's stable is certainly good over a distance. What emerges from the preceding discussion is the point that there is indeed an intimate link between the "uniqueness of the work of art" and religion or "spiritual value." The authors of *Ways of Seeing* would like to think of this as mere archaism, as a pitiful and doomed survival in the modern world. But they do not actually persuade us of anything except their strenuous determination to reinforce this view, in bold type and at considerable length.[5]

Clearly I cannot, in the space available to me, indicate the reasons why Marden's paintings impelled this kind of revision, but I can note that his work was not alone in this regard: one year earlier I had written, apropos Ian Hamilton Finlay, of "the repression of religious discourse in discussion of contemporary culture."[6] The point is that my experience in those years demonstrated the sheer implausibility of Benjamin's basic distinctions *as regards the art that was being produced*, despite the fact that they chimed in all too well with a particular mood in art criticism and cultural politics. Benjamin had set up his thesis on the opposition between ritual and politics, and on the distinction between cultic aura and the demythologized forms of mechanical reproduction.

3. Marden, *Actualité*, p. 91.
4. Bann, "Adriatics," pp. 116–29.
5. Bann, *Brice Marden*, pp. 9–10.
6. Bann, *Nature over Again*, p. 11.

Yet it was clearly not adequate if the politics opposed to ritual amounted to no more than a propaganda exercise by intellectuals disaffected by the delusory gains of the 1960s. And if artists still continued to insist on the validity of nonmechanical techniques, and the public continued to respond to them, then what was the basis for seeing this cultic behavior as a form of nostalgia or bad faith?

I have constructed this scenario of myself, the solitary critic responding to the challenge of new art, as a way of dramatizing the situation. Clearly, I was not alone. Clearly, there was a whole constellation of theorists and historians who were already patiently attempting to unpick the assumptions that underlay the Benjaminian thesis, in its broader and more popular form. In particular, it is worth noting that France, which was remarkably late in diffusing the thought of Benjamin, witnessed a remarkable upsurge, in the 1970s, of important works that re-examined from an unprejudiced point of view the discourses of theology and religion and their connections with contemporary culture. One need only mention Jean-Louis Schefer's *L'Invention du corps chrétien* (1975), René Girard's *Des choses cachées depuis la fondation du monde* (1978), and Julia Kristeva's *Pouvoirs de l'horreur* (1980). What these diverse studies had in common was the conviction that questions of cult and ritual were not simply to be viewed with an anthropologist's detachment: they provided, at the same time, indispensable tools for understanding the character of contemporary expressions, whether it be the writings of Proust and Céline or the paintings of the 1970s. At base, the contention was that two centuries of "Enlightenment" had not effaced the cultural history of two thousand years, or transmogrified what Roland Barthes called in his last book, published in 1980, "the religious substance from which I am kneaded."[7]

I need, however, to distance myself at this stage from the *parti pris* of the 1980s, at least insofar as it appears to be a comprehensive rejection of the thesis implied in Benjamin's essay. The polemical needs of that period required adversarial tactics. Now, the secondhand travesties of Benjamin's thought are mercifully not so prominent, and we can afford to consider his thesis dialectically, as it was no doubt intended to be read. However much we may dispute the implicitly evolutionary claims about mechanical reproduction, and the modernist ideology that underlies them, we cannot fail to notice the central importance of the concept of aura, and its continued fertility to inspire research along

7. Barthes, *La chambre claire*, p. 129.

tracks quite different from those envisaged by Benjamin himself. The current of exploration set off by works such as those cited in the previous paragraph has resulted in more studies than I would care to mention. One of the most acute of recent years (and itself a successor to several equally pertinent studies by the same author) is Georges Didi-Huberman's *Ce que nous voyons, ce qui nous regarde* (1992), which is nothing less than a resounding justification of the concept of aura in the territory apparently most remote from it—that is, the American minimal art of the 1960s and 1970s. As Didi-Huberman remarks, apropos of Benjamin's judgment on the obsolete nature of art as ritual:

> The point stands: between Dante and James Joyce, between Fra Angelico and Tony Smith, modernity has precisely enabled us to break open this connection, and investigate this concealed relationship. Modernity has completely re-symbolized it, agitated it in all directions, displaced and overturned it. But in doing so, it has given us access to what might be called its fundamental phenomenology.[8]

Benjamin's essay stands as a potent reminder of the "agitation" and "re-symbolization" initiated by modernism, without in any way obstructing (as it now turns out) the return to a "fundamental phenomenology" of the effect of aura, which remains the most productive strategy open to historians and critics of the visual arts.

It might be asked, in conclusion, if any of the more specific claims made by Benjamin about the evolutionary superiority of mechanical reproduction bear examination, from the present point of view. I doubt it. Far more significant than any claim about the obsolescence of traditional media and the nonauratic character of photography and film is the process of engagement with the human body, including certain inevitable cultic and ritual associations, now being attempted by many visual artists. Who cares if Andres Serrano's striking images of the Morgue are in the form of cibachrome color prints? Does this make them any less auratic? And, if the cinema has distanced itself as a modern medium from the traditional painted image, then why have such contemporary directors as Godard, Rivette, Greenaway, and Straub (to name only a few) made their different, but equally profound identifications with painting as process and product?

The point is that modern media undoubtedly condition and inflect modes of expression. This piece of writing has surely been influenced by the fact that it was produced "spontaneously" (as the editors re-

8. Didi-Huberman, *Ce que nous voyons*, p. 115.

quested) and without the benefit of word processing. But no item of electronic wizardry—no supposedly unsurpassable effect of virtual reality—can suppress the evidential richness of traditional media and their capacity to reveal what are the deepest stakes of our culture. Unfortunately, Benjamin's essay became a weapon for those who wished to disavow the links between religion and representation. But it has been a double-edged weapon, and the cutting edge is now perhaps turning in the right direction.

Bibliography

Editions of Benjamin's *Artwork* essay cited in the volume

Benjamin, "Das Kunstwerk" (*Drei Studien*)
> Benjamin, Walter. "Das Kunstwerk im Zeitalter seiner technischen Repro-duzierbarkeit," in *Drei Studien zur Kunstsoziologie*. Frankfurt-am-Main Suhrkamp, 1963, pp. 9–63.

Benjamin, "Das Kunstwerk" (*Gesammelte Schriften, 1974*)
> Benjamin, Walter. "Das Kunstwerk im Zeitalter seiner technischen Repro-duzierbarkeit, Zweite Fassung," in *Gesammelte Schriften*, ed. Rolf Tiede-mann and Hermann Schweppenhäuser. Frankfurt-am-Main: Suhrkamp, 1974, I, 2, pp. 471–508.

Benjamin, "Das Kunstwerk (1935)"
> Benjamin, Walter. "Das Kunstwerk im Zeitalter seiner technischen Repro-duzierbarkeit, Erste Fassung," in *Gesammelte Schriften*, ed. Rolf Tiede-mann and Hermann Schweppenhäuser. Frankfurt-am-Main: Suhrkamp, 1974, I, 2, pp. 431–70.

Benjamin, "Das Kunstwerk" (*Illuminationem*)
> Benjamin, Walter. "Das Kunstwerk im Zeitalter seiner technischen Repro-duzierbarkeit," in *Illuminationem: Ausgewählte Schriften*. Frankfurt-am-Main: Suhrkamp, 1961, pp. 148–84.

Benjamin, "Das Kunstwerk (Zweite Fassung)"
> Benjamin, Walter. "Das Kunstwerk im Zeitalter seiner technischen Repro-duzierbarkeit (Zweite Fassung)," in *Gesammelte Schriften*, ed. Rolf Tiede-mann and Hermann Schweppenhäuser. Frankfurt-am-Main: Suhrkamp, 1989, VII, 1, pp. 350–84.

Benjamin, "L'Oeuvre d'art"
> Benjamin, Walter. "L'Oeuvre d'art à l'époque de sa reproduction mé-canisée," in *Gesammelte Schriften*, ed. Rolf Tiedemann and Hermann Schweppenhäuser. Frankfurt-am-Main: Suhrkamp, 1991, I, 2, pp. 709–39.

Benjamin, "Work of Art"
> Benjamin, Walter. "The Work of Art in the Age of Mechanical Reproduc-tion," in *Illuminations*, ed. Hannah Arendt, trans. Harry Zohn. New York: Schocken, 1969, pp. 217–51.

Other writings of Benjamin cited in the volume

Benjamin, Walter. *The Arcades Project*, trans. Howard Eiland and Kevin McLaughlin. Cambridge, MA: Harvard University-Belknap, 1999.

———. "A Berlin Chronicle," in *Selected Writings, II: 1927–1934*, ed. Michael W. Jennings, Howard Eiland, and Gary Smith. Cambridge, MA: Harvard University-Belknap, 1999, pp. 595–637.

———. *Charles Baudelaire: A Lyric Poet in the Era of High Capitalism*, trans. Harry Zohn. London: Verso, 1997.

———. "The Concept of Criticism in German Romanticism," in *Selected Writings: 1913–1926*, ed. Marcus Bullock and Michael W. Jennings, trans. David Lachterman, Howard Eiland, and Ian Balfour. Cambridge, MA: Harvard University-Belknap, 1996, pp. 116–200.

———. *The Correspondence of Walter Benjamin*, ed. Gershom Scholem and Theodor W. Adorno, trans. Manfred W. Jacobsen and Evelyn M. Jacobsen. Chicago: University of Chicago, 1994.

———. *Ecrits Français*, ed. and intro. by Jean-Maurice Monnoyer. Paris: Gallimard, 1991.

———. "Erfahrung und Armut," in *Gesammelte Schriften*, ed. Rolf Tiedemann and Hermann Schweppenhäuser. Frankfurt-am-Main: Suhrkamp, 1977, II, 1, pp. 213–19.

———. "Der Erzähler," in *Gesammelte Schriften*, ed. Rolf Tiedemann and Hermann Schweppenhäuser. Frankfurt-am-Main: Suhrkamp, 1977, II, 2, pp. 438–63.

———. "Franz Kafka: On the Tenth Anniversary of His Death," in *Illuminations*, ed. Hannah Arendt, trans. Harry Zohn. New York: Schocken, 1969, pp. 111–40.

———. *Gesammelte Briefe*, 5 vols., ed. Christoph Gödde and Henri Lonitz. Frankfurt-am-Main: Suhrkamp, 1995–99.

———. *Gesammelte Schriften*, ed. Rolf Tiedemann and Hermann Schweppenhäuser, 7 vols. Frankfurt: Suhrkamp, 1972–89.

———. "Goethe's Elective Affinities," in *Selected Writings, I: 1913–1926*, ed. Marcus Bullock and Michael W. Jennings. Cambridge, MA: Harvard University-Belknap, 1996, pp. 297–360.

———. "Goethes Wahlverwandtschaften," in *Gesammelte Schriften*, ed. Rolf Tiedemann and Hermann Schweppenhäuser. Frankfurt-am-Main: Suhrkamp, 1991, I, 1, pp. 123–201.

———. "Kleine Geschichte der Photographie," in *Gesammelte Schriften*, ed. Rolf Tiedemann and Hermann Schweppenhäuser. Frankfurt-am-Main, 1974, II, 1, pp. 368–85.

———. "Marcel Proust: Im Schatten der jungen Mädchen, Übersetzt von Walter Benjamin und Franz Hessel," *Gesammelte Schriften*, supplement II, ed. Hella Tiedemann-Bartels. Frankfurt-am-Main: Suhrkamp, 1987.

———. "N [Re the Theory of Knowledge, Theory of Progress]," in *Benjamin Philosophy, Aesthetics, History*, ed. Gary Smith, trans. Richard Sieburth. Chicago: University of Chicago, 1989, pp. 43–83.

———. "On the Program of the Coming Philosophy," in *Selected Writings: 1913–1926*, ed. Marcus Bullock and Michael W. Jennings, trans. Mark Ritter. Cambridge, MA: Harvard University-Belknap, 1996, pp. 100–110.

———. *The Origin of German Tragic Drama*, trans. John Osbourne. London: Verso, 1985.

———. "Passagen-Werk (Aufzeichnungen und Materialien," in *Gesammelte Schriften*, ed. Rolf Tiedemann and Hermann Schweppenhäuser. Frankfurt-am-Main: Suhrkamp, 1989, V, 1, pp. 79–989.

———. "Reflexionen zum Rundfunk," in *Gesammelte Schriften*, ed. Rolf Tiedemann and Hermann Schweppenhäuser. Frankfurt-am-Main, 1977, II, 3, pp. 1506–7.

———. "Short History of Photography," trans. Phil Patton. *Artforum*, 15 (Feb. 1977), pp. 46–51.

———. "A Small History of Photography," in *One Way Street and Other Writings*, intro. Susan Sontag, trans. Edmund Jephcott and Kingsley Shorter. London: NLB, 1979, pp. 240–57.

———. "The Storyteller," in *Illuminations*, ed. Hannah Arendt, trans. Harry Zohn. New York: Schocken, 1969, pp. 83–109.

———. "Der Sürrealismus: Die letzte Momentaufnahme der europäischen Intelligenz," in *Gesammelte Schriften*, ed. Rolf Tiedemann and Hermann Schweppenhäuser. Frankfurt-am-Main: Suhrkamp, 1974, II, 1, pp. 295–310.

———. "Theater und Rundfunk: Zur gegenseitigen Kontrolle ihrer Erziehungsarbeit," in *Gesammelte Schriften*, ed. Rolf Tiedemann and Hermann Schweppenhäuser. Frankfurt-am-Main: Suhrkamp, 1977, II, 2, pp. 773–76.

———. "Theses on the Philosophy of History," in *Illuminations*, ed. Hannah Arendt, trans. Harry Zohn. New York: Schocken, 1969, pp. 253–64.

———. "Über den Begriff der Geschichte," in *Gesammelte Schriften*, ed. Rolf Tiedemann and Hermann Schweppenhäuser. Frankfurt-am-Main: Suhrkamp, 1991, I, 2, pp. 691–704.

———. "Über einige Motive bei Baudelaire," in *Gesammelte Schriften*, ed. Rolf Tiedemann and Hermann Schweppenhäuser. Frankfurt-am-Main: Suhrkamp, 1974, I, 2, pp. 605–53.

———. "Ursprung des deutschen Trauerspiels," in *Gesammelte Schriften*, ed. Rolf Tiedemann and Hermann Schweppenhäuser. Frankfurt-am-Main: Suhrkamp, 1991, I, 1, pp. 203–430.

———. "What Is Epic Theater?" in *Illuminations*, ed. Hannah Arendt, trans. Harry Zohn. New York: Schocken, 1969, pp. 147–54.

Works by other authors cited in the volume

Adorno, Theodor W. *Aesthetic Theory*, ed. and trans. Robert Hullot-Kentor. Minneapolis: University of Minnesota, 1995.

———. "Einleitung zu Emile Durkheim, *Soziologie und Philosophie*," in *Gesammelte Schriften*. Frankfurt-am-Main: Suhrkamp, 1972, VIII, 1, pp. 245–79.

Adorno, Theodor W., and Walter Benjamin. *Briefwechsel*, ed. Henri Lonitz. Frankfurt-am-Main: Suhrkamp, 1994, vol. 1.

Agamben, Giorgio. "The Coming Community," in *Theory Out of Bounds 1*, ed. Sandra Buckley, Michael Hardt, and Brian Massumi, trans. Michael Hardt. Minneapolis and London: University of Minnesota, 1993.

Alpers, Svetlana. *Rembrandt's Enterprise: The Studio and the Market*. Chicago: University of Chicago, 1988.

Auerbach, Erich. "Philology and *Weltliteratur*," *Centennial Review*, 13, no. 1 (1969), pp. 1–17.

Baecker, Dirk. "Die Adresse der Kunst," in *Systemtheorie der Literatur*, ed. Jürgen Fohrmann and Harro Müller. München: Fink, 1996, pp. 82–105.

Bann, Stephen. "Adriatics—à propos of Brice Marden," *20th Century Studies*, special issue on Visual Poetics (Dec. 1976), pp. 116–29.

———. *Brice Marden*, exhibition catalogue. London: Whitechapel Art Gallery, 1981.

———. *Nature Over Again after Poussin*, exhibition catalogue. University of Strathclyde: Collins Exhibition Hall, 1979.

Barthes, Roland. *La chambre claire*. Paris: Seuil, 1980.

Bateson, Gregory. *Steps to an Ecology of Mind: Collected Essays in Anthropology, Psychiatry, Evolution, and Epistemology*. San Francisco: Chandler, 1972.

Baudelaire, Charles. *Oeuvres Complètes*. Paris: Gallimard-Bibliothèque de la Pléiade, 1954.

Baudrillard, Jean. "The Masses: The Implosion of the Social in the Media," *New Literary History*, 16 (1985), pp. 577–89.

———. *La transparence du mal: Essai sur les phénomènes extrêmes*. Paris: Gallilée, 1990.

Baxandall, Michael. *Painting and Experience in Fifteenth-Century Italy: A Primer in the Social History of Pictorial Style*, 2d ed. Oxford and New York: Oxford University, 1988.

Benhabib, Seyla. "Critical Theory and Postmodernism: On the Interplay of Ethics, Aesthetics, and Utopia in Critical Theory," *Cardozo Law Review*, 11 (1990), pp. 1435–48.

———. *Critique, Norm, and Utopia: A Study of the Foundations of Critical Theory*. New York: Columbia University, 1986.

Berger, John. *Ways of Seeing*. London: BBC and Penguin Books, 1972.

Bergson, Henri. *Creative Evolution*, trans. Arthur Mitchell. New York: Henry Holt, 1911.

Berlin, Akademie der Künste. *John Heartfield*, ed. Peter Pachnicke and Klaus Honnef, exhibition catalogue. Köln: DuMont, 1991.

Bloch, Ernst, et al. *Aesthetics and Politics*. London: NLB, 1977.

Bolz, Norbert. *Am Ende der Gutenberg-Galaxis: Die neuen Kommunikationsverhältnisse*. Munich: Fink, 1993.

———. *Theorie der neuen Medien*. Munich: Raben, 1990.

Bourdieu, Pierre. *Les règles de l'art: Genèse et structure du champ littéraire.* Paris: Seuil, 1992.

———. *Le sens pratique.* Paris: Minuit, 1980.

Braun, Christina von. "Ce n'est pas une femme: Betrachten, Begehren, Berühren—von der Macht des Blicks," *Lettre,* 25 (1994), pp. 80–84.

Brecht, Bertolt. *Arbeitsjournal: Erster Band 1938 bis 1942,* pref. Werner Hecht. Frankfurt-am-Main: Suhrkamp, 1973.

———. "Der Dreigroschenprozeß," in *Gesammelte Werke,* 20 vols. Frankfurt-am-Main: Suhrkamp, 1967, XVIII, pp. 139–209.

———. *Journals,* ed. John Willet, trans. Hugh Rorrison. New York: Routledge, 1993.

———. "Radio—eine vorsintflutliche Erfindung?" in *Gesammelte Werke,* 20 vols. Frankfurt-am-Main: Suhrkamp, 1967, XVIII, pp. 119–21.

———. "Der Rundfunk als Kommunikationsapparat," in *Gesammelte Werke,* 20 vols. Frankfurt-am-Main: Suhrkamp, 1967, XVIII, pp. 127–34.

———. "Über Verwertungen," in *Gesammelte Werke,* 20 vols. Frankfurt-am-Main: Suhrkamp, 1967, XVIII, pp. 123–24.

Brockhaus Verlag. *Brockhaus' Konversations-Lexikon,* 14th ed., 16 vols. Leipzig: F. A. Brockhaus, 1894.

Brown, G. Spencer. *Laws of Form,* 2d ed. New York: Julian, 1972.

Brown, Peter. *Society and the Holy in Late Antiquity.* Berkeley: University of California, 1982

Bumke, Joachim. *Die vier Fassungen der Nibelungenklage: Untersuchung zur Überlieferungsgeschichte und Textkritik der höfischen Epik im 13. Jahrhundert.* Berlin, New York: Walter de Gruyter, 1996.

Burke, Kenneth. *Permanence and Change: An Anatomy of Purpose,* 3d ed., with new afterword. Berkeley: University of California, 1984.

Burke, Peter. *The Renaissance Sense of the Past.* London: Edward Arnold, 1969.

Butler, Judith. *Bodies that Matter: On the Discursive Limits of Sex.* London: Routledge, 1993.

Carpenter, Edmund. *Oh, What a Blow that Phantom Gave Me!* Toronto, London, New York: Bantam Books, 1972.

Cazeneuve, Jean. *Sociologie du Rite.* Paris: PUF, 1971.

Cerquiglini, Bernard. *Éloge de la variante: Histoire critique de la philologie.* Paris: Seuil, 1989.

Chartier, Roger. "Figures of the Author," in *The Order of Books: Readers, Authors, and Libraries in Europe between the Fourteenth and Eighteenth Centuries,* trans. Lydia G. Cochrane. Cambridge: Polity, and Stanford: Stanford University, 1994, pp. 25–59.

Cortázar, Julio. "Blow-Up," in *End of the Game and Other Stories,* trans. Paul Blackburn. New York: Harper Colophon, 1978, pp. 114–31.

Deleuze, Gilles. *Difference and Repetition,* trans. Paul Patton. New York: Columbia University, 1994.

Dennett, Daniel. *Darwin's Dangerous Idea: Evolution and the Meaning of Life*. New York: Simon and Schuster, 1995.

Didi-Huberman, Georges. *Ce que nous voyons, ce qui nous regarde*. Paris: Minuit, 1992.

———. *L'invention de l'hystérie: Charcot et l'iconographie photographique de la Salpétrière*. Paris: Macula, 1982.

Durkheim, Émile. *Sociology and Philosophy*, trans. D. F. Pocock. Glencoe, IL: Free Press, 1953.

Eagleton, Terry. *Walter Benjamin or Towards a Revolutionary Criticism*. London: Verso, 1981.

Eco, Umberto. "Travels in Hyperreality (1975)," in *Travels in Hyperreality: Essays*. San Diego, New York, London: Harcourt Brace, 1990, pp. 3–58.

Eisenstein, Sergei M. "The Filmic Fourth Dimension," in *Film Form: Essays in Film Theory*, ed. and trans. Jay Leyda. Cleveland, New York: World Publishing-Meridian, 1965, pp. 64–71.

———. "Word and Image" (originally published as "Montage in 1938"), in *The Film Sense*, ed. and trans. Jay Leyda. Cleveland, New York: World Publishing-Meridian, 1965, pp. 1–65.

Emrich, Wilhelm. *Die Symbolik von Faust II: Sinn und Vorformen*. Bonn: Athenäum-Verlag, 1957.

Foucault, Michel. "What Is an Author?" in *Language, Counter-Memory, Practice: Selected Essays and Interviews*, ed. Donald F. Bouchard. Ithaca, NY: Cornell University, 1977, pp. 113–38.

Friedmann, Georges. *La crise du Progrès: Esquisse d'histoire des idées, 1895–1935*, 2d ed. Paris: Gallimard, 1936.

Fuld, Werner. "Die Aura: Zur Geschichte eines Begriffes bei Benjamin," *Akzente*, III (1979), pp. 352–71.

Geulen, Eva. "Zeit zur Darstellung: Walter Benjamins *Das Kunstwerk im Zeitalter seiner technischen Reproduzierbarkeit*," *Modern Language Notes* (German Issue), 107 (1992), pp. 580–605.

Giedion, Siegfried. *Mechanization Takes Command*. Oxford: Oxford University, 1948. German ed. with commentary as *Die Herrschaft der Mechanisierung: Ein Beitrag zur anonymen Geschichte*, preface by Henning Ritter with afterword by Stanislaus von Moos. Hamburg: Europ. Verl.-Anst., 1994.

Ginzburg, Carlo. *Spurensicherungen: Über verborgene Geschichte, Kunst und soziales Gedächtnis*. Berlin: Wagenbach, 1983.

Goethe, Johann Wolfgang von. *Goethes Briefe*, 4 vols., ed. Karl Robert Mandelkow and Bodo Morawe. Hamburg: Christian Wegner, 1962–67.

———. *Maxims and Reflections*, trans. Elisabeth Stopp. Harmondsworth: Penguin, 1998.

Gregor, Ulrich. "Meyerholt und das Kino der Revolutionäre," *Theater Heute*, 4, no. 3 (1963), pp. 30–32.

Grimm, Jacob, and Wilhelm Grimm. *Deutsches Wörterbuch*, 2 vols. Leipzig: S. Hirzel, 1860.

Gumbrecht, Hans Ulrich. "Beginn von 'Literatur'/Abschied vom Körper?" in *Der Ursprung von Literatur: Medien, Rollen, Kommunikationssituationen zwischen 1450 und 1650*, ed. Gisela Smolka-Koerdt, Peter M. Spangenberg, and Dagmar Tillmann-Bartylla. Munich: Fink, 1988, pp. 15–50.

———. "It's Just a Game: On the History of the Media, Sport, and the Public," in *Making Sense in Life and Literature*. Minneapolis: University of Minnesota, 1992, pp. 272–87.

Hagen, Wolfgang. "Mediendialektik—Am Beispiel Radio: Lazarsfeld, Adorno, Benjamin, Enzenberger, Kluge," in *Medien und Öffentlichkeit: Positionierungen, Symptome, Simulationsbrüche*, ed. Rudolf Maresch. München: Boer, 1996, pp. 41–65.

Hansen, Miriam. "Of Mice and Ducks: Benjamin and Adorno on Disney," *South Atlantic Quarterly*, 92 (1993), pp. 27–61.

Haskell, Francis, and Nicholas Penny. *Taste and the Antique: The Lure of Classical Sculpture, 1500–1900*. New Haven and London: Yale University, 1981.

Heidegger, Martin. *Being and Time*, trans. John Macquarrie and Edward Robinson. New York: Harper and Row, 1962.

———. *De l'Orgine de l'Oeuvre d'Art* (première version inédite 1935), trans. Emmanuel Martineau. Paris: Authentica, 1987.

———. "The Origin of the Work of Art," in *Basic Writings from Being and Time (1927) to The Task of Thinking (1964)*, ed. David Farrell Krell. New York, San Francisco: Harper and Row, 1977, pp. 143–87.

———. "Der Ursprung des Kunstwerkes," in *Holzwege*, 6th ed. Frankfurt-am-Main: Klostermann, 1980, pp. 1–72.

Henkel, Nikolaus. "Kurzfassungen höfischer Erzähltexte als editorische Herausforderung," *Editio*, 6 (1992), pp. 1–11.

Hennion, Antoine. *La passion musicale: Une sociologie de la médiation*. Paris: Métailié, 1993.

Hutchins, Edwin. *Cognition in the Wild*. Cambridge, MA: MIT, 1995.

Jennings, Michael W. *Dialectical Images: Walter Benjamin's Theory of Literary Criticism*. Ithaca: Cornell University, 1987.

John of Damascus. *On the Divine Images: Three Apologies against Those Who Attack the Divine Images*, trans. David Anderson. Crestwood, NY: St. Vladimir's Seminary, 1980.

Jünger, Ernst. *An der Zeitmauer*. Stuttgart: Ernst Klett, 1959.

Kant, Immanuel. *The Critique of Judgement*, trans. James Creed Meredith. Oxford: Oxford University, 1952.

———. "What Is Enlightenment?" in *The Enlightenment: A Comprehensive Anthology*, ed. Peter Gay. New York: Simon and Schuster, 1973.

Kantorowicz, Ernst H. *Die zwei Körper des Königs: Eine Studie zur politischen Theologie des Mittelalters*, trans. Walter Theimer. München: Dt. Taschenbuch-Verlag, 1990.

Karnow, Curtis E. A. "Data Morphing: Ownership, Copyright and Creation," *Leonardo*, 27 (1994), pp. 17–22.

Keats, John. "Ode on a Grecian Urn," in *Poetical Works*, ed. H. W. Garrod. London: Oxford University, 1956, pp. 209–10.

Kittler, Friedrich A. *Discourse Networks 1800/1900*, trans. Michael Metteer, pref. David Wellbery. Stanford: Stanford University, 1990.

———. *Grammophon, Film, Typewriter*. Berlin: Brinkmann and Bose, 1986.

———. *Die Nacht der Substanz*. Bern: Bentelli, 1989.

Kracauer, Siegfried. *From Caligari to Hitler: A Psychological History of the German Film*. Princeton: Princeton University, 1974.

Kroker, Arthur, and Michael A. Weinstein. *Data Trash: The Theory of the Virtual Class*. New York: St. Martin's, 1994.

Kuhn, Hugo. "Minnesang als Aufführungsform," in *Kleine Schriften, II: Texte und Theorie*. Stuttgart: Metzler, 1969, pp. 182–90.

Kuleshov, Lev. "Art of the Cinema," in *Kuleshov on Film: Writings by Lev Kuleshov*, ed. and trans. Ronald Levaco. Berkeley: University of California, 1974, pp. 41–123.

Lacan, Jacques. *The Four Fundamental Concepts of Psycho-Analysis*, ed. Jacques-Alain Miller, trans. Alan Sheridan. New York: W. W. Norton, 1978.

———. "Les quatre concepts fondamentaux de la psychoanalyse," in *Le séminaire de Jacques Lacan, Livre XI*, ed. Jacques-Alain Miller. Paris: Seuil, 1973.

———. *Das Seminar: Buch II*, trans. Norbert Haas. Olten: Walter, 1980.

Latour, Bruno. *Science in Action: How to Follow Scientists and Engineers through Society*. Cambridge, MA: Harvard University, 1987.

———. *We Have Never Been Modern*, trans. Catherine Porter. Cambridge, MA: Harvard University, 1993.

Le Clerc, Jean. *Sentimens de quelques théologiens de Hollande sur l'histoire critique du Vieux Testament, composée par P. Richard Simon*. Amsterdam: Henri Desbordes, 1685.

Leroi-Gourhan, André. *Le geste et la parole*, 2 vols. Paris: Albin Michel, 1964–65.

Link, Jürgen. "Literaturanalyse als Interdiskursanalyse: Am Beispiel des Ursprungs literarischer Symbolik in der Kollektivsymbolik," in *Diskurstheorien und Literaturwissenschaft*, ed. Jürgen Fohrmann and Harro Müller. Frankfurt-am-Main: Suhrkamp, 1988.

Link-Heer, Ulla. "'Male Hysteria': A Discourse Analysis," trans. Jamie Owen Daniel. *Cultural Critique*, 15 (1990), pp. 191–200.

Luhmann, Niklas. "The Medium of Art," in *Essays on Self-Reference*. New York: Columbia University, 1990, pp. 215–26.

———. "Das Problem der Epochenbildung und die Evolutionstheorie," in *Epochenschwellen und Epochenstrukturen im Diskurs der Literatur- und Sprachhistorie*, ed. Hans Ulrich Gumbrecht and Ursula Link-Heer. Frankfurt-am-Main: Suhrkamp, 1985, pp. 11–33.

———. *Social Systems*, trans. John Bednarz and Dirk Baecker. Stanford: Stanford University, 1995.

———. "Die Soziologie und der Mensch," in *Soziologische Aufklärung, VI*. Opladen: Westdeutscher Verlag, 1995.

————. "The Work of Art and the Self-Reproduction of Art," in *Essays on Self-Reference*. New York: Columbia University, 1990, pp. 191–214.

Lukàcs, Georg. *History and Class Consciousness*, trans. Rodney Livingston. Cambridge, MA: MIT, 1971.

————. *The Theory of the Novel: A Historico-philosophical Essay on the Epic Forms of Great Literature*, trans. Anna Bostock. Cambridge, MA: MIT, 1971.

Lyotard, Jean-François. "After the Sublime: The State of Aesthetics," in *The States of "Theory": History, Art, and Critical Discourse*, ed. David Carroll. New York: Columbia University, 1990, pp. 297–304.

Marchal, Guy P. "Bildersturm im Mittelalter," *Philosophisches Jahrbuch der Görres-Gesellschaft*, 100 (1993), pp. 255ff.

Marcuse, Herbert. *One-Dimensional Man: Studies in the Ideology of Advanced Industrial Society*. Boston: Beacon, 1964.

Marden, Brice. *Actualité d'un bilan*, exhibition catalogue. Paris: Yvon Lambert Gallery, 1972.

Marx, Karl. *Capital: A Critique of Political Economy*, 3 vols., trans. Ben Fowles and David Fernbach. Harmondsworth: Penguin Books, 1976.

McCole, John. *Walter Benjamin and the Antinomies of Tradition*. Ithaca: Cornell University, 1993.

McLuhan, Marshall. *The Gutenberg Galaxy: The Making of Typographic Man*. London: Routledge and Kegan Paul, 1962.

————. "The TV Image: One of Our Conquerors," in *Letters of Marshall McLuhan*, ed. Matie Molinaro, Corinne McLuhan, and William Toye. Oxford-Toronto-New York: Oxford University, 1987.

McLuhan, Marshall, and Quentin Fiore. *War and Peace in the Global Village: An Inventory of Some of the Current Spastic Situations that Could Be Eliminated by More Feed Forward*. New York: Bantam, 1968.

Menke, Christoph. *Die Souveränität der Kunst: Ästhetische Erfahrungen nach Adorno und Derrida*. Frankfurt-am-Main: Suhrkamp, 1991.

Menocal, Maria Rosa. *Shards of Love: Exile and the Origins of the Lyric*. Durham: Duke University, 1994.

Moulin, Raymonde. "La genèse de la rareté artistique," *Ethnologie française*, 8, nos. 2–3 (Mar.-Sept. 1978), pp. 241–58.

Nietzsche, Friedrich. "Die fröhliche Wissenschaft," in *Sämtliche Werke*, ed. Giorgio Colli and Mazzino Montinari. München and Berlin: Dt. Taschenbuch and Walter de Gruyter, 1980, III, pp. 343–651.

————. *Werke*, 3 vols., ed. Karl Schlechta. Munich: Hanser, 1969.

Nunberg, Geoffrey. "The Place of Books in the Age of Electronic Reproduction," *Representations*, 42 (spring 1993), pp. 13–27.

Ong, Walter J. *Orality and Literacy: The Technologizing of the Word*. London: Methuen, 1982.

Ortmann, Christa, and Hedda Ragotzky. "Minnesang als 'Vollzugskunst': Zur spezifischen Struktur literarischen Zeremonialhandelns im Kontext höfischer Repräsentation," in *Höfische Repräsentation: Das Zeremoniell und die*

Zeichen, ed. Hedda Ragotzky and Horst Wenzel. Tübingen: Niemeyer, 1990, pp. 227–58.

Otto, Rudolf. *Das Heilige: Über des Irrationale in der Idee des Göttlichen und Sein Verhältnis zum Rationalen*. München: C. H. Beck'sche, 1963.

———. *The Idea of the Holy: An Inquiry into the Non-rational Factor in the Idea of the Divine and Its Relation to the Rational*, trans. John W. Harvey, 2d ed. London: Oxford University, 1957.

Partridge, Eric. *Origins: A Short Etymological Dictionary of Modern English*. New York: Greenwich House, 1983.

Proust, Marcel. *Remembrance of Things Past*, 3 vols., trans. C. K. Scott-Moncrieff and Terence Kilmartin. New York: Random House, 1981.

———. "Within a Budding Grove," in *Remembrance of Things Past*, 3 vols., trans. C. K. Scott-Moncrieff and Terence Kilmartin. New York: Random House, 1981, I, pp. 465–1018.

Rancière, Jacques. *Les noms de l'histoire*, rev. ed. Paris: Seuil, 1992.

Rose, Mark. *Authors and Owners: The Invention of Copyright*. Cambridge, MA: Harvard University, 1993.

Sacks, Oliver. *Migraine: Understanding a Common Disorder*. Berkeley: University of California, 1985.

Said, Edward W. *Musical Elaborations*. New York: Columbia University, 1991.

Schleiermacher, Friedrich. *Über die Religion. Reden an die Gebildeten unter ihren Verächten*, ed. and intro. by Rudolf Otte. Göttingen: Vandenhoek und Ruprecht, 1899.

Schmitt, Carl. *The Concept of the Political*, trans. and notes by George Schwab. New Brunswick, NJ: Rutgers University, 1976.

———. *Political Theology: Four Chapters on the Concept of Sovereignty*, trans. George Schwab. Cambridge, MA: MIT, 1985.

———. "Das Zeitalter der Neutralisierungen und Entpolitisierungen," in *Der Begriff des Politischen: Text von 1932 mit einem Vorwort und drei Corollarien*. Berlin: Duncker and Humboldt, 1987, pp. 77–95.

Schmitz-Cliever-Lepie, Herta. *Die Domschatzkammer zu Aachen*, photographs by Ann Münchow, 2d ed. Aachen: Domkapitel, 1980.

Schoenberg, Arnold, and Wassily Kandinsky. *Letters, Pictures, Documents*, ed. Jelena Hahl-Koch, trans. John C. Crawford. London: Faber and Faber, 1984.

Shapin, Steven, and Simon Schaffer. *Leviathan and the Air-Pump: Hobbes, Boyle, and the Experimental Life*. Princeton: Princeton University, 1985.

Shiff, Richard. "Handling Shocks: On the Representation of Experience in Walter Benjamin's Analogies," *Oxford Art Journal*, 15, no. 2 (1992), pp. 88–103.

Simon, Erika. *Ara Pacis Augustae*, 10 vols. Tuebingen: Wasmuth, 1967.

Snyder, Joel. "Benjamin on Reproducibility and Aura: A Reading of *The Work of Art in the Age of Its Technical Reproducibility*," in *Benjamin: Philosophy, History, Aesthetics*, ed. Gary Smith. Chicago and London: University of Chicago, 1989, pp. 158–74.

Soeffner, Hans Georg. "Rituale des Antiritualismus—Materialen für Außeralltägliches," in *Materialität der Kommunikation*, ed. Hans Ulrich Gumbrecht and K. Ludwig Pfeiffer. Frankfurt-am-Main: Suhrkamp, 1988, pp. 419–46.

Sörensen, Bengt Algot. *Allegorie und Symbol: Texte zur Theorie des dichterischen Bildes im 18. und frühen 19. Jahrhundert.* Frankfurt-am-Main: Athenaum, 1972.

Stackmann, Karl. "Die Edition—Königsweg der Philologie?" in *Methoden und Probleme der Edition mittelalterlicher deutscher Texte*, ed. Rolf Bergmann and Kurt Gärtner. Tübingen: Niemeyer, 1993, pp. 1–18.

———. "Neue Philologie?" in *Modernes Mittelalter: Neuer Bilder einer popularen Epoche*, ed. Joachim Heinzle. Frankfurt-am-Main, Leipzig: Insel, 1994, pp. 398–427.

Starkman, Ruth. "Unaesthetic States: Lacoue-Labarthe and de Man on Fascism," *Vanishing Point: Studies in Comparative Literature*, 1 (1994), pp. 113–26.

Stoessel, Marleen. *Aura, das vergessene Menschliche: Zu Sprache und Erfahrung bei Walter Benjamin.* München: C. Hanser, 1983.

Strauss, Leo. *Die Religionskritik Spinozas als Grundlage zu seiner Bibelwissenschaft: Untersuchungen zu Spinozas theologish-politischem Traktat.* Darmstadt: Georg Olms, 1981.

Strohschneider, Peter. "Aufführungssituation: Zur Kritik eines Zentralbegriffs kommunikationsanalytischer Minnesangforschung," in *Kultureller Wandel und die Germanistik in der Bundesrepublik: Vorträge des Augsburger Germanistentags 1991*. Tübingen: Niemeyer, 1992, III, pp. 52–67.

———. "Höfische Romane in Kurzfassungen: Stichworte zu einem unbeachten Aufgabenfeld," *Zeitschrift für deutsches Altertum und deutsche Literatur*, 120 (1991), pp. 419–39.

Taylor, Charles. "To Follow a Rule," in *Rules and Conventions: Literature, Philosophy, Social Theory*, ed. Mette Hjort. Baltimore, MD: Johns Hopkins University, 1992.

Tervooren, Helmut. "Die Frage nach dem Autor: Authentizitätsprobleme in mittelhochdeutscher Lyrik," in *'Dâ hœret ouch geloube zuo': Überlieferungs- und Echtheitsfragen zum Minnesang* (Beiträge zum Festkolloquium für Günther Schweikle anläßlich seines 65. Geburtstags), ed. Rüdiger Krohn. Stuttgart and Leipzig: Hirzel, 1995, pp. 195–204.

Thomasin von Zirclaria. *Der Wälsche Gast des Thomasin von Zirclaria*, ed. Heinrich Rückert, index by Friedrich Neumann. Berlin: de Gruyter, 1965.

Valéry, Paul. "Le problème des musées," in *Oeuvres*. Paris: Gallimard-Bibliothèque de la Pléiade, 1972, II, pp. 1290–92.

———. "The Triumph of Manet," in *The Collected Works of Paul Valéry*, 15 vols., ed. Jackson Matthews, trans. David Paul. New York and Princeton: Bollingen Foundation-Pantheon and Princeton University, 1956–71, XII, pp. 104–14.

Virilio, Paul. *Krieg und Fernsehen.* Munich/Vienna: Hanser, 1993.

Vittinghoff, Friedrich. *Der Staatsfeind in der römischen Kaiserzeit: Untersuchungen zur "damnatio memoria."* Berlin: Speyer, 1936.

Vogel, Paul. "Von der Selbstwahrnehmung der Epilepsie: Der Fall Dostojewski," *Der Nervenarzt,* 32 (1961), pp. 438–41.

Wandhoff, Haiko. *Der epische Blick: Eine mediengeschichtliche Studie zur höfische Literatur.* Berlin: Erich Schmidt, 1996.

Warburg, Aby. "Dürer und die italienische Antike," in *Die Erneuerung der heidnischen Antike: Kulturwissenschaftliche Beiträge zur Geschichte der Europäischen Renaissance,* ed. Gertrud Bing and Fritz Rougemont. Leipzig, Berlin: B. G. Teubner, 1932, pp. 443–54.

Warner, Michael. *The Letters of the Republic: Publication and the Public Sphere in Eighteenth-Century America.* Cambridge, MA: Harvard University, 1990.

Weber, Samuel. "Der posthume Zwischenfall: Eine Live Sendung," in *Zeit Zeichen: Aufschübe und Interferenzen zwischen Endzeit und Echtzeit,* ed. Georg Christoph Tholen and Michael O. Scholl. Weinheim: VCH-Acta Humaniora, 1990, pp. 177–98.

Wenzel, Horst. "Imaginato und Memoria: Medien der Erinnerung im höfischen Mittelalter," in *Mnemosyne: Formen und Funktion der kulturellen Erinnerung,* ed. Aleida Assmann and Dietrich Harth. Frankfurt-am-Main: Fischer-Taschenbuch, 1991, pp. 57–82.

———. "Partizipation und Mimesis: Die Lesbarkeit der Körper am Hom und in der höfischen Literatur," in *Materialität der Kommunikation,* ed. Hans Ulrich Gumbrecht and K. Ludwig Pfeiffer. Frankfurt-am-Main: Suhrkamp, 1988, pp. 178–202.

———. "Die Verkündigung an Maria: Zur Visualisierung des Wortes in der Szene oder Schriftgeschichte im Bild," in *Maria in der Welt: Marianverehrung im Kontext der Sozialgeschichte; 10.–18. Jahrhundert,* ed. Claudia Opitz, Hedwig Röckelein, Gabriela Signori, and Guy P. Marchal. Zurich: Chronos, 1993, pp. 23–52.

Willett, John. *Art and Politics in the Weimar Period: The New Sobriety, 1917–1933.* New York: Pantheon, 1978.

Woodmansee, Martha, and Peter Jaszi, eds. *The Construction of Authorship: Textual Appropriation in Law and Literature.* Durham and London: Duke University, 1994.

Yonnet, Paul. *Jeux, modes et masses.* Paris: Gallimard, 1985.

Young, Edward. "Conjectures on Original Composition," in *The Complete Works,* 2 vols., ed. James Nichols. London: William Tegg, 1854, II, pp. 547–86.

Zglinicki, Friedrich von. *Der Weg des Films: Die Geschichte der Kinematographie und ihrer Vorläufer.* Berlin: Rembrandt-Verlag, 1956.

Zilsel, Edgar. *Die Entstehung des Geniebegriffes.* Tubingen: Mohr, 1926; rpt. New York-Hildesheim: Georg Olins, 1972.

Zumthor, Paul. *Essai de poétique médiévale.* Paris: Seuil, 1972.

Index of Names and Titles

Brackets [] around page numbers signal a footnote reference.

Ackerman, Chantal, 304
Adkins, Helen, 72–73, [74]
Adorno, Theodor W., 10, [10], 11, 16, 35, [35], 96, [99], [115], 136–37, [136], [155], [162], [163], 177, 271, [295]
Adorno, Theodor W., and Max Horkheimer: *Dialectic of Enlightenment*, 42
Agamben, Giorgio, 272, [272]; *The Coming Community*, 272
AIZ, 72
Akademie der Künste of Berlin, 71
Alexander the Great, 215
Alexander, Amir, [274]
Allen, Woody, 219; *Play It Again Sam*, 219; *The Purple Rose of Cairo*, 219
Alpers, Svetlana, 95, [95]
Anders, Günther, 72, [72], [73]
Andersen, Hans Christian, xii; "Emperor's New Clothes," xii
Arendt, Hannah, 319
Aristotle, 133
Armstrong, Louis, 306
Arnheim, Rudolf, [185]
Arp, Jean, 144
Atget, Eugène, 67, 98, 100, 245
Auerbach, Erich, 255, [255]
Aura, Roman Goddess, 154

Bach, Johann Sebastian, 95, 155
Bacon, Francis, 163
Baecker, Dirk, [20]
Ball, Hugo, 144
Bann, Stephen, [321]
Baraduc, Hippolyte, 99, [99], 116–17, [116], 118
Barthes, Roland, 322, [322]
Bateson, Gregory, [19]
Baudelaire, Charles, 24, 43, 67, 89, 114, 118, 249, [249], 253, 261, 285–88; *Loss of a Halo*, 249
Baudrillard, Jean, 14, [14], [35], 237
Baxandall, Michael, [111]
Beethoven, Ludwig von, 297; Ninth Symphony, 143
Bell, Clive, 2
Benhabib, Seyla, [222], [224]
Benjamin, Walter: *The Arcades Project*, 39, 137, [137], 221, 223, 263, 269; Artwork essay, xi–xiv, 9, 10, 21, [26], [28], [30], 35, 39, 40, 41, 42–43, 50, 53, 64, [64], [65], 67, [67], 89, 90, 91, 92, 97, 105, 109, [109], 114, 117, [117], 129, 137, 139, 141, 142, 158, 164, 165, 167, 168, 169, 173, 175, 179, 180, 183, 188, 190, 192, 195, 198, 199, 201, 202, 203, 211, 216, 221, 222, 223, 224, 225, 226, 227–28, 230, 242, 243, 244, 253, 256, 275, 276, 279, 282, 283, 285, 286, 288, 289, 301; "A Berlin Chronicle," 301, [301]; *Briefwechsel*, [136]; *Charles Baudelaire: A Lyric Poet in the Era of High Capitalism*, [67], 89, [260], 261, [287], [288]; *Correspondence*, [168]; *Drei Studien zur Kunstsoziologie*, [212]; *Ecrits Français*, [109]; "Erfahrung und Armut," [66]; "Der Erzähler," [115]; "Franz Kafka," [67]; *Gesammelte Briefe*, [24]; *Gesammelte Schriften*, [28], [99], [115]; "Goethe's Elective Affinities," 100, 102; "Goethes Wahlverwandtschaften," [102], [103], [104]; *Grimmsche Wörterbuch*, [185]; *Illuminationem*, 188; *Illuminations*, 188, 319; "Kleine Geschichte der Photographie," [117]; *One-Way Street*, 44; *The Origin of German Tragic Drama*, 164, [164], [168], 244;

"Passagen-Werk," [27]; "Proust-Papière," [122]; "Reflections on the Radio," 233; "Reflexionen zum Rundfunk," 233, [233]; "Short History of Photography," 64, [64], [65], 66, [66], [67], 160; "A Small History of Photography," [256], [286], [287]; *The Storyteller*, 221, 222, 223, 224, 225, 226, 227–28, [259], 271; "Der Sürrealismus," [114], [232]; "The Task of the Translator," 28–29; "Theater and Radio," 234; "Theater und Rundfunk," [234], [235]; "Theses on the Philosophy of History," [222]; "Über einige Motive bei Baudelaire," [32], [114], [119], 285, [286]; "Ursprung des deutschen Trauerspiels," [100], [103]; "What Is Epic Theater?," [67]

Berger, John, 319, [319]; *Ways of Seeing*, 319, 321

Bergson, Henri, 53, 282, 288–89; *Creative Evolution*, 288, [289]; *Matière et mémoire*, 288

Berma (character), 64–65

Beuys, Joseph, 22, 219

Bloch, Ernst, 11, [136], 253

Bloom, Allan, 296

Blum, Léon, 90

Boccaccio, [293]

Bogart, Humphrey, 165, 219

Bolz, Norbert, 43, 230, 235, [235], 236, [236], 237, [237], [238]

Bono, 305

Botticelli, Sandro, 284, 309

Bourdieu, Pierre, [92], [110], 268, [268]

Bourneville, Desire, 119

Boyle, Robert, 135, 137

Brando, Marlon, 282

Braun, Christiana von, [218]

Brecht, Bertolt, 2, 11, [37], 47, 85, 105, [105], 114, [114], 166, 173, 191, 231–33, [231], [232], [233], 236, 238, 253, 260, 262

Brockhaus, Verlag, [188]

Brown, G. Spencer, 18, [18]

Brown, Peter, [217]

Bumke, Joachim, [213], [214]

Burke, Kenneth, 11, [11]

Burke, Peter, [151]

Butler, Judith, [223]

Carpenter, Edmund, 80, [81]

Casablanca, 219

Cazeneuve, Jean, 200

Céline, Louis-Ferdinand, 322

Cézanne, Paul, 257

Chaplin, Charlie, 11, 107, 207, 208, 251, 305; *Modern Times*, 207, 251

Charcot, Jean-Martin, 118–20

Charlemagne, 215

Chartier, Roger, [110]

Chaucer, Geoffrey, 263, [293]; "Pardoner's Tale," 263

Chopin, Henri, 145

Clair, René, 251; *A Nous la liberté*, 251

Clapton, Eric, 267, 297; "Layla," 267

Clark, Sterling, 266

Cleopatra (character), 282

Clericus, Johannes, 188

Cohn, Alfred, 25, [25], 39

Coleman, Ornette, 306

Constable, John, 309

Cortazar, Julio, 138–41; *Blow Up*, 138

County Joe and the Fish, [298]

Dante, [295]

Dardanus, 95

Daudet, Léon, [256]

Davis, Miles, 306

Deleuze, Gilles, [59], 131

Demeny, Georges, 36

Dennett, Daniel, 134, [134]

Derain, André, 98

Derrida, Jacques, 16

Didi-Hubermann, Georges, [98], [99], 116, [116], [118], [120], [121], 323, [323]; *Ce que nous voyons, ce qui nous regarde*, 323

Doisneau, Robert, 143

Dostoyevski, Fodor, 120; *Devils*, 120

Douglas, Mary, 219

Duchamp, Marcel, 219

Duhamel, Georges, [93]

Duhamel, Jean-Marie Constant, 143

Duhousset, Captain, 36

Duras, Madame de, 203

Durkheim, Emile, 177–78; *Sociology and Philosophy*, 177

Dylan, Bob, 138, [138], 299; "All along the Watchtower," 138, 299

Eagleton, Terry, [258], 260–62, [260], [261], [262], 267

Eco, Umberto, 157, [157]

Egginton, Bill, [249]

Eisenstein, Sergei, 37, 50–51, 58, 143, 210, 304; "The Filmic Fourth Dimension," 51; "Word and Image," 51
Empire State Building, 136
Emrich, Wilhelm, [104]
Engels, Fredrick, 236
Enzensberger, Hans Magnus, [35]
Erec, 215
Evans, Bill, 306

Finlay, Ian Hamilton, 321
Fiore, Quentin, [42], [43]
Flaubert, Gustave, 250; *Madame Bovary*, 250
Ford, Henry, 47
Ford, John, 304
Foucault, Michel, 95, [95]
Frankenstein (character/thing), 136, 137
Freud, Sigmund, 116, 119–20, 261; *Interpretation of Dreams*, 116
Friedmann, Georges, 89; *La Crise de progrès*, 89
Fry, Roger, 2
Fuld, Werner, [114], [256]

Galen, 116
Galton, Francis, [120]
Gance, Abel, 143, 240
Gates, William, 266, 278
Gawain, 215
George, Stefan, 155, [155]
Gervinus, Georg Gottfried, 100
Geulen, Eva, [62]
Geuss, Raymond, [136]
Giacometti, Alberto, 163
Giedion, Siegfried, 42, [42]; "Mechanization Takes Command," 42
Gilbreth, Frank, 37
Ginsburg, Jane C., [95]
Ginzburg, Carlo, [151]
Girard, René, 322; *Des Choses cachées depuis le fondation du monde*, 322
Godard, Jean-Luc, 304, 323
Godfather, the (character), 282
Goethe, Johann Wolfgang von, 99–108, [100], [101], [103], [104], [105]; *Maxims and Reflections*, 103; *Wilhelm Meisters Lehrjahren*, 103
Gould, Glenn, [295], 300
Grateful Dead, [298]
Greenaway, Peter, 323
Greenberg, Clement, 2

Gregor, Ulrich, [37]
Griffith, D. W., 252
Grosz, Georg, 75
Guattari, Felix, [59]
Gumbrecht, Hans Ulrich, [212], [252]
Gundolf, Friedrich, 102

Habermas, Jürgen, [224]
Hafis, Mohammed Schensed-Din, 208
Hagen, Wolfgang, [34]
Hamlet (character), 98
Hansen, Miriam, 135, [135]
Harzfeld, Helmut, 74
Haskell, Francis, 93, [93]
Heartfield, John, 71, 74–76, [75]
Heartfield, Wieland, 74
Hebrew Bible, 154
Hegel, Georg Wilhelm Friedrich, 5, 207, 241, 280
Heidegger, Martin, 20, [20], 30–31, [30], [31], 34, 127, 173–74, 176, 178, 281, [310]; *The Origin of the Work of Art*, 30, [30], 33, 34
Heiniman, Richard, [274]
Hendrix, Jimi, 299–300, [300]; "Purple Haze," 300, [300]
Henkel, Nikolaus, [213]
Hennion, Antoine, [95]
Herrmann, Hans-Christian von, [37]
Herzfeld, Wieland, [75]
Hesse, Carla, [95]
Hessel, Franz, 63, [63], 122
Hippolyte, 95
Hitchcock, Louise A., [157]
Hitler, Adolf, 253
Hobbes, Thomas, 137
Höch, Hannah, 71
Hume, David, 5
Husserl, Edmund, 121
Hutchins, Edwin, 133, [133], 140, [140]
Huxley, Aldous, [93]

Iconographie photographique de la Salpêtrière, 118–20
Institute for Social Research, 34
Ivory, James, 144
Iwein, 215

Jarmusch, Jim, 304
Jean, duc de Berry, 266
Jennings, Michael, [256], [263]
John of Damascus, 266, [266]

Johnson, Robert, 297
Jünger, Ernst, 38, 235, [235]

Kafka, Franz, 135
Kandinsky, Wassily, 2, 163, [163]
Kant, Immanuel, 5, 53, [55], [113], 134,
 199
Kantorowicz, Ernst H., [217]
Kaplan, Morris, [222]
Karplus, Gretel, 24, [24]
Keats, John, 141, [141]
King Kong (character), 136
King, Rodney, [55], [66]
Kittler, Friedrich, [56], 230, 234, [234],
 235, [235], 236, [236], [237], [238], 254,
 [254]
Klee, Paul, 154; "Angelus Nova," 154
Klossowski, Pierre, [109], 139, 159
Kracauer, Siegfried, 58, [59]
Kraus, Karl, 164
Kristeva, Julia, 322; *Pouvoirs de l'horreur*,
 322
Kroker, Arthur, [59]
Kronos Quartet, [300]
Kuhn, Hugo, [213]
Kuleshov, Lev, 37, 50–51; "Art of the Cin-
 ema," 50

Lacan, Jacques, 32, [32], 121–22, [122]
Lang, Fritz, 251; *Metropolis*, 251
Lanzmann, Claude, 106–7; *Shoah*, 106–8
Laocoön, 192
Latour, Bruno, 133, [134], 135–37, [136],
 138; *Science in Action*, 133
Le Clerc, Jean, [188]
Léger, Fernand, 207
Lenin, Vladimir, 159
Leroi-Gourhan, André, [212]
Leskov, Nikolai, 224
Lessing, Gotthold Ephraim, 166, 192
Lieberman, Fredric, [298]
Link, Jürgen, [105], 115, [116]
Link-Herr, Ulla, [98], [119]
Locke, John, 5
Luhmann, Niklas, [9], [19], [23], [212],
 216, [216]; "The Work of Art and the
 Self-Reproduction of Art," [9]
Lukács, Georg, 101, 225, [225]; *History
 and Class Consciousness*, 225; *Theory of
 the Novel*, 225
Lyotard, Jean-François, 17, [17]

MacBeth (character), 189–90
Madonna, 305
Mallarmé, Stéphane, 11, [225], 285
Malraux, André, 12
Manet, Edouard, 287
Marchal, Guy P., [217]
Marcuse, Herbert, 148, 154–56, [155]
Marden, Brice, 320–21, [321]
Marey, Etienne-Jules, 36
Marinetti, Filippo Tommaso, 276
Marrinan, Michael, [121]
Marx, Karl, 38, 106, 180, 203, 224, [224],
 229, 230, 235, 236, 241, 253, 275; *Das
 Capital*, 224
Mazón, Patricia, [274]
McCole, John, 258–59, [258], [259–60]
McLuhan, Marshal, 42–43, [42], [43],
 [212], 234, 235; *Gutenberg Galaxy, The*,
 43; *Understanding Media*, 43, 234
Meier-Graefe, Julius, 2
Menke, Christophe, 16, [16], [17]
Menocal, Maria, 267, [267], [295]
Mercury, Freddo, [291]
Meyerholt, Ulrich, 37
Michael, George, [291]
Michelangelo, 309
Mignon (character), 103, [103]
Milton, John, 136; *Lost Paradise*, 92
Mommsen, Theodor, 38
Morgan, J. P., 265–66
Morisot, Berthe, 287
Morris, William, 265
Moses, 93, 148
Moulin, Raymonde, [94]
Mukarovsky, Jan, 191
Musil, Robert, 80
Mussolini, Benito, 253
Muybridge, Eadweard, 36

Neumann, John von, [237]
Nietzsche, Friedrich, 33, [34], 38, 150,
 [150], 250, 253
Nizami (Ganjavi), 267; *Mayla and Majnun*,
 267
Novalis (a.k.a. Friedrich von Hardenberg),
 198
Nunberg, Geoffrey, [112]

Ong, Walter J., [212]
Ortmann, Christa, [213]
Otto, Rudolf, 199–200, 201

Packard, David, Jr., 279
Parker, Charlie, 306
Partridge, Eric, [185]
Penny, Nicholas, 93, [93]
Perot, Ross, 276
Petrarch, 292, [293], 295, [295]; *Can-
zonière*, 295
Philippe VI, 266
Picasso, Pablo, 208
Plato, 132
Proust, Marcel, 63, [63], 98, 106, 115, 122,
[122], [123], 165, 287, 288, 318, 322;
The Guermantes Way, 122; *Remem-
brance of Things Past*, 63, 123; *Within a
Budding Grove*, 63

Ragotzky, Hedda, [213]
Rameau, Jean-Philippe, 94
Rancière, Jacques, [268]
Rang, Martin, 137
Raphael, 5; *Sistine Madonna*, 5
Régnard, Jean-François, 119
Reitz, Edgar, 107; *Die Zweite Heimat*, 107
Rembrandt, 95, 130, 257
Resnais, Alain, 98
Richards, Keith, 297
Rilke, Rainer Maria, 98, 105
Rimbaud, Arthur, 255
Río Bravo, 304
Rivette, Jacques, 323
Rodin, Auguste, 204
Rohmer, Eric, 144
Roman de la Rose, 265–66
Rose, Mark, [95], [110]

Sachsse, Rolf, 72, [75]
Sacks, Oliver, [64]
Said, Edward, 295, [295]
Sartre, Jean-Paul, 314
Satan, 150
Schaffer, Simon, 135, [135]
Schefer, Jean-Louis, 322; *L'Invention de
corps chrétien*, 322
Schiller, Friedrich, 100, [101], 102, [104],
166
Schlegel, Friedrich, 198–99
Schleiermacher, Friedrich, 199; *Über die
Religion*, 199
Schmitt, Carl, 244–47; "The Age of Neu-
tralization and Re-Politicization," 244;
The Concept of the Political, 244; *Politi-

cal Theology*, 244; "Über den Begriff der
Geschichte," 244
Schmitz-Cliever-Lepie, Herta, [215]
Schoenberg, Arnold, [155], 163, [163]
Scholem, Gerhard, 198
Schön, Ernst, 39
Schubert, Franz, 95
Das Schwarze Korps, 244
Serrano, Andres, 323
Shakespeare, William, 95; *Othello*, 95
Shapin, Steven, 135, [135]
She Wore a Yellow Ribbon, 304
Shiff, Richard, [64], [67]
Simmel, Georg, 177
Simon, Erika, [154]
Snyder, Joel, [111]
Soeffner, Georg, [218], 219, [220]
Sörenson, Bengt Algot, [100], [103]
Spielberg, Steven, 106–8; *Schindler's List*,
106–8
Spinoza, Benedict (Baruch), 5, 151
Stackmann, Karl, [213]
Stanford, Leland, 36
Starkman, Ruth, [228]
Sternberger, Dolf, 167; *Panorama of the
Nineteenth Century*, 167
Stoessel, Marleen, [114]
Straub, Jean-Marie, 323
Strauss, Leo, 151, [151]
Stroheim, Eric von, 252
Strohschneider, Peter, [213]

Tasso, Torquato, 136
Tatlin, Vladimir, [75]
Taylor, Cecil, 306
Taylor, Charles, 268, [268]
Taylor, Elizabeth, 282
Taylor, Frederick, 37, 88
Tervooren, Helmut, [213]
Tieck, Ludwig, 198
Tristan, 213
Tristan (character), 215
Troeltsch, Ernst, 177
Tucholsky, Kurt, [56]
Tzara, Tristan, 144

Über die Religion, 199

Valéry, Paul, 143, 179, 250–51, [250],
[251], 254, 287–88
Venus, 98

Vertov, Dziga, 37
Virgil, 34
Virgin Mary, 12, 218
Virilio, Paul, 230, [230]
Visconti, Luchino, 98
Vittinghoff, Friedrich, [217]
Vogel, Paul, [121]

Wandhoff, Haiko, [216]
Warburg, Aby, 154, [154]
Warner, Michael, [113]
Wayne, John, 304
Weber, Max, 25, 177
Weber, Samuel, 33, [33]
Weinstein, Michael A., [59]
Wenders, Wim, 98, 107; *Wings of Desire*,
 107
Wenzel, Horst, [213], [216]
Werfel, Franz, [180]

Wigman, Mary, 162; "Witch Dance," 162
Wilhelm, August, 198
Willett, John, [56]
Woodmansee, Martha, [95], [110]
Woodstock, [298]

Yonnet, Paul, [96]
Young, Edward, 150, [150]
Young, Neil, 300; "My My, Hey Hey,"
 300

Zglinicki, Friedrich von, [36]
Zilsel, Edgar, [110]
Zirclaria, Thomasin von, 214–15, [214],
 [215], [216]
Zohn, Harry, [55], 58
Zumthor, Paul, [213]; Introduction à la
 poésie orale, 142; La Lettre et la voix,
 144; Les Riches heures de l'alphabet, 145

Index of Concepts

Brackets [] around page numbers signal a footnote reference, parentheses () a subdivision of the principal concept.

1935, 30
1936, 25, 51, 71, 112, 145–46, 176, 222, 223, 243, 253, 256, 272, 318, 320
1920s and 1930s, 2, 4, 71, 78, 244
1930s, xii, [35], 89, 218, 245, 258
1940s, 144
1950s, 42, 145
1960s, 145, 322, 323
1970s, [35], 319, 320, 323
1980s, 322

absence, 285–90
Abstract Expressionism, 320
abstract public, 113
actor, film, 4 (cult of), 47, 65, 85, 88, 94, 135, 138, 165–67, [182], 183–84, [185], 186, 195–96, 207, 276, 282–83
actor, stage, 47, 66, 135, 183
advertising, 25, 146, 252
aesthete, 17, 18, 20, 225
aesthetic autonomy, 2
aesthetic deconstruction, 26
aesthetic idealism, 206, 210
aesthetic object, 62, 191
aesthetic operation, 18
aesthetic perception, 1
aesthetic praxis, 25, 26
aesthetic theory, 28, [259]
aesthetic understanding, 16–17
aesthetics, 3 (philosophical), 24 (media), 25, 28 (post-Hegelian), 37 (fascist), 38, 39, 41, 42, 43, 53, 54, [61], 110, 207 (Hegel's), 243–45, 269, 270 (Kantian), 283, 292, 299
aesthetics, politicization of, 112, 272
alienation, [35], 225, 229
allegory, 41, 103, 168, 302

American, 96
ancient Egypt, 148
aphorism, 271–72
apparatus, 38, 45–48, 59, 66, 119–20, 125–28, 172–73, 184, 186, 232, 247
appearance, 15–16
applause, 66
archaeology, Italian, 93–94
architecture, 9, 54, 206, 214, 302
art, 1 (concept of), 10 (value of), 21 (conceptual), 22 (performance of), 40 (politics of), 92 (sacralization of), 96 (modern perversion of), 134 (pop), 153 (Roman), 182 (unity of), 203 (polemics of), 222
art, avant-garde, 37 (Soviet), 208–9
art, contemporary, 205, 206
art, mass, 137, 146, 204, 210
art, minimalist, 320, 323
art, modern, 144, 208
art, politicization of, 4, 53, 269–70, 272
art, theory/theory of, 15, 16, 203
art, traditional, 25, 144–45, 204, 206, 209, 210
art critic/art criticism, 57, 85, 156, 320
artifact, 191
artist's signature, 75, 128
asceticism, 165
assembly line, 47, 88, 263
audience, 49, 65, 139, 170, [184], 208, 232, 233, [295], 298 (live)
aura, xii, 7, 11, 16, 18, 21, 25, 30, 33, 34, 59, 63, [64], 69, 82, 83–86, 98, [99] (waves), 102, [105], 106, 114, 115, [115], 116–17, [121], 125, 128, 132, 138, 139, 142, 144, 154, 158, 162, 166, 170, 180, 181, 183, 186, 187, 188–89,

195, 198, 201, 204, 207, 212, 216, 217, 220, 226, 231, 249–50, 251, 256, [256], 258, 259–60, [260], 261, 262, 264, 266, 267, 270, 284, 288, 297, 298, 299–300, 309, [310], 312, 319–20, 321
aura, Benjamin's definition of, 64, 83, 99
aura, destruction of, 99, 147
aura, loss of/decay of, 9, 12–13, 18, 70, 105, 153, 155, 157, 161, 205, 212, 253, 270, 275, 276, 290, 299
aura, theory of, 209, [259]
aura hysterica, 118, 121
auratic event, 64
auratic fascinosum, 122
auratic presence, 168
auratic status, 77
aureole, 83–84, 154, 189–90, 193, [256]
authenticity, 30, 32, 80, 125–28, 132, 142, 149, 151, 152, 156, 161, 195–96, 198, 201, 204–5, 212, 214, 217, 220, 226, 243, 251, 257, [257], 275, 290, 291, 292, 295, [295], 296
authentic location, 179
authentification, 128
author, 70, 95, 110, 127, 231, 283
autonomy/*l'art pour l'art*, 2, 11, 109–10, 166, 189, 201, 205–6, 224, 285, 286, 288

Baroque, 25, 41, 244, 302
Baroque, German, 39, 168
Beethoven sonata, 162
Benjaminian, 28, 300, 319
Berlin Retrospective of 1991, 78
bibliophile/bibliomania, 145, 265
Bibliothèque Nationale de Paris, 264
Bibliothèque Royale, 266
biocybernetic, 237
biomechanics, 37
black community, 306
blasphemy, 86
blindness, 14–15
body/bodies, 6, 7, 36, 58, 59, 67, 83, 99, 127, 135, 140, 150, 185, 196, 216, 217, 254, 255, 282–83
bourgeois/bourgeoisie, 10, 59, 68, 70, 92, 150, 156, [184], 221, 231
BTX, 82

California, 36, 42, 279
camera, 6, 31–32, 37, 38, 46, 51, 58, 59,

65, 66, 88, 119, 133, 135, 139, 140–41, 165, 166, [182], 184, [184], 185, 186
cameraman, [37], 46, 66, 183, 185
capital, 196
capitalist, 9, 110, 180–81, 224–25, 231
caption, 51, 56
Cartesian thought, 281
casting (of sculpture), 149
chrono-photography, 36
class conflict, 279
close-ups, 80
Club Med, 302
codex, 111
cognitive psychology, 6
collage, 73, 77
collective, 27, 29, 49, 82, 194, 228, 229, 232–33, 235, 252, 263
collector(s), 195, 196, 265–66, 283
comic strip, 308
commercials, 304–5
commodity, 260, 262
communication, 16, 19–23, 82, 235–38, 254
communist/communism, 43, 112, 254, 255, 269, 271, 272
compact discs (CDs), 132, 276
composer, 94–95
computer(s), 34, 69–70, 82, 106, 111, 235, 237, 274, 302
computer hardware, 278
computer software, 111, 278
conditions of production, 230
constructivist, [75]
consumption, 75–76, 99, 105
conveyer belt, 160
copy/copies, 77, 93–94, 126, 128, 131–32 (replicas), 152–53, 156, 161, 164, 181, 192, 193, 204, 218, 256
criminology, 35
critique, 171
cult/cultic, 1–2, 15, 18, 19, 85, 190, 205, 217, 219, [260], 276
cult object, 13, 182, 200, 262, 283
cult of the original, 205
cultural imperialism, 251
cultural studies, xi
cult value, 3, 5–6, 11, 12–13, 14, 92, 117, 125, 126, 196, 200, 286
currency, 24, 28
cutting, 59, 65, 70, 183
cyber-sex, 82
cyberspace, 81, 82, 274, 277, 278

Dada/Dadaist/Dadaism, 49, 69, 72 (1920 Fair), 73, [73], 75, 77, 85, 144, 209, 210
daguerreotypes, 66–67, 119, 286
databases, 278
deconstruction, 10, 34–35, [35]
defetishizing criticism, 197, 222, [222], 229
demystification, 222, 272
depersonalization, 167
destruction, 112, 180, 187, 189
differentiation, 13
digital age, xiv, 38, 76, 87, 113, 117, 291
digital data, 6
digital media, 32, 33
digital photography, 66, 69, 76
digital recording, xii, 132
digital technology, 274, 278, 279
digitization, 69–70, 105
Dionysian, 296, 299
discontinuity, 239
discourse, 3, 64 (medical), 112–13, 157, 171–74, 279
Disney, 209
displacement, 179
dissimulation, 150–51, 153
distance, 2, 12, 15–16, 17, 18, 83, 96, 99, 125, 146, 128, 182, 216, 228, 256, [310]
distinction, 112
distraction, 55, 176, 196
division of labor, 48, 224, 231
double exposure, 50

economy/economic, 2, 87, 96, 110, 128, 230
eighteenth century, 3, [95], 151, 191, 192, 195, 203, 231
empathy, 60
empiricist, 6
engraving, 12, 109, 144, 145, 211
enlargement, 58
Enlightenment, 84, 171, 322
enlightenment, 275
environmentalist(s), 276
Erfahrung and *Erlebnis*, 258–61
erotic, 54, 99
etching(s), 12, 126, 211
exhibition value, 3, 5–6, 71, 72, 126, 180, 198, 201, 270

fairy tale, 208, 223
fake(s), 109, 126, 128, 149–51, 152, 153, 156, 170, 195

fascism/fascist, 9, 10, 40, 43, 53, 68, 78, 112, 156, 166, 168, 209, 236, 243–45, 247, 252–53, 92, 195–97, 222, 224–25, 226, 227–28
fetish value, 92–93
film, black and white, 106–8
film, color, 106–8
film/cinema/movies, xii, 9, 10, 12, 28, 31, 33, 36, 42, 45–48, 49–51, 53–62, [58], [59], [61], 65, 67–68, 70, [71], 77, 79–81, 82, [93], 94, 100, 105, 109, 116, 117, 133, 134, 135–36, 138, 160, 164, 165, 166, 172–73, 178, [180], [182], 183, 184, [184], 186, [186], 193, 196, 203, 205, 206, 207, 208, 209, 212, 219, 227–28, 231, 232, 235, 239, 245, 246, 251, 252, 254, 258, [260], 270, 274, 276, 279, 282, 283, 303–5
film editing, 69, 79, 206, 305
film theory, 25, 50
flaneur, 165
Foucauldian, 59, 105
fourteenth century, 266
fragmentation, 47, 66, 67
frame-by-frame, 55, [55], [61], 69, 88
Frankfurt Market, 100–101, 104
Frankfurt School, [35], 42, 91, 96, 197, 229
frescoe(s), 216
Führer cult, 112, 244
future, xi, 4, 62, 145–46, 202, 278

gaze, 67, 79–80, 114–16, 119–22, [121], 217, 218–19, 220
German Expressionism, 40–41
German Idealism, xi
German intellectualism, 166
German Reunification, 71, 78
gramophone, 31, 60
graphic effects, 22
guided tour, 309

habitus, 268, [268]
handcraftmanship, 214
Heartfield exhibits, 72–73
Hegelian, 222, 239, 241
here-and-now, 12, 21, 143, 144, 204–5
hero/heroine, 215
historicity, 56, 142
historicization, 283
history, 2, 38, 41, 60–62, 80, 84, 88 (industrial), 128, 196, 229, 239–42, 255, 257, [260], 262, 267–68 (literary), 275,

278, 290, 320
Hollywood, 252, 274
Holocaust, 106–7
humanist, 139–41, 151, 152, 177
hybrid(s), 82, 133, 136, 137, 139, 165
hypertext, 236, 264, 278
hysteria, 118–22

icon, 218
idealism, 96, 225
image(s), dialectical, 60, 61
image(s), prohibition of, 33–34
image(s), proliferation of, 148
industrial age/society, 156, 210, 251, 277
industrial engineering, 37, [37]
industrial revolution, 257, 274
information age, 225, 227, 274
information media, 221
infotainment, 82, 238
intellectuals, 2 (avant-garde and Bohe-
 mian), 110, 127, 137, 172 (Marxist and
 socialist), 242, 253
Internet, 227–28, 276–78
irony, [219], 284, 292–95, [295]

jazz, 11, 306–7
Jewish/Jews, 33, 108, 150

Kantian, 17
knowledge production, 173

Lacanian, 261
landscaping, 302–3
law, 271, 273
Leibnizian, 12
Leninism, 159–60
likeness, 117, [117], 118, 119, 167, 191,
 192, 204
literature/literary works, 105, 162, 213,
 [213] (courtly), 215–16 (courtly)
lithography, 12, 32, 68, 144, 145, 159, 211
Louvre, 266
Lukácsian, 226
lyric, medieval/troubador, 267, 268, 294

machine, 26–27, 76, 88–89, 134, 138, 139–
 40, 251, 257
magic, 46, 153, 154–55, 200, 223
magical value, 286
manuscript, 263–65
mapping, xii–xiv
Marxist(s)/Marxism, 2, 47, 89–90, 91, [92],
 97, 177, 197, 222, 226, 238, 239, 241,
 245, 258, 260, 270, 275
mass audience, 53, 177, 222
mass culture, 145, 147, 154, 169, 170, 205,
 210
mass market, 96
masses, xii, 2, 3–4, 8–9, 19, 35, [35], 36,
 38, 67, 70, 96–97, 106, 108, 112, 144,
 164, 165, 168, 173, [186], 207–8, 209,
 226, 227, 232, 233, 234, 239, 241–42,
 245, 246, 247, 270, 275, 276, 283, 284
materialism/materialist/materiality, 39, 62,
 84, 91, 96, 116, 177, 197, 206, 210, 241,
 250, 259–60, 285
Matignon accords, 90
media, 8 (of perception), 80–83, 212
 (concept of), 236, 255, 323–24 (modern)
media, digital, 32, 33
media, electronic, [59], 110, 113, 142
media, mass, 35, 36, 37, 38, 75–76, 78, 96
media, new, 3, 9, 106, 240, 247, 274, 280
media technology, 27, 32, 236, 238, 270
media theory, 24, 27, 32, 34, 35, [35], 43–
 44, 79, 211, 230, 235, 236, 238
melodramatic, 4
memory, 13, 61, 288
Middle Ages/medieval, 212–13, [213], 258,
 263, 264–65
Minitel, 82
modern, 91–92, 137, 242, 257
modernism, 25, 162, 251
modernist, 84, 258, 292, 322
modernity, 25 (archaeology of), 27, 76, 92,
 93, 96 (theorists of), 97, 226, 249, 263
montage, 45–47, 49–51, [61], 79, 144, 184,
 [184], 206, 239, 271, 309
Morelli's method, 151
museum(s), 151, 152, 157 (wax), 209–10,
 250–51, 253, 254, 278–79, 283–84, 308,
 316
museum shops, 131, 284, 307–9
music (see also "rock music"), 94–95, 306
mystique/mystification, 205, 256, 319

nativist, 5, 6
Nazi(s)/Nazism, 96, 144, 244, 270
negative idealism, 208
Neoplatonic, 130, 296
network(s), 82, 113, 133–34, 135, 138,
 236–37
newspaper, 70, 232
newspaper, illustrated, 68, 117

Nibelungen themes, 213
Nietzschean, 33
nineteenth century, 2, 3, 24, 25, 40, 46, 74,
 145, 172, 191, 224, 250, 257
Nintendo and Super-Nintendo, 276
nostalgia, 107, 258, 302–3
novel, 224–25, 259
Nuremberg, 96

object, 17, 22 (*objet montré* and *objet
 trouvé*), 85, 173, 183, [184], 197, 207,
 [237], 256, 262, 283
object, cult, 13, 182, 200, 262, 283
oral traditions, 142, 212
original(s), 32, 70, 72, 73, 77, 93–94, 109,
 126, 131–32, 147, 149–50, 153, 155–57,
 164, 182, 192, 193, 194, 205, 212, 231,
 256, 262, 264, [291], 292, 295, 296, 299,
 307–8, [310], 315–16, 317

painter, 46
painting(s), 72, 75, 76, 183, 190, 206, 228,
 264, 287, 317, 320–21
paradox, 15, 18, 20, 21, 46, 81, 137, 152,
 234
Paris, 67, 139, 318
Parisian salons, 203
perception, 3, 5–7, 20–23, 25, 26, 28
 (theory of), 32, 37, 49, [55], 58, 66, 67,
 [259] (crisis of)
performance, 88, 143, 144, [182], 183, 184,
 [185], 206, 254, 293, [295]
Petrarchan, 300
phenomenology (of looking), 14
phonograph, 193
photograph(s), 35, 56, 73, 111, [118],
 [184], 286, 319
photographic plate, 116, 193
photography, 2, 3, 12, 53, 68, 77, 94, 109,
 116, 117, 121, 133, 140, 148, 162, 192–
 93, 204, 205, 211, 228, 256, 270, 286,
 287, 318
photography, digital, 66, 69, 76
photomontage, 71–78
photomonteur, 71, 73–75, [75], 78
piano, 162
pixels, 69
Platonism/Platonic, 130–31, 250, 296,
 316
play, concept of, 19, 26
poem/poetry, 142, 214–15, 228, 249
politics, xi, xii, 2, 4 (aestheticization of),

43–44, 53, 70, 78, 86, 96, 112, 138,
 172–73, 198, 210, 217, 226, 242, 243–
 47, 253, 269, 271, 272, 284, 322
portrait/portraiture, 66, 82, 117, 286
postindustrial, 66, 278
post-Marxist, [92]
postmodern, 26–27, 215, 269
premodern, 148–49, 215, 221, 257
presence, 85, 125, 281–84
pretechical/pretechnological, 115, 212–13
print(s), 126, 131
printing/print culture, 81, 95, 110, 144,
 211, 292, 293–94, 295
progressive, 48
proverb, 271
psychoanalysis, 59, 119, 209, 254, 261–62

radio, 32, 34, 81, 232–33, 235, 274, 277–
 78
rationalist, 5, 89
reality TV, 82
Reason, 113
recycling, 78
relic, 92, 262
religion/religious, 13, 19, 83–84, 86, 92,
 102, 196, 216–17, 242, 324
remote control, 305, 309
Renaissance, 58, 151, 152, 224
replica/replication, 129–32, 204
representation, 175–78, 180 (destruction
 of), 182, 184, [186], 187, 314, 324
reproducibility, 30, 31, 33, 53, 105, 204,
 [260], 272
reproducibility, manual, 31
reproducibility, technical, 12, 31, 105–6
reproduction, 30, 91 (means of), 94, 99,
 105, 109, 115, [117], 120–21, 143, 147,
 158, 181, 191, [257], 299–300, 309, 319
 (modern methods)
reproduction, digital, 274
reproduction, manual, 77
reproduction, mechanical, 45, 65, 77, 84,
 85, 93, 94, 95, 112, 128, 141, 144–45,
 158, 175–76, 178, 205, 221, 226, 227,
 [237], 256–57, 262, 264, 289, 293, 295,
 297, 319, 320, 321, 323
reproduction, technical, 6, 11, 77, 84, 87,
 94, 126, 127, 130, 148, 149, 152, 154,
 159, [159], 161, 162, 167, 169–70, 175,
 181, 182, 184, 192, 211, 247, 291, 307
Resurrection, 224
revolution, 40, 111, 235, 246, 247, 253,

254, 273 (media), 307
Revolution, Conservative, 127
ritual, 1, 131, 198–202, 205, 217–18, 220, 322
rock concert, 296–98
rock music, 267, 291, [291], 295, 297, [298], 299, 300, [300]
Romantic(s)/Romanticism, 25, 57 (German), 94, 198–99, 201
Rome, 153

sacred, 26, 85, 148, 216, 262
Salpêtrière hospital, 119–22
scanning/scanner, 69, 81, 264
scroll, 111
sculpture(s), 204
Second Commandment, 148, 154
secular/secularization, 19, 25, 155, 196, 217, 226
shock, 33, 34, 35, 42, 54, 55, [61], 68, 178, 210, 260–61
shopping malls, 301–3
sign(s), 81, 148, 151
signified, 58
signifier, 58, 283
simulation, 58, 81
sitter, 66
skyhook(s), 134
slippage, 191
slow motion, 37, 58, [61], 80, 88
sound recording, 143, 193, 293, 295, 299
Soviet Union, 33–34
spectator, 50
spirituality, 178
star system, 252
statue(s), 93–94, 216, 311
story/storytelling, 221, 223, 224, 225, 259, 293, [293]
story of Job, [293]
subject/subjectivity, 121–22, 135, 173, 229, [237]
surgeon, 46, 59, 66, 183, 185, 316
surrealist/Surrealism, 85, 114, 232
symbiotic mechanisms, 23
symbol(s), 99, 100, [100], 168, 217
symbolic cloak, 99–100, 101–2, 104, 107
symbolism, 102, 103–4, 105, 122, 257

taboos, 170, 200
tactile/tactility/touch, 42, 43, 49, 50, 51, 54, 59, [61], 85, 127, 174, 197, 254, 282,

284, 308
Taylorism, 88–89, 159, 263
technique, 93–96, 112
technocrats, 278
technology, 7, 26, 60, 65 (cinematic), 66, 68 (development), 81 (military), 87–90, [93], 138, 175, 207 (cinematic and industrial), 231, 234, 235, 241, 244, 269, 272, 274, 300, 302, 305
technology, digital, 274, 278, 279
technology, media, 27, 32, 236, 238, 270
technology of reproduction, 25, 30, 204, 212, 218, 258
telegraph, 32
teleology, 84
telephone, 60
television, 34, 43, 81, 82, 97, 117, 276, 278, 305
test/testing, 46, 51, 59, 88, 206–7
text, 111, 130
textuality, logic of, 149–50, 152
theater, 283
Thirty Years' War, 40
time and space, 30, 60, 127, 130, 131, [257], 282, 284, 306
tool(s), 139–40, 211
Torah, 188
totalitarian, 96
trace, 260–61
transcendence, 108, 155
transference, 120
transistors, 156
transmission, 32–33
Trauerspiel, 41, 165, 169
tree(s), 302–3
tribal societies, 148
twelfth century, 267
twentieth century, 4, 25, 95, 126, 137, 145, 242, 279, 284
twenty-first century, xii, 278
typewriter, 60, 140

unconscious, 58, 59, 261
uniqueness, 12–13, 20–22, 95, 99, 126, 144, 162–63, 181, 184, 190, 191, 192, 204, 231, 257, [257], 293
U.S. Department of Defense, 277
utopia/utopian, 27, 29, 45, 223, 224, 229, 231, 236, 238, 255, 279

variation, 292, 293, 299, 305
video clips, 304

viewer, 165
virtual worlds/virtual reality, 81, 194, 277, 278, 324
visual medium, 193–94

Wagnerian, 296
Walkmen, 156
Warhol effect, 105
Weimar Republic, [56]
white/white society, 306–7

wissenschaftlich, 172
woodcut/woodcutting, 145, 159, 211
worker(s)/ proletariat(s), 3, 37–38, 88, 144, 171, 270
World-Mystification, 25
World War I, 32, 34, 35, 37, 40
writing, 110–11, 113, 152, 216

zapping, 118, 305–6